George Grosz

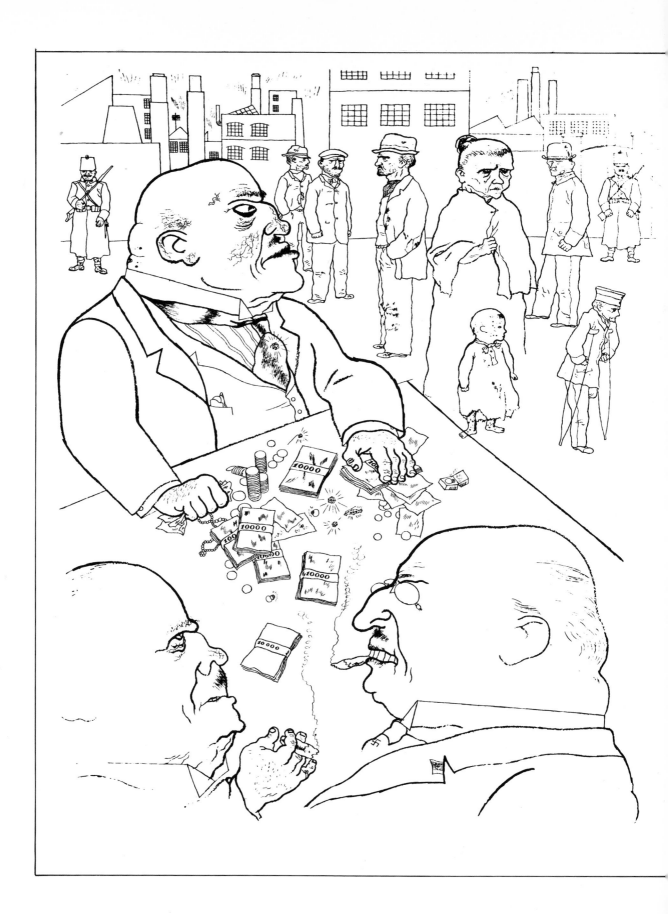

George Grosz

Hans Hess

Macmillan Publishing Co., Inc.
New York

Front jacket illustration
People in the street 1919
Watercolour, pen and ink
Back jacket and title page
Toads of property 1921
pen and ink drawing

Macmillan Publishing Co., Inc.
866 Third Avenue, New York, N.Y. 10022

First published in the UK by Studio Vista, a division
of Cassell and Collier Macmillan Publishers Ltd

Library of Congress Catalog Card Number: 74-7414

First American Edition 1974

Printed in Great Britain

Printed by The Shenval Press, London and Harlow

Contents

Acknowledgements

The present work is a critical biography of Grosz's development as a man and an artist. It is based on original material which is preserved in the Grosz Archives in Princeton, New Jersey, as well as on the rich collection of original and secondary material in the special Grosz Archive at the Akademie der Künste, Berlin. Grosz was a great writer of letters and post-cards. The many friends and acquaintances with whom Grosz exchanged letters are too numerous to mention: Brecht, Piscator, Wieland Herzfelde, John Dos Passos, Walter Mehring, are well known for their own work, but many of his personal friends did not rise to fame. Most were gifted and often amusing, and their letters fill the background of Grosz's life. Some have written about Grosz in their own published memoirs.

The Archives in Princeton contain nearly all the letters sent and received by George Grosz from 1932, as well as irregular entries from 1912 onwards. The Berlin Archives contain mainly earlier material, the correspondence with Otto Schmalhausen and Robert Michael (Bob) Bell. No doubt other potential sources of original material have remained untapped, but Grosz's writings and opinions are not only consistent but expressed so frequently in often repetitive forms, that much more of the same need not have shed new light.

The very personal help of Peter Grosz, the elder son, is gratefully acknow-ledged, as well as the permissions given by the Grosz Estate administered jointly by Peter and Martin Grosz, the younger son of the artist. Without the help of the Grosz Estate and its unusual generosity for allowing me to retain the original material for several years, the work could not have been done.

My thanks for personal information are due to Lilian Grosz, Lotte Schmalhausen, Professor Dr Felix J. Weil, Bernard Reis, and other friends of the artist. The most valuable source of information has been Professor Herzfelde, the lifelong friend of the artist, in personal conversations, letters and the valuable publications he has edited, particularly the complete Malik Verlag Bibliography; he has been most critical and informative. There is also a good bibliography on Grosz's work by Lothar Lang as a separate publication. Articles on Grosz from 1916 onwards are numerous, so are his

own writings, frequently reprinted. Yet the serious literature is not all that large. Amongst the articles, the best still are by Theodor Däubler, Willi Wolfradt and Mynona, essays and introductions by Wieland Herzfelde, Pierre MacOrlan, Marcel Ray, Günther Anders. The only recent book of any merit is the very readable and accurate study, *George Grosz: Art and Politics in the Weimar Republic* by Beth Lewis (University of Wisconsin Press, Madison 1971). Dr Alexander Dückers of the Kupferstichkabinett, West Berlin, has a catalogue of the artist's graphic work in preparation.

The bibliography has been selective, as two good bibliographies already exist. For bibliographical assistance, I wish to thank Mr Hans Beilhack, as well as the librarian of the German Institute, London, the Wiener Library, the British Museum, the Victoria and Albert Museum, the City and Business Library, London, the University of Sussex Library, and Mr V. Tasiemka.

In searching for photographs and the owners of Grosz's work, the help of many has to be acknowledged: Mr Peter Romilly of Sotheby's, who has been indefatigably helpful; Dr Emilio Bertonati, Galleria del Levante, for placing his knowledge of Italian owners at my disposal; Marlborough Fine Art (London) for their friendly assistance; Mr Mario Tazzoli, Mrs Vera Lazuk, Mr Achim Moeller, who have been most active; Erich Frommhold of VEB Verlag Der Kunst, Dresden; Mrs H. Ritscher of the Akademie der Künste, Berlin; Miss Ingrid Krause of Munich, and Mr Lunn of Graphics International.

Every possible effort has been made to trace the present ownership of Grosz's works. Wherever this quest has been successful, thanks are due the owners for their cooperation and permission to reproduce the work. Acknowledgements are made in the appropriate place.

A detailed biographical table has been included, as there is much information on Grosz's life and the locus for his many letters can be established— as a table of reference it should be of value.

The references (notes) in the text give the source, and nothing else. They are essential for documentation and verification of the evidence, but can be overlooked by the reader as they contain no additional information.

In the preparation of the book, I must thank Lillie E. Hess for the immense work of picture research, the tracings of originals and photographs, the identification of pictures from photographs in the Grosz Estate, from books, periodicals, catalogues, broadsheets and other forms of reproduction. She has also established the biographical table, the list of exhibitions, and checked the apparatus of notes and sources.

The helpful cooperation of the publishers, particularly Miss Jenny Towndrow, Mr Stephen Adamson and Mr Keith Kail should not go un-acknowledged. A book like this is something much nearer to a construction job rather than one author's literary work, the contributions of writer, researcher, editor and designer are of equal importance.

Hans Hess

I. Growing up in Stolp 1893—1909

Grosz's father had been a publican in Berlin, where Georg Ehrenfried Grosz was born in 1893 of Prussian Lutheran parents. The father had moved to Stolp five years later, where he became caretaker and barkeeper of the local Freemasons' lodge. Grosz remembered his father sitting in the porter's lodge reading illustrated magazines and drinking *Schnaps*, possibly too much for his own good.

The boy's earliest memories are of gaudy and gruesome pictures of the Boer war, the Russo-Japanese wars, and the German colonial wars, which were the weekly fare of the Magazine Circle to which the lodge subscribed. These cheap and reactionary magazines carried the ideas of German nationalism into the educated and half-educated petty bourgeois minds. Grosz later recalled,[1] with bitter sentimentality, the photographs in an album of his father and mother amidst the kitchen and cellar staff, and of his cousins and uncles, one in railway uniform. These photographs were lost, much to Grosz's regret—they were a reminder of the milieu in which he had grown up.

His father died when Georg was six, and the widowed mother moved back to Berlin to the poorer quarters, where she and her sister made a living by sewing blouses. The misery of the surroundings in the Wöhlerstrasse and the genteel poverty of their basement flat impressed themselves deeply on the child, and Grosz was to refer to them time and again in later life.

Hoping to escape from her wretched life as a self-employed poor seamstress, the mother obtained the position of housekeeper in the officers' mess of the Fürst Blücher Husaren, an arrogant élite regiment in Stolp. East of the Elbe the Junkers ruled, and little of the spirit of the cities pervaded the silent, reactionary climate of the place. It was as the son of the housekeeper of the officers' mess that Georg grew up. Thus, from his earliest childhood, Grosz was imprisoned in the meanest of German milieus, in Stolp, a desperately provincial town.

In Pomerania his mother's social position had certainly been raised; living on the premises, 'all found', with no worry about bills, she was sufficiently well placed to cherish some modest ambitions for her only son.

There were two sisters—Clara, the elder, and Martha, both older than Georg—but it was in Georg Ehrenfried that she had her hopes. He might go to the Realgymnasium, the second highest type of grammar school, leading to a final examination qualifying for university admission. (In fact, he went to an *Oberrealschule*, a lower level of school.)

In a German schoolboy's day there was much free time: school started early, at seven, and was over by twelve. All afternoon the boys could roam the countryside. Playing Red Indians, Georg and his friends built themselves a Red Indian wigwam in a timberyard, but they also spent whole days in the *Kneipen* where the farm labourers drank their cheap *Korn*. There Grosz met soldiers from the German colonial wars who filled the boys with tales of adventure in exchange for some cigarettes or a drink. They gave them intimations of a big adventurous world beyond the narrow horizon of Stolp which fired the boys' imagination. These early impulses and the sources of his imagination are worth recording, as they form his style and his character.

At the beginning of the century, schoolboys suffered from what can be called 'the America Cult'. It had two sources. One, the Red Indian mythology, expounded in Germany by the devastating and ubiquitous works of Karl May in forty-two volumes—best sellers for a generation—and the other the penny dreadfuls. The fantasy image of a remote wild world has its reflections in the works of Brecht and of Georg Grosz: a would-be Americanism in dress, expression and attitude. The mythical picture of America contained the schoolboy's dream of adventure, freedom, lawlessness and success. In an autobiographical essay[2] Grosz enumerates at length the many trashy books he devoured—his fascination with horrors of all sorts, particularly the electric chair and new forms of torture and cruelty. He also reveals the impact made on him by the gaudy cyclorama and panoptica of battles, arson, crime, rape and murder, which were shown at the annual fairs. On a raw youth like Georg Grosz, these horror scenes made the cruel sexual impact on which such representations depend for their effectiveness. No doubt thousands of other provincial youths saw the same things and reacted in the same predictable way, but only Georg Grosz became an artist, and in his work we can find the after-effects of such adolescent impressions.

He wanted to become a racing cyclist and trained on the track in Stolp with a number of friends, whose names he remembered forty years later,[3] but when he was only eleven he gave up this ambition and went on sketching tours. The low, flat countryside, with its dunes and sparse grasses, he remembered with love throughout his life. He even painted in oils. In a letter to his mother (Christmas 1937) he recalls the small oils which were then still in her rooms in Berlin. He had sold a picture through a local bookshop which pleased him very much. He filled many sketchbooks, which are still preserved.

In the evenings he drew by the light of a petrol lamp with a hard pencil, whilst above his room the officers of the Hussars were dancing the cakewalk and drinking champagne. The young boy's view of the world from below stairs becomes strangely distorted. The boy was impressed by the nonchalance and manners of those officers; their easy conquests, their riotous nights, and the popping of champagne corks. The 'high life', which the cheap

novelettes depicted, he actually experienced by proxy. His cousin Martin and he stole cases of champagne, carried them to the attic, and treated themselves to champagne and pornographic pictures collected at the nearby port of Stolpmünde. Grosz was growing up. The sailors in Stolpmünde knew a tattooing barber. Grosz later reported: 'I myself have just a little tattoo on a secret part of my body.'[4]

Grosz had a natural admiration for Kitsch, of which he was never ashamed. The pictures, after Bouguereau, which came with the chicory packets in Webers Karlsbad coffee additive,[5] impressed him as much as the heroic deeds in the illustrated magazines, the dirty postcards, and the cheap trash and glitter of the funfairs, and he continued to collect Kitsch throughout his life.

We now have to introduce to art history a form of painting not previously recorded: the 'soap painters', a now forgotten class of itinerant artists, who painted crude and vulgar pictures on mirrors in pubs with soap, or with chalk on the scoreboards of the bowling alley of the lodge, for the price of a few drinks. Those coarse sexual representations impressed Grosz, and when the bowling alley was empty he would improve the picture. But more important than the subject matter was the direct simplicity of the drawing—similar to children's drawings—which was to remain a definite source of Grosz's later work[6] and was recognized by him as such.

Georg was a schoolboy with the usual vices and virtues of that species: not well educated, adventurous, easily misled by boys somewhat worse than himself, and curious about sex.

Grosz is frank about his early erotic excitements. In a chapter of his autobiography,[7] he describes what one could otherwise only assume from his later work. The particular eroticism of a partly undressed woman in corset and stockings can be traced to his very first experience of watching as a boy, hidden and unobserved, a woman undressing. The chapter is a condensed version of a number of more or less successful youthful adventures with some of the cooks at Frau Grosz's kitchen. The kitchen of the officers' mess was not without influence on his life and art. His image of women, food and wine was partially formed by his early experiences. His mother's own excellence as a cook was duly appreciated by Field Marshal von Mackensen, who, lacking a sense of the ridiculous, bestowed a minor military decoration upon her.

Grosz had formed a friendship with a boy of his age who introduced him to the popular reading room, and tried to interest him in Haeckel's *Riddles of the World*. Haeckel, a crude pseudo-philosopher, was very influential with the under-educated of the time. His monist thought served as an answer to all the riddles of the world for those in need of a simple panacea. But Grosz preferred to read popular science books, and regularly *Das Neue Universum*, which was written in easy language for schoolboys, enthusiasts of popular mechanics, and naturalists.

A friend, named Kügler, had informed Grosz, in strictest confidence that 'God did not exist',[8] after Grosz had been confirmed in his Sunday best in the Marienkirche in Stolp.[9]

Half-digested knowledge with ill-assorted urges makes something like a private hell of a schoolboy's weird and dirty mind. Grosz was more honest about it than most, and his imagination was more vivid and more sustained.

A gift for expanding tiny events into romantic daydreams and speculating about his own importance in a world too big to be comprehended made him aware of his smallness, but also of his ambitions. It was then that he formed a mildly megalomaniac ambition of becoming a man of importance. The greatest of such ambitions in modern literature can be found in Thomas Mann's *Felix Krull*, in the seduction of the young Krull, never a very honest or serious young man, but one who might, according to his own choice, have gone straight or crooked. In a crucial scene which sets Krull on his course of petty crime as a con-man, he stands outside an elegant shop in Frankfurt looking at its display of leathergoods; and the poor and mean boy is seduced by being shown in one glance what a man can have for his money. It is a manly scene: leather belts, fine travelling trunks—all the paraphernalia which set a rich and well-groomed man apart from the common man. With sure instinct, Thomas Mann chose leather, illustrating one of those crucial encounters which determine the future life of a young man: his choice of road to the county gaol or the railway pension scheme.

A similarly decisive scene faced Grosz, as described in his autobiography[10] and in many letters. Once a week, the Paris-St Petersburg Express stopped at Stolp. This was the main sensation of the town. Every week he went and stared at the mysterious travellers and the beautiful, enigmatic women. This brief passing glance attracted and involved him in a glamorous world, outside his reality but well within the power of his dreams.

Once, 'The Biggest Show on Earth', Barnum and Bailey's Circus, came to Stolp, bringing Tom Thumb and other world famous artistes. Its arrival opened up a vision of escape for Grosz. 'Who', he asked, 'did not envy the artist?'[11] An unformulated urge for freedom from the constraints of his life was strengthened by the barrack-like atmosphere and discipline of a Prussian state school. All Prussian institutions exuded the grey, sinister atmosphere of the barracks and the prison. The fear of cruel punishment was the constant companion of a schoolboy's life. Opposite their house in Stolp was a reformatory which Grosz describes as a stark, prison-like building with unscalable walls, next to the cemetery. When its heavy iron gates opened, a sad column of boys in prison garb was led out to work. Boys who were in some trouble were told by their parents that if they did not mend their ways they would end in the reformatory.

The military discipline expected at the school was shattered one day when the young Georg could stand the humiliation no longer and slapped a teacher in the face. He was expelled from the school. He was fourteen years old and had not yet completed his first examination at the grammar school, the 'Einjährige', which was of crucial importance for a man's life. Not only was this the accepted certificate of a completed higher education, but those who passed the examination were privileged to do only one year's military service, as opposed to two years' for everybody else.

Whilst overnight the event had made Grosz the hero of his schoolboy friends, it was also a minor schoolboy tragedy. No professional employment was open to him and a career had closed before it had begun. The thought frightened his mother and worried the boy, and both were forced to make a decision. In the boy's mind a road of escape from the narrow, confined world of Stolp began to formulate itself. The expulsion from school was the final blow which determined the young Grosz to go and seek his fortune in

the great world. But to seek a fortune one must either have some capital, or connections, or be an adventurer. At that age, almost every boy is prepared to be an adventurer.

The adventure Georg Grosz chose was not to run away to sea or become a cowboy or a gold prospector, but to become an *Artist*. This was the escape road most likely to carry any weight with his mother. Being an Artist, and devoting one's life and soul to the pursuit of the fleeting goddess of Art, was thought to set a man above the rest of common humanity. The pursuit of Art was one of the few escape routes from narrow social restrictions. The only escape from commerce, regarded as a form of low life in the Kaiser's Germany, was the army, but this was reserved in its glorious forms for the nobility. The bourgeois and the petty bourgeois could escape from trade only by way of the university where one acquires *Bildung*, which sets one above the multitude, or, for the rare and gifted individual, by way of Art.

To the young Grosz, whose milieu was that of the meanest and most narrow of the German petty bourgeoisie, becoming an artist must have appeared as the road of escape to salvation. The possibility was given by a marked gift of accurate draughtsmanship, and a quite robust imagination.

His choice of profession, then, was already a protest against all the prospects which were open to him, which could not have been higher than that of a policeman or a railway clerk. His mother hoped that her son would be worthy of a secure and pensionable post, because the fear of the widowed poor is understandably the fear of an impoverished old age. A petty official with a state pension was every mother's dream for her son, and it was that of the widow Grosz as well. To be a railway man with a uniform meant being a member of the élite, within the narrow but realistic horizon of working class hopes. But that was not to be.

Georg Grosz's first revolt was in not conforming to the reasonable pattern of behaviour expected of him. He now had to face the consequences of his sudden and unexpected freedom.

He received his first drawing instruction from the head of a firm of decorators, a Mr Grot, who was trained in the Munich school and introduced Grosz to the linear style of *Die Jugend* as well as to the drawings of Wilhelm Busch. The *Jugendstil*, the German version of Art Nouveau, had some influence by making Grosz aware of the power of the line.

His own ambition was to become a genre painter like Grützner, and his dream was to paint Cavalry pieces. He copied Grützner's and other history paintings mainly from the officers' mess, relishing battles, soldiers and uniforms. He also began to send drawings and caricatures to the editors of magazines, but all were returned. Fortunately, Mr Pabst, the drawing master of his old school encouraged both him and his mother and prepared him for the entrance examination of the Academy at Dresden.

Thus, very early in his life, the conflict between producing caricature as a means of earning a living, and history paintings in the service of Art, presented itself in an uncomplicated form to Grosz.

2. At the Academy in Dresden 1909-12

Grosz had learned from his drawing master the elements of academic draughtsmanship: copying plaster casts on toned paper in chalk, charcoal or hard pencil, with hatching and modelling in the approved manner. When the sixteen-year-old boy presented himself, in his Sunday best and a new green *Jägerhut,* for the ordeal of the entrance examination, he met with the approval of the examining Professor Sperl, and was accepted. Then began the dreary, daily task of copying from casts. He did not in the least rebel against the strict discipline or the very dry and old-fashioned teaching. Grosz even became the sole pupil in a very nearly defunct class of composition, where History Painting was still taught. He wanted to be a painter and carried in his head the pictures he hoped to paint: carousing cardinals with wine glowing in their glasses, and military pieces with resplendent uniforms. These two recognized genres he hoped to combine, and present a mounted soldier receiving a glass of golden wine from a beautiful maiden.

His taste had been formed in Stolp, and so had his ambition to escape. What drove him on was a 'dark urge to succeed'. But to the true academician, Genre Painting is only a debased form of grand History Painting. This he learned when one day he brought a portfolio with assorted battle-pieces to his professor, who informed Grosz that only elevated thoughts could develop an elevated style. Such great thoughts could only be found in the Bible, and in classical antiquity, but never in the present. Grosz attempted a *Christ in the Garden of Gethsemane,* but he realized that this kind of subject did not move him.[1] He concluded that such elevated thoughts were not in him because they were not of his time. Baudelaire's dictum—that a painter must be 'of his own time'—had become axiomatic with young artists, and had spelled the death of ideal academic art. Grosz, discovering it for himself, drew the logical conclusion.

Grosz was a punctual and punctilious student, who met all the harsh disciplinary demands of the Academy. He lived in very modest circumstances and behaved in an exemplary manner, befitting his modest means. Yet in this undistinguished young man, some features of his personality began to develop. His days of schoolboy adolescence were over. He now

suffered some of the joys and troubles of a still very immature man. Trying to shed his provincial clumsiness, he became a smart dresser,[2] as a sign of emancipation, but it was a form of embarrassed dandyism of the young man who can't quite afford it. The figure of the 'gent' can be found in his own drawings.

More important than such outward signs of an unresolved embarrassment and an uncertainty about his position are his mental and artistic developments. At the Academy he could learn nothing new, and whilst constant application improved the mechanical skills, it could not add much to his thought. He had made friends with a number of students, and it was in that small circle that his own narrow horizon began to widen. His friend Kittelsen, a Norwegian, introduced him to the fantastic, demonic stories of Gustav Meyrinck. 'We two fed our fantasies with our own diabolic imagery of the future.'[3] Grosz was a great reader, now of better books. His taste for demonism and satire was satisfied by Meyrinck or Hanns Heinz Ewers. He discovered in himself a leaning towards the grotesque, the macabre, the fantastic. Mystical, erotic inventions were also found in Kittelsen's drawings, peopled with strange beings, part bird, part spider, in perspective distortions. The year was 1910, and the work of Kubin was known. Grosz occasionally followed such 'excursions into irreality' as he calls it,[4] but ultimately his scepticism and commonsense prevailed.

Through another friend, an artist from Prague named Barkus, Grosz became acquainted with the modern movement of his own day. They annoyed their teachers by taking books on Nolde or Van Gogh to the Academy, and listening with immense amusement to their professor's violent tirades against the degeneration of art.

The work of the painters of the Brücke group, active in Dresden, and the Blaue Reiter, in Munich, became familiar to the art students. The French painters became better known in Germany at the time, and Van Gogh became almost the object of a cult. Munch was admired. The very richness of the many experiments in painting and colour excited the students. But at the Academy, the separation of art from what was happening in the real world, even in the world of art, remained complete. Fully aware that he could learn little more at the Academy, Grosz began his own studies after nature. Drawing in small sketchbooks, aimed at the rapid capture of fleeting impressions, learning to draw anything and everything, appeared to him the best preparation for his future as an illustrator. He studied Japanese draughtsmanship as well as the work of Daumier and Toulouse-Lautrec. At this time he was constantly attempting to bring his own drawing nearer to life; it was, he said, still too ornamental and decorative. The draughtsmen of the *Simplicissimus*, Bruno Paul, Preetorius, and Gulbransson, impressed him, and after seeing an exhibition of original work by the illustrators he began to change his style. He now began to draw the contours of a figure in one even line, and lay in a wash in ink. He also began using a reed pen, still following a pencil outline. Slowly he moved away from the deadly practices of the academic conventions. His use of colour for such delineated drawings was still decorative, and in good taste, as he said. Any idea of grandiose painting was given up, as he thought more of making his way with illustrations and caricatures. He was still sending drawings to the illustrated papers, and still they came back. But one day, *Ulk*, the

satirical weekly supplement of the *Berliner Tageblatt*, one of Germany's best-selling newspapers, accepted a drawing. Grosz's pride was great, and with his fee of twelve marks he bought himself a new pair of American patent leather shoes. When he saw his work in print he was unbelievably happy. He was only seventeen, and had come to the point where his 'small Pomeranian footpath reached the broad highway of the comic illustrators'.

Café (fig. 1), a pencil drawing of 1909, is an example of what Grosz called *Linienstilistik*. Although this is, as Grosz knew, not a particularly original drawing and owes everything to the prevailing mode, it is in some respects more interesting than the artist may have known, because, contrary to the usual silhouetted drawing, there is in this café scene already an interest in the simultaneity of different events within still orderly perspectives. His first published drawing for *Ulk* (fig. 2), however, in 1910 is far more conventional in the style of *Die Jugend*.

In his watercolour *River Landscape at night, Thorn* (fig. 3), his work and technique are influenced by the prevailing school of poster artists. This strong composition with its large, closed forms does not lack in concentration and monumentality. The young man who organized this picture was certainly capable of further development.

1
Café 1909
pencil drawing, signed and dated, 9⅜ × 9 in., 23·9 × 29·2 cm.
Formerly Estate of George Grosz

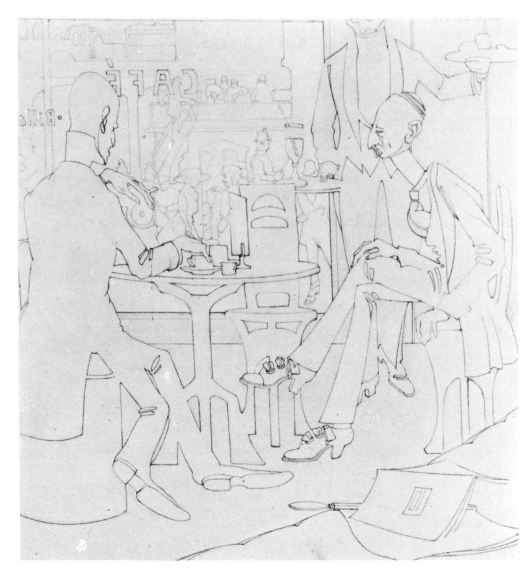

2
Two Men watching a Couple
1910
pen and ink drawing, signed
Ulk 4 February 1910

His small success with *Ulk* encouraged Grosz so much that he drew hundreds of sheets which 'always represented the same subject in modification —two opposed grotesque figures'. He also invented his own jokes, which according to him were as unoriginal as the drawings. Later in life he considered these efforts worthless and imitative of Klinger, Beardsley, Preetorius and the Simplicissimus artists, though at the time he was somewhat smugly satisfied with himself.

Already then, not without some resentment, he began to despise Art: 'The concept of artistic value did not play any part in my decision to become a caricaturist', and when he made the decision to become a caricaturist he was, so he says, moving away from the 'educated circles where the artistic judgements of the time were made'.

Politics, Grosz wrote, played no part in his thinking. He remembered a social democratic demonstration demanding universal suffrage, which was dispersed by the police and the army. The students, he recalled, sympathized with the crowd, but they had come out of curiosity and not as partisans: 'we all came from more or less petty bourgeois surroundings'.[5]

3
River Landscape at Night,
Thorn 1910
watercolour, signed, $8\frac{3}{4} \times 11\frac{1}{4}$
in., $22 \times 28{\cdot}5$ cm.
Piccadilly Gallery, London

Fashionable philosophers, too, played little part in his thinking. A friend of his called Erwin Liebe had not only written a bad (and involuntarily funny) long play—*Jesus Christ in Zeitz* (about a Christ figure returning to the modern world)—but he had also absorbed that vast body of pseudo-philosophic literature which was confusing the minds of soul-searching young men. It is not always the original writer or philosopher, but his disciples who create that confusing welter of half-digested thoughts mixed up with emotional aspirations that form the body of a prevailing intellectual climate. The very literacy and the thirst for knowledge which prevailed amongst the under-educated but aspiring young minds of Grosz's time, made them easy victims of high-sounding but empty philosophies and panaceas. Revolting against their underprivileged material position, they decried what they thought of as 'materialism', and devoted their lives to the cultivation of their souls. When a young man like Liebe tried to convince the young Georg Grosz (over a bottle of very bad liqueur) that the aim of all art was spiritualization, the absolute spiritualization of the filth of this earth into the mystic symbolism of the Lotus flower or the Holy Grail, he only repeated what more respected artists also claimed as the purpose of art. And if young Liebe found the mystic kernel in the spiritual,

symbolic, arch-Germanic soul, and the writings of Houston Stewart Chamberlain, Langbehn's *Rembrandt als Erzieher*, oriental philosophy, and the theory of the German race,[6] he was not unique but merely typical, and just as near to fascism as his more respected masters. That poor Liebe even found such wisdom in the writings of Karl May, whom he put on a pedestal with Nietzsche, shows a lack of literary discrimination. Yet, if one chooses to see the superman in Karl May's *Old Shatterhand*, then Liebe had at least understood the unity of all hero worship.

Despite the fact that his upbringing and background were not all that different from Liebe's, Grosz never fell for pseudo-philosophies. A cool and sceptical disposition preserved him from belief in easy, mystical solutions. He was not a tormented soul; he had quickly grown out of his adolescent romanticism. Although his mistrust had prevented him from falling into the trap of mysticism, he formed a parallel mistrust against science.

In *Das neue Universum*, month by month science was presented as infallible and positively certain of all its assertions. Grosz mistrusted it.[7] Any thought claiming to be scientifically proved aroused his suspicion. Grosz never shed that mistrust, which he had formulated so early. He mistrusted simplification and became the victim of his own form of simplified mistrust. There is a form of popular scepticism which is the reverse of the coin of popular ignorance, and just as fatal.

Before he left Dresden, the Academy had acquired from Grosz *Male nude*, a chalk drawing, and a 'fantastic' (as he calls it) pen and ink drawing, *The Yellow death*. This sign of recognition, which was not infrequently given to promising students, was to have some totally unexpected consequences twenty-odd years later. Grosz also received a diploma and a certificate of merit.

In 1912 he moved from the Dresden Academy to Berlin, for the simple economic reason that a Prussian citizen could not get a State Scholarship in Dresden in the Kingdom of Saxony. His student days were not quite over, but it was a changed young man who set out for Berlin: no more the raw youth from Stolp, but an aspiring caricaturist.

3. In Berlin before the war 1912-14

What Berlin lacked in antiquity and tradition, it tried to make up for with modernity. Originally the capital of Prussia and since 1871 the capital of the German Reich, Berlin enjoyed a new industrial and commercial prosperity. It was self-consciously promoting itself as a metropolis—what the Germans called a *Weltstadt*. Since the unification of Germany, the role of the constituent kingdoms and principalities had been weakened. This loss of independence made itself felt outside the capital. The royal academies of Bavaria in Munich and of Saxony in Dresden lived mainly on their traditions. But Berlin, now the centre, appeared modern and lively. The young Grosz felt it and said so.

The masters of German Impressionism: Liebermann, Corinth and Slevogt, worked in Berlin. The Art School, where Grosz went to study, was much more open to modern influences than the academies had ever been. Art dealers exhibited not only Cézanne and Van Gogh, but also Matisse, Picasso and Derain.[1] Newspapers were livelier than anywhere else, theatres better, and the circuses, variety theatres and cabarets, were wittier than elsewhere in Germany. The Berlin newspapers, particularly the *Berliner Tageblatt*, quite deliberately promoted Berlin as a centre of the world of the arts and entertainment. A number of competent critics wrote for the daily press, and an uncountable number of periodicals devoted to the graphic arts, literature, poetry, design, architecture and interior decoration appeared weekly or monthly.

For an eager, curious and adventurous young man from the provinces, Berlin appeared as a real centre of attraction. All the things Grosz had only read about were actually happening there. Life was not expensive, and even with only a few marks it was not too difficult to have a good time.

But next to the arts of the 'high culture', which are reviewed seriously and form the subject of educated discourse, a different sort of art flourishes, which is overlooked, yet is more popular and more influential than the arts of the museums, the dealers, and the literary periodicals. The submerged arts and entertainments are not only important because of the numbers they attract, but because they attract artists whose own work is eventually adopted by the 'higher culture'.

Grosz at the age of twenty-one was vastly more entertained and in-fluenced by the gruesome pictures of the panoptica of his youth than by Delacroix. In Berlin he went to circuses, six-day bicycle races, and dancing competitions. He loved the funfairs, where whole families of itinerant artists, acrobats, and dancers, lived in their garishly coloured caravans. Grosz made many sketches and painted a picture in orange, green, and gold, inspired by a red, green and gold booth with dancers who performed, even that early, pastiches of the tango. He preferred the lowliest drinking places for the atmosphere, the types, the colours, and the spirit, and felt at home there. To him, 'the people' was not an amorphous mass of strangers or workers, but living, colourful oddities of the human species. If he invented types, they were the summary of experiences of individuals. They were known, studied, and even loved. Grosz was a sociable person, a good story-teller, a good drinker, who liked to spend the night out with friends and strangers. He went to the beer palaces 'as big as railway stations', the huge wine restaurants covering four stories, as well as the many small, sordid, noisy, corner pubs (called *Stehbierhallen* in German). What attracted Grosz was any popular expression of life—vulgar, but honest and real. He also spent his time in the accepted elegant cafés, sitting for hours on the terrace sketching the various types of humanity.

A friend from the Dresden Academy, Herbert Fiedler, who was to be a close friend to the end of his life, had arrived in Berlin before Grosz. He concentrated on painting 'men at work', 'men in the open air', 'railway men', 'linesmen', and similar subjects. Together they went on sketching excursions, and discovered a new world, the periphery of the city: semi-deserted acres, with half-finished new buildings, railway crossings, rubble heaps and allotments.[2] It was a fringe world between the city and the country, a phenomenon of the expanding town devouring the countryside. The strange silhouettes of the cityscape interested Grosz.

Once in Berlin, the progress made by Grosz as a draughtsman was astonishingly fast and clearly visible in his work. If in 1912 his *Linienstilistik* was still static, as can be seen in the well-composed drawing for an illustration (fig. 4), which owes a good deal in conception to Feininger whose work

4
Group of People 1912
pencil drawing, signed
Kunst und Künstler November
1930, p. 59

as a caricaturist, also for *Ulk*, was of a very high order and admired by Grosz,[3] the next drawing, of a street scene in one of the suburbs (fig. 5), shows a break in style and content. People at action are portrayed, but the straitjacket of the *Linienstilistik* has been somewhat loosened. And in a sketch of a hurdy-gurdy player (fig. 6), a total freedom of observation has been achieved, and a quick retention of outline and weight is fully realized. This drawing is also very similar to Feininger's (unpublished) pencil sketches, and both artists, quite independently, had reached very similar conclusions. This identity of view was purely coincidental, and both developed in very different directions, but at the same time a similar task and a similar aim produced very similar results. The outcome of this greater ease is shown in the way a drawing of 1912 for *Lustige Blätter* (fig. 8) has totally freed itself from self-conscious stylization, and gone a long way in depicting life and reality.

The semi-deserted patches of no-man's land in the suburbs of Berlin, at the time took the place of nature studies for Grosz as in the simple drawing of terraced houses (fig. 7). Such orderly habitations will soon disappear from his work, but the basis of his art was that of a close study

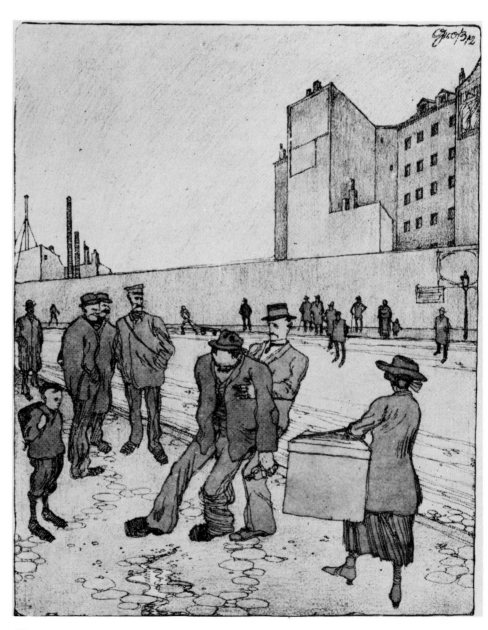

5
Street Scene, Berlin suburb 1912
coloured crayon drawing,
signed and dated
Kunst und Künstler November
1930, p. 56

6
Hurdy-Gurdy Man 1912
pencil drawing, dated and
inscribed
Kunst und Künstler November
1930, p. 60

of the subject. The big city, the metropolis, the *Grosstadt*, that novel,
megalomaniac monster devouring men and women, impressed Grosz before
he could find forms of expression for this new historic experience.

The modern city, loud, glaring, fast and anonymous, attracted Grosz
more than anything else. Although Berlin was a sedate and spacious city,
it had an aggressive spirit—jovial and bad-tempered, bitter and senti-
mental, at the same time.

Grosz described a scene in a cheap dive, which can be read as premonition
of Dada. In the Café Oranienburger-Tor, a *Radaukapelle*, which Grosz
describes as a Palm Court Orchestra gone mad, erupted. The conductor tram-
pled on the instruments, threw the bits into the audience, picked a fight with
the musicians, stood on the piano and poured beer into the trumpet, and the
public roared with approval.[4] Grosz described the scene as a premonition
of the dance of death that was to come, but it is also a pre-Dada manifesta-
tion, for original Dada was meant as a protest against the dance of death
which was then ending.

7
Suburb in Berlin 1911
pencil drawing, signed,
$5\frac{1}{8} \times 10\frac{9}{16}$ in., $13 \times 26 \cdot 9$ cm.
Formerly Estate of George
Grosz

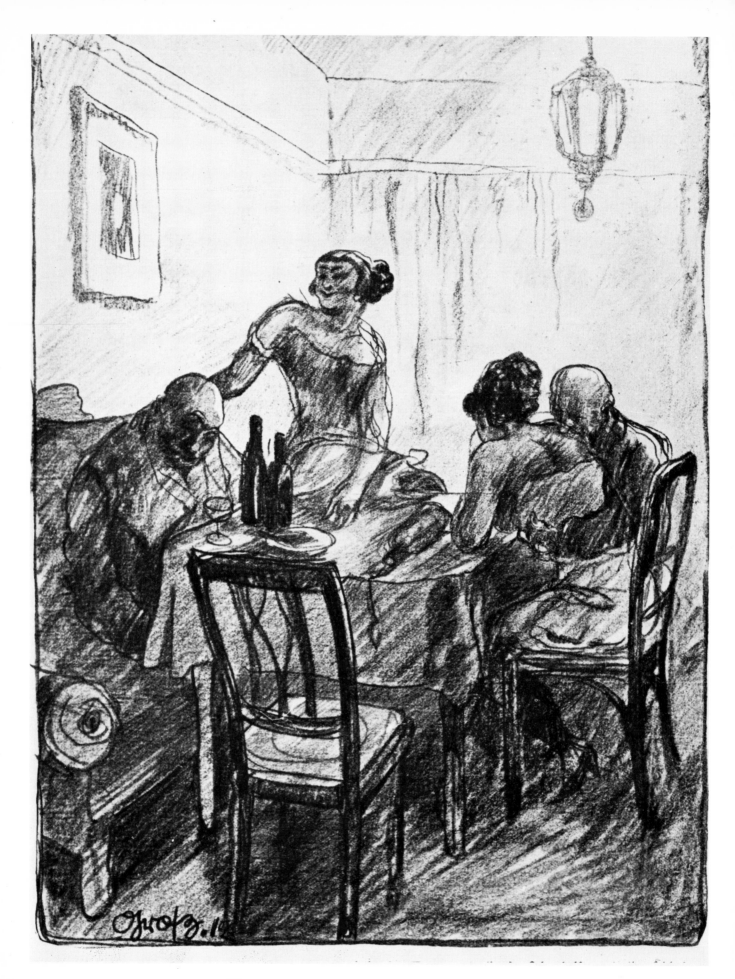

For Grosz, those years before the war were the age of great parties—fancy-dress parties, artists' parties, theatre parties, carnival parties—and the age of sexual liberation in literature and the arts, and in society behind closed doors. There is an eye witness account of Grosz at the Art School Ball in a letter written by Feininger to Schmidt-Rottluff many years later: 'George Grosz I had seen . . . at the *Kunstgewerbeball* in 1912. Then he was a shy frail young man—who had drunk a bit more than was good for him—he was hacking away with a bayonet in a frightening way on the pretty white tablecloth so that deep cuts appeared on the edge of the table. That evening he was not the shy youth but a Viking.'[5] After one year in Berlin Grosz had changed a good deal.

The desolation of the individual in the big city becomes a silent subject in Grosz's work of the time. The *Tramps* of 1912 (fig. 9) is a wonderfully observed drawing of types, almost symbolic in their alienation. Grosz depicts the totality of their hopelessness. The tramps are outcasts, but in

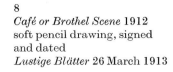

8
Café or Brothel Scene 1912
soft pencil drawing, signed
and dated
Lustige Blätter 26 March 1913

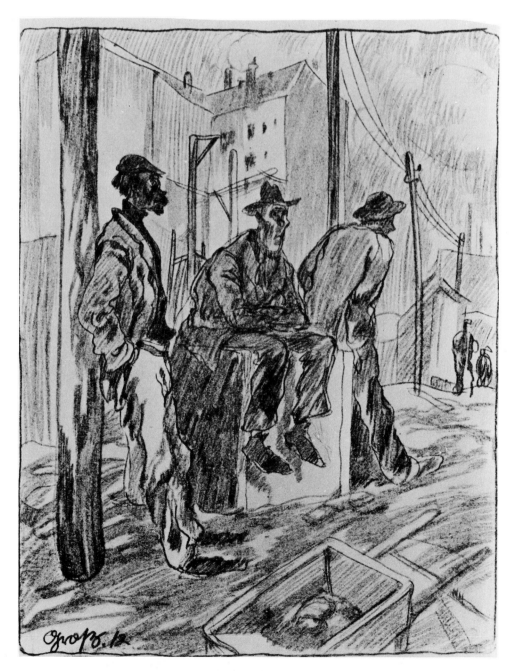

9
Tramps 1912
black crayon drawing
Ade Witboi, p. 6

10
Ants I 1913
lithograph
Die Gezeichneten 1930

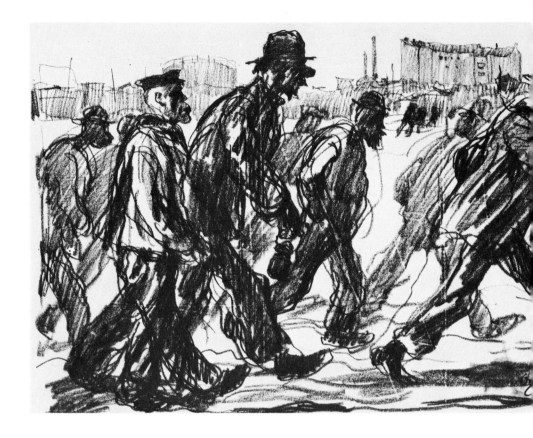

11
Street fight 1912
charcoal drawing, signed and
dated, $10\frac{3}{4} \times 14\frac{5}{8}$ in., $27\cdot4 \times$
$37\cdot1$ cm.
Estate of George Grosz

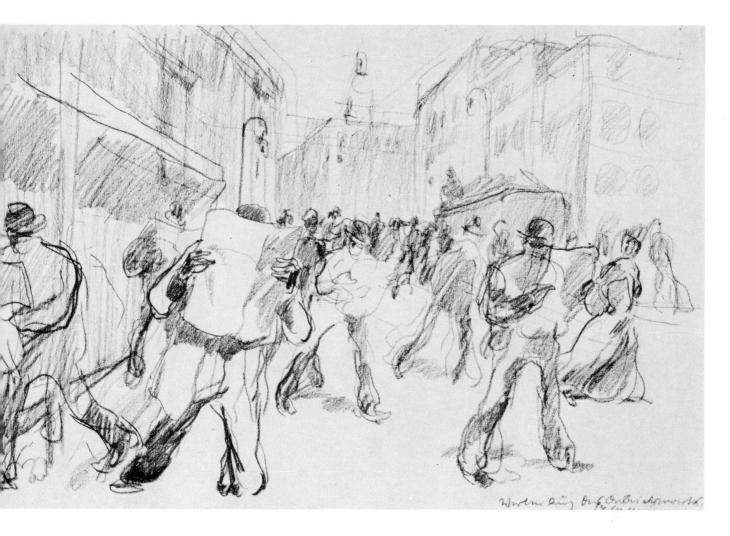

Ants (fig. 10), a proletarian theme is chosen which is still bleak. The men are going to the factory in the cold of the morning; they carry the proletarian overtones of the realism of Steinlen. This symbolic realism is heightened to the point of a more traditional symbolism. A suburban setting of murderous appearance has become the scene for *Street fight* (fig. 11). These drawings have a controlled mastery of the medium and an intense concentration.

Grosz had become aware of Futurism and its intensity, and whilst these drawings do not owe anything to the Futurist organization of the picture space, a very similar spirit pervades Grosz's work. The 'fleeing in all directions' characteristic of Futurism is exemplified by a drawing of 1912, *Situations vacant* (fig. 12): the hunt for jobs; the rush of competing individuals.

In Berlin, bourgeois streets were enhanced by the large number of prostitutes, observed by Grosz with their large feather hats and feather

12
Situations vacant 1912
charcoal drawing on brown
paper, dated and inscribed,
$8\frac{1}{2} \times 12\frac{7}{8}$ in., $21 \cdot 4 \times 32 \cdot 5$ cm.
Estate of George Grosz

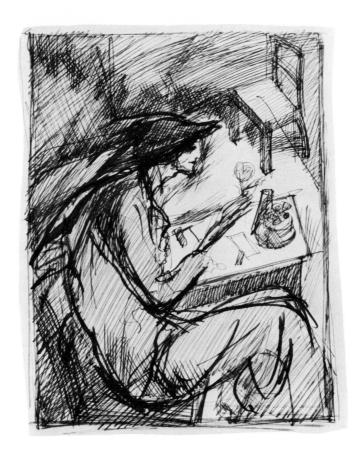

13
Woman Seated at a Desk 1913
pen and coloured ink drawing,
signed, $5\frac{3}{8} \times 4$ in., $13\cdot3 \times 10\cdot2$
cm.
Minneapolis Institute of Arts,
Minneapolis, Minnesota

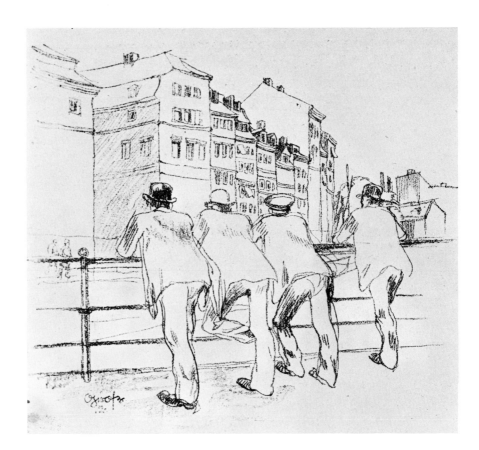

14
Connoisseurs 1912
Lustige Blätter, vol. 28,
no. 4, 1913

boas,[6] looking as they are painted by Kirchner in his many versions of women in the Friedrichstrasse. They were also described and drawn by Grosz in 1913 (fig. 13).

At this time he lived in a studio in Berlin Südende, a dreary part of the city to which he remained attached, dividing his time between studies under Professor Orlik at the Art School, his own work, and a good deal of serious dissipation. Much of his work was published. His drawings for *Lustige Blätter*, neither caricatures nor cartoons, are serious drawings of a quality rarely equalled by him or other draughtsmen of the time. Owing something to Daumier and Käthe Kollwitz, they are yet wholly original in concentration and execution. They rank amongst Grosz's best drawings and amongst the very best of the time. The editor of *Lustige Blätter* must have been aware of their quality, because there was no obvious reason for a satirical weekly to take these drawings at all. They are independent works of art, without any specific topical relevance (figs. 14 and 15).

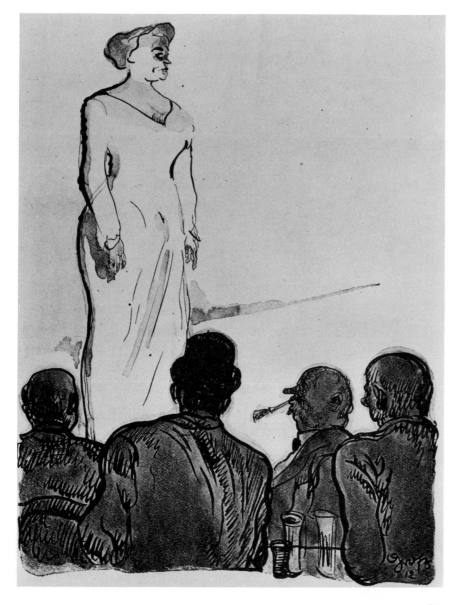

15
Yvette 1912
Lustige Blätter, vol. 28,
no. 8, 1913

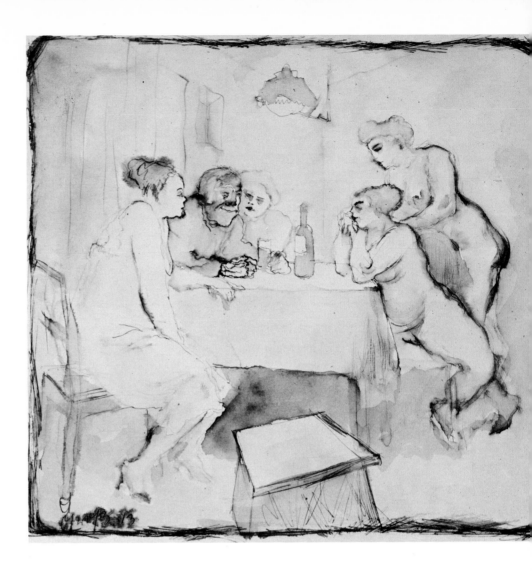

16
Intimate supper 1913
ink wash drawing, signed and
dated, 8 × 8½ in., 20·3 × 21·6
cm.
Richard L. Feigen Gallery,
New York

The way Grosz was developing his style is apparent in two contrasting drawings, similar in subject. In *Intimate supper* (fig. 16), an almost pastoral mood still prevails. There is a touch of gentleness in treatment and spirit, and the draughtsmanship of French Rococo used ironically. In *Orgy* (fig. 17) the hard, crude and realistic touch of his contemporary Zille is heightened into a sordid scene. The harshness of the drawing, its play with light and shade, takes Grosz a step forward. Yet it is in manner still a traditional drawing.

The next step, taken in an ink and watercolour drawing—the *Harem* (fig. 18)—goes farther in the direction Grosz was to take. Stylistically it is not as novel as it appears. Slevogt had developed a very similar manner, and the mildly allegorized subject kept the drawing firmly in the field of acceptable art.

Grosz had not quite got over the shock of having been thrown out of school—he still thought of himself as a miscreant. Knowing that he liked the easy life and had expensive tastes, he was never quite certain if he

17
Orgy 1912
pen and ink drawing, signed,
dated and inscribed, $7\frac{11}{16} \times$
$10\frac{5}{8}$ in., $19 \cdot 6 \times 27$ cm.
Private collection

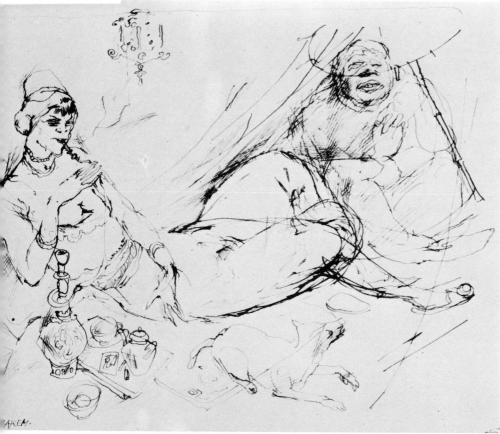

18
Harem 1912
pen and ink drawing, signed
and inscribed, $7\frac{1}{2} \times 9$ in.,
$19 \cdot 1 \times 22 \cdot 9$ cm.
Achim Moeller Ltd, London

might not end badly, and hovered between a petty bourgeois sense of responsibility and an easy-going life. A revealing postcard to Bob Bell reads: 'I reaffirm to those who think ill of me, that I am a pure, tasteless, good, moral, honest and stupid person. P.S. Furthermore I am blond and blue-eyed.'[7] 'I am not an artist any more; I have given that up. I am now a bourgeois, or rather attempt to be one. I have therefore adopted all his habits.'[8] This he writes from a very dull holiday in Thorn, where his mother had since moved, cooking no more for the Fürst Blücher Hussars but for another regiment, and overfeeding her son. What rings true in the statement is that Grosz saw a distinction between his life as a good son being fed by his mother, and the life he led in Berlin and liked so much better.

In reality, Grosz never became a permanent bohemian. His sense of work, his respect for craftsmanship and solid achievement, were too strong to allow him to end his early days as a drunken genius.

Whilst in Thorn, Grosz made excursions to the country along the Vistula with his sketchbooks. He described the mixture of peoples—Russians, Poles, Jews (all poor)—who filled the square where the Copernicus monument stands, and observed their crude habits, their hard and dirty work, their hard drinking, their stupor and backwardness. There speaks the Pomeranian boy to whom the East is strange, dirty and menacing, and it is a memory which will remain. Thorn then was an overcrowded garrison town, full of soldiers. He blames the bad temper of his letter on 'his social democratically infected anti-militarist brain, which is badly affected by the uniforms. . . . There are so many soldiers,' he writes, 'that the civilians have disappeared.'[9]

And here a question must be asked, which cannot be answered. When, where and how did Grosz acquire his social democratic anti-militarist outlook? Of course, he could read all the papers and pamphlets which were published, but a selection has to be made of those one wants to read. Certainly *Simplicissimus* was outspoken and radical, and made fun of Prussian officers and bureaucracy. *Ulk*, too, had a liberal inclination, but satirical magazines, which interested Grosz both for their drawing and for their content, are not enough to determine a young man's political commitment. What had happened in the few years in Berlin to turn the unpolitical young man into a 'social democratically infected anti-militarist'?

Was it the influence of one or more friends, discussions in Berlin cafés, or the Art School? We do not know. All we have is his own evidence that he detested the military system already in peacetime. Certainly, he followed his inclination and temperament; he disliked subordination and blind obedience. He may well have been a rebel, but even rebels are in need of some argument and theory. Not that his theoretical political knowledge ever amounted to much, but his emotional capital of disgust was considerable.

Back in Berlin he began painting in oils. He had never been taught painting (only drawing at the Academy). He bought a few books and taught himself. He began to compose in the manner of his drawings, drawing on the canvas in ink, and painting afterwards with oils. The pictures were, he says, conceived from the line, more coloured than painted.[10] This statement is of great significance, as it betrays Grosz's uncertainty about his paintings. He felt himself to be a self-taught amateur and not a real painter. How

wrong he was, we shall see, but that feeling remained and was to be crucial in his later development.

Herbert Fiedler had gone to Paris in 1912, and his enthusiastic letters persuaded Grosz to follow. When Grosz went to Paris, he studied at the Atelier Colarossi. This was important to him, as it was to many other painters of the time, for Colarossi taught one thing, and it appears one thing only, and that was the 'five minute sketch'. At Colarossi's the model stood in one pose for five minutes. During those few minutes the student had to finish his work. This, of course, was exactly what Grosz had tried to teach himself in the Café Josty: to observe people and capture them in a moment. At Colarossi's a pose had to be seen and fixed in those five minutes, whereas at the Academy in Dresden it had been three weeks. Of all the teaching Grosz had received, those few months with Colarossi were the most valuable for a man of his temperament and gifts.

Much later[11] Grosz recalled the happy days at the Bobino Music Hall, Rue de la Gaité, probably the favourite place of the artists of the time. He remembered the Café du Dôme, and Pascin, whom he had already met in Berlin and with whom he shared some similarities of style. Kisling he knew too, and no doubt some other painters presumably of the 'Dôme' circle. At the time Paris appeared as 'enchanted', so he tells Pechstein.[12] Pascin he admired[13] for his erotic drawings, the *raffinement* of the line, the minimal hint, and the omissions. Pascin could, when he was stimulated, draw for hours and 'weave his arabesques' around the model's most sensitive parts.

The year 1913 was the most important year for his personal development as an artist. Grosz was only twenty. His growth towards maturity had been fast; he had laid a good foundation of draughtsmanship. With a sudden simultaneous burst of invention in manner as well as in subject matter, he found a new form for his ideas. Having developed from tradition and convention, it was given to him to become totally original, one of the most remarkable and remarked upon figures of the twentieth century, who even as a young man acquired wide fame for his unique inventions.

Grosz was amused by any form of freakish behaviour, not because he thought it unusual, but on the contrary, because he thought that everybody was a freak of sorts. He collected absurdities as some people collect butterflies. His drawing *Sideshow (abnormalities)* (fig. 19) is one of the many examples. His work began to centre on the outcast, the freaks, the circus, the unreality of the masked ball. From the abnormal, abnormal in the sense of living on the fringe of bourgeois society or in the masked ball for the bourgeois, himself pretending for a night to live in an abnormal situation, Grosz drew the subjects of his work. In the process of forming his subjects, he ceased to be the observer and became a participant in the rhythm and the mobility of the action. In the *Entrance of the clowns* of 1913 (fig. 20), a tumbling spiralling rhythm is not only expressed but experienced, and in *Variety act* (fig. 21) we see for the first time a new spatial organization in the picture, where the viewpoints are multiplied and several conflicting picture planes form a space, based not on traditional perspective but on a combined perspective of invisible planes. The picture creates a sense of movement and of flight which becomes part of the spectator's experience.

The Affaire Mielzynski (fig. 22), considered for its spatial organization,

19
Sideshow (abnormalities)
c. 1913
ink and watercolour drawing,
signed and inscribed,
$7\frac{7}{8} \times 9\frac{3}{4}$ in., 20×48 cm.
Private collection

20
Entrance of the clowns c. 1913
watercolour, pen and ink
drawing, inscribed,
$7\frac{1}{2} \times 10\frac{1}{2}$ in., $19 \times 24\cdot1$ cm.
Richard L. Feigen Gallery,
New York

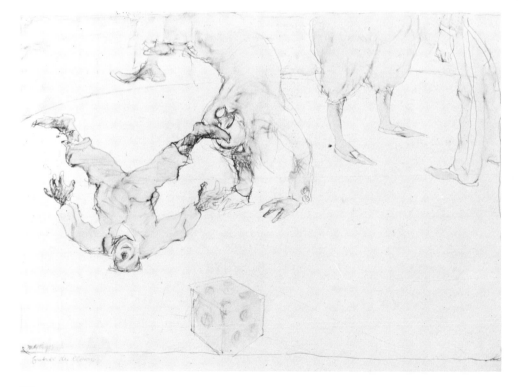

contains a Futurist element of simultaneous action, unified still by the depiction of one event but organized in a wholly new way. Even more powerful is *Assassination* (fig. 23). The direct participation of the spectator as part of the events of the picture distinguishes this new development from a drawing of the same year: *End of the road* (fig. 24) which, with its conventional space organization, remains an illustration, strong and competent but lacking in that new power, leaving the spectator outside the event. Such drawings are the forerunners of some of Grosz's paintings, and are in themselves entirely valid and new creations in the expanding field of modern art, where the space concept of the past was questioned by all the innovators of the time. Without the benefit of theory, possibly without realizing it himself, Grosz was in the forefront of the artistic advance.

21
Variety act c. 1912
pen, ink and wash, signed and inscribed, 11½ × 9 in., 29·3 × 22·9 cm.
Achim Moeller Ltd, London

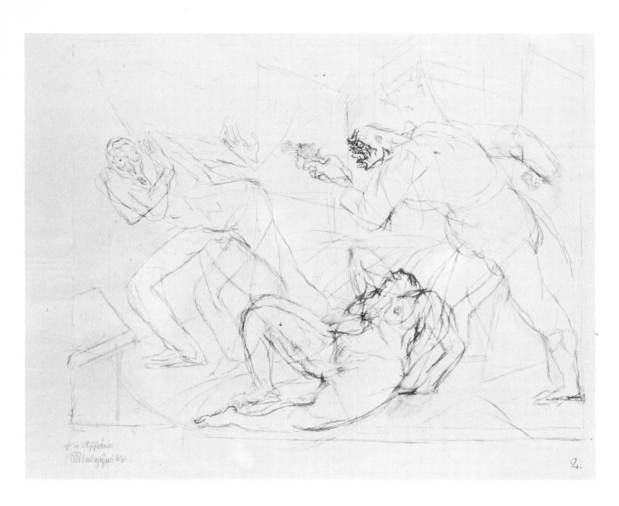

24 (*right*)
End of the road 1913
watercolour and pen
signed, $10\frac{7}{8} \times 8\frac{5}{8}$ in.,
$27 \cdot 7 \times 21 \cdot 7$ cm.
Museum of Modern A
New York

22
The Affaire Mielzynski
c. 1912–13
pen and ink drawing,
inscribed, $9 \times 11\frac{1}{2}$ in.,
$22 \cdot 9 \times 29 \cdot 2$ cm.
Richard L. Feigen Gallery,
New York

23
Assassination c. 1912
pen and ink drawing with
wash, $10\frac{1}{4} \times 10\frac{7}{16}$ in.,
$26 \times 26 \cdot 5$ cm.
Galleria del Levante, Milan

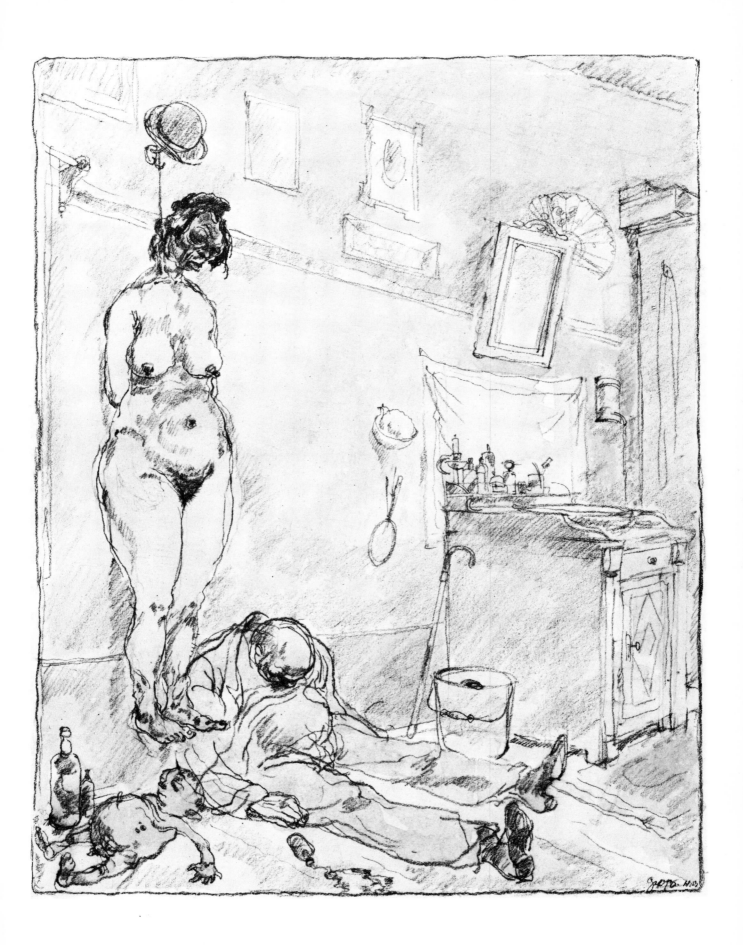

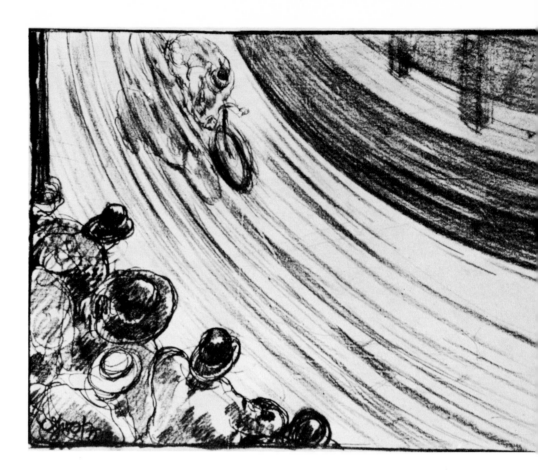

25
The Six day bicycle race 1913
crayon drawing, signed and
dated, $7\frac{7}{8} \times 10\frac{1}{8}$ in.,
$20 \times 25 \cdot 7$ cm.
Private collection

The Six day bicycle race (fig. 25) depicted one of Berlin's annual attractions. The race was really a big circus act, and, like every circus event, it left the spectator firmly outside the arena. Thus Grosz's composition, with all its trappings of speed, remains fixed at the point of Seurat's *Circus* of 1891; a high viewpoint, but one only, makes this a vigorous but traditional drawing. In *Crime of passion*, probably executed in 1912 or 1913 (fig. 26), Grosz had already achieved a more dramatic composition, for an admittedly more dramatic scene.

Crime, murder, suicide and rape had a strange attraction for Grosz that was to last most of his life. Was it because there man could be depicted at his rawest? Perhaps the scenes of arson and horror had made such a lasting impression on the young Grosz, or maybe there was something far deeper and stronger in his own make-up that drew him to the scene of crime? Or was he so modern that he thought of murder as a form of art, its accomplishment equalling the difficulty of a tightrope act? Did Grosz see the potential for murder in every face, or was the murderer and his victim one of the realized situations of human possibilities? There is no simple answer.

Grosz was a gentle and kind man, kind to the point of softness, but he could also be the suicidal drunkard, a noisy bar-room brawler, an insulting friend, and the most loyal companion. A large number of virtues and vices combined in him. In the art of his early years, he was drawn towards the exceptional more than to the normal; more to the freaks than to the humdrum.

His idea of woman, parodistically as *Circe*, in modern dress (fig. 27), and in the untitled drawing of an erotic scene (fig. 28), give some of the flavour of his experience and imagination.

An American friend from San Francisco, Lewis Hymers, owned a gramophone and American records[14]—in those days a novelty and rarity. Jazz rhythms were a strong element in the new rhythms in painting, some of the broken forms and syncopations of Grosz's work can be traced back to these rhythms. Grosz was susceptible to music, and even more to noise and the ragged contours of noisy events.

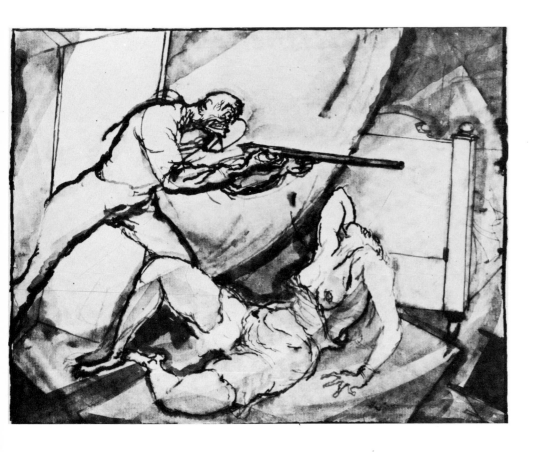

26
Crime of passion 1912–13
ink and wash drawing,
7¾ × 9¾ in., 19·7 × 24·8 cm.
Private collection

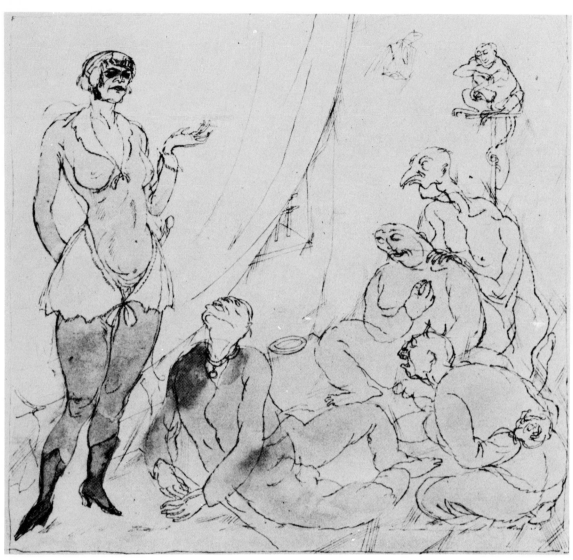

27
Circe 1912
ink and watercolour drawing,
8 × 8½ in., 20·3 × 21·6 cm.
Private collection

28
Erotic scene c. 1912
ink drawing, signed,
6¾ × 9½ in., 17·2 × 24·1 cm.
Piccadilly Gallery, London

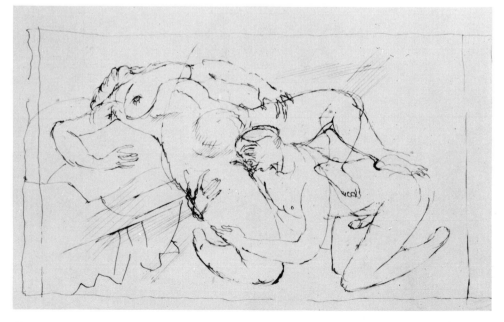

During 1913 Grosz took to engraving, a medium well-suited to his incisive line. But he made very few engravings, possibly because he was too impatient with the quite laborious process. In fact, his drawings themselves appear etched anyway. *At the café*, of 1914, is one of his early etchings (fig. 29). *Crime*, a pen and ink drawing, has the sharpness of an etching (fig. 30).

Grosz used all media available: pencil, crayon, charcoal, pen and ink, indian ink, or colour wash. He developed a true mastery of all techniques, and achieved a remarkable spatial depth with his washes. A wash drawing of the *Girl friend* (fig. 31) manifests all the art of drawing from Constantine Guys onwards. *Woman with muff*, of the same year (fig. 32), is a composition which places Grosz amongst the very best draughtsmen of his day. In firmness, economy, and expressiveness, it has not many equals amongst the German Expressionists, of whom Nolde and Kirchner showed similar concerns in their café and street scenes.

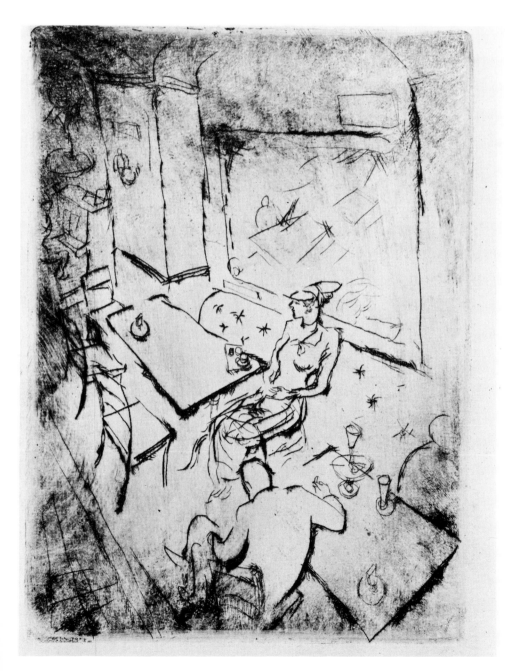

29
At the café 1914
etching, $6\frac{5}{8} \times 4\frac{5}{8}$ in.,
$16 \cdot 8 \times 11 \cdot 8$ cm.
Staatsgalerie, Stuttgart

30
Crime 1912
pen, ink and wash drawing,
$7\frac{7}{8} \times 10\frac{1}{8}$ in., 20×30 cm.
Galleria del Levante, Milan

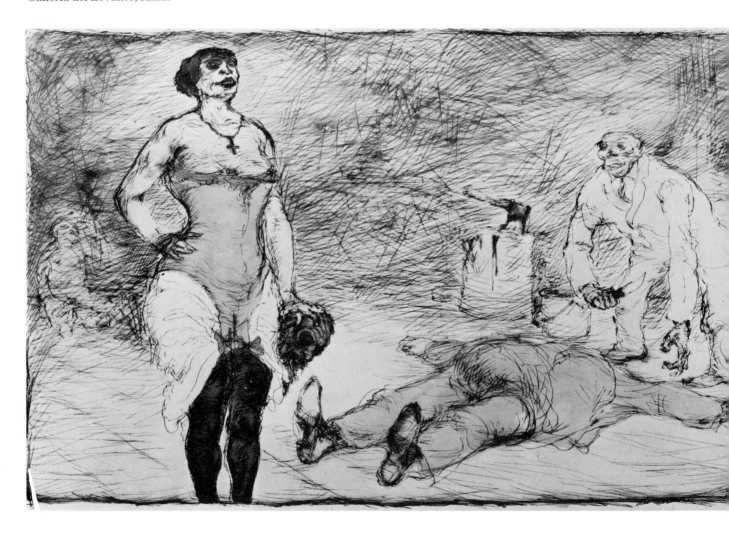

32
Woman with muff 1913
ink and watercolour drawing,
$10\frac{3}{4} \times 4$ in., $27 \cdot 4 \times 10 \cdot 2$ cm.
Private collection

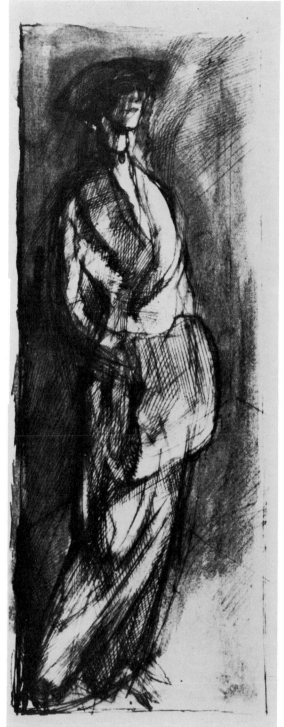

31
Girl friend 1913
ink and watercolour drawing,
$8\frac{1}{4} \times 6\frac{3}{4}$ in., $21 \times 17 \cdot 2$ cm.
Private collection

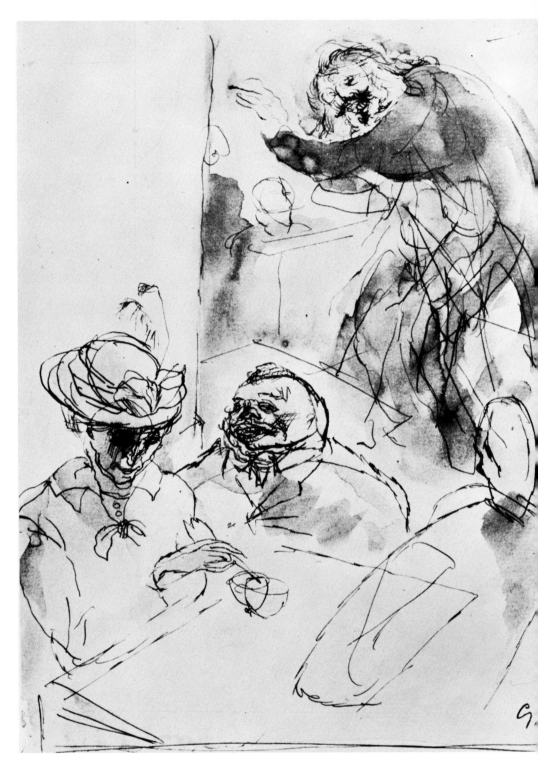

33
Café scene 1913
ink and wash drawing, signed,
$9\frac{1}{2} \times 7\frac{7}{8}$ in., 24·1 × 20 cm.
Private collection

These, then, are the works of Grosz which place him in the contemporary tradition. They are as good as those of the best, but they are not specifically Grosz. What he had done up till then was certainly his own, but it was not all that different from what other artists of equal rank were doing in their own way as well. But in 1913 a new Georg Grosz, a draughtsman of a quite different sort, arises, and arises logically from within his own work, but going, very probably without deliberation, in a direction which will lead him to stand alone.

In another café-scene drawing of the same year, however, a few traces of the developing style of Grosz can be seen, foreshadowing the very rapid development that was about to take place (fig. 33). The figures are still clearly modelled, though line and space take a more independent role. But the tendency towards drawing the 'hollow figure', or the bare outline, points to a break with tradition and the beginning of a totally new form of drawing. True, the figures in this drawing are still modelled, but they carry their form and significance in their lines alone. This half-way stage between modern draughtsmanship and Grosz's own style points the way in which the new Grosz will develop.

4. Against the war 1914-17

During the summer of 1913 Grosz went to see his mother in Thorn. She told him one morning: 'The Hussars are riding out in their new uniform.' The new uniform was field grey, the colour of the First World War.[1] A year later the war started, to the satisfaction of the German militarists.

The first victims of the war were the great and noble ideals of the Socialist International. In a few days the illusion of the brotherhood of man was dispelled, and very few had the courage and clarity to oppose the wave of patriotic enthusiasm, but amongst them was the not particularly important young artist Georg Grosz. He was one of the few who were not carried along by the stream of patriotic fervour. His loathing of the military and of uniformed discipline was so strong that his stance may even be seen in unpolitical terms as a form of revulsion against masses of men on the move. He had a cheerfully low opinion of men and credited them with every vice and every stupidity. He even upheld the theory that the war would never end because people liked it so much, and was well prepared by his cynicism for the unbelievable spectacle of a whole generation of young men clamouring for destruction. 'The outbreak of war made it clear to me that the masses marching wildly cheering through the streets were without a will under the influence of the press and military pomp. The will of the statesmen and generals dominated them. I also sensed that will above my head, but I was not cheering because I saw the threat to the individual freedom in which I had lived hitherto.'[2] Even those poets and painters whose previous work might have stamped them as liberals or socialists were caught by patriotic fervour. There were few dissenting voices, and the stream of patriotic poetry was fed not only by the hacks, but by some of the best writers of the day, many of whom were later to appear as enthusiastic supporters of the revolutionary movement.

Grosz did join the army as a volunteer in November 1914, but this need not be taken as a sign of enthusiasm. On the contrary, the enthusiasts had joined in the first days. But as Grosz was of military age he was certain to be called up, and there was a small advantage in volunteering as it allowed one a limited choice. Grosz joined a Guards' regiment. He had so far escaped compulsory military service in peacetime, although he had reached

the age of eighteen in 1911. It is certain that he had not been conscripted, but it seems that no personal decision, one way or the other, was involved.

On 6 August 1914 the police at Berlin-Steglitz issued him with a good conduct certificate. 'It is herewith certified that the artist Georg Grosz, born 26 July 1893 at Berlin, has been resident here from 1 April 1912 until today, and that nothing unfavourable has been brought to our notice.' In the years to come, however, the Berlin police would be able to accumulate some unfavourable pieces of information.

Grosz was in the army only from 13 November 1914 to 11 May 1915, but even his short experience of military treatment found expression in his sketchbooks. The touch of organized insanity, which militarized institutions exhibit and engender, left indelible traces in Grosz's mind. He spent a short time at the Western front, long enough to smell the rotten corpses in barbed wire entanglements,[3] before he was honourably discharged for medical reasons: 'conduct good, punishments none'. He wrote to his friend Bob Bell, 'Since April I have been a civilian again,' and went on to say, 'If it were not a sin against the prevailing sacred custom in patriotic matters, I would allow myself a feeling of happiness . . . in short, I am free, free from

34
Aerial attack 1915
lithograph, signed and
inscribed, $7\frac{13}{16} \times 9\frac{3}{4}$ in.,
$17 \cdot 7 \times 24 \cdot 5$ cm.
Museum of Modern Art,
New York, the gift of Mr and
Mrs Eugene Victor Thaw

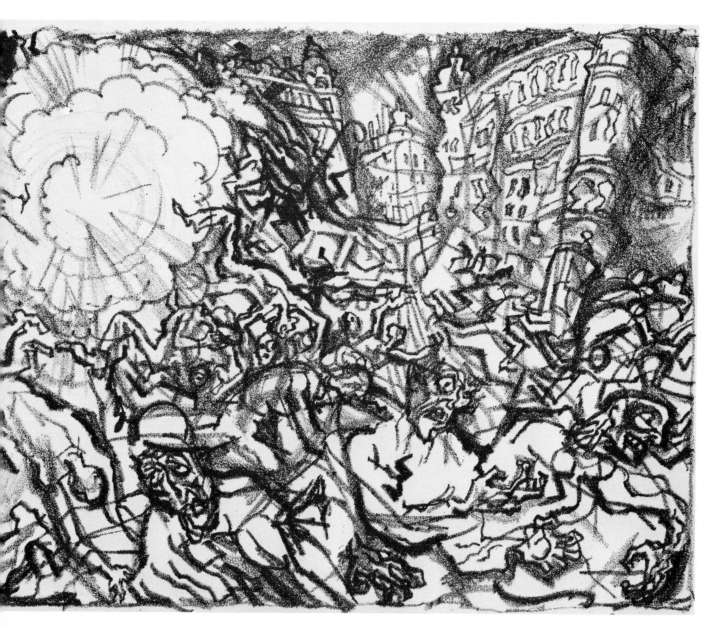

the Prussian military.'[4] Grosz could thus settle down again in his studio in Südende, and resume a peacetime life in wartime Berlin.

His work in 1915 shows traces of Futurist simultaneity and intensity. In *Aerial attack* (fig. 34) his subject is the madness of war, and the way it drives people frantic. An explosion disperses the people caught in the city, with Futurist rapidity. War has invaded the city. It is rare in Grosz's work for real horror to be shown on the faces, and this is one of the few pictures where an event happens to the participants; in most of Grosz's work they are the perpetrators.

Several elements of modern art, which Grosz fused and absorbed into his work, meet in *Street with elevated railway bridge* (fig. 35), a powerful drawing depicting the turmoil of the modern city. The Futurist pictorial event in its simultaneity is here used near realistically. It owes its obsessiveness to the common mood which Grosz shared with Kirchner of the sickness of the city. The buildings squash and oppress the traffic and the people. The pressure from the sides creates a claustrophobic tension, as opposed to the other works in the same series where man tries to escape by a mad rush through the threatening insanity.

Grosz's studio in Südende resembled a tent or a booth at a funfair; furnished with *bric-à-brac*, decorated with labels from wine bottles, cigar bands, and photographs of circus artistes. It was an extension of himself, a setting in which to play his role as an artist and an entertainer.

Apart from his favourite clowns and café scenes, his main subject was the city. Considering the roles of artist and clown very close he treated the concept of art with little respect. He admired the popular performer, be it a 'soap painter' or an acrobat, more than the great masters. He loved the honest vulgarity, which he shared and turned into his own art, and had a true insight into the unordered primitive impulses and joys of the unspoilt and uneducated. Grosz's own love of role-playing or play-acting in life is well attested by his friends,[5] and has been noted by all who have written about him. There are several reasons for this cultivation of uncertainty: he was truly uncertain as he was, in fact, outside his class and milieu, having become an artist to escape from a narrow pre-ordained role; he was playing a game of anonymity and fame, but playing it, maybe, for himself and searching for what he might be. 'I am infinitely lonely, i.e. I am alone with my doubles (*Doppelgänger*), phantom figures which fulfil quite definite dreams and tendencies, etc.'[6] To solve his identity problem, he invented three identities. 'I project three different people from my inner life of the imagination. I believe in those pseudonyms. By and by, three firmly delineated types have arisen: (1) Grosz; (2) Count Ehrenfried, the nonchalant aristocrat with manicured fingernails out to cultivate only himself—in one word, the elegant aristocratic individualist; (3) the physician, Dr William King Thomas, the more Americanized, practical, materialist—counterpart of the mother-figure Grosz.'[7] Numbers two and three, Count Ehrenfried and Dr William King Thomas, are well defined. However, number one, Grosz, remains hermetically sealed. Throughout his life he signed his post-cards and letters with these and many other invented names. Returning to reality, he wrote: 'There are hours when Grosz sits on the sofa in his smoke-filled studio, brooding like a dumb animal, a left-over from my military past. The recall of the disabled (a visionary picture, ha! ha!).'[8] The drawing

35
Street with elevated railway bridge 1915
ink and coloured pencil drawing, signed and inscribed, $11\frac{1}{8} \times 8\frac{3}{4}$ in., $28 \cdot 3 \times 22 \cdot 3$ cm.
Carlo Ponti, Rome

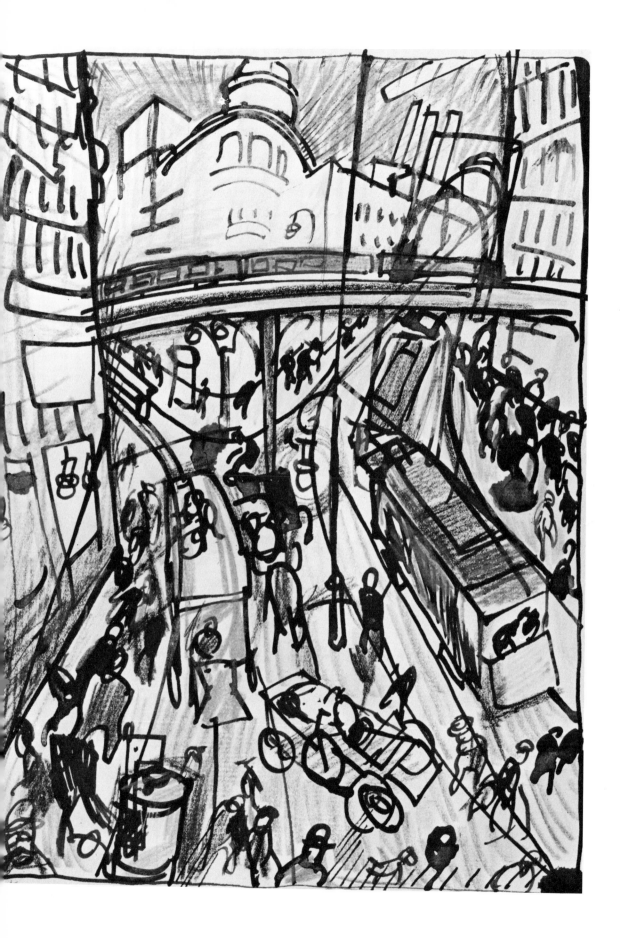

49

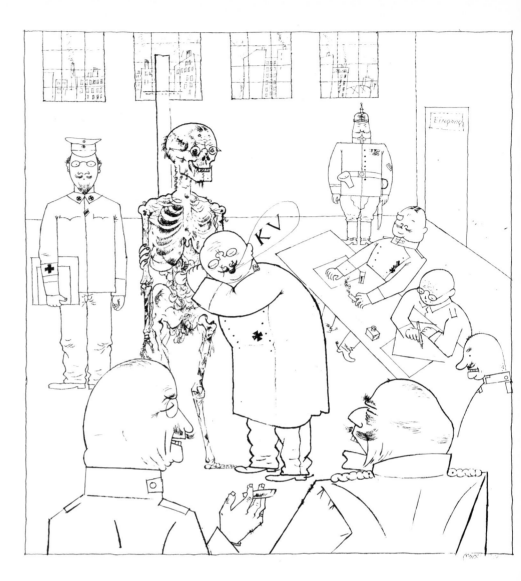

36
K.V. (*Fit for active service*)
1916–17
pen, brush, indian ink drawing
on ivory paper, signed,
20 × 14⅜ in., 50·8 × 36·5 cm.
Museum of Modern Art,
New York
A. Conger Goodyear Fund

in his mind was executed (fig. 36), and became one of Grosz's most famous drawings, entitled *K.V.*, short for *Kriegsverwendungsfähig* (fit for active service). Grosz feared being called up again. 'The sword of Damocles hangs above my head. Heavens, when shall we be strong enough to resist?'[9] The idea of resistance, of action, still has a dreamlike quality. 'A dream of mine: revolts will happen and one day spineless international socialism may gain the strength for open rebellion, and then W. II and the Crown Prince will be no more. They still post the call-up papers on the hoarding. To the slaughterhouse!'[10]

Very few literary publications opposed the war, and one of the few was *Die Aktion*. Amongst its activities was the publication of anti-war post-cards, and it is worth noting that Grosz, as early as 1915, had sent these

cards to his friends. *Die Aktion*, he reported, had taken some of his drawings and a poem.[11] Early in the war, then, Grosz had become aware of an open opposition to the war, and Pfemfert's *Aktion* had a circle of outspoken and active contributors and subscribers, to which Grosz was soon to belong. His own outlook was very much in line with the policy of *Die Aktion*, which directed its attacks against servile journalists and once-reputable writers and poets whose patriotic outpourings knew no bounds. 'The time is favourable for charlatans . . . from meat substitute manufacturers to courtly lyric poets, those prisoners of war.'[12] In this bitter and acute analysis, Grosz identifies meat ersatz with poetry ersatz, establishing the unity of the production of shoddy goods and shoddy writing; the identity of the ideology of patriotism and corruption. 'Germany', he says, 'shows her true face—a hopeless harlequinade.'[13]

Demonstrations of German patriotism had an immediate counter-productive effect on Grosz. 'Day after day my hatred of the Germans is nourished afresh to hot flames by the impossibly ugly, unaesthetic, badly dressed Germans. From an aesthetic point of view, I am happy about every German who dies a hero's death on the field of honour. To be German means always to be ill-mannered, stupid, ugly, fat, and to be the worst sort of reactionary —to be unwashed.'[14] A satirist, like a revolutionary, has primarily the duty to fight within his own setting. Only a German has that right to be anti-German. That Grosz's attitude was not purely an expression of aesthetic disgust he makes clear; his concern was ethical as well as aesthetic. He drew a hearse (fig. 37) with the title *Stick it out!*, the slogan of the time for winning the war.

37
Stick it out! c. 1915
pen and ink drawing,
Neue Jugend July 1916

From 1915 to the end of 1916 Grosz was free to work in Berlin. He matured and developed the new style for his intentions. 'I drew vomiting men with clenched fists carrying the moon; murderers of a woman playing cards on the wooden box with the victim inside; wine drinkers, beer drinkers, liquor drinkers; and a frightened little man, washing blood off his hands. I drew military scenes using my notebooks.'[15] *Rape and murder* (fig. 38), *The Apaches* (fig. 39) and *On the fourth floor* (fig. 40) are such scenes. 'My views of the war years can be summarized: men are swine . . . Life has no meaning, except the satisfaction of one's appetite for food and women. There is no soul . . . Thus I expressed in my work a strong disgust of life and an even stronger disgust of its processes.'[16] Personal despair and political protest began to unify in Grosz's mind, and the political implications of his personal statements will become obvious to him and to others.

38
Rape and murder c. 1915
pen and brush indian ink
drawing, signed, 7¾ × 6½ in.,
20 × 16·5 cm.
De' Forscherari Galleria,
Bologna

39
The Apaches 1917
pen and ink drawing, no. 58 in
Ecce Homo

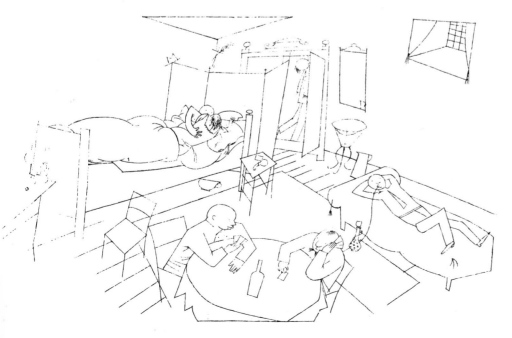

40
On the fourth floor 1916
pen and ink drawing, no. 49 in
Ecce Homo

What Grosz put into his work is his hatred. It is an individual artist's reaction to a social event; it is an emotional reaction, but was it a political one? 'I drew and painted in opposition and attempted in my work to show the world in all its ugliness, sickness and lies. I did not have any success. I also had no high hopes, but I felt very revolutionary as I took my resentments for wisdom.'[17] 'Actually, the socialists have failed, *but the theory will not die*.'[18] This firm statement of faith in a theory which cannot be defeated gave him hope. 'Maybe some of the politically indifferent ones will begin to seek knowledge and . . . join the camp of those called the discontented or the socialists.'[19] Though his equation of discontent and socialism is naive, it is relevant for Grosz. He sees the revolution as a hope for the discontented, for the masses, but he himself stands aside. 'Personally I have developed beyond . . . socialist teaching, and am at present a distinguished individualist. I know that new ideas can only be executed by the hungry and the discontented.' His letter ends with a quotation from Zola: 'Hatred is sacred.'[20] This attitude will determine Grosz's political commitments, as well as his withdrawals. He was formulating his own personality during these fateful years, and he was developing his thinking and his style.

Café scene (fig. 41) is one of the earliest drawings in which the future George Grosz becomes visible. The figures are purely linear, not yet 'hollow', but tend that way. There is still light modelling; the perspective and lines of action are intersecting. The scene is vast, unified, and yet each figure is isolated. A tendency towards Futurist spatial organization, as well as the opposite tendency of the isolated outlined figure, are both contained in this work. Both tendencies will be developed and carried to their ultimate conclusion.

In *Riot of the insane* (fig. 42) and *Pandemonium* (fig. 43), the process of simplification evident in *Café Denis*, which led to the creation of the 'hollow' figure, extended to all objects—houses, ships, lamps—made it possible for Grosz to develop a new language of signs. The figures become signs and symbols, which in their recurring reassembly will be able to tell new tales of horror, depravation and despair. The creation of that new language makes Grosz the new artist and satirist. He has found new forms of expressing what he intended, and it is that new language which will make him famous. Without it, his message and vision could not have been told.

As early as 1915, in *The Street* (fig. 44), Grosz was beginning to search for a translation of his developing style into the medium of oil, and almost without visible effort he emerges as a *Naturtalent*. Self-taught as he was, he had assimilated the current Expressionist and Futurist developments. With great vigour he achieved a totally original and forceful composition, not more literary than many other Expressionists, but less nervous, more direct, aggressive and positive. Out of all the pictures he had seen at the Sturm Galleries, where Herwarth Walden exhibited year in year out the most advanced painters from Italy, France, Russia and Germany, the young painter found his own mode without much soul-searching. He had invented a new formal language.

Grosz's drawings are always autobiographical, in the sense that he is always in them. He participates as a spectator or *flâneur*—a superior being standing above the mêlée in his own work. His drawings reflect his attitudes

41
Café scene 1914
pen and ink and coloured
crayon drawing, signed, dated
and inscribed, 11¼ × 8¼ in.,
25·5 × 21 cm.
Murray B. Cohen, New York

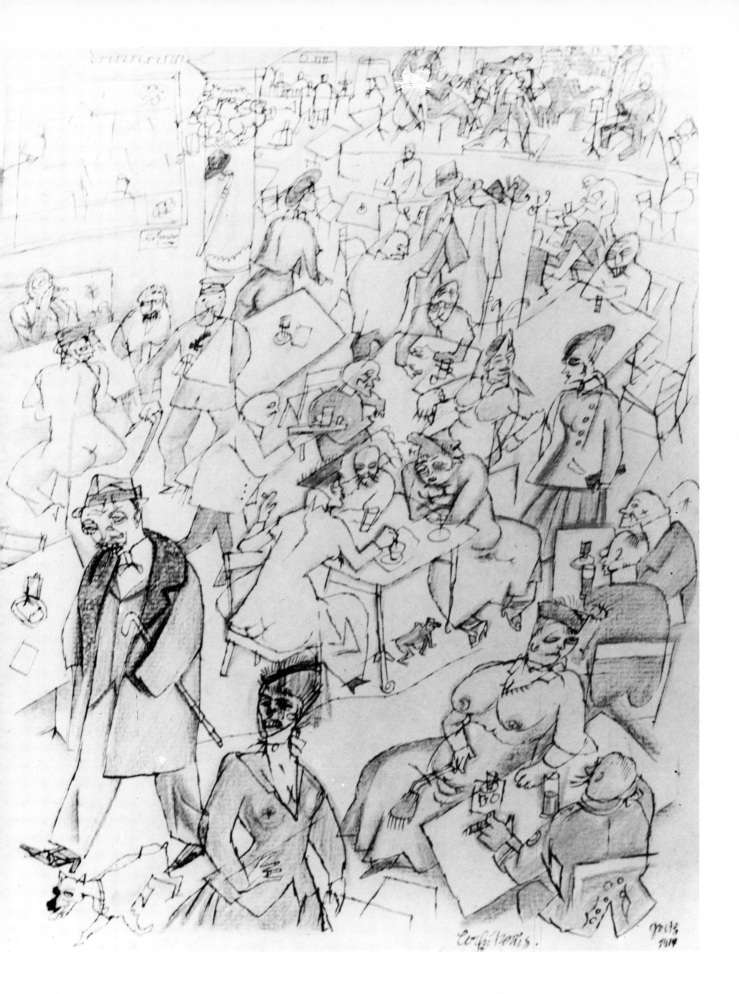

55

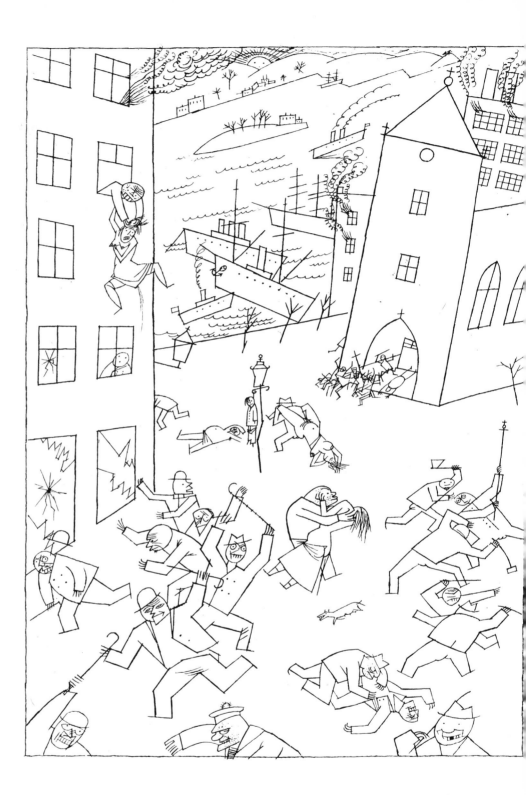

42
Riot of the insane 1915
Pen and ink drawing, signed,
dated and inscribed,
$12\frac{5}{8} \times 8\frac{7}{8}$ in., $32\cdot1 \times 22\cdot6$ cm.
Collection Bernd Schultz,
Berlin

43
Pandemonium 1914
ink drawing, signed and dated,
$18\frac{1}{2} \times 12$ in., $47 \times 30\cdot5$ cm.
Mr and Mrs Bernard Reis,
New York

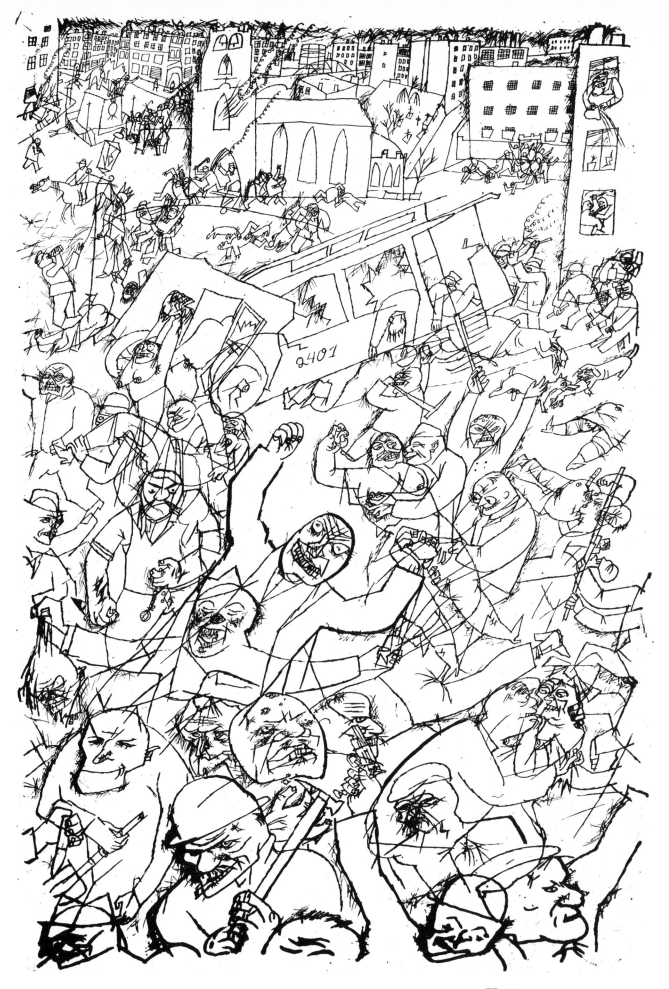

44
The Street 1915
oil on canvas, $17\frac{15}{16} \times 14$ in.,
45·5 × 35·5 cm.
Staatsgalerie, Stuttgart

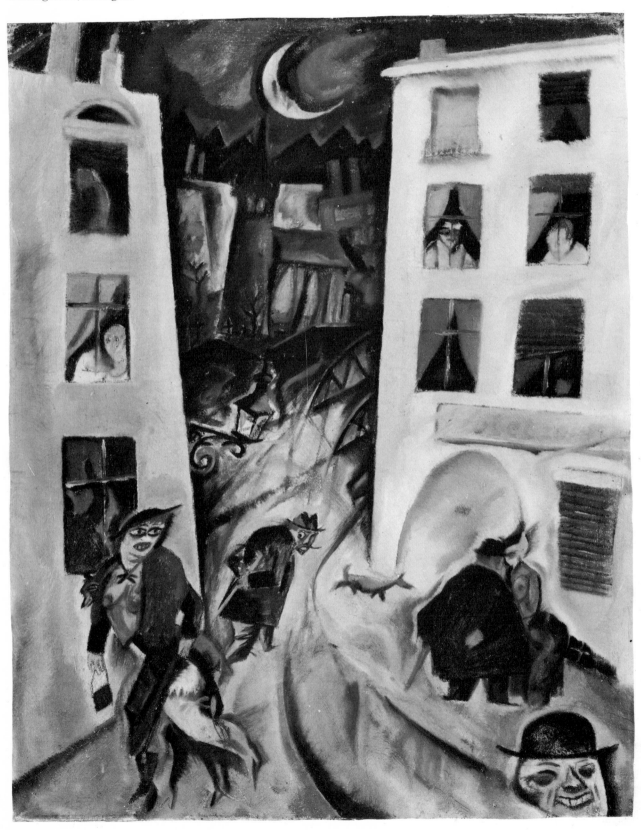

and thoughts as an active event. They combine Dada and Futurist theories, not only in a spatial simultaneity, but in the aleatory coincidence of disconnected events.

The figures are more personal than one might suspect. In a letter[21] he wrote of his yearning for the hot sun of the cities of Peru and his cowboy romanticism. He wrote as well of his love for the fabulous civilization of steel construction and elastic grain elevators—the gigantic manifestos of the American world: heads with sharp edges, outlined by a chisel; square shoulders; the essence of the unfeeling brutal thought. 'Now and then such figures appear in my drawings next to abrupt, squashed, squinting figures who somewhere lost the balance of their miserable lives.'[22]

In *Memory of New York* (fig. 45) the city takes over. It is Grosz's tribute to his America cult. The use of letters and figures, similar to Cubist collage, foreshadows Dadaist methods. In *The Adventurer* (fig. 46) Grosz depicts himself in his American Western garb—a subject repeated in his drawings of cowboys and Indians. *Old Jimmy* (fig. 47) is the outcome of the America cult, Karl May and the mythology of the Wild West, and the gin parlour. The trappings are also found in the post-war drama of Brecht and Feuchtwanger.

45
Memory of New York 1916
ink drawing
no. 1 in *Erste George Grosz-Mappe*

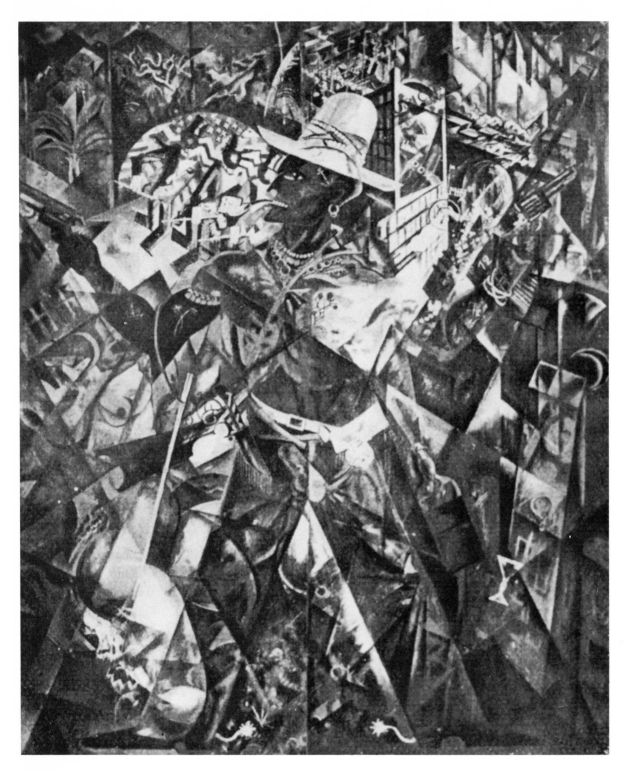

46
The Adventurer 1916
oil on canvas
Present ownership unknown

47
Old Jimmy 1916
pen and ink drawing,
Neue Jugend July 1916

In his writings of this time Grosz developed an Expressionist intensity, which in his drawings is transformed to a skeletal reduction. If one wants a descriptive statement of the content of Grosz's work, there is no better source than the artist himself. Grosz combines in a form, rare for graphic artists, the gift of poetic writing with the gift of graphic poetry. His ability to express the state of his emotions and thought is of remarkable unity. Translating his experience into different forms of artistic coherence, Grosz was equally powerful in both media. In 1917 *Die Neue Jugend* published his poem 'The Song of the Golddiggers':

'The engineers are ready
and cranes, steam, song
and the factories red
and over the red day
are distant airmen!
Express trains cross the country
faster!
From San Francisco to New York—
Everything! ! !
The international white slave traffic.
World conflicts. Wars.
Department stores and brothels
in Rio—
You brown prostitutes
Penang—Cochinchina, Algiers, Marseille
See! Steamers are lying ready
belching smoke
Gold! Gold! Gold! ! !
Up golddiggers
go!
Klondyke calls again! ! !
Faster the knives and spades—
the engineers are ready,
black magicians in American three-piece suits.
America! ! ! The Future! ! !
Engineer and businessman!
Steamers and Pullmans!
Above my eyes
vast bridges span
and the smoke of a hundred cranes.'

Georg Grosz drew pictures of himself and his thoughts and views of his world. The figures he drew were related to his actions and reactions; his work thus appears as a form of his language—readable because it is unified and stereotyped. When he drew a stereotype it was not because of poverty of the imagination or subject matter, but was the necessary vocabulary of a continuing *écriture*. In that continuing text, until the very end, even his last phase can be seen to belong to the continuity because it is in the dialogue with himself that his work arises.

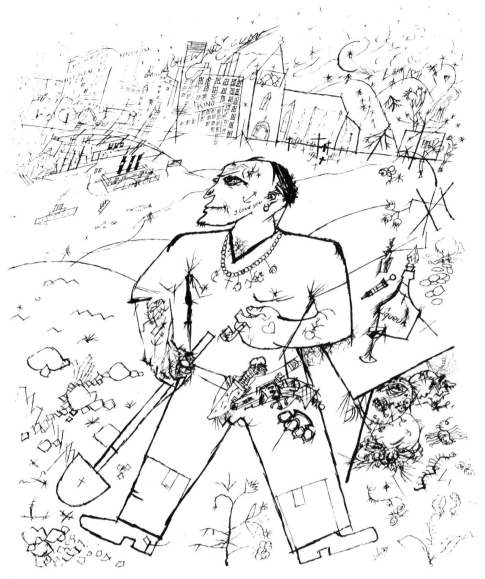

48
The Golddigger 1916
pen and ink drawing, signed,
dated and inscribed,
$16\frac{1}{16} \times 11\frac{5}{8}$ in., $41 \times 29{\cdot}5$ cm.
From the private collection of
Murray B. Cohen, New York

It was that new Grosz, whose work, still unknown, awaited recognition. An encounter between Grosz and Wieland Herzfelde in 1915 was to be for both of them their point of entry into history.

Wieland Herzfelde, a young poet, had been discharged from the army as 'unworthy to wear uniform'.[23] At the Café des Westens he met Else Lasker-Schüller, whom he greatly admired, Theodor Däubler, Johannes R. Becher, Martin Buber, Gustav Landauer, Hugo Ball, Walter Benjamin, Albert Ehrenstein, Franz Jung, Richard Hülsenbeck, Mynona (the pseudonym of Salomo Friedländer), and the painters Ludwig Meidner, Heinrich Maria Davringhausen, Mopp (Max Oppenheimer) and Carlo Mense, many of them contributors to Pfemfert's *Die Aktion*. Grosz also was at home in

this circle, and one evening in the summer of 1915[24] Wieland met Grosz in Meidner's studio. Wieland Herzfelde intended to found a periodical devoted to the idea of peace, in words and pictures. The decisive moment came when Wieland Herzfelde visited Grosz in his studio. They became close friends, including in their friendship Wieland's brother, Helmut (a painter and graphic designer). Grosz's cool, cynical mind acted like a cold shower on the more warm-hearted, pacifist brothers. Grosz did not share their naive faith in the human race. 'The hopes held by some of my friends for peace I considered unfounded,' he was to write later.[25] Both Wieland and his brother Helmut were totally captured by the quality and power of Grosz's work, and they decided that for the sake of Grosz's drawings alone the venture should be pushed forward as quickly as possible. As there was a war-time ban on the issue of new periodicals, Wieland had the idea of acquiring an existing but dormant title, and found a schoolboys' magazine called *Die Neue Jugend*, a not unsuitable title and a good cover for his intentions.[26]

In the spring of 1916 a prospectus for *Die Neue Jugend* was printed in an edition of 30,000 copies, with a drawing by Grosz and Johannes R. Becher's *Ode to peace*. During July, the first issue appeared with two of Grosz's drawings. The August number had one drawing and an advertisement for the *Georg Grosz Mappe* (Portfolio). The September 1916 issue had no drawings, but a poem by Grosz and a new advertisement, this time for the 'George Grosz Mappe'. It seems a small point that Grosz had added one letter to his first name, but by changing from the German 'Georg' to the English 'George', he demonstrated his anti-patriotic attitude, just as Helmut Herzfeld changed his name to John Heartfield as a protest against the German hate-campaign against England. The name 'George' remained Grosz's most cherished attribute.

Die Neue Jugend was a dignified, well-produced periodical; conventional, almost conservative, in layout and typography. Whilst Wieland Herzfelde was at the front, political differences with the nominal publisher, Heinz Barger, led to the foundation of the Malik Verlag (Malik Publishers). Its first publication was the issue of February/March 1917, still in the traditional format. The April number was banned, and the next issue appeared in May as *Die Neue Jugend*, (Weekly Edition) *No. 1*, in the form of a broadsheet. No. 2 appeared in June, disguised as an advertisement announcing the forthcoming appearance of the *Kleine Grosz-Mappe*, a totally novel invention, not only in the field of typography, but also in the field of modern art (fig. 49). Here John Heartfield breaks the traditional identity of the sign and the signified: he breaks into the form and meaning of the letters of the alphabet and the symbols of the printed page. He destroys in one fit of creative imagination the good manners of printing.

With the publication of the *Erste George Grosz-Mappe* in spring 1917, and the *Kleine Grosz-Mappe* in the autumn, the rising fame of the artist began. The *Berliner Tageblatt* had already noted: 'Amongst the contributors of *Die Neue Jugend*, George Grosz is the most genuine modern. Full of healthy scepticism, he has looked behind the wings of life and has shed all illusion, but this did not make him weak or soft.'[27]

Theodor Däubler met Grosz in 1916, through the *Neue Jugend*, and published the first critical, important article on Grosz, in his *Die Weissen*

**Soeben
erschienen!**

**Soeben
erschienen!**

**Soeben
erschienen!**

49
*Grosz-Heartfield Advertisement
for Die Kleine Grosz-Mappe*
1917
Collage *Neue Jugend*, weekly,
May 1917, no. 2

Blätter in November.[28] He was the first to analyse Grosz's work:

'His drawings are full, but he does not fill them, he spaces them with
lines, with wires . . . His view of the city is apocalyptic: houses appear
(the houses are geometric) naked as after the bombardment. Men are the
expressions of their lust: bewildered. At the café, one of them will end a
suicide. Who? All are suspected of crime. One cannot acquit anyone from
the possibility of committing crime; all are accused. George Grosz is at
the moment the Futurist temperament of Berlin.'[29]

Die Neue Jugend arranged literary evenings in Berlin and other big cities,
where the authors read their own works. Grosz read his poems, together with

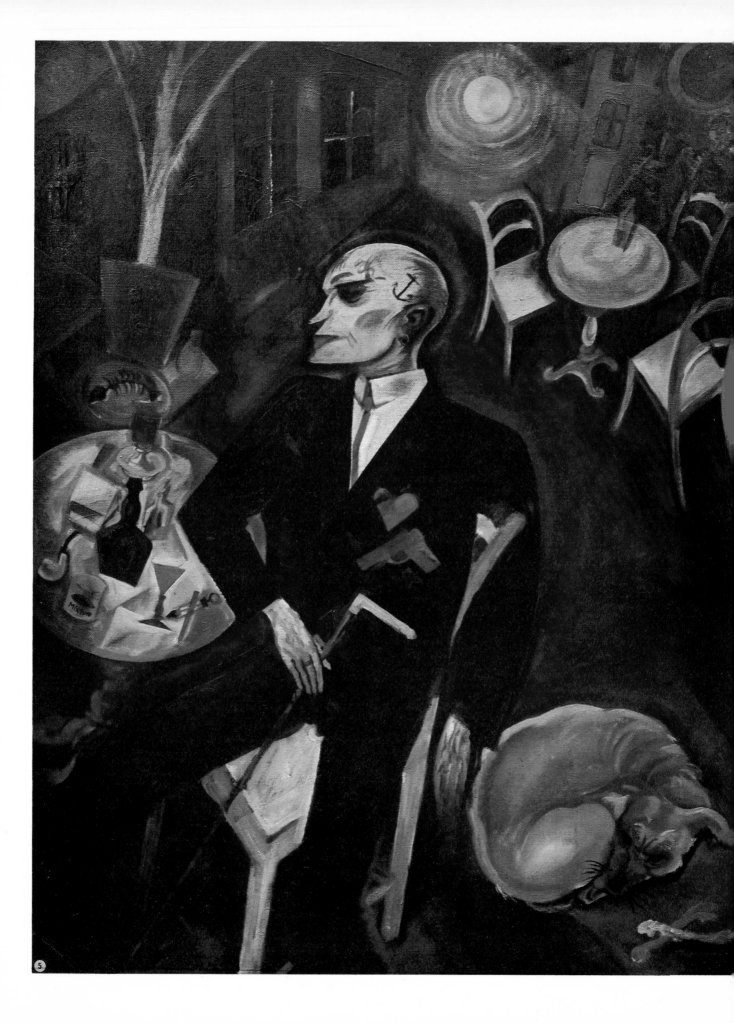

some major poets of the time. For Wieland Herzefelde's *Sulamith* he produced a cover in blue and silver (fig. 51). Apart from publishing Grosz's work, *Die Neue Jugend* offered Grosz's original graphics for sale, then in numbered and signed editions, priced at ten and five marks.

The foundation of the Malik Verlag was the single most important event in Grosz's life. It was John Heartfield's enthusiasm and Wieland Herzfelde's publishing genius which created the portfolios and books which spread the work of George Grosz and made his types proverbial. Through the distribution by the committed Malik Verlag, the satirical work of George Grosz was received as being political. What made Grosz's work overtly political was its presentation by the Malik Publishers, for there the drawings were selected and grouped to perform their function of demythologizing social reality. They were equipped with captions that made the implicit points explicit. With the portfolios of the Malik, Grosz's work entered the public domain,

and this reception was as decisive as his drawings. In 1916–17, we can only trace the beginning of the impact his work was to make in the near future.

That future contained the revolution and the flight of the Kaiser. The winter of 1917–18 was the grimmest and ugliest of the war. All illusions had been lost. After the treaty of Brest-Litovsk, the German High Command assumed that it could mobilize reserves and attempt to break the stalemate on the Western Front. By the summer of 1918 that hope had vanished, and the High Command informed the Kaiser that the war was lost, but still it went on, with growing hunger and long lists of casualties.

In 1917 resistance to the war had begun to take open political forms and ceased to be the concern of romantic dreamers or individual political activists. The first mass strikes of munition workers and a sailors' revolt in Germany, the mutiny of the army in France, the naval mutinies at Spithead in Britain, and the February Revolution in Russia, were signals of the coming revolt. Wieland Herzfelde, whose temperament was not given to despair but to an optimism which lasted him through his long life and which occasionally drove Grosz to despair, saw hope in the current political developments, the very hope of revolt, which Grosz shared.

The civilian life of Grosz, aged twenty-four, still an art student under Professor Orlik at the Art School and still a nightly visitor at the literary cafés of Berlin, came to a sudden end. The sword of Damocles—the recall to the army—was coming down in the last days of 1916. He reported to the regiment on 4 January 1917. On the 5th he was in a military hospital,[30] first at Guben and then at Görden, the latter an institution for the insane, where he was being treated. His own diagnosis, however, he had already given to Bob Bell in 1915 during his first military experience: 'An instinctive revolt against any form of discipline caused an inflammation of my forehead (this the diagnosis of a doctor friend of mine), but I claim that I was thinking too much during military service.'[31]

'All round me is darkness, and the hours, black like bones . . . My hatred of men has grown to enormity. It seems I shall slowly approach the madness of despair . . . I am crossing bare hell—white, skull white. The ragged sky stands in the window, but I never see the stars. Above the beds hang black birds; the nameplates of the sick animals. All human features have disappeared from their faces. Often Death rattles melodiously amongst the swinish beds. Someone with evil spectacles plays the piano, penetrating the trenches and dug-outs of my brain. From the retort of my mind I extract much poison and hatred. I am still a fighter!'

And he signed the letter 'Your G. deceased'.[32] On 26 April he was released and returned to Berlin. He noted his visual experiences in sketchbooks, producing works like *Sanatorium* (fig. 52).

In the military hospital Grosz had pursued his old inclination of seeking the absurd and making it visible. He invented a therapeutic system, a kind of proto-Dada prescription, by making picture-postcards out of price lists of expensive liqueurs, printed instructions on the use of collar studs, cookery recipes, ration cards, stock exchange reports and society gossip, giving 'a more varied cross-section of life than any single novel, no matter how good'.[33]

The moment had come when Heartfield's typographical break-up and break-through, combined with Grosz's therapy, could lead to a new form of expression, which came to be associated with the growth of Dada. 'Sitting in my Berlin studio, John Heartfield and I invented photomontage. We had no inkling then of the huge success nor of the fantastic difficulties.'[34] Heartfield's revolutionary typography, and Grosz's and Heartfield's collages were part of the deliberate breakdown of accepted artistic formalization, in an iconoclastic desire for the destruction of established values. The negation and desecration of art was the aim. 'The enemies of Dada shouted "Hands off holy art! Art is in danger! The spirit is disgraced!"'[35]

The same idea of showing up the incongruities of events had been used by the editor of *Die Aktion*, who had introduced a column, 'Ich schneide die Zeit aus' (Cuttings of the Time), as a regular weekly feature. This literary device foreshadowed montage effects, which were used with similar intention. He inserted samples of current idiocies and vulgarities amongst serious material, making them critically explosive.

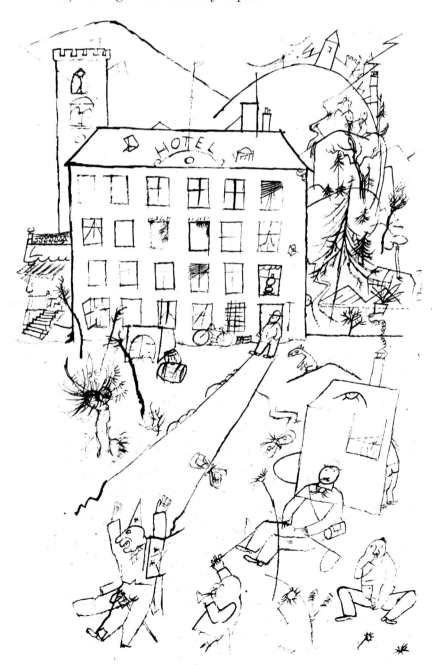

52
Sanatorium 1917
pen and ink drawing, signed and inscribed, $34\frac{3}{8} \times 17\frac{1}{16}$ in., 61.4 × 43.3 cm.
Wallraf-Richartz-Museum, Cologne, Ludwig Collection

Dada developed at this time, but in fact Dada was not invented by artists; Dada was invented by reality:

When the German Under Secretary of State, Michaelis,[36] could say, in 1917, in the official German War Bulletin, that even after the war food rationing would have to be continued, and deduced therefrom that the revolutionary call: 'Give us Peace—Give us Bread' had no justification; Dada was on the way!

When the Grand Duchess Luise von Baden, visiting a military hospital, promised a soldier to have the bullet removed from his body set in gold, and after his death from his wounds, send the bullet to his father as a souvenir,[37] Dada was on the way!

When the War Office was selling French steel helmets with certificates of authenticity in aid of war widows,[38] and *when* the Social Democratic *Vorwärts* carried[39] an advertisement by the food processing firm Florian & Co., Berlin Britz, Chausseestrasse 68: 'War invalids with arm wounds sound legs wanted immediately to crush Sauerkraut';[40] Dada can't be invented!

Berlin Dada and its subsequent recorded history is as confused as its original intention. Grosz wrote:[41] 'A civilian again, I lived through the earliest days of the Dada movements. Its beginning coincides with the turning point of Germany, winter 1917, known in popular language as the "turnip winter".' Hans Richter recognized Grosz's part in this: 'Above all there was Georg Grosz, who had recently become well-known through his drawings . . . A savage fighter, boxer and hater . . . his elemental strength was the life-blood of Dada even before the movement got under way.'[42] But the movement was not, of course, a movement which would have an organization. The main quality of Dada was its disorganized anarchic character. Dada was a process, not a programme, and if one now lists the facts and chronology, one imposes too much of an order on the actual events.[43]

In Futurism, Grosz had recognized a means of expressing his own vitality in the chaos of the city. 'Oh sacred simultaneity: streets rushing onto the paper; the starry sky circles above the red head; the tram bursts into the picture; the telephones ring; women scream in childbirth; whilst knuckledusters and steel knife rest peacefully in the hot trouserpocket of the pimp; the labyrinths of mirrors; the magic street gardens where Circe transforms men into swine.'[44]

That simultaneity, which Grosz had already caught in his drawings, he was now able to transform into his paintings. In the year between military service and the military asylum at Görden, he painted some remarkable pictures.

In *Lovesick* of 1916 (fig. 50) a self-portrait places Grosz in the picture in his actual position, both in art and in life. The dandified, disdainful young man, paints himself in the colours of sweet liqueurs, in a proto-Futurist space. Seen from a higher viewpoint than a traditional portrait, space flees into the distance and the houses penetrate the interior.

In *The City* (fig. 53), the Futurist attempts made in his drawings of streetscenes are fully developed and powerfully organized. It is a remarkable picture, with its control of the deranged multitude, its interpenetration of the lines of force, its perspective discipline, its strong division into two nearly

equal, conflicting yet unified, parts. Its gaudy end-of-the-world illumination is reminiscent of El Greco's *View of Toledo in a storm*. The city becomes man's destiny. Living beings become automata. Man is trapped in his own construction. The use of letters is not only part of the realism of the scene, it gives added dimension to the reading of the picture. The alphabet, too, has invaded the street; the word itself has been abused.

In his praise of simultaneity, Grosz wrote: '. . . the song of the signs: the dance of the letters and the port-red kidney-destroying nights where the

53
The City 1916–17
oil on canvas, signed and
dated, 39½ × 40¼ in.,
100 × 102 cm.
Mr and Mrs Richard L. Feigen,
New York

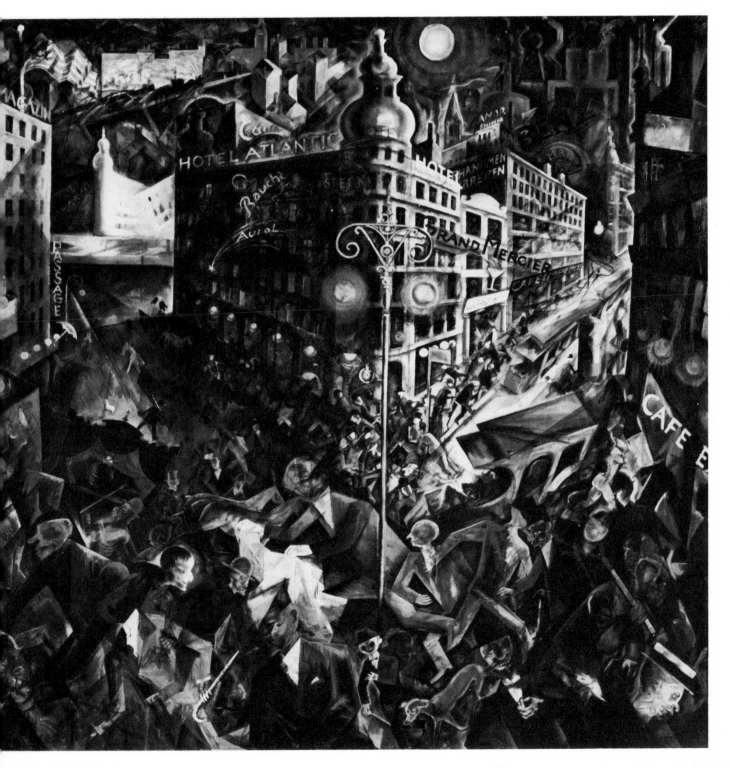

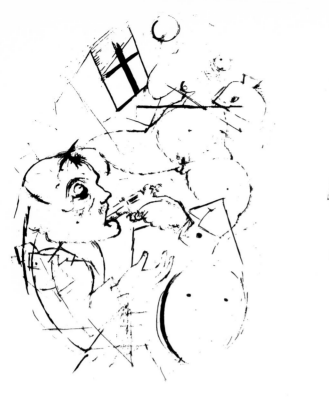

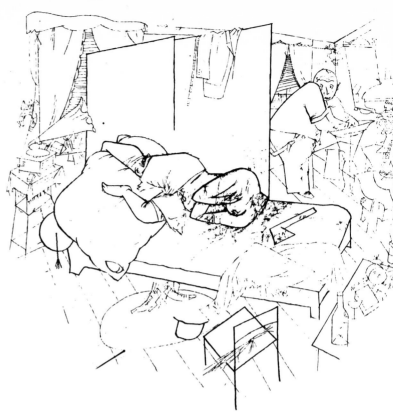

moon is next to the infection and angry cab drivers, and in coal cellars people are strangled; emotion of the big cities'.[45] This Expressionist hymn to the unleashed powers of life, as a recent writer observed,[46] shows a fascination, though a hateful fascination, with life; the sensuous animal reaction to destruction. Grosz said that all experience turned to putrefaction, poison and decay.[47]

Such simultaneity of love and hate, crime and survival—the simultaneity of the anonymous events of the city—are expressed in some of Grosz's most haunting works, such as *Tragedy* (fig. 54), and *Rape and murder in the Ackerstrasse* (fig. 55) which was treated as a 'still life' in the most awful sense of the words. With loving care, the petty sentimental horse shoe, the neat little doily with fringes, the prim and proper curtains with the still-life representation of 'debauchery'—a bottle and a glass with cigarettes and matches—make this latter work a 'morality' in the traditional sense.

The General makes its statement with equal clarity (fig. 56). There is no doubt about Grosz's genuine hatred of war, uniforms, and generals.

There is no doubt about his hatred of the fat, bloated, war profiteers, and the Church conniving in war and profits. *Germany, a winter's tale* (a title after Heine; fig. 59) can be read as clearly as a medieval painting. A philistine Nationalist is eating his dog bone, surrounded by patriotic beer and nationalist newspapers, safely guarded by Church, Army and School, with

the silhouetted Grosz looking angrily into the picture in the position of the painter in late medieval 'donors' ' altarpieces. In a city of chaos, law and order dominates—whose order? whose chaos? are the questions implied. This allegorical composition is a collage on top of a Futurist painting. It summarizes Grosz's view of art and society.

Grosz was, in an ironical way, becoming what he had aspired to be: a painter specializing in genre and military scenes. On 5 February 1919 Count Kessler wrote that he was shown 'a huge political painting—*Germany, a winter's tale*'. Count Kessler was a diplomat of high rank, an admirer of Grosz's work, the friend of many artists and writers, and himself a man of strong internationalist leanings. His diaries are amongst the most fascinating documents of the time, containing insights and observations as his comments on Grosz: 'Grosz wants to become a German Hogarth, deliberately realistic and didactic. Art for Art's sake, does not interest him at all. Grosz argues that art as such is unnatural, a disease, and the artist a man possessed. Mankind can do without art. He loathes painting and the pointlessness of painting as practised so far.'[48]

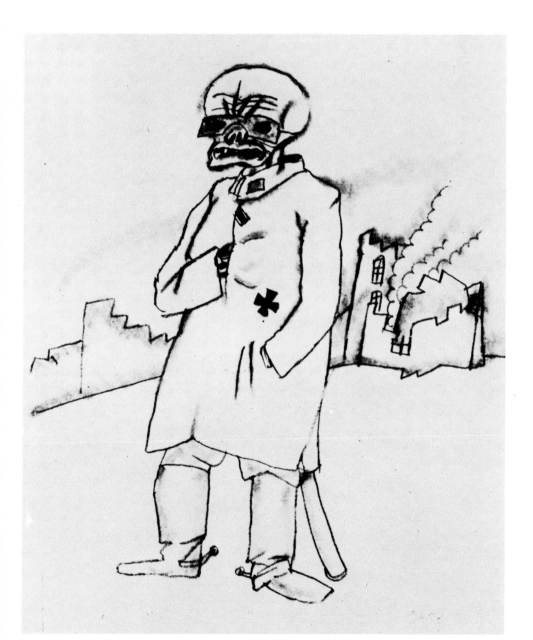

56
The General c. 1916
soft pencil drawing, signed and inscribed, $7\frac{7}{8} \times 7\frac{1}{4}$ in.,
20×18.5 cm.
Formerly Estate of George Grosz

58 (*opposite*)
White slaver 1918
watercolour, pencil, ink,
$12\frac{1}{2} \times 9\frac{3}{8}$ in., $31\cdot7 \times 23\cdot8$ cm.
Hessisches Landesmuseum,
Darmstadt

57
Explosion 1917
oil on composition board,
$18\frac{7}{8} \times 26\frac{1}{2}$ in., $47\cdot8 \times 68\cdot2$ cm.
Museum of Modern Art, New
York, Gift of Mr and Mrs
Irwin Moskowitz

This attitude was not held by Grosz alone. In an article in the *Zeit Echo*[49] called 'A Painter Speaks to Painters' Hans Richter asked 'What are we doing about the ten battles on the Isonzo? Does it not concern us? Who says that still life and nudes and other pictures do something against that? One day, the painter will discover how to act.'

Explosion (fig. 57), based on a previous drawing, is a rare painting in Grosz's work, whose interest did not lie with physical forces but rather with the unfathomable evil of men and society.

During 1918 Grosz painted at least ten oils, of which several cannot be traced. The subject which occupied him most was the slayer of woman— at least three different versions were painted. The Hamburg picture, *John the woman-slayer* (fig. 63), is a coherent and wholly original composition which marks Grosz as a master of twentieth-century painting. He shares with Chagall a deliberate, naive sophistication, a dream-like floating re-collection. But there the similarity ends, though the bouquet of flowers is a touch of Chagall. Where ideal love floats through Chagall, in Grosz, fear, death and destruction have found their colours and shapes. A mechanical figurine quality is shared by the articulated victim and the propelled murderer. The deed is suspended between heaven and earth.

The woman-slayer (fig. 61) is more direct and gruesome: red in teeth and claw, and the victim still in ecstasy, the gratification of the killer's lust and sacrifice painted in what Grosz himself called 'the blood red of my suicidal palette'.[50]

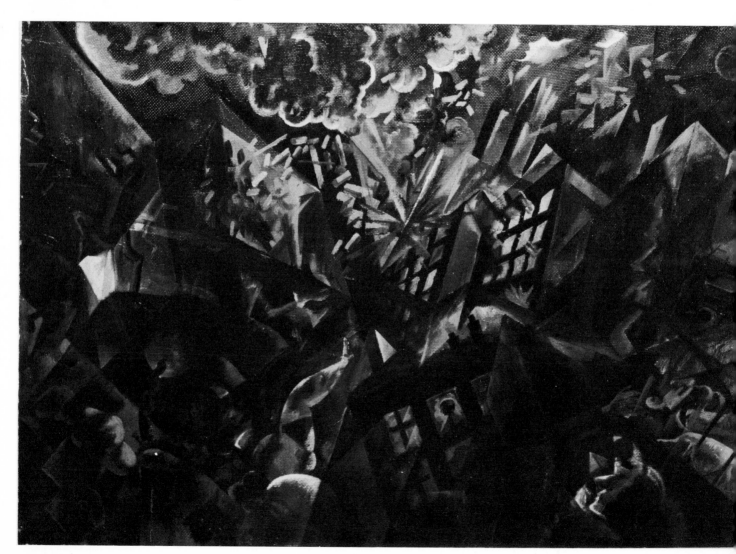

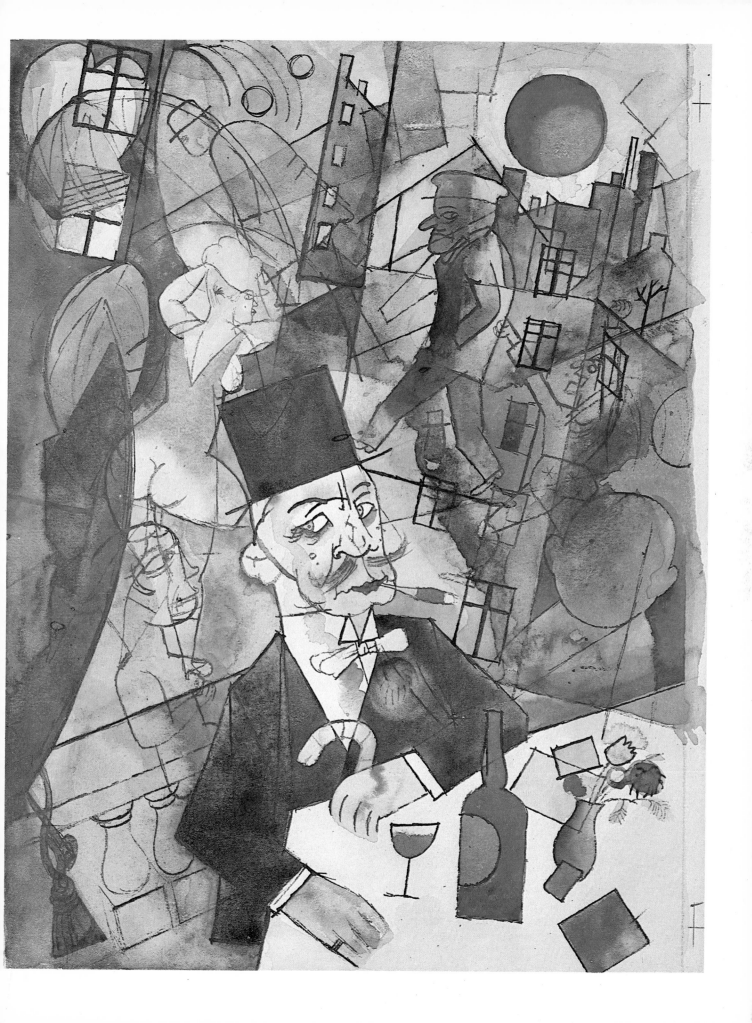

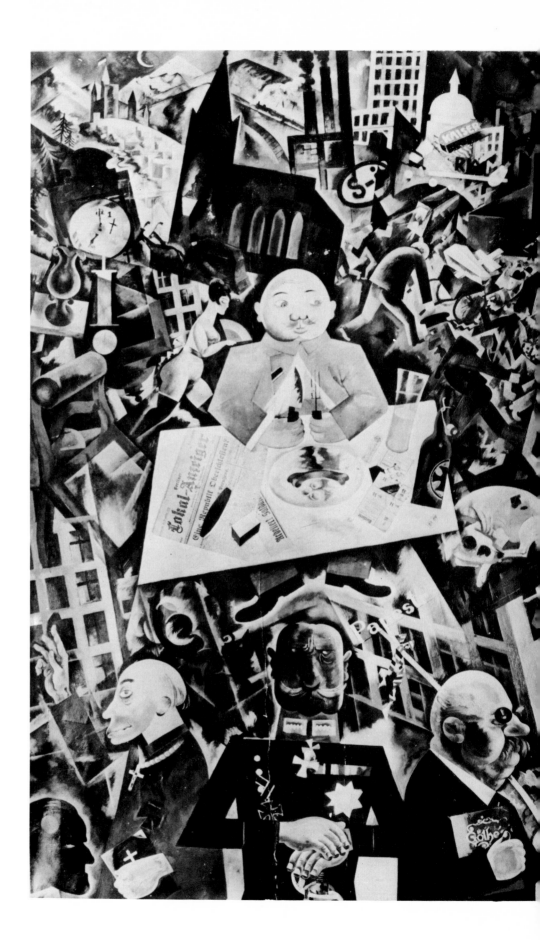

59
Germany, a winter's tale
1917–19
oil on canvas
Wieland Herzfelde, Berlin,
GDR, present whereabouts of
the painting unknown

That Grosz could carry almost the same intensity into his watercolours is shown by *White slaver* (fig. 58). Again a transparent Futurist composition, as rich as a film in a sequence of incidents, and as informative as a short story, it is a modern form of narrative art. His figures live as literary creations in a descriptive cityscape, illuminated by the insight and experience of the painter. He has several choices in his work; in *The Case 'G'* (fig. 60) he uses his figures in a more allegorical form and lends to the scene a fairy-tale quality of lighthearted unconcern, with murder for gain. The paintings owe something to the current concern with Cubism and Futurism, supported by the new freedom which the painters had found. But that was only the basis on which Grosz could build his own work. His use of colour is brilliant and bitter, of a stridency and sharpness all his own. The pictures are extremely well painted, with a sure grasp of technique; they show no traces of hesitancy or incompetence. The reason for making this point is that Grosz, himself, in later life suffered agonies when he thought of himself as an inexperienced painter. Strange, then, that he never became aware of his own competence in the mastery of this medium.

These paintings demonstrate Grosz's own development from Futurism towards a form of Realism with an intensity of colour and form, something no one else mastered or attempted. There was a painter, now rarely recalled, who exhibited at the Sturm, Arnold Topp, whose paintings in construction, though not in content, are not unlike the work of Grosz.

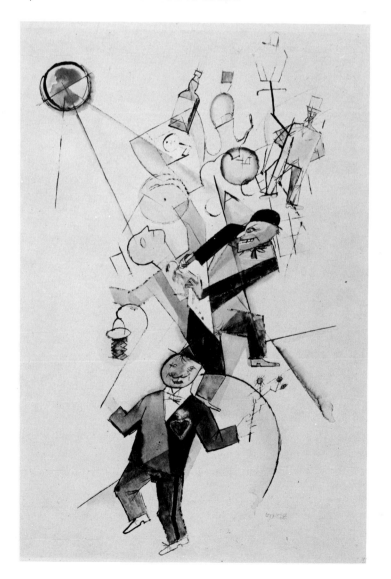

60
The Case 'G' 1918
watercolour, pen and ink,
18½ × 12¼ in., 47 × 31 cm.
Nationalgalerie, West Berlin

62
Dusk 1922
watercolour
20½ × 16 in., 52 × 40·7 cm
Roman Norbert Kettere
Campione d'Italia,
Switzerland

61
The woman-slayer 1918
oil on canvas, signed and
dated, 26 × 26 in., 66 × 66 cm.
Private collection, Milan

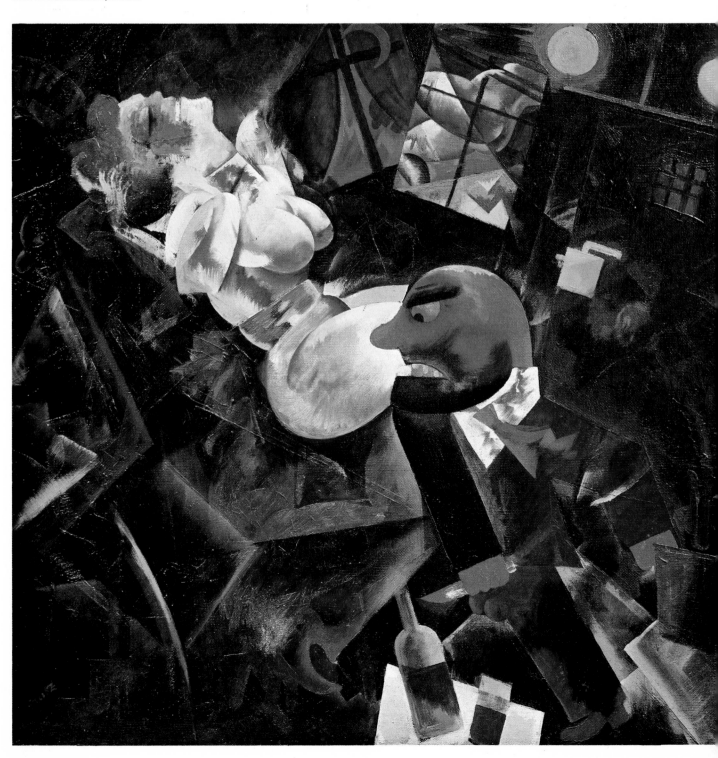

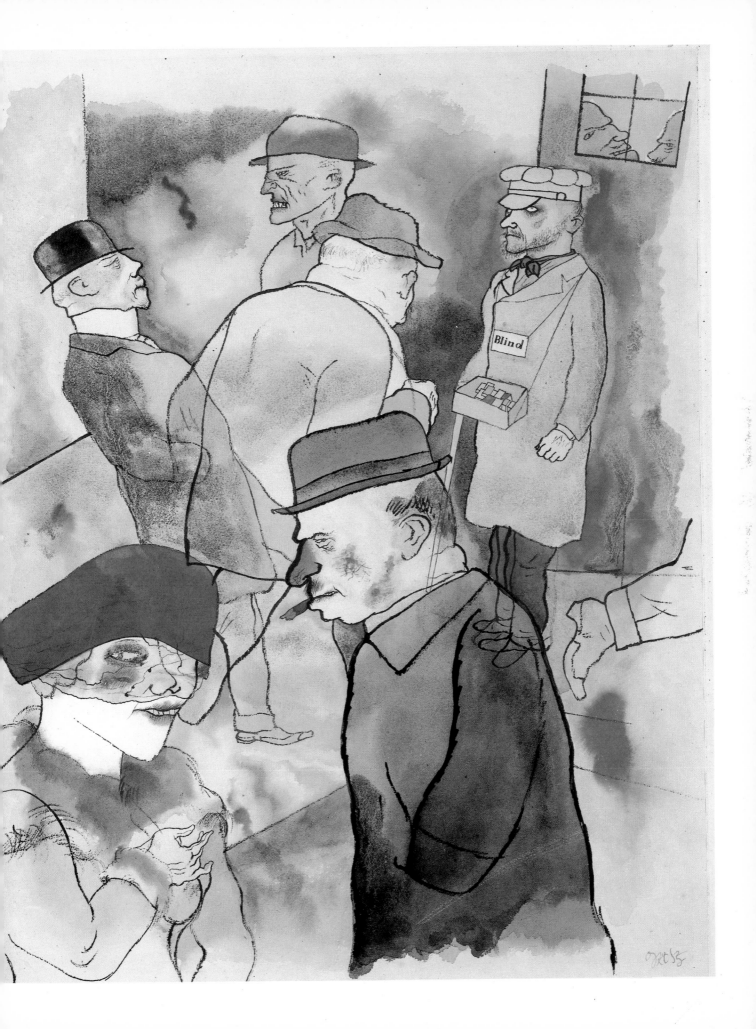

This intensification of the power of expression, of which Grosz was capable and which his subject demanded, was recognized by at least one collector, Kirchhoff, who acquired the painting *Dedicated to Oskar Panizza* (fig. 64), for his own collection. Grosz had painted this unique work in the winter of 1917, it ranks as a document and as one of the masterpieces of the century. The meaning and intention of the picture are given by Grosz in a statement which he later prepared for his trial for blasphemy.[51] The *Curriculum Vitae*, inscribed by him 'Notes for the trial 3 December 1930', reads:

'In 1917 . . . I began to draw what moved me in little satirical drawings. Art for Art's sake seemed nonsense to me . . . I wanted to protest against this world of mutual destruction . . . everything in me was darkly protesting. I had seen heroism . . . but it appeared to me blind. I saw misery, want, stupor, hunger, cowardice, ghastliness. Then I painted a big picture: in a sinister street at night a hellish procession of dehumanized figures rolls on, faces, representing Alcohol, Syphilis, Pestilence. One figure blows the trumpet, and one shouts "hurrah!", parrot fashion. Over this crowd rides Death on a black coffin—direct as a symbol, the boneman. The picture was related to my ancestors, the medieval masters, Bosch and Breughel. They, too, lived in the twilight of a new epoch and formed its expression . . . Against Mankind gone mad, I painted this protest.'[52]

This carnival of Death is the quintessence of Grosz. The philosopher Salomo Friedländer ('Mynona') spoke of Grosz's 'Dadantesque Inferno'.[53]

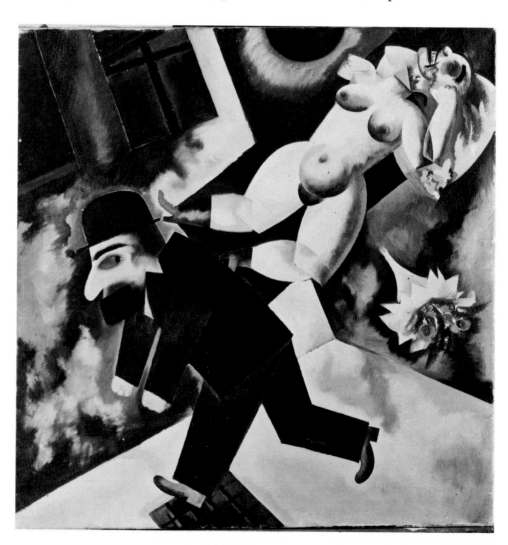

63
John the woman-slayer 1918
oil on canvas, signed,
dated and inscribed,
$34\frac{1}{16} \times 31\frac{7}{8}$ in., 86·5 × 81 cm.
Kunsthalle, Hamburg

5. Revolution and Counterrevolution 1918-22

After the defeat of the German armies on all fronts, the Kaiser and the other princes ruling in Germany were forced to abdicate. The Republic was declared on 9 November 1918. Revolution had rocked the established order, but not broken it, and the whole apparatus of the state remained intact. A Social Democratic government was set up, and, assisted by the general staff and all the active forces of reaction, established 'law and order' with a rapidity noted by Count Kessler: '17 December 1918, Berlin. Arrived at eight in the morning. Brandenburger Tor, Pariser Platz and Potsdamer Platz decked with flags and garlands for the returning troops. Noticeable that not a red flag to be seen. The officers . . . are wearing epaulettes again. The contrast with mid-November is considerable.'[1] All efforts by the more radical revolutionary forces to take power were defeated.

In the early January days Karl Liebknecht and Rosa Luxemburg, the two most prominent revolutionary leaders of the Spartakus Bund, were murdered by soldiers of the government in the service of the counter-revolution. George Grosz's drawing (fig. 65) is one of the many tributes paid by the revolutionary artists of the time.

The White Terror was fiercer than the outside world then admitted, or history books now admit. Shooting of strikers and court martials of revolutionary workers, happened day and night.

The spearhead of the counterrevolution was formed by the Freikorps, a paramilitary body of ex-officers, soldiers and nationalist students. They terrorized workers and crushed local attempts to form left-wing governments, in all parts of Germany, but particularly in the Baltic area and in Saxony, Berlin and Bavaria. There was no unity among the working class and the social democrats collaborated with the reactionary forces in society —indications that the state had remained in the power of the bourgeoisie and landowners, shorn of the trappings of imperial pomp. Army, police, law courts and schools, in fact the whole apparatus of the state, remained firmly in reactionary hands. The German Republic was to be the continuation of Imperial Germany by other means. The form the state took differed but the content was the same; the new regime was the old regime. A famous novel by Theodor Plivier summarized the whole truth in its title: *Der*

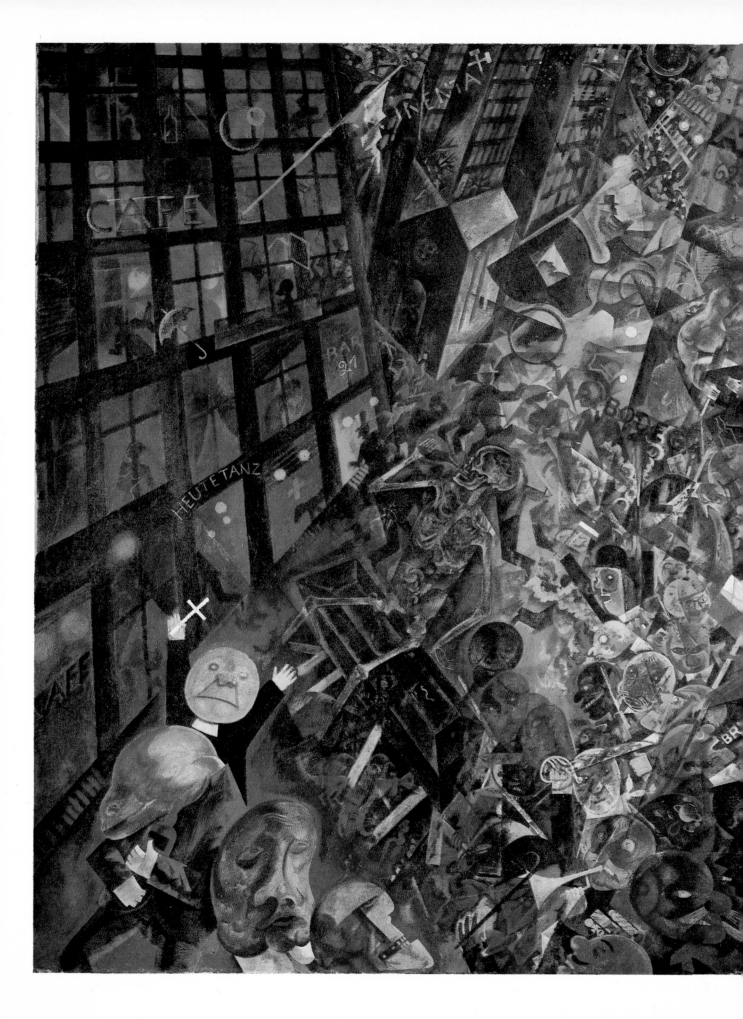

Kaiser ging, die Generäle blieben (The Kaiser went, the Generals remained).[2]

In February 1919 the National Assembly was held in Weimar to give a constitution to the new Republic. Weimar, with its associations with Goethe and Schiller, was chosen as a symbol for the new Germany, to contrast in spirit with Potsdam. In German thought these two towns traditionally stood for the assumed opposition of the poetic and the military spirits. But the choice of Weimar was no more than an ideological cloak for the new regime, kept in power by the forces of Potsdam.

The Revolution had been greeted with enthusiasm by poets, writers, painters, sculptors and architects, who formed themselves into the *Novembergruppe*, and signed their names to a manifesto. In reality their contact with the revolutionary forces was slight. They could offer sympathy that was valuable and often genuine, but had no great power. True, when in Munich in February 1919, Eisner was murdered, intellectuals and poets, Landauer, Mühsam and Toller, led a workers' rising, but it was its proletarian organization that kept it alive until it fell to the bayonets of the quickly reassembled army and the mercenary Freikorps, who murdered Landauer, and imprisoned Toller, and also Mühsam, who was later to be tortured to death by the Nazi successors of the Freikorps. *Ich Dien* (fig. 66), an almost idyllic landscape—a pastiche of Impressionist boating parties— is Grosz's comment on the events in Munich.

What made most poets and writers even less effective than they might have been was their total ignorance of political reality. The rhapsodic

64 (*opposite*)
Dedicated to Oskar Panizza
1917–18
oil on canvas, signed, dated and inscribed, $55\frac{1}{16} \times 43\frac{5}{16}$ in., 140×110 cm.
Staatsgalerie, Stuttgart

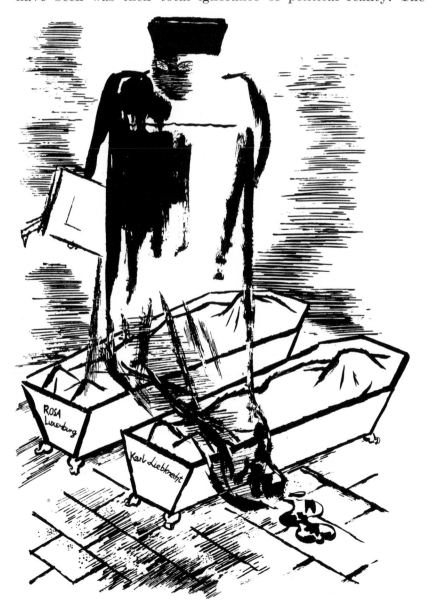

65
Remember c. 1919
(In memory of Rosa Luxemburg and Karl Liebknecht)
pen, brush and ink
$23\frac{1}{4} \times 15\frac{15}{16}$ in., 59×40.5 cm.,
Barnett Shine, London

Expressionists, the lyrical lovers of the universe and writers of odes to humanity, were all concerned with abstractions, with spiritual values, or with the spiritual as such unattached to any manifestation of social reality. Grosz noted: 'When the tide seemed to turn, the most esoteric brushes discovered their hearts beating for the working masses, and for a few months, red and pale pink allegories and pamphlets were produced in large numbers. But soon, law and order returned, and, lo and behold, our artists noiselessly made their way back to the higher spheres.'[3] Very few intellectuals were prepared to give up their dreaming, which appeared to them like effusions of genius, and come down to an earth which was sordid enough without poetry. George Grosz was one of the few who did attempt to make himself and his work available for the practical day-to-day tasks of political

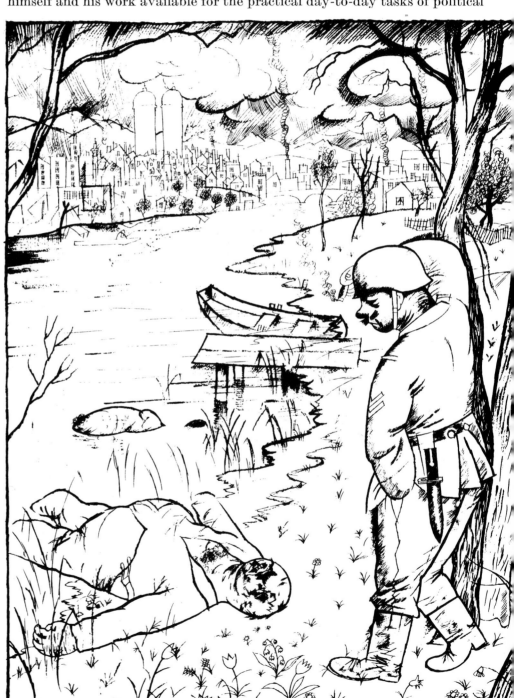

66
Ich dien 1919
pen and ink drawing
no. 3 in *Gott mit uns*

action. Those who did were hunted men. Kessler noted: 'Grosz says that numerous artists and intellectuals . . . are making their escape from one abode to another. The government intends to deprive the Communists ruthlessly of their intellectual leaders. He (Grosz) himself . . . is preparing a second issue of *Pleite* with still more caustic caricatures . . . Grosz now professes himself to be a Spartacist.'[4] One of these caricatures shows Noske, the Social Democratic Minister of the Interior, who had accepted his appointment with the sentence *Einer muss der Bluthund sein* (someone has to be the butcher). He lived up to his resolution, and Grosz illustrates no more than the truth of the day (fig. 68).

Count Kessler noted on Friday, 21 March 1919: '. . . a visit from Wieland Herzfelde . . . He spent about a week in Moabit and Plötzensee prisons. His description of them is so dreadful that I felt sick with nausea and indignation . . . After what he has seen, he feels it impossible to strike a light-hearted note in his periodical. Only a struggle waged with the most extreme means matters any longer.'[5] As an immediate expression of his experience, Wieland Herzfelde wrote and published *Schutzhaft*, which appeared with a jacket illustration by Grosz (fig. 67) as no. 2 of *Die Pleite* (Bankruptcy), a new bi-monthly from the Malik Verlag.

A leaflet by Grosz advertising *Der Blutige Ernst*, a satirical weekly, apart from its directness and stylistic novelty, is of great importance for its text (fig. 69). One of the slogans reads: 'Against bourgeois ideologies'. What preoccupied Grosz, Heartfield and Herzfelde at this time was the relation of art to ideology. Count Kessler noted: 'Sunday, 23 March 1919 . . . Helmut Herzfelde (John Heartfield) expressed his utter repugnance to the publication of poems . . . or indeed anything, that is just art. He and his friends, . . . are becoming more and more hostile to art. Wieland's and George Grosz's achievements are, it is true, artistic, but only, so to speak, as by-products.'[6]

On 31 December Grosz, together with John Heartfield and Wieland Herzfelde, joined the newly formed Communist Party.

The discussions of the day were reflected in the work produced at the time, while the ideas were summarized and published in *Die Kunst ist in Gefahr* only in 1925. This little-known pamphlet is of exceptional importance, not only for Grosz, but for understanding the function of art. 'Was it not the height of deception pretending that [art] creates spiritual values? Was art not incredibly ridiculous taking itself seriously, whilst nobody else would?'[7] There never was art free from ideology. Grosz and Herzfelde said:

'There are still artists who deliberately and consciously attempt to avoid all tendentiousness, remaining silent in the face of social events, not taking part, not accepting responsibility. As far as art is practised for its own sake, it propagates a blasé indifference and irresponsible individualism. The artist cannot withdraw himself from the laws of social development—today the class struggle. A detached stance, above or on the side lines, still means taking sides. Such indifference and other-worldliness supports automatically the class in power—in Germany its bourgeoisie . . . The artist today, can only choose between technical construction and propaganda in the class struggle. In either case he will have to give up pure art.'[8]

67
Schutzhaft 1919
ink drawing, signed
Wieland Herzfelde, Berlin,
GDR

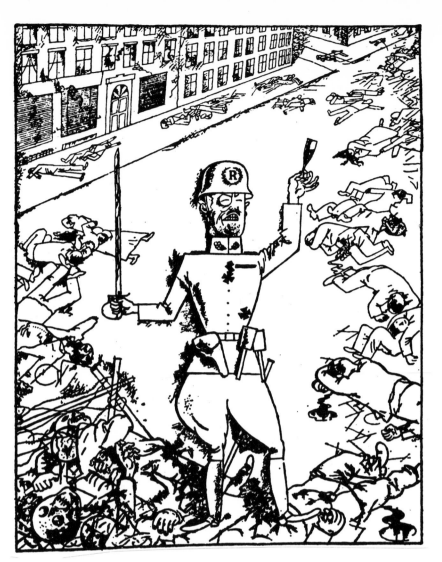

68
*Cheers Noske! – the workers
have been disarmed* 1919
pen and ink drawing
title page, *Die Pleite* 1919

69
*The advertising leaflet for
Der Blutige Ernst* 1919
pen and ink drawing

GEGEN DIE AUSBEUTER!!

Der blutige
Ernst

TÖDLICHE
WIRKUNG!!

HIEBE durch die dickste HAUT

Heft 60₰

SATIRISCHE WOCHENSCHRIFT

GEGEN
DIE BÜRGERLICHEN
IDEOLOGIEN!

HERAUSGEBER
CARL EINSTEIN
GEORGE GROSZ

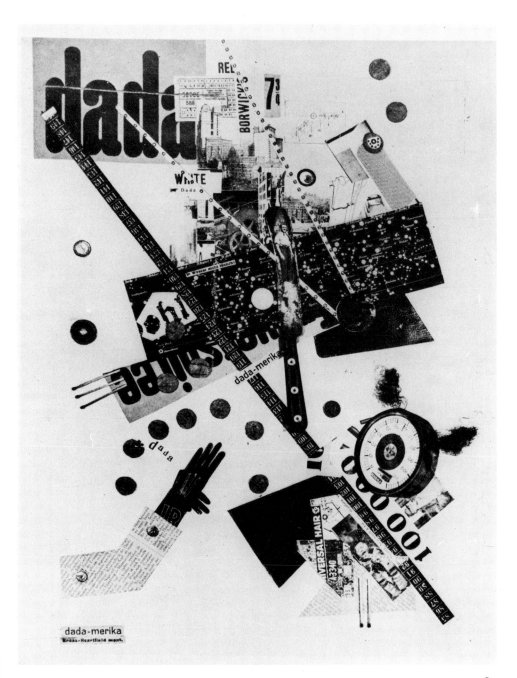

70
Grosz-Heartfield *Dadamerika*
1919
collage
Present ownership unknown

The destruction of bourgeois art was also to be the concern of Berlin Dada. In 1919, Grosz, together with John Heartfield, produced a series of collages, where fragments of photographs were married to Grosz's drawings. This conflation of several forms of artistic reality, producing mutual references between typeface, photos and drawings, made a fresh impact. *Dadamerika* is one such construction (fig. 70).

The Guilty one remains unknown (fig. 71), a collage, relates closely to Grosz's transparent interpenetrating planes and events. *Cross section* (fig. 72), as programmatic a drawing as Grosz could make, shows all his concerns summarized amongst other contemporary events.

The deliberate mechanization, a German echo of Constructivism, and the relation of men and machines, together with the new artists' stand against old-fashioned individually produced works of art, led Heartfield and Grosz

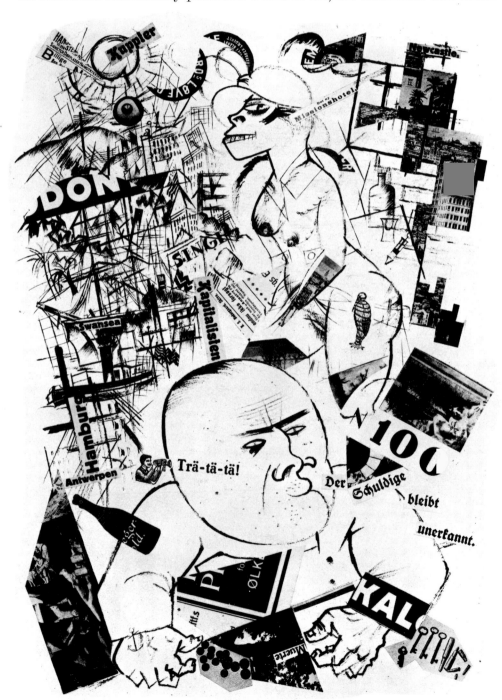

71
The Guilty one remains unknown 1919
collage, pen and ink, signed, dated and inscribed, $19\frac{7}{8} \times 14$ in., $50\cdot5 \times 35\cdot6$ cm.
Art Institute of Chicago, Dept of Prints and Drawings, Chicago, Ill.

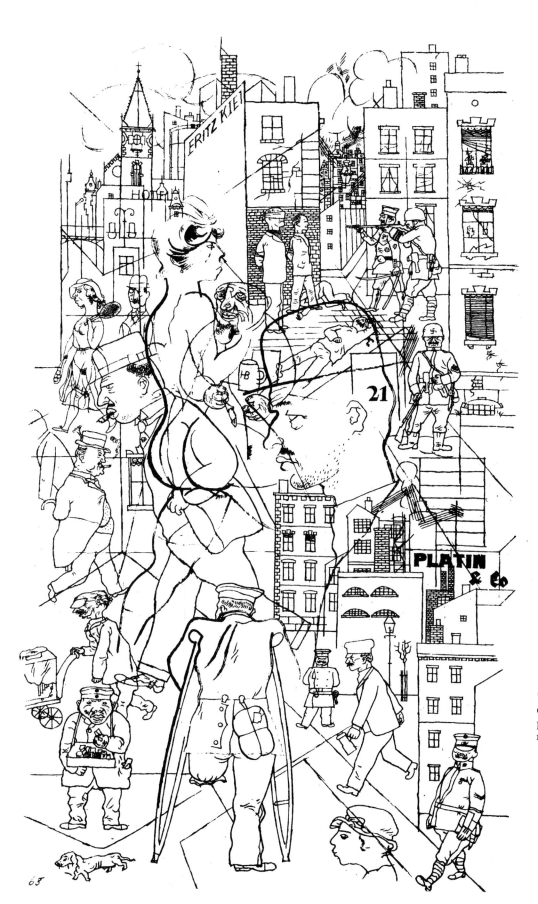

72
Cross section 1920
pen and ink drawing
no. 68 in *Ecce Homo*

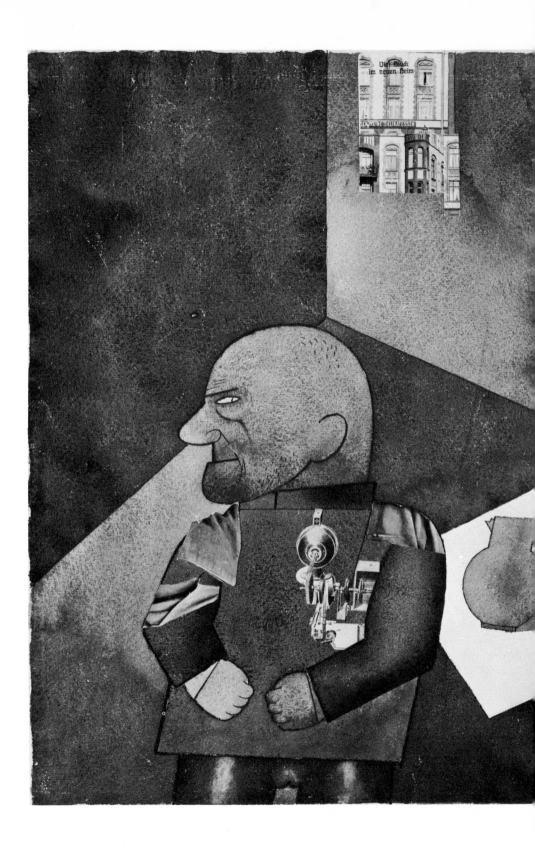

73
Heartfield, the mechanic 1920
watercolour and pasted
postcard, 16 × 11 in.,
41·9 × 30·5 cm.
Museum of Modern Art,
New York, gift of A. Conger
Goodyear

74
Suburb 1920
watercolour, pen and ink,
signed and dated, 15½ × 11 in.,
40 × 28 cm.
Norman Granz, Geneva

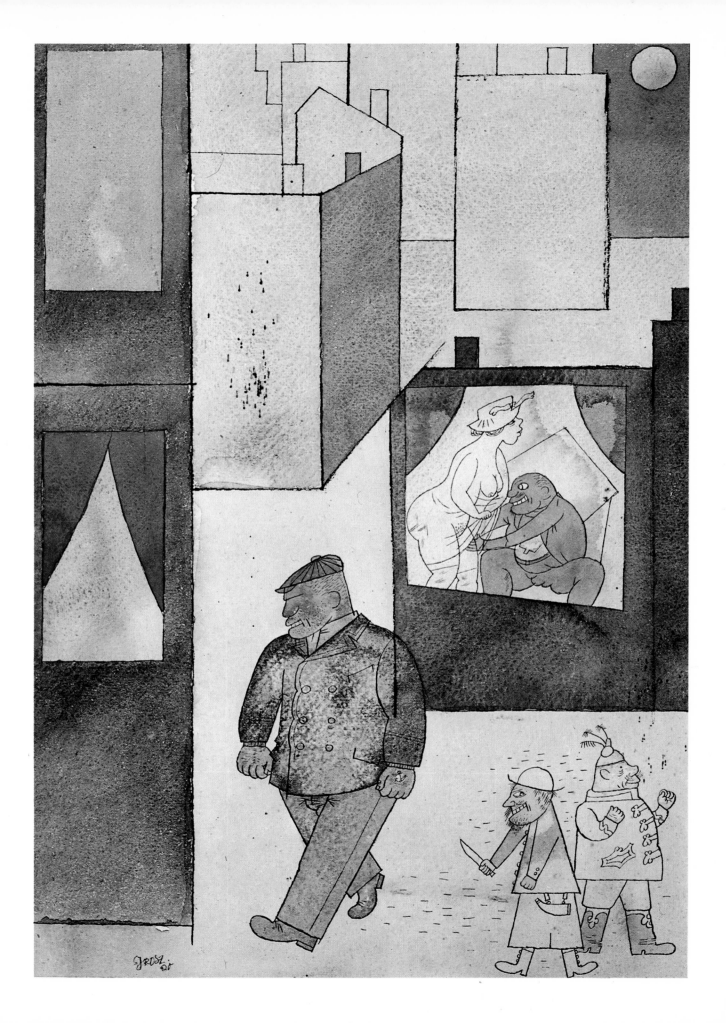

to call themselves *Monteurs* (mechanics) and to adopt a proletarian stance. *Heartfield, the Mechanic* (fig. 73) is a montage of styles, including Surrealism and Cubism, as criticism of art. In *Suburb* (fig. 74) mechanization allows for a variety of human impulses. This non-objective style was to be developed further by Grosz in later works.

By the end of 1918 Grosz had achieved a form of drawing, quite unique, the unmistakable 'Grosz', which was to be his and to make him known. It stamped itself on the consciousness of the public, but it also stamped him with a mark which he would find difficult to eradicate. Because in Grosz's work form and content had become so closely welded that they were one, he was to find it difficult to separate the two when he felt the need to do so. By having made his mark so forcefully, he was to be a marked man.

'To achieve a style which was drastic and unbowdlerized to represent my subjects, I studied the most immediate manifestations of artistic urges. I copied the folkloristic drawings in lavatories; they seemed to me the most direct expression and translation of strong sensations. Children's drawings stimulated me, because of their single-mindedness. Thus I acquired a knife edge line which I needed to record my observations dictated by an absolute negation of man. But there was the danger of rigidity of stylization.'[9]

He asked Schmalhausen, who shared his interests,[10] to collect for him pornographic postcards, photos, folkloristic poems, drawings, lavatory graffiti, to add to his small but selective collection.

An analysis of the style will reveal its novelty. It was deliberately inartistic. The line is neither beautiful nor personal, and is reduced to its minimal function. The observation underlying the development of his types and the style to express their characteristics, is threefold: physiognomic, psychological and sociological. In their unity they reveal that a man's social position imbues his psychological responses, which in turn shape his physiognomy. This would be the materialist interpretation, but if the opposite view is preferred, it works just as well. Giving the primacy to character or the spirit, the reading would be that that sort of man would look like that and act in his social position as he is known to do. Two examples of style and type are shown in: *Guilty conscience* (fig. 75) and *The Absolute*

75 (*below left*)
Guilty conscience 1915
no. 60 in *Das neue Gesicht der herrschenden Klasse*

76 (*below right*)
The Absolute monarchist 1918
pen and ink drawing, signed,
no. 35 in *Ecce Homo*

monarchist (fig. 76). One has a moral title and the other a general title. One appears more individualized, the other more generalized. Yet both are the outcome of the same experience, and the unity of attitudes, character and looks. The ugliness Grosz depicts is moral, personal, political and social.

This unified mode of understanding and description is the basis of Grosz's style. It is the language in which he will tell people what they are like: *Parasites* (fig. 77), *The Visit* (fig. 78) and *Home sweet home* (fig. 79) are such simple domestic scenes of everyday life.

The artist set himself the task of combating a state of mind, a mode of thought. The old pictorial clichés had lost their vitality, yet the artist needed visual images, type images, with which to represent an experience. Grosz's new pictorial language was one he had to invent. He thus transcends the lampoon, the caricature, the cartoon, and reaches the sphere of satire, castigating the mores of a whole society. Having understood that society is a political creation and that the state is an apparatus of oppression, he attacked the exponents of the state itself, realizing that state and state power are not abstract concepts but active forces invested in actual people.

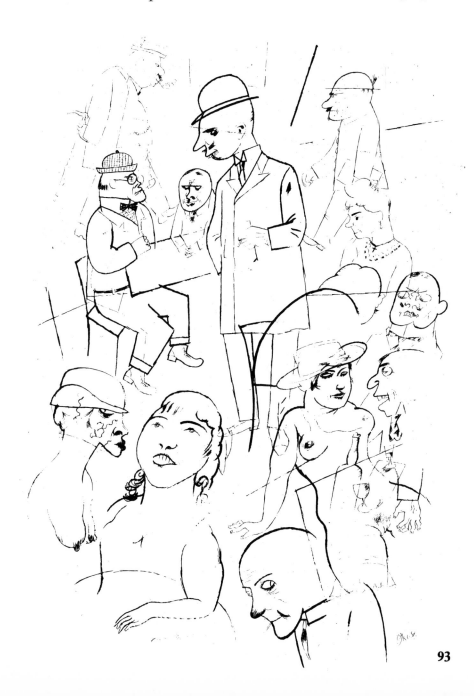

77
Parasites 1918
pen and ink drawing, signed,
illustration to *Dr Billig am Ende*

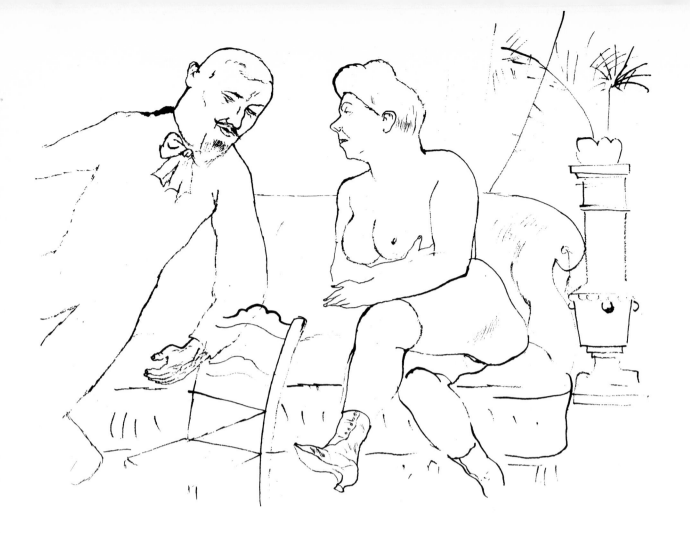

78
The Visit 1920
no. 11 in *Ecce Homo*

79
Home sweet home c. 1920
pen, brush and ink drawing,
signed, $15\frac{1}{16} \times 22$ in.,
$38 \cdot 2 \times 56$ cm.
National-Galerie, Berlin
GDR

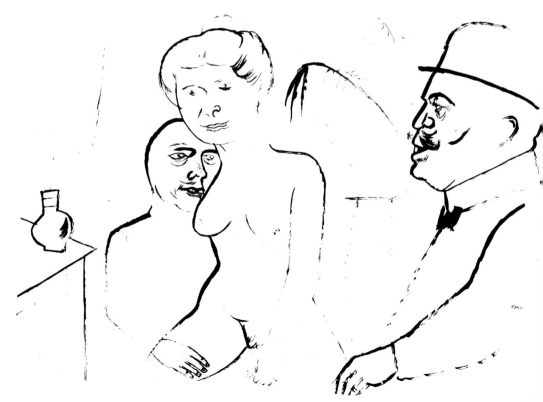

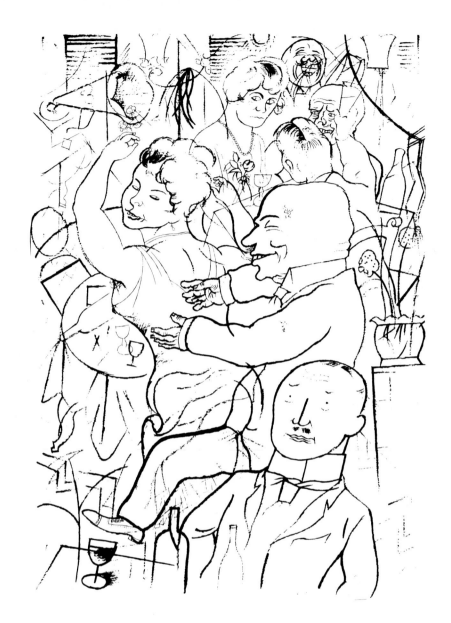

80
Pleasure 1920
pen and ink drawing, signed
and inscribed, $14\frac{1}{2} \times 10\frac{3}{4}$ in.,
$36 \cdot 8 \times 27 \cdot 3$ cm.
Marlborough Galleries, New
York, London, Zürich

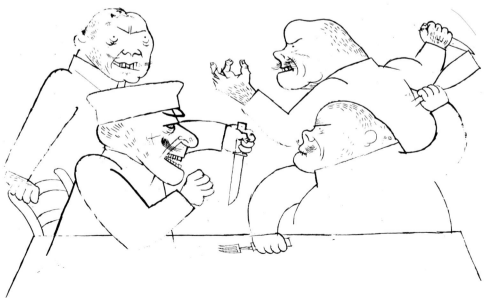

81
Argument 1919
pen and ink drawing, signed,
$14\frac{3}{4} \times 21$ in., $37 \cdot 5 \times 53 \cdot 5$ cm.
Galleria del Levante, Milan

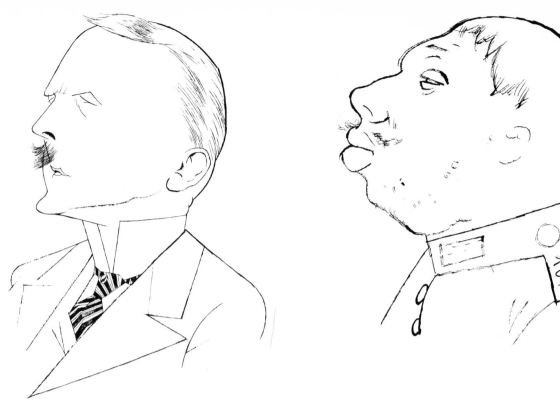

82
Cover drawing for *Des Gesicht der herrschenden Klasse* 1919
pen and ink drawing

83
Den macht uns keiner nach! Honi soit qui mal y pense Made in Germany 1919
pen and ink drawing
no. 9 in *Gott mit uns*

84 (*opposite*)
Beauty – thee I praise 1919
watercolour, with pen and ink, dated, $16\frac{1}{2} \times 11\frac{7}{8}$ in.,
$42 \times 30{\cdot}2$ cm.
Galerie Nierendorf, Berlin

He created in his very types an emblematic typology, and in his physiognomic types the typical physiognomy of a group or caste. The Germanic heads in *Pleasure* (fig. 80) and *Argument* (fig. 81) are the product of one system of education: the militarized schools, producing rulers who ruled with prototypal monotony, and who appear as the German academic, lawyer, officer, civil servant in figs 82 and 83 (which was originally entitled *Made in Germany*).

What was for Grosz the most terrifying fact, however, was the realization that the harmless philistine is also the exponent of the ruling class, that in fact, the ruling class, almost by definition, must consist of philistines and that it can only rule with the support of the philistine. In his work Grosz tries to show that not only do these types rule the world, but that no world ruled by such types can be a good one. Grosz's comments might well have been shared by others, but he made them manifest, and found a new and singularly telling form for them. In a watercolour, *People in the street*, (fig. 130), he presents some figures from his repertoire which play their roles in many different drawings by the artist.

Grosz's world was a man's world—in that he was a philistine—and in his man's world women are the victims, sacrificed on the altar of lust. They are degraded or self-degraded, willing or unwilling victims, and Grosz's women are women as seen by man, and also women as they want to be seen by man. Both men and women act as machines, drunk or sober, propelled by impulses. In the Christian sense it is a hellish world, and it differs only in that it contains the seven deadly sins alone, to the exclusion of the seven virtues *Beauty—thee I praise* (fig. 84), and *Far in the South, beautiful Spain* (fig. 87).

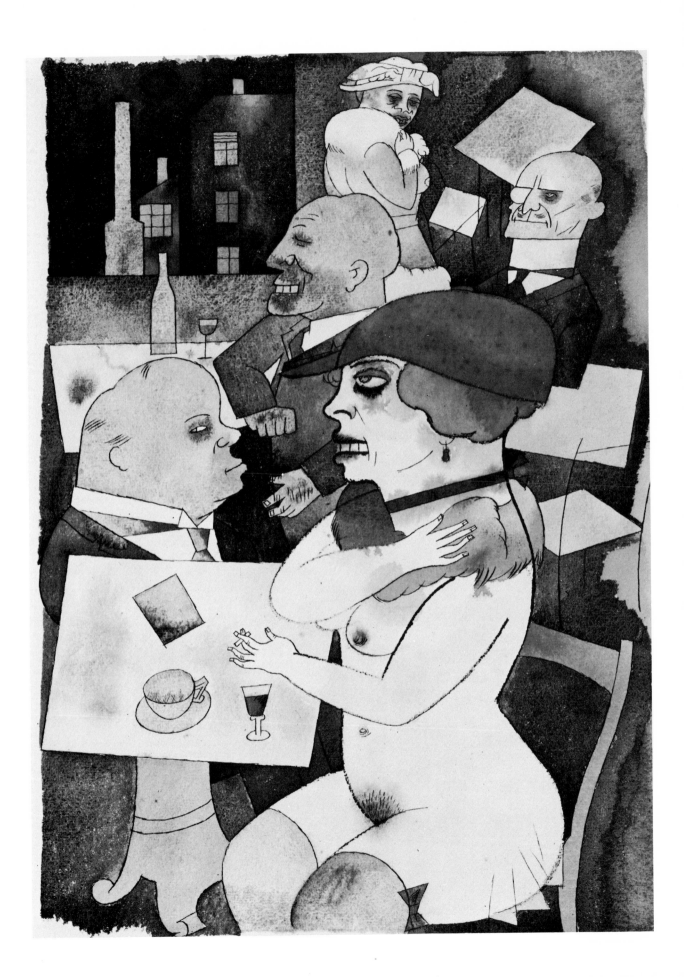

Grosz made erotic and pornographic representations of ordinary popular predilections. The erotic drawings in his own work are as little 'appealing' as his other drawings. They are revealing, literally and metaphorically; they reveal his views and attitudes of the participants, their play-acting and their myth-making. *Far in the South, oh beautiful Spain* shows Grosz's assembly of his figurines in a Futurist strip cartoon, a twentieth-century morality play.

At this time Grosz was attached to a girl called Succi, a rather ambitious young woman who was the manageress of a fashion house. He had already met Eva and Lotte, two sisters, the first a student at the Art School and the other a photographer. These two young, reasonably independent girls from a petty bourgeois background, are both important in his life. He was to marry Eva in 1920 and his friend, Otto Schmalhausen was to marry her sister Lotte. So that from then onwards these two families were closely linked.

Eva's role in Grosz's development, though not well documented, can nevertheless be quite clearly traced. That she was an attractive, sensible and likeable person, is not in doubt. She was quite openminded for the time, but she retained a narrower outlook and attitude than her husband, as was apparent in her reactions to him. She considered Grosz's friendship with Wieland Herzfelde to be very damaging for him because Herzfelde adored him and would do practically anything Grosz wanted and encouraged him in his wildest schemes and ideas. But she was very perceptive about Grosz himself. In answer to a letter from Schmalhausen, she wrote: 'George only knows extremes . . . and how right you are in saying that he exterminates systematically all human impulses within himself, and that he holds on to the evil in men only. What will become of him?'[11] Her letter is that of a very emotional sensitive girl. Grosz's need of her and his genuine love for her was to last a lifetime.

Berlin Dada events, those which have gone for ever and those publications which remain, have been considered for their political as well as for their aesthetic relevance. Grosz himself was an active Dadaist, that is an insulting entertainer and conscious destroyer of artistic values. In his collages with Heartfield he produced striking destructions of accepted visual imagery, as much as he destroyed conventional ideas of beauty in his drawings. Dada was most meaningful as a symptom of disgust and revolt.

Politically, one has to distinguish between Dadaist illusions and social reality. Berlin Dada had found a temporary home with Malik, which established a 'Dada Section' to make the difference between Malik and Dada reasonably clear. *Dada 3* was published in 1920, with typography by John Heartfield (numbers one and two had appeared under the imprint of Freie Strasse). The contributors were members of the non-existent 'Club Dada', Berlin, meeting in studios, cafés or at the publishers. Everybody was entitled to call himself a Dadaist. Richard Hülsenbeck, Franz Jung, Walter Mehring and Carl Einstein were all connected with Dada events. Grosz supplied an anonymous portrait of Dada man (fig. 85).

The first international Dada fair, arranged by Grosz, Hausmann and Heartfield, was a most spectacular affair. Its catalogue was published by Malik, Section Dada, the editors calling themselves Marshall G. Grosz,

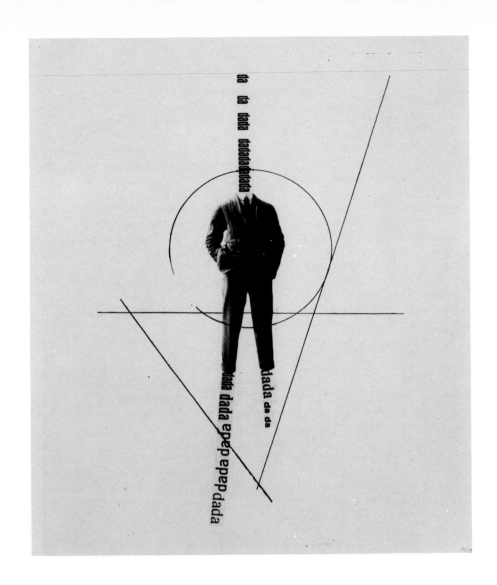

85
Dada man c. 1919
photomontage
$11\frac{13}{16} \times 14\frac{5}{8}$ in., 30×37 cm.
Galleria del Levante, Milan

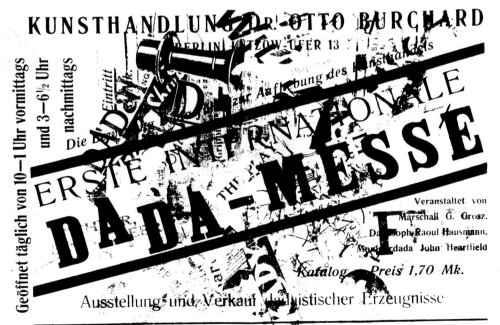

86
Catalogue, Dada Fair 1920
collage
11×14 in., 28×35.7 cm.

Dadasoph Raoul Hausmann and Monteurdada Heartfield (fig. 86). The fair became a minor sensation. A large pig in a German officer's uniform was suspended from the ceiling and gave the expected offence. A banner proclaimed Dada's solidarity with the international proletariat and world revolution. *Die Rote Fahne*, the official daily of the Communist party of Germany, published on 25 July 1920 an article on the fair. Quoting a poster: 'Dada is God and John Heartfield his prophet. Dada is no bluff. Dada sees,' it ridiculed the exhibits. *Die Rote Fahne* considered that, if the Dadaists thought that by such means bourgeois society could be attacked, they were mistaken. Did they really believe that they could damage the bourgeoisie by such means? One could pass over Dada as a manifestation of megalomania, a pathological event, if these contributions were not so ridiculously tiny and insignificant compared to the powerful struggle of the working class for its liberation. The working class, it continued, would win the battle without the extra campaign against art and culture carried out by a bourgeois clique of *littérateurs*. The only thing these people should not do was to call themselves Communists.

At the Dada fair, Grosz's portfolio *Gott mit uns* was confiscated by the police. At the Malik publishing house the originals were also confiscated at the request of the army, because it felt insulted. Tucholsky commented at the time: 'Either Grosz's drawings don't look like Reichswehr officers and therefore the Reichswehr was not insulted, or the officers look like Grosz's drawings and therefore Grosz is right.'[12] But this argument did not prevail, and Wieland Herzfelde, Grosz and others were tried for insulting the army. Tucholsky, reporting the trial, approved Wieland Herzfelde's outspoken defence, but was disappointed with Grosz's, whose work, which was serious, was presented as a joke, and Grosz himself did not say a word which could compare in sharpness with his graphic line.

When the Dadaists claimed to be communists, they used the term in exactly the sense in which the bourgeoisie used it. To them, too, Bolshevism was the destroyer of those sacred values which the Dadaists intended to destroy. No communist could have sympathized with Dada, whilst it was easy for Dada to mistake communism for the Messiah of Destruction. The Dadaists, like all *littérateurs*, over-rated art and literature. They were as much the dupes of bourgeois misrepresentation as the very bourgeoisie they were aiming to defeat. Their sympathy with the bolshevist bogeyman was genuine, but their acts were reactionary, contrary to their intentions. The bourgeoisie did not tremble for its poets, it trembled for its pockets.

There are not many Dada products in Grosz's work. Dada, in any case, was a process, a happening of the moment, and it was not meant to last. But in his work there is a Dada spirit of illogical coherence, and there is certainly the Dada mood which sees even irony as futile.[13] Of all the Dadaists, only Grosz and John Heartfield drew political conclusions. 'Today I know that it was our only mistake to concern ourselves seriously with art at all . . . We saw then the mad end-products of the ruling order of society and burst out laughing. We did not yet see that there was a system underlying the madness.'[14]

Returning to his and John Heartfield's earlier constructivist phase, Grosz attempted to mechanize his pictures. Grosz wrote about his new work: 'I intend creating an absolutely realistic picture of the world . . . Man is no

87
Far in the South, beautiful Spain 1919
watercolour, signed, dated and inscribed, $15 \times 11\frac{13}{16}$ in., 38×30 cm.
Klaus Hegewisch, Hamburg

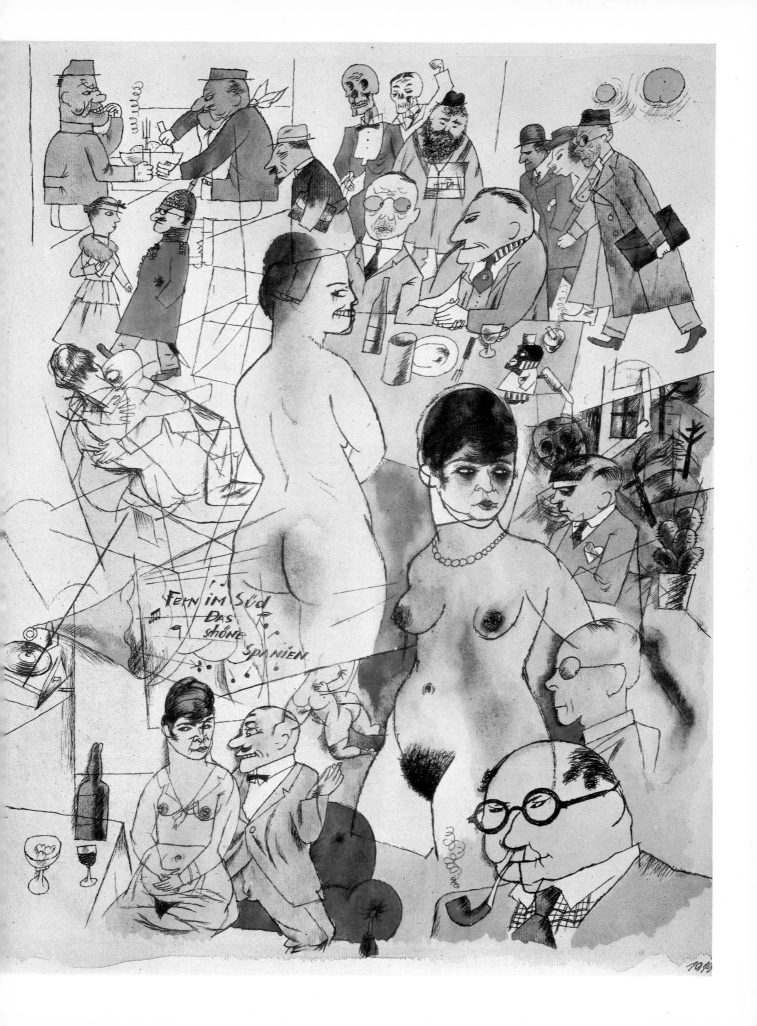

longer an individual, represented with acute psychological insight, but is a collectivist, almost mechanical concept. I suppress colour. The line is drawn in an impersonal photographic construction to give volume. Again, stability, reconstruction, function, e.g. sport, engineer, machine. No more dynamic Futurist romanticism.'[15] As Grosz had written about John Heartfield and himself: 'We, however, saw the big new task of a tendentious art in the service of the revolutionary cause.'[16] These works then are an attempt to overcome the anarchy of Dadaism by conscious construction as a positive aim. The watercolours reproduced in *Das Kunstblatt*,[17] which are signed with a rubber stamp, indicate the business-like impersonality of the product. In composition, the pictures of the period resemble the work of Carrá, which he acknowledged in the article, and, although Grosz claimed that his own work was anti-metaphysical, the work cannot free itself from that timeless space and the eternalization of the generalized figure which distinguished the *pittura metafisica of* Carrá and de Chirico. *The Cyclist* of 1920, originally intended as a design for a Workers' Sports Centre (fig. 89), is signed with a rubber stamp which reads: 'George Grosz, 1920, construiert'.

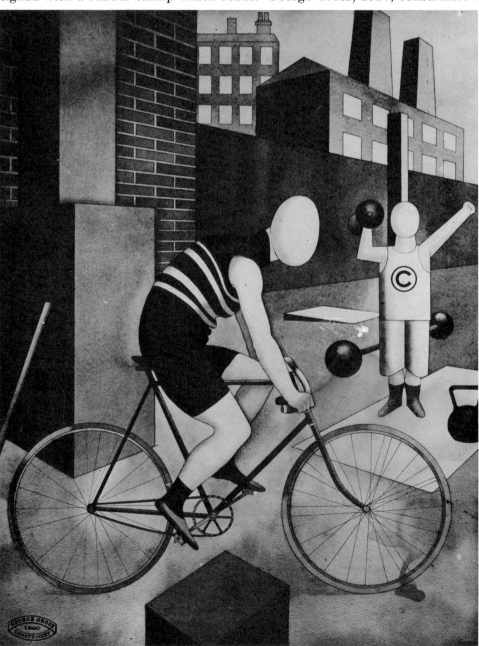

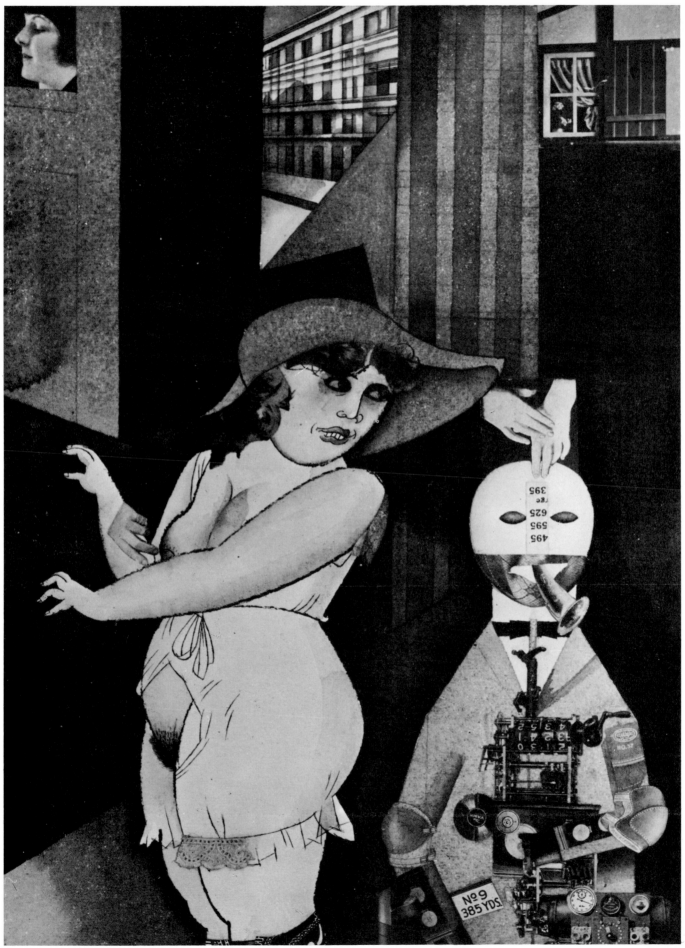

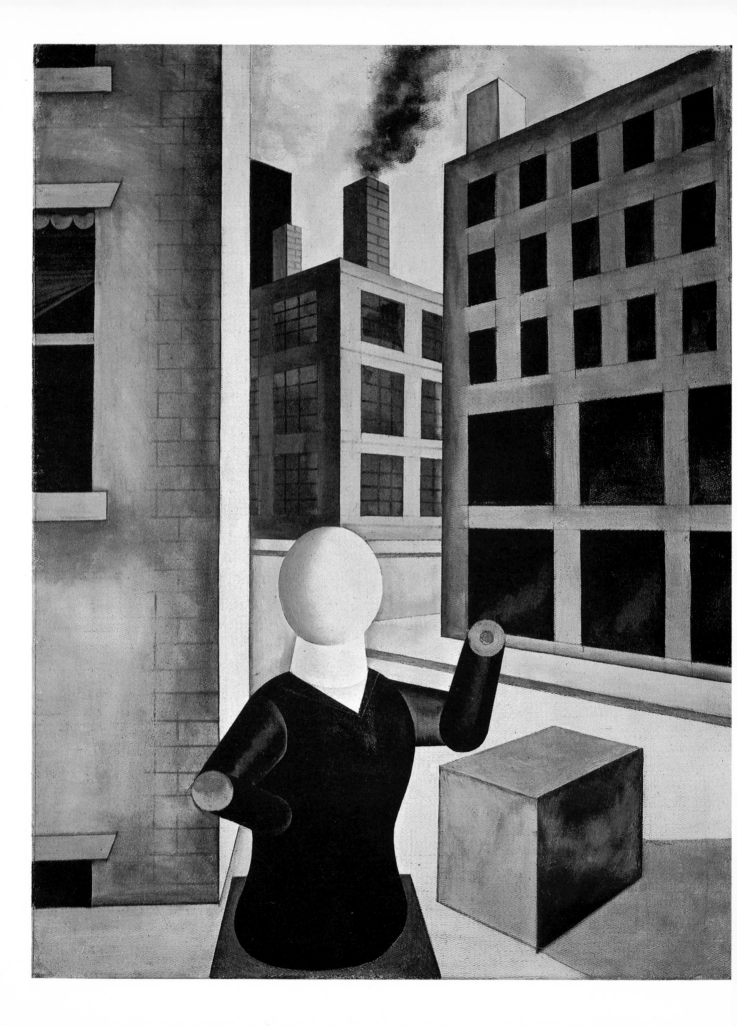

Untitled (fig. 90) could not possibly have a title, as it depicts the total anonymity of mechanical man.

That mechanical phase, more typical for Grosz's serious collective intention and commitment than for his temperament, did not last long. Already in 1920, there was a backsliding to the old Grosz in a hybrid picture of mechanical man and non-mechanical woman: *Daum marries* (fig. 88). The subtitle reads: 'Daum marries her pedantic automaton George in May 1920, John Heartfield is very glad of it; *Metamech. Konstr. nach Prof. Hausmann* (metamechanical construction after Prof. Hausmann).' 'Daum' is the anagram for Maud, the name given by Grosz to his wife Eva. It is thus Grosz's idea of a wedding card. In *Berlin C*, a streetscene (fig. 91), the perspectives

90 (*opposite*)
Untitled 1920
oil on canvas, signed and
dated, 31¾ × 24 in., 81 × 61 cm.
Kunstsammlung Nordrhein-
Westfalen, Düsseldorf

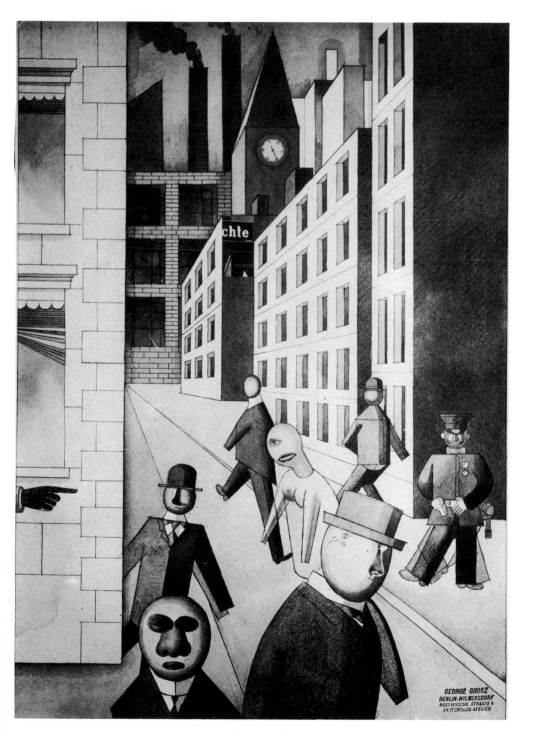

91
Berlin C 1920
watercolour, signed and dated
Present ownership unknown

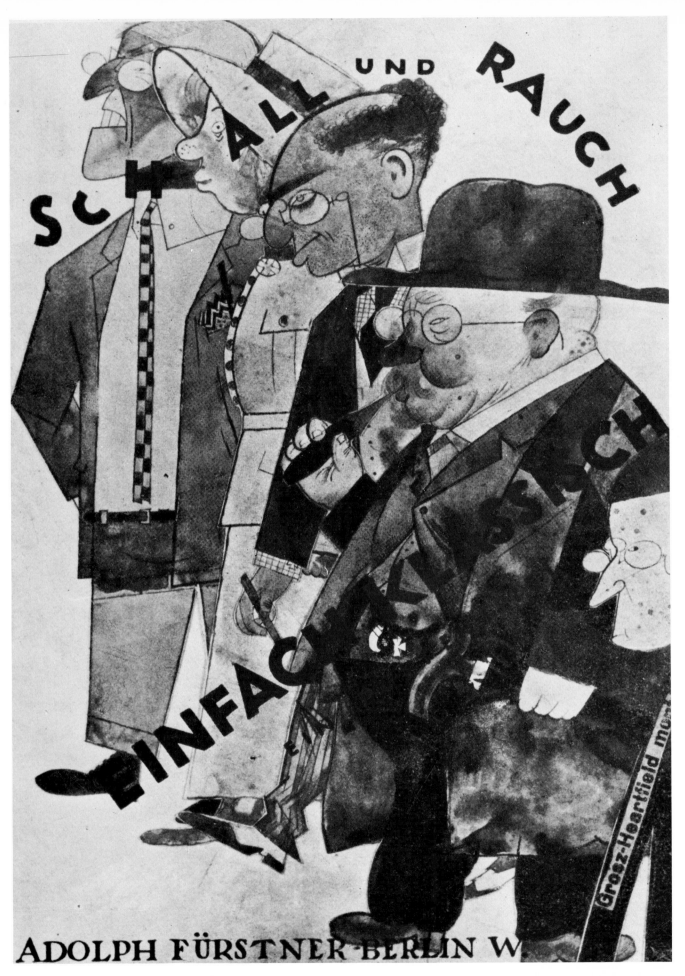

of Surrealist and Metaphysical paintings are inhabited by automata, who could only have been designed by Grosz himself. Malik published some of the works of this time under the title *With brush and scissors—materializations*.

In Reinhardt's theatre the cabaret 'Schall und Rauch' was established in the basement, where he not only designed the programme with John Heartfield (fig. 92), but also performed.

It was in the years around 1920 that Grosz was beginning to be recognized as a great satirist. A satirical statement lives by contrast with the real. The closer the parodied or satirized is to reality, the greater will be the tension which results from it. Grosz's mastery is exactly that he achieves that nearness, that quasi-identity of the real with the satirized. With hardly any exaggeration, with barely a distortion, the essential is drawn and transformed into the sphere of the satirical. In Grosz, the satirized begins to look like the actual, and in the end one doubts whether his officers and men are modelled on real life, or the other way around. His searching vision is imbued with an exact knowledge of what form of thought, action and morals, underlies each outline. Grosz is clinically correct in his diagnosis, and the anatomical and emotional correlation between bodily organs and their function. It is the recognition of the figure, and then knowing his thoughts, his past, his actions, which stand out so clearly in a drawing by Grosz. It is here that the political truth is revealed. They look like that because they are like that, and they are like that because they think like that. In *Rush hour* (fig. 93) and *In the street* (fig. 94) the interrelations are public, in *German oaks* (fig. 95) and *Teutonic day* (fig. 96) relations are domestic and patriotic.

92 (*opposite*)
Grosz-Heartfield, programme cover for Cabaret *Schall und Rauch* 1920
collage

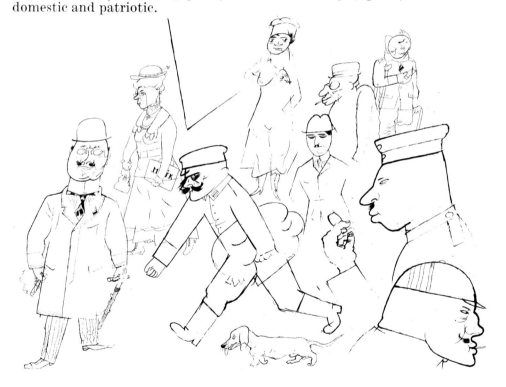

93
Rush hour 1920
pen and ink drawing
no. 45 in *Ecce Homo*

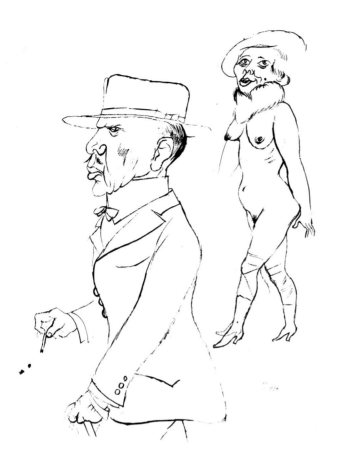

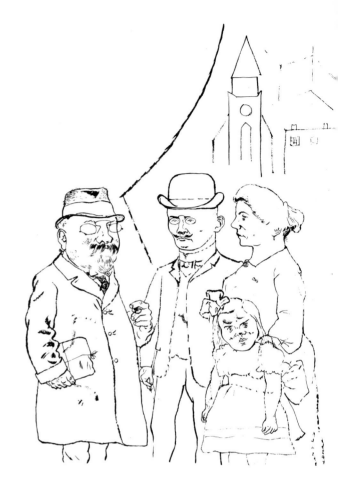

94
In the street c. 1922
pen and ink drawing
$19\frac{5}{16} \times 14\frac{1}{2}$ in., 49×37 cm.
Galleria del Levante, Milan

95
German oaks c. 1922
pen and ink drawing,
24×19 in., $61 \times 48\cdot3$ cm.
Margit Chanin, New York

Grosz's types and Grosz's drawings live in a horrible symbiosis. Every-thing Grosz hated and loathed, he was also himself. He drank too much; he was the vicious small-town bourgeois whom he understood so well in his own inner self. The impulses and ferocities were also his own. Though he hated his subjects, he was also in love with them. Mynona recognized that 'very pious antipathies are instinctive self criticism'.[18]

During the years 1920–21, some of the best of Grosz's drawings appeared as original lithographs or prints in the *Mappen* published by Malik. The *Mappen* were portfolios lithographically printed. It is with these *Mappen* that the work of Grosz found at the time a wide distribution. *Gott mit uns* (God is on our side) was the title of one of these, a political port-folio with nine lithographs, each one with a title in French and English as well as in German, directed against capitalism and war. *Das Gesicht der herrschenden Klasse* (The face of the ruling class) was a volume of fifty-five political drawings. Its impact was considerable. A first edition of 6,000 copies was quickly sold out, so was the second edition of 25,000 copies. The title of the work is self-explanatory, as is *Im Schatten* (In the shadows) with nine lithographs. In two different versions of the same subject from the

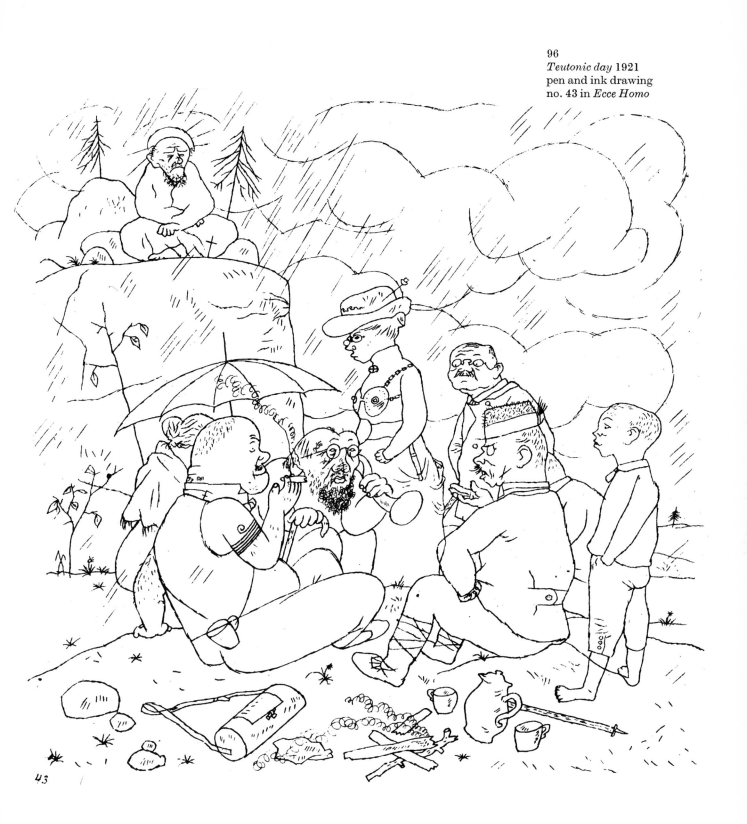

96
Teutonic day 1921
pen and ink drawing
no. 43 in *Ecce Homo*

43

97
The Matchseller 1921
pen and ink drawing
no. 4 in *Im Schatten*

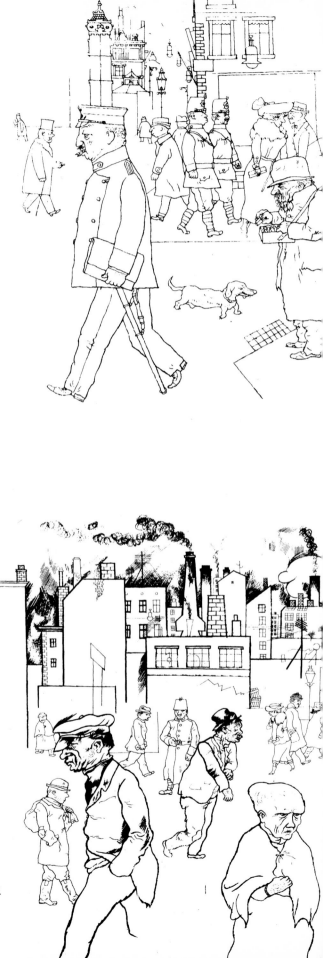

98
Dusk 1921
pen and ink drawing
no. 6 in *Im Schatten*

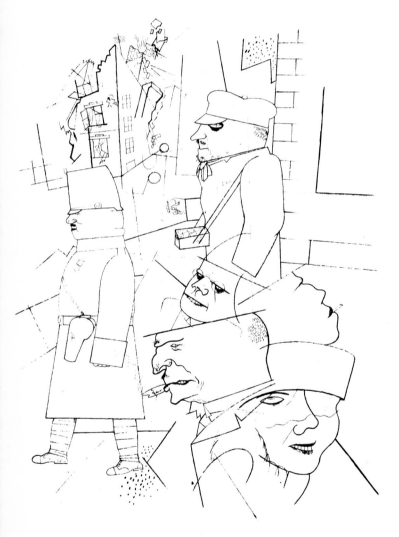

99
Outside the factories 1921
pen and ink drawing
no. 2 in *Im Schatten*

same portfolio, *The matchseller* (fig. 97) and *Dusk* (fig. 98), a change of style in Grosz's work can be observed. *Dusk* still depends on Futurist inter-penetration of planes, while *Matchseller* is a far more realistic drawing. Although *Im Schatten* is a powerful collection, as seen in the silent indict-ment of *Outside the factories* (fig. 99), the portfolio *Gott mit uns* is the most hard-hitting publication. It contains the *Pimps of death*, 1919 (fig. 100), incisive and dirty graffiti on the new Republic which had been made secure by the army and police in the interest of 'business as usual'. This collection also included *Die Kommunisten fallen und die Devisen steigen* (Communists fall and shares rise); the title in French was *Écrasez la famine*, and the title in English: *Blood is the best sauce* (after Goethe) (fig. 101). *They thunder sweetness and light* (fig. 102) takes up the subject of every country's parsons praying for victory. The very title of the portfolio, 'God is on our side', refers to the same irony.

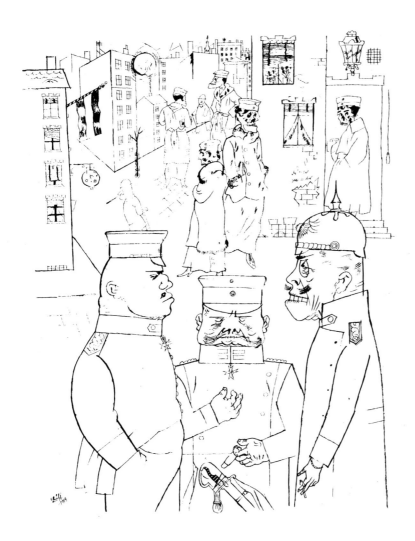

100
The Pimps of death 1919
pen and ink drawing, signed
and dated
no. 6 in *Gott mit uns*

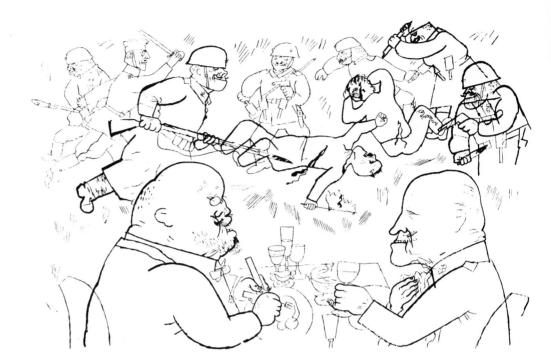

101
Ecrasez la famine – Die Kommunisten fallen – und die Devisen steigen – Blood is the best sauce 1919
pen and ink drawing
no. 8 in *Gott mit uns*

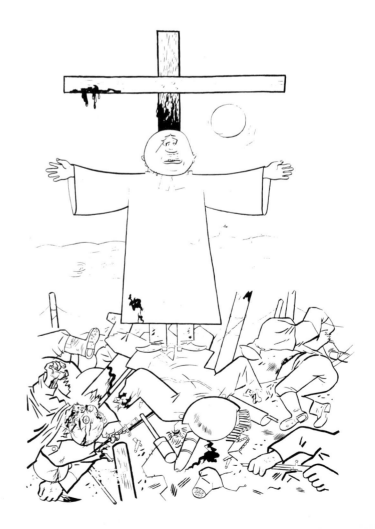

102
They thunder sweetness and light from their clouds and offer human sacrifice to the God of love 1922
The Robbers by F. v. Schiller, II, iii pen and ink drawing
no. 7 in *Die Räuber*

Grosz's drawings were not specially drawn for the various portfolios but were selected from work he had already done. Some were used and re-used with new titles, according to the situation, illustrating in that process the relativity of art and its meanings and devaluing, very deliberately, the idea of originality by stressing the element of use.

A lithograph produced for *Die Räuber*, The robbers (after Schiller's play), with suitable quotations from Schiller, is in itself an example of the use to be made of art and literature in the service of a definite political aim. It had appeared first in *Das Gesicht der herrschenden Klasse* as Toads of property (see title page); in *Die Räuber*, it was: 'In my domain we shall bring it about that potatoes and small beer are a treat for feastdays.'

War and profit, capitalism and religion, the army and the state, are the obvious themes of the political struggle, as far as it is visible in the open. But behind that struggle lies the hidden ideology of the home, the family and all its assumptions. *God's visible blessing rests upon me* (fig. 103), in *Die Räuber*, denounces the German sentimental Christmas vulgarity; *A faithful wife, a loyal child, that is my heaven on earth* is the title given in another

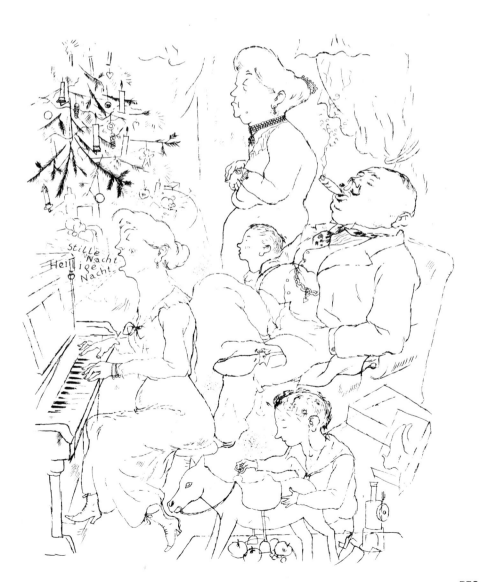

103
God's visible blessing rests upon me 1921
The Robbers by F. v. Schiller, III, iii
pen and ink drawing
no. 6 in *Die Räuber*

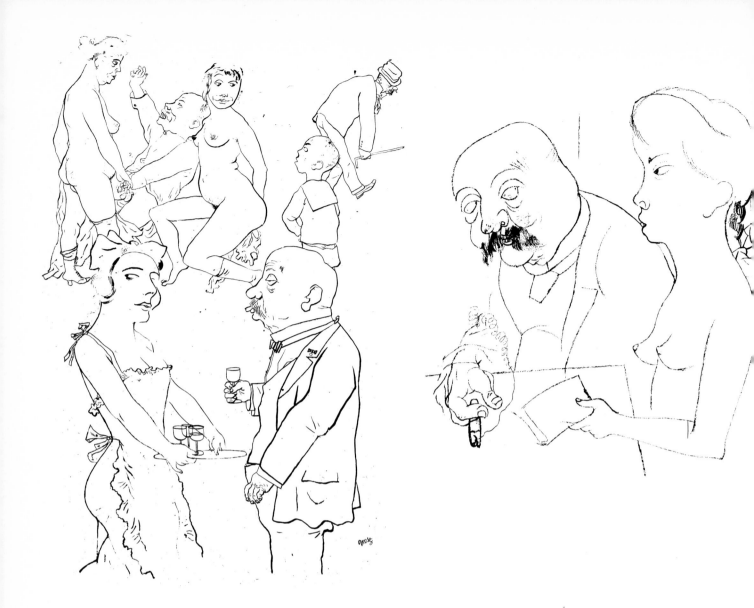

104 (*above left*)
Genrescene 1922
pen and ink drawing, signed
no. 61 in *Ecce Homo*

105 (*above right*)
Spring's awakening 1922
pen and ink drawing
no. 26 in *Ecce Homo*

portfolio. As a companion piece, *Genrescene* (fig. 104) places the family and prostitution in the same market. Family relations are also illuminated in the benevolent drawing of everybody's niece in *Spring's awakening*, given the title of Wedekind's play (fig. 105).

Grosz's sardonic realism had replaced the hectic Futurist simultaneity of the earlier years. An attempt at factual, critical reporting, politically committed yet 'objective' in the representation of events, is another aspect of Grosz's work. A watercolour, *Brindisi, O.D.* (fig. 106), marks a transition from the 'mechanical' style to a stylized objectivity which was to be developed in some of his oils.

Grosz's drawings of sexual aggression not only show up the prevailing hypocrisy of the peculiar deep-rooted identification of sex with sin but also its identification with reaction as such.

106 (*opposite*)
Brindisi, c. 1921
watercolour, signed
$17\frac{1}{8} \times 12$ in., $43 \cdot 5 \times 30 \cdot 5$
Barry Miller, London

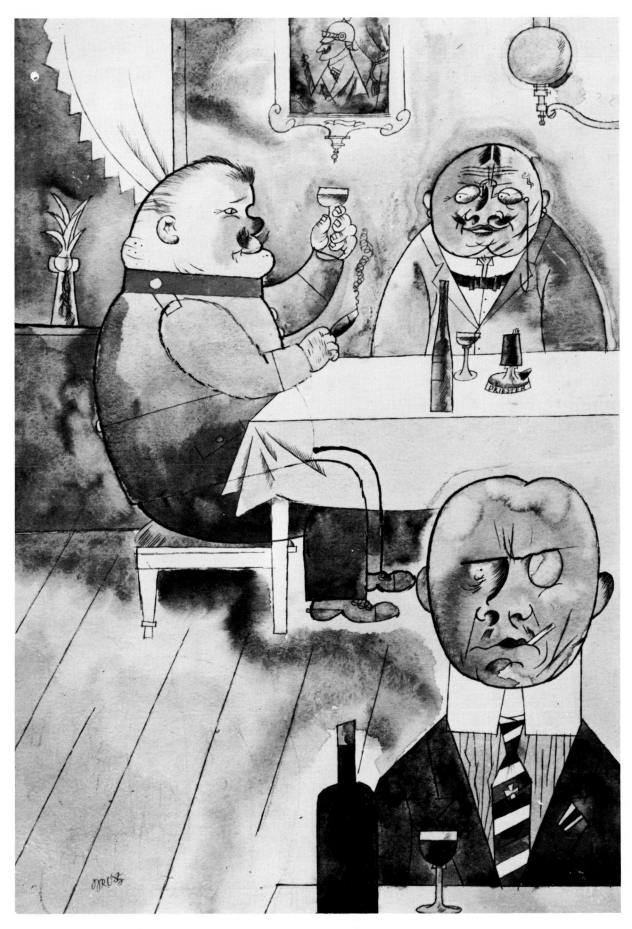

107
Munke Punke Dyonisus 1921
pen and ink drawing
illustration in *Munke Punke
Dyonisus, groteske Liebesge-
dichte* by Alfred Richard
Meyer

An illustration from Munke Punke's Dionysian grotesque love poems of
1921 (fig. 107) shows the two sides of the struggle in Grosz's style. Altogether,
Grosz is moving from the formal dynamic conflict in his pictures to a
'realistic' form of representation. His political commitment, as well as the
more settled normal development of social life, made the literary, factual
content of his drawings more important. He attempted to depict and portray
relations between figures in social life without obscuring the class relations
of those figures. *Redundant* (fig. 108) makes an explicit statement and has
many titles: 'Half a century of Social Democracy' in an earlier portfolio, and
'It is a miserable role to be the rabbit in this world, but our betters need
rabbits' in another portfolio. The accusation is against the mutual consent
of the exploiter and the exploited which does not alter from the factory to
the nightclub. What makes his attack so grimly effective is the recognizable
unity of Grosz's style. His personal line, used for the varying subjects,

108
Redundant 1922
pen and ink drawing
no. 14 *Die Gezeichneten*

relates the themes to each other. By drawing a wife with the same line as he draws a whore, he makes whatever difference there might be imperceptible. This was the quality of Grosz which Wieland Herzfelde had been the first to recognize for its political effectiveness. Grosz was able to pour his own bitter contempt into his subjects, like a language his line carried its overtones of bias into the neutral subjects. It was his tone of voice, which made the different scenes speak the same language.

The largest and best-known collection of Grosz's drawings appeared in *Ecce Homo*, with eighty-four lithographs and sixteen watercolours. *Dusk* (fig. 62) is typical of the watercolours which appeared in the limited edition of *Ecce Homo*, in which the use of colour is as acid as that of line. During the period, a steadily growing number of publications carried drawings by Grosz.

Grosz's name became a household word, and his types acquired a nearly proverbial standing. People referred to a particularly unpleasant passer-by as a 'typical Grosz figure'. Grosz's vision had been generalized. Rarely had an artist achieved so much. In the words of Ilya Ehrenburg: 'The Germany of those days found her portraitist—George Grosz.'[19]

109
Hitler, the saviour 1923
pen and ink drawing, signed
Die Pleite no. 8, November
1923
'*Siegfried Hitler*'

6. Berlin in the twenties 1923-27

By 1923 the hectic period of the post-war years was nearing its end. The ruinous inflation which had impoverished many families who had once seen better days came to an end as well. The mark was stabilized in November 1923, and with this, a relative stabilization of the capitalist economy was achieved. The way Grosz reacted to events can be seen in his work and thus in his style. His line and composition became less acid; still personal, but nearer to the conventions. This apparent mildness might appear to be a sign of softening in Grosz's attitude, but in fact there was a hardening process going on.

There is no doubt that Grosz understood the growing menace of the totally successful counterrevolution, that was becoming visible in Weimar Germany. His *The White general* (fig. 110), with the swastika, appeared in 1923, a horrible vision of the future. This drawing, as well as *Hitler, the saviour* drawn as early as 1923 (fig. 109), does not so much reveal political foresight, it stands as proof of a clear understanding of the history of his day. For the satirist the question was not of transforming the potential absurdities of reality into the world of art. The nightmare itself presented itself as real and faced the artist with the impossible problem of transposing it into another form. It is in this historic situation that Grosz's search for a new role in a changing climate can be understood. After 1923 his work became more topical in the sense that overtly political scenes are illustrated, whilst his non-political work escaped into a still satirical, but more light-hearted, world of false elegance.

Grosz's marriage in 1920 was something of a turning-point in his life. He was to have two sons, and acquired and accepted family obligations. Henceforth he was most concerned to cut a respectable figure, pay his bills, and establish a settled mode of life. He had become a successful artist of a somewhat novel type as far as his popularity or notoriety went. Morally he was in an awkward position, for he despised the art market and art dealers. He despised the high-sounding claims made for art, having seen through 'the ideological swindle', as he called it, earlier than most. Yet he was an artist by temperament and tradition, with his unique personal vision of torment and hell. But he had his commitments to his political convictions

110
The White general c. 1923
pen and ink drawing, signed
Die Pleite November 1923

as well, which led him to work consistently for communist periodicals—*Die Pleite, Der Blutige Ernst* and *Der Knüppel*—and occasionally for *Die Rote Fahne,* and he always worked with and for Herzfelde's Malik Verlag. He knew that the artist's position in society was precarious. He saw the artist very much in his role of a trickster, a con-man, a juggler, or a clown; a view similar to Thomas Mann's identification of the artist with the crook. The strength of this view can be seen in a letter he wrote to Vladimir Sokoloff, the actor: 'We all wanted to become bicycle champions or travelling clowns. Now you have somehow become a clown, and I have too. Don't we both have to make a living with rabbits—I mean those you pull out of the nothingness of a top hat?'[1]

This ambiguity in the position of the artist, of which Grosz was so well aware, is reflected in his social life. Personally he was acceptable above and below, like an entertainer: he was welcomed by society and equally at home with bums. Grosz dined with bankers, drank with tramps, and discussed the next issue of *Der Knüppel* with party members. His work at the time reflected his own experience, and if the work lacks a single style and direction, so did his life. He did not think of himself as a painter or as a satirist only: he saw himself playing a number of parts.

For some time he had been a cabaret artist with Walter Mehring and John Heartfield in their cabaret *Schall und Rauch* (fig. 92). He worked for the theatre, designing scenery, costumes and cut-out figurines. In 1920 he designed Shaw's *Caesar and Cleopatra* for a production at the Deutsche Theater by Max Reinhardt. Shaw's *Androcles and the lion* had costume designs by Grosz (*The Emperor*, fig. 111), and many other plays had sets by him. An interesting project, Ivan Goll's *Methusalah*, did not materialize.

During 1922 Grosz spent five months in Russia. He was acutely disappointed with conditions in Russia at the time. In contrast to the paradisical picture too often painted by enthusiasts he found a country that was still poor, and in many places dirty and neglected. He met Lenin, who, it was said, was an admirer of Grosz's work, in the last days of his life, when he was already seriously ill, and also had conversations with Lunarcharsky, Sinoviev, Radek, and Trotsky, as well as Tatlin and other artists.[2] There were several reasons for this visit, the main one being an exhibition of his work which was to be held in the country. But the material for the exhibition failed to arrive, further feeding his anger and his disappointment. Much

111
The Emperor 1920
watercolour
Costume study to Bernard
Shaw's *Androcles and the Lion*
Formerly estate of George
Grosz

later, a number of the originals from 1920 and 1921 were found in the Hermitage.[3] The trip was made more unhappy by the fact that he did not get on very well with his travelling companion, Anderson-Nexö, for whom he was illustrating a book. There can be little doubt that his unhappy experiences and impressions influenced Grosz's attitude, though for many years to come he continued to work with and for communist periodicals.

Grosz had his first exhibitions as an artist with Goltz in Munich in 1920, with Garvens in Hanover in 1922, and at the Alfred Flechtheim Gallery in Berlin in 1924, and from this time one can trace a slow but important change in his work and direction. With Flechtheim he was in the world of expensive art. Flechtheim's gallery had been one of the first in Berlin to show the works of the modern French masters, and was the most fashionable and expensive establishment in Berlin. Flechtheim himself was a sharp and witty impresario; he had his mind firmly on money and prestige. He rarely exhibited German painters at all, but mainly dealt in French paintings, and he carefully cultivated the aura of prestige which gathered around the owners of works of modern art. The exhibition at Flechtheim's was in itself a mark of arrival. For a German artist to be given that distinction was rare. Flechtheim, of course, knew what he was doing. He had recognized Grosz's talents and hoping to develop them for their mutual benefit, placed Grosz under contract.

112
The Best years of their lives
c. 1923
watercolour, signed and
inscribed, 24⅝ × 29½ in.,
62·5 × 49·5 cm.
Bernhard Sprengel, Hanover

Flechtheim also owned and edited, together with H. von Wedderkopp, *Der Querschnitt*, a monthly with often very amusing literary, poetic and graphic contributions. Grosz was regularly represented in this elegant magazine. His work, selected by Flechtheim on aesthetic grounds, still added a touch of sarcasm to the liberal flavour of that artistic concoction. *The Best years of their lives* (fig. 112), a watercolour of *c.* 1923, exemplifies his less acid line and his milder form of irony. In *The Glutton*, dedicated to his friend Garvens (fig. 113), though more ferocious, Grosz returns to an earlier manner of brushdrawing, which he was to use eventually for his political cartoons, as seen in a slightly later brushdrawing of 1925 depicting men playing at trains (fig. 114), showing Hugo Stinnes, the post-war profiteer.

113
The Glutton 1923
brush and ink drawing,
signed, dated and inscribed,
$23\frac{5}{16} \times 18\frac{1}{8}$ in., $59 \cdot 2 \times 46$ cm.
Wallraf-Richartz Museum,
Cologne, Ludwig collection

114
Men playing with toy railway
1925
brush, pen and ink drawing,
$20\frac{1}{2} \times 25\frac{5}{8}$ in., $52 \cdot 2 \times 65$ cm.
Illustration for *Kobes* by
Heinrich Mann
Private collection

115
Le petit moulin 1925
watercolour
Present ownership unknown

In April 1924 Grosz travelled to Paris for the first time since the war. With his old friend, Pierre MacOrlan, he visited Pascin, and with Francis Carco and Man Ray, explored 'Montmartre at night', making the typical remark all visitors make that they 'went to those hidden places which no foreigner ever gets to know'.[4] *Le petit moulin*, a watercolour, depicts one of the places he liked at the time (fig. 115). Grosz and Pascin had met before the war. In subject matter, as well as style, their work had much in common, but as temperaments they were very different. Grosz described the unspeakable disorder and dirt of Pascin's studio with 'hundreds of thousands of drawings'.[5] He felt that he was too pedantic himself to understand such a way of life. As Pascin was frail and small, all his shirts were too long; he cut them off with a razor—a method Grosz found difficult to approve. He considered such Bohemianism a form of arrested development.

The artist he liked most was Frans Masereel, 'a sympathetic and decent man' in Grosz's words. With Masereel too, Grosz had something in common: in this case their political conviction and their aim to use their art in the service of the revolution. Masereel was an idealist in the stamp of Romain Rolland, to whom capitalism and exploitation were monsters of the deep. He depicted pure humans who would arise from the ashes of this industrial world. He was a socialist sentimentalist, appealing to the generous and idealist aims of young people, in contrast to the complete absence of that sentimental, rapturous enthusiasm for man in Grosz. The two artists shared the common themes of the modern city, the crowd and corruption, but Masereel was didactic and allegorical in his work, an optimistic socialist of

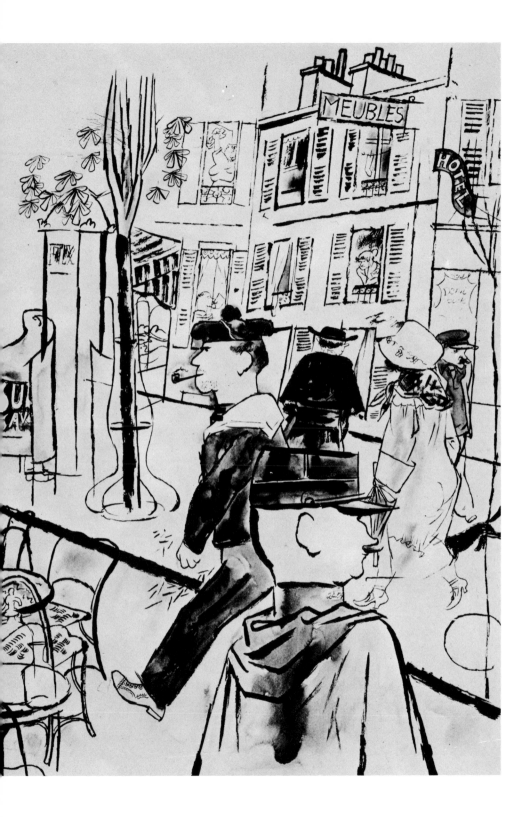

116
Paris street scene 1924
watercolour
Present ownership unknown

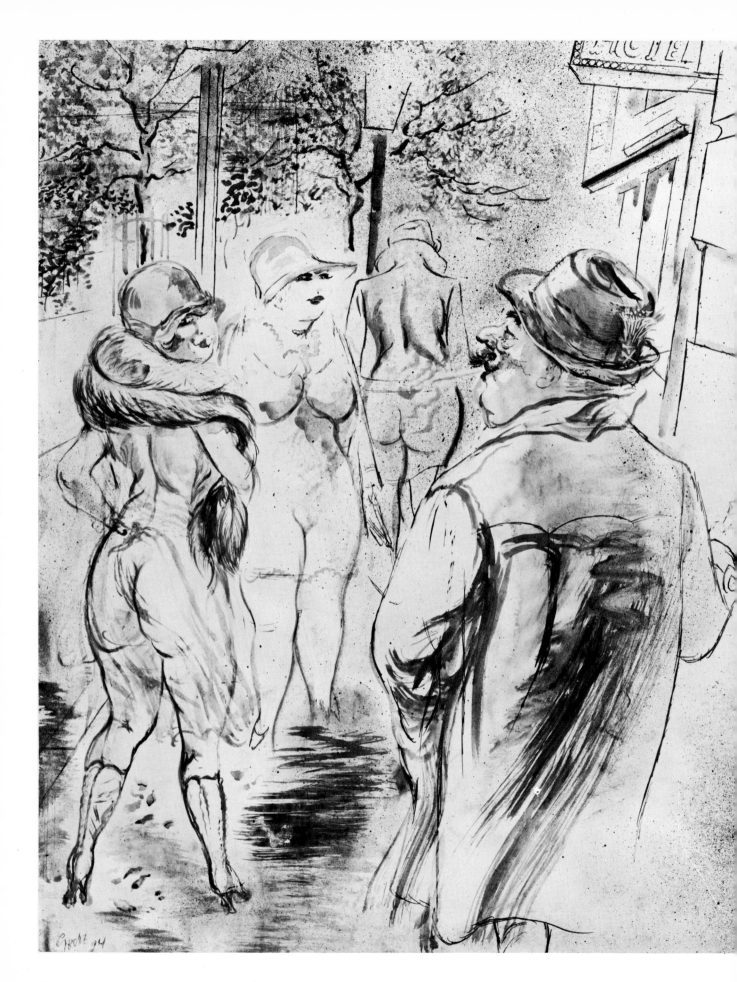

the purest water. Grosz remained a pessimist in all he did. At the time, Masereel was working on a series of woodcuts called *The city*. 'He distinguishes himself', Grosz wrote, 'from other painters in Paris, by not painting guitars.'[6] That cubist guitar had always been Grosz's *bête noir* and symbol of 'art for art's sake'.

Paris seemed prosperous. 'The standard of living is much higher, no beggars and war cripples, in one word the façade has not yet become as transparent . . . as in Germany.'[7]

Amongst the many people he saw, he most frequently met Tucholsky who was then living in Paris, though working for the *Weltbühne* in Berlin. Tucholsky was one of Grosz's great admirers, because he saw in his graphic work the exact counterpart of his own contributions, written with an equally acid pen, for the *Weltbühne*. Of Grosz Tucholsky wrote 'his secret is, he does not only laugh, he hates. He does not only draw, he shows.'[8] Both artist and writer infuriated German conservatives equally. That both fought equally hard against the same enemy, and that both were eventually defeated—Tucholsky committing suicide and Grosz giving up in despair—is both a personal tragedy and part of the history of the time.

He published 'Pariser Eindrücke',[9] arguing against the old romanticized view of Paris as the 'Mecca of German painters' where alone the secrets of *peinture* were to be acquired. The word *peinture* meant for Grosz, as his constant ironic references to it make clear, 'painting for painting's sake'.

How much a satirist depends on the almost visceral understanding of his victims, Grosz had shown in his work at home. As a visitor in France, Grosz made drawings and watercolours of Paris street scenes. Though a little more kindlily disposed towards French soldiers and policemen than their German counterparts, he nevertheless failed to bring out their specific characteristics. His drawings are competent tourist impressions of different places and people (fig. 116), but only as long as he saw Paris as a tourist. When he makes fun of the tourist, obviously a German, face to face with Paris tarts, Grosz can see the scene again as a mild satirist, as in *Country cousins, Paris* (fig. 117). For *Night café, rue Blondel* (fig. 118), a polite title for Paris's best-known brothel of the time, Grosz used a not untraditional style of illustration, only partly his own, owing more to the stylistic conventions of the French illustrators working for popular magazines.

During his first visit to Paris he worked very hard. Eva wrote 'Böff (one of his nicknames) sits next to me. Like an original American he gives the impression of a savage beast waiting for its prey. He sketches with colossal eagerness—he often works for hours in our small hotel room'[10] (fig. 119). But in the following year Eva recorded that Grosz had been talking and drinking for seven solid weeks without doing a stroke of work, going to ten different bars every night. Though it nearly killed her, for Grosz it meant a collection of new impressions.[11]

At this stage it is possible to visualize Grosz sitting in a small Paris hotel room with his wife, drawing what the trade still calls 'erotica', and stating very clearly that, quite contrary to the impressions one might form from his work, he led a very conventional life. He loved bars and brothels, and all forms of high and low nightlife, but his plain direct and outspoken sexuality was reserved for his wife. Not only did he love Eva, she was the one and only begetter of his sexual fantasies.[12]

117 (*opposite*)
Country cousins, Paris 1924
watercolour, signed and dated,
$20\frac{5}{8} \times 18$ in., 52.4×45.7 cm.
Ella Winter, London

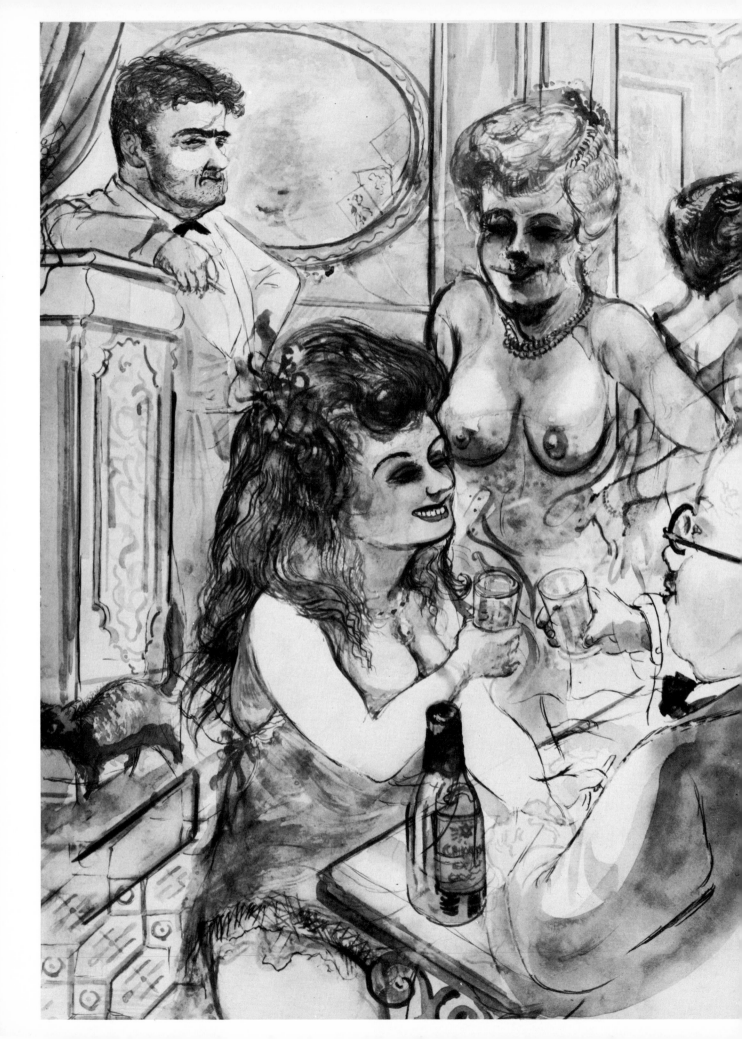

118
Night café, rue Blondel 1925
watercolour 22 × 16 in.,
55·9 × 40·6 cm.
Frank and Lydia Kleinholz,
Florida

119
Bar du Dingo 1925
watercolour, signed and
inscribed, 24¼ × 17½ in.,
61·5 × 44·5 cm.
Private collection, USA

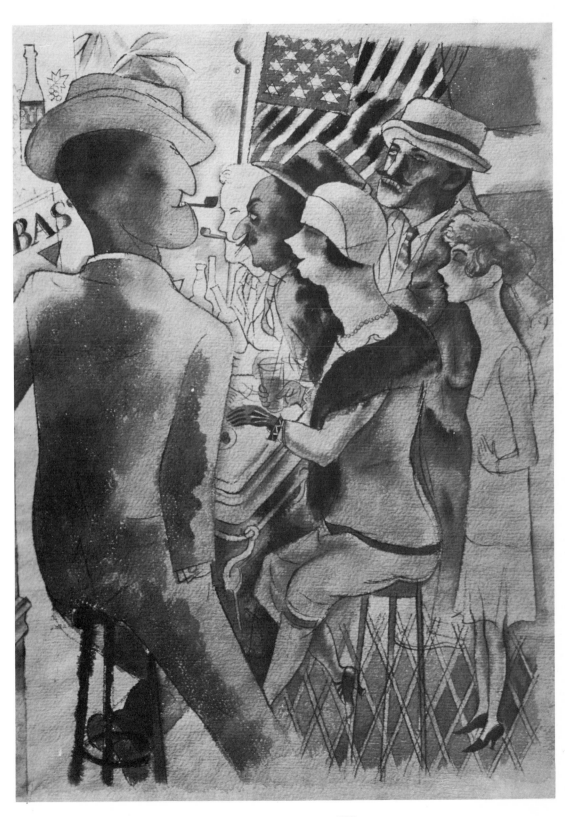

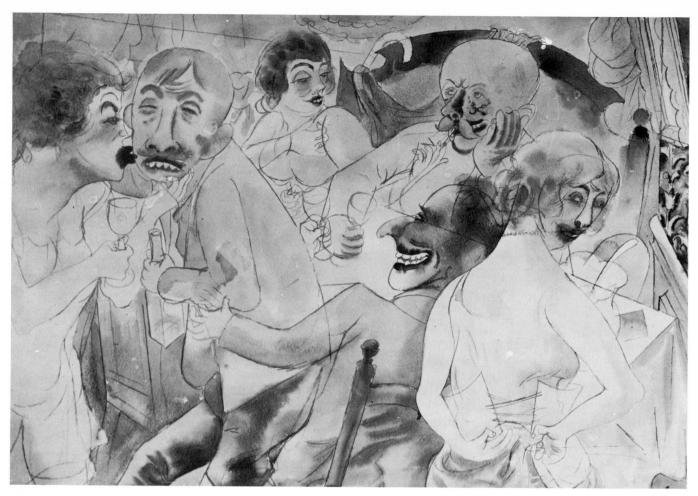

120
Happy people, rue Blondel
1925
watercolour, signed and
dated, 26 × 37¼ in., 66 × 96·5
cm.
Private collection, USA

121 (*opposite*)
For the Fatherland – To the Slaughterhouse 1924
pen and ink drawing
Der Knüppel 25 July 1924

A new form of satirical drawing appears in *Happy people, rue Blondel* (fig. 120), also a brothel scene from the rue Blondel, a watercolour which really extends the means of his graphic description; this is a style which will be continued.

Back in Berlin, Grosz did some new drawings for *Der Knüppel* as topical commentaries on current events. His style for these works owed its strength to his own work as well as to the realistic conventions of radical draughtsmanship from Steinlen to Kollwitz. 'For the Fatherland' is the inscription above *To the slaughterhouse*, a cartoon of July 1924 (fig. 121). Other cartoons for *Der Knüppel* were directed against the non-political worker and the upholders of peace in the class struggle (fig. 122). The drawings are as self-explanatory as they were meant to be, for Grosz made it his duty to be didactic and clear. Another cartoon, less direct and more allegorical, needs a brief commentary. It appeared just after the national holiday of the Weimar Republic—Constitution Day (11 August). Grosz shows the Republic being seduced by the army, with Ebert, the husband, unaware because he is incapacitated (fig. 123). Ebert is amongst the few public figures actually portrayed by Grosz. Others, Hindenburg, Noske, some parliamentarians and generals, appear occasionally, but most of his political cartoons are generalized beyond individual caricature.

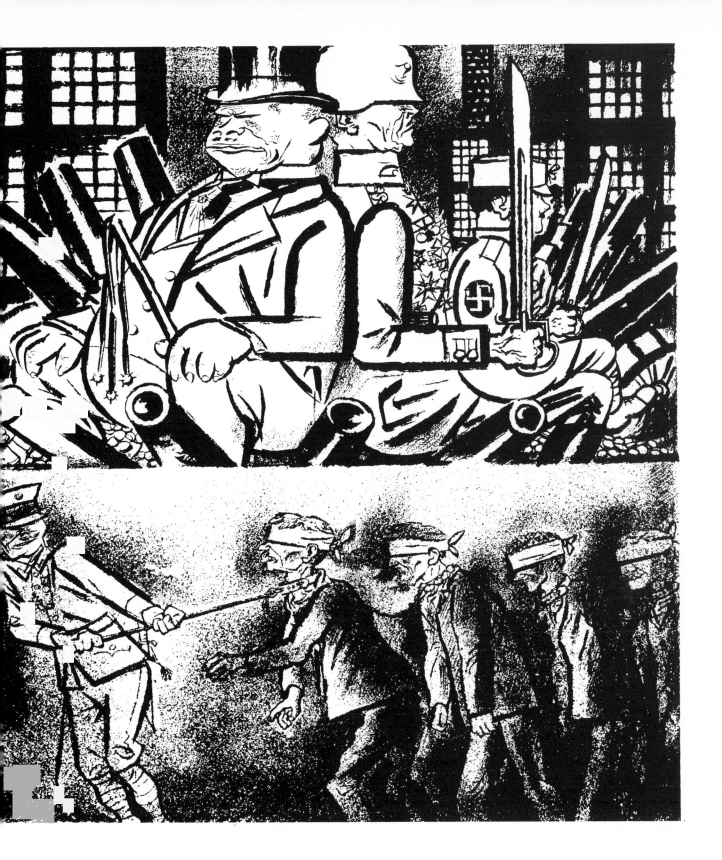

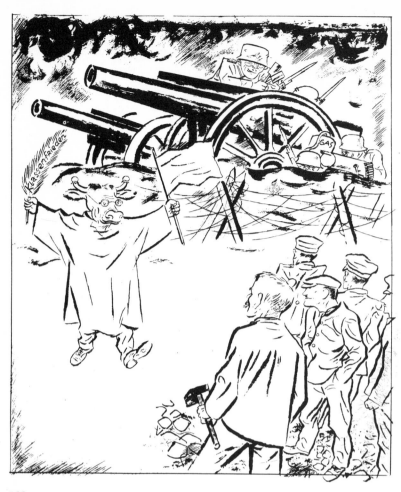

124 (*opposite*)
Eclipse of the sun 19
oil on canvas, signe
dated, $82\frac{3}{4} \times 72\frac{1}{2}$ in.,
210×184 cm.
Heckscher Museum
Huntington, New Y

122
What a fool! 1924
pen and ink drawing
Der Knüppel 25 August 1924

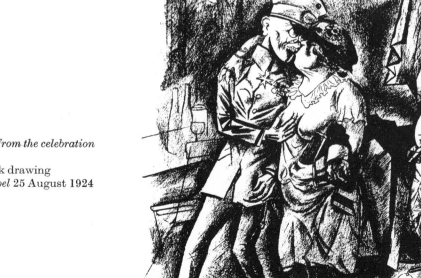

123
Returning from the celebration
1924
pen and ink drawing
Der Knüppel 25 August 1924

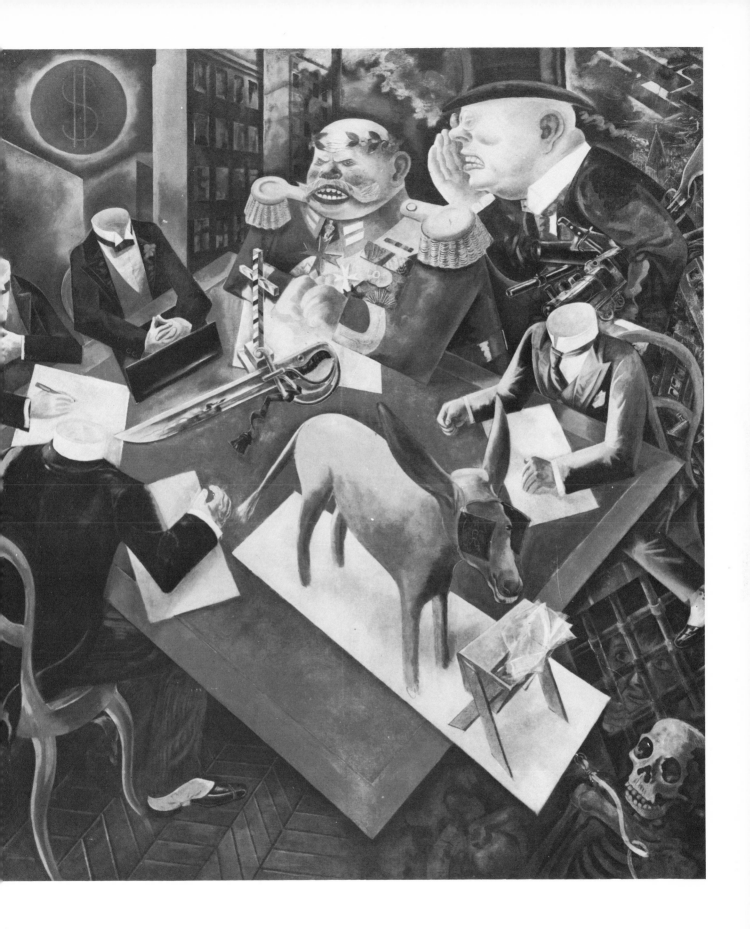

Ever since his contract with Flechtheim, Grosz had to reconcile two quite separate tasks. That reconciliation was difficult. He had to be an artist and a satirist, but not at the same time, and the unity of his work was broken. This artificial separation, unknown to him then, was eventually to be the source of his self-destruction as both an artist and as a satirist. It is strange that this fate was to befall Grosz, who had thought more deeply about the function of art than most artists. The dilemma is made clear in his own words: 'My plan is (with Flechtheim's financial speculation of course) to paint "saleable landscapes". When these are sold, I shall start during the winter with my favourite pictures on a large scale—such as *Eclipse*, 1925, or *Pillars of society*, 1926. Courbet did the same. He painted Lake Geneva several times for wealthy clients.'[13] In an attempt to square his conscience, he recalls Courbet as an apology for his own compromise.

At the time he seemed justified. The two paintings *Eclipse of the sun* and *Pillars of society* are amongst his greatest works.

Eclipse of the sun, an oil of 1926 (fig. 124), is one of the great successes of allegorical realism, where the achievements of modern art, from Futurism to *pittura metafisica*, are absorbed for a very non-metaphysical purpose. A savage portrayal of the destruction of blind-folded people, ruled by faceless and even headless men, with a general taking his orders from Capital, it lays bare Grosz's thinking. Such a painting transforms political thought into a readable allegory—not a new form of art, but, Grosz found, new forms for a new way of thinking.

In his painting *Pillars of society*, also of 1926 (fig. 136), the ruling powers are symbolized very directly by an officer, a priest, a Social Democrat, a Nationalist with his reactionary paper, a retired officer, an ex-Corps student, a Judge or Minister, and an early Nazi. It is very much an altarpiece with the wings missing. It has a mock-religious inspiration, a glorification of evil reaction. The picture has found its rightful place, in West Berlin's National Gallery.

When in 1926, Count Kessler visited the New Society for Politics, Science and Art, he met there Johannes R. Becher, Heinrich Vogler-Worpswede, George Grosz and Erwin Piscator. Grosz told him that he had recently returned to painting and that he hoped to acquire greater facility and then do modern historical paintings, such as *Parliament*, something on the lines of Hogarth's political satires.[14] In an ironical way, Grosz was fulfilling his youthful ambition of becoming a history painter. *Parliament* was not painted, but the *Rabble rouser* (fig. 125), originally a water-colour of the period, on which an oil painting was based in 1928 might indicate the style and idea which Grosz had in mind for his Hogarthian satires.

In 1925, Reissner published a major collection of Grosz's work under the title *Der Spiesserspiegel* (The Mirror of the philistine). There is in this non-Malik publication a distinct shift of emphasis. The pictures are mild satires of bourgeois life—*Gentleman dressing* (fig. 127) is one of the series. His watercolours of the period are an extension of his drawing, in which there is a gain in textural richness, but a loss of bite. This is, of course, not only a stylistic question. Grosz was hesitant between his role as a committed and a non-committed artist. His work shows the ambiguity of the situation, as can be seen in a watercolour of 1925, *In the park* (fig. 129). His painting

125
The Rabble rouser 1928
oil on canvas, 42 × 32 in.,
108 × 81 cm.
Stedelijk Museum,
Amsterdam

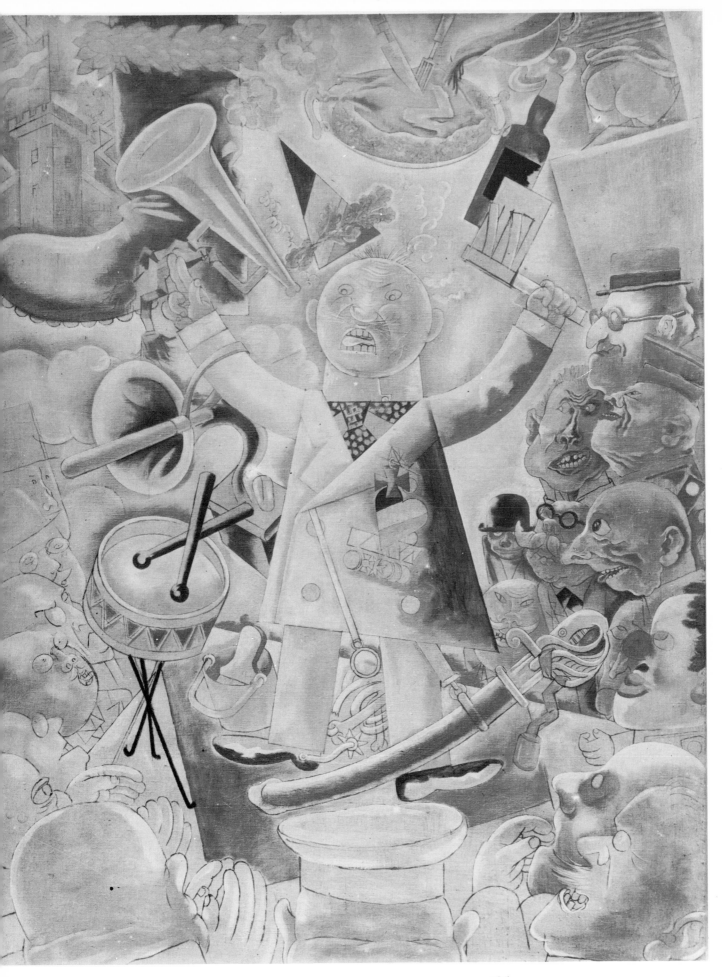

Street scene, Berlin (fig. 128) owes little to his earlier paintings: it is much more like a watercolour transposed into another medium.

In fact Grosz's political line was not only the carrier of his intention, but inseparable from the intention, as he was to discover later when he tried to free his drawing from any political or polemical tone. At the time, he was still able to combine his new pictorial interest with an indictment. Almost as if aware himself of the duality of his art, he presented a dual picture in the watercolour *Insider and outsider* (fig. 132). It is as clear in content and meaning as one could wish. It is all too clear in its simple opposition of rich and poor. As a picture it hovers uncomfortably between allegory and reality; the line is softened on the edges without gaining in strength. In spite of its grim content it becomes almost decorative.

Possibly in search of a widening of his pictorial range, Grosz spent part of the summer in the countryside of his youth. He wrote in a letter from Leba (Pomerania): 'The flat landscape is beautiful and clear. My youthful memories return . . . It might sound banal, but nature is more sympathetic, cleaner and more familiar to me than men.'[15]

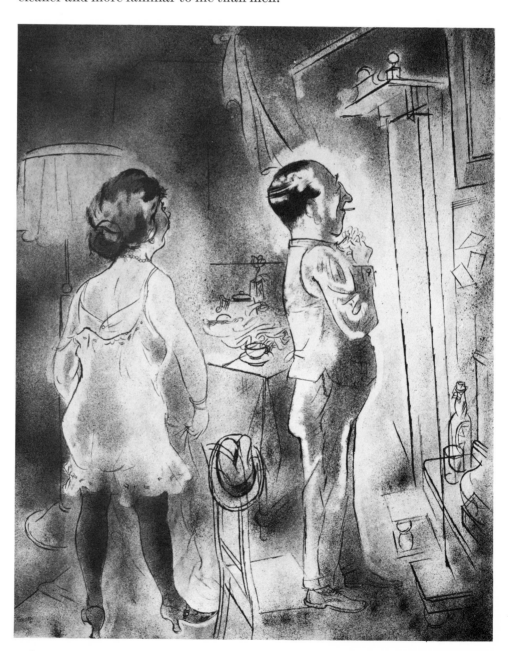

136

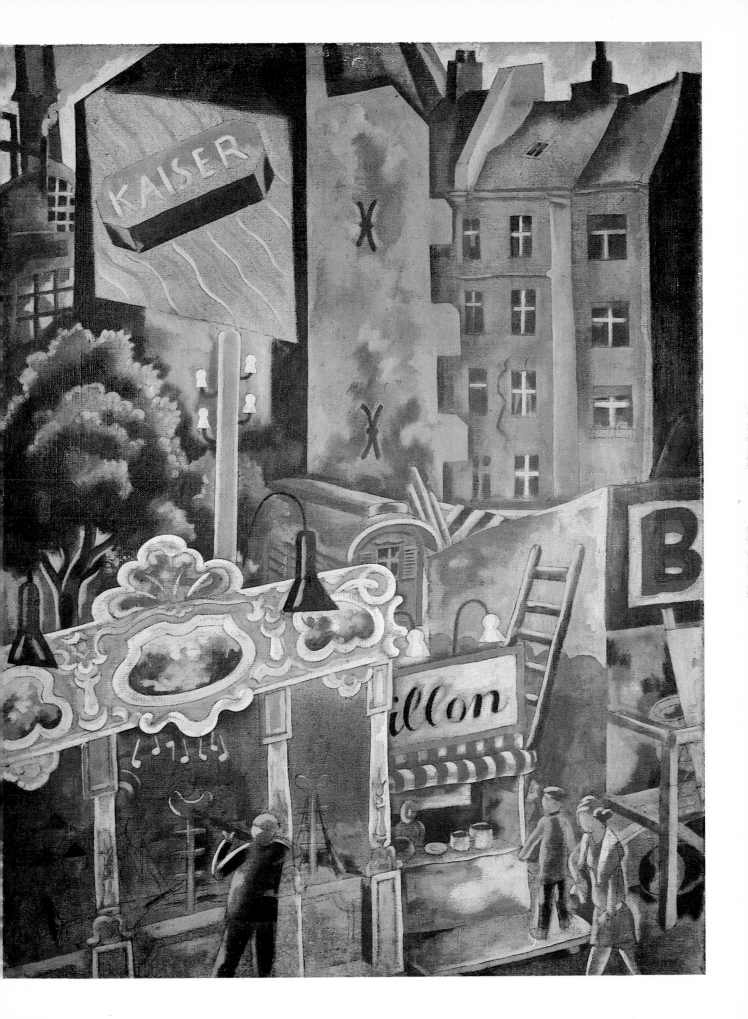

128 *(opposite)*
Street scene, Berlin 1925
oil on canvas, signed, dated
and inscribed, 32 × 24 in.,
81 × 60·5 cm.
Private collection, Germany

129
In the park 1925–6
watercolour
Present ownership unknown

People in the street 1919
watercolour, pen and ink,
signed, dated and inscribed,
$16\frac{1}{2} \times 11\frac{7}{8}$ in., $42 \times 30 \cdot 2$ cm.
Carlo Ponti, Rome

Kakimono 1926
watercolour, signed and dated
$38\frac{3}{8} \times 25\frac{1}{4}$ in., $95 \cdot 7 \times 64 \cdot 2$ cm.
Carlo Ponti, Rome

In a sensitive drawing of 1924 *Dunes at Sohrenbohm, Pomerania* (fig. 133), he attempts to come to terms with nature and tranquillity—a forerunner of many similar attempts he was to make with French, and later American, landscapes. The gift of grasping form and texture, of receiving a stimulus from any shape or movement in nature, was one he lacked. The only subjects he totally understood were people and their surroundings, and anything touched by man—a lamp, a knife. He penetrated social relations; a man and his bottle; a woman and her washbasin. Without their social implications, the objects were lifeless. Grosz could paint life; he could not come to terms with still life. His attempts to paint landscapes or still life failed, not because he could not paint, as he often thought, but because his was a gift of penetration and revelation. But when Grosz drew in the same spirit of tranquillity and kindness—a simple woman, Frau Hanke or his mother—his lines begin to tell and the shapes hold their volumes. Grosz was at his best as a painter of the human condition (figs 134 and 135).

132
Insider and outsider 1926
watercolour, signed, dated and
inscribed, 18½ × 25⅝ in.,
47 × 65 cm.
Carlo Ponti, Rome

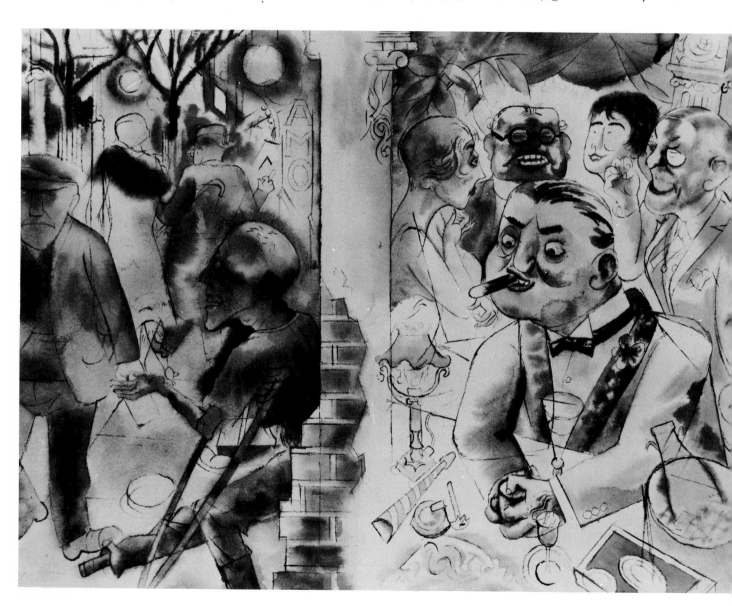

133
Dunes in Sohrenbohm,
Pomerania 1924
pencil drawing, signed, dated
and inscribed, $13\frac{1}{8} \times 17\frac{3}{4}$ in.,
33.2×45.0 cm.
Estate of George Grosz

135
The Mother of the artist 1925
pencil drawing, signed,
$23\frac{5}{8} \times 18\frac{1}{8}$ in., 60×46.3 cm.
Estate of George Grosz

134
Frau Hanke 1924
pen, brush and ink drawing,
signed, dated and inscribed,
$25\frac{5}{8} \times 19\frac{1}{2}$ in., 65×49.5 cm.
Fritz Niescher, Aix-la-
Chapelle

143

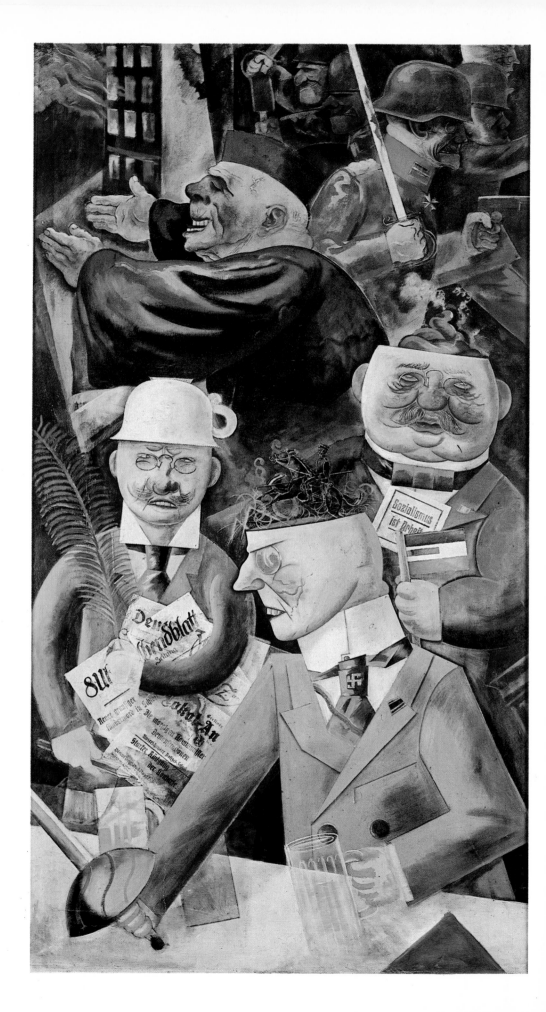

136
Pillars of society 1926
oil on canvas, signed and
dated, 78¾ × 42½ in.,
200 × 108 cm,
Nationalgalerie, West Berlin

At the time Grosz painted a number of portraits: that of his mother, Max Schmeling the boxer, Walter Mehring, Wieland Herzfelde, and Max Hermann Neisse. All competent, but none made any advance in either the old art of portraiture or a new form of penetrating the form of the subject. When Grosz had to deal with people he knew and liked his academic draughtsmanship enabled him to create a convincing likeness. Colour is used realistically and with care. The paintings are traditionally well composed; the concentration on the character of the sitter is strong, but painting *con amore* was not in his character.

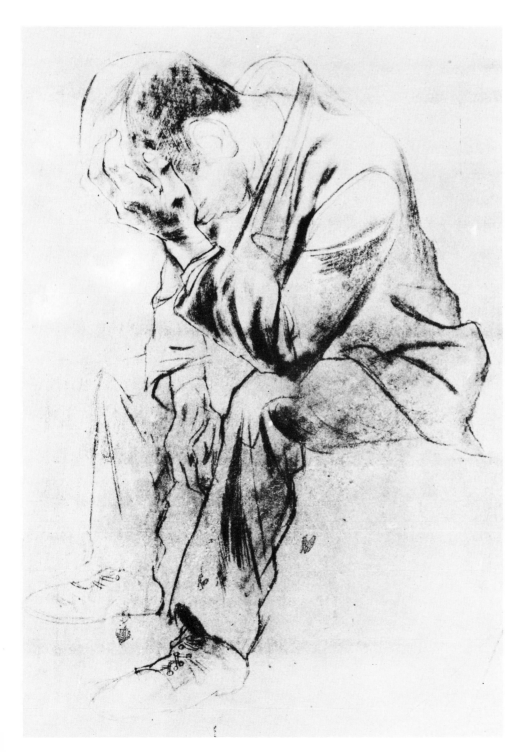

137
The Song of the poor 1925
soft pencil drawing
Der Knüppel 15 September
1925

145

138
*Hindenburg swearing the oath
of allegiance* 1925
brush and pen and ink
drawing
Der Knüppel 14 May 1925

139
*Hindenburg: 'As I understand
the Republic, any monarchist
can support it with a good
conscience'* 1927
brush and ink drawing
Title page of *Der Knüppel* 1927

Some of his work which appeared in *Der Knüppel* shared this new concern in greater realism. His drawing for *The Song of the poor*, published in 1925 (fig. 137), has the same powerful compassion as the drawing of the simple Frau Hanke. In two very powerful black and white brush drawings he shows Hindenburg, the old monarchist Field Marshal, swearing his oath of allegiance to the Republic on his election as President (fig. 138). Grosz and *Der Knüppel* returned to the subject two years later, in 1927: 'As I understand the Republic, any monarchist can support it with a good conscience' (fig. 139). Not many years later, Hindenburg broke the oath and handed the Republic over to Hitler. This, however, was a mere formality.

Grosz's growing tendency towards realism is also a reflection of a trend in the development of the art of the period. He had always reacted against Expressionism—in Hartlaub's words 'subjective high tension'.[16] As a reaction against individualism, a group of artists had been formed under the title Neue Sachlichkeit (New Objectivity): Otto Dix, Carlo Mense, Carl Hofer, Georg Schrimpf, Henrich Maria Davringhausen, and Rudolf Schlichter, with whom Grosz exhibited. They chose objective reality as

140
Neue Sachlichkeit c. 1929
pen and ink drawing
no. 57 in *Über alles die Liebe*
1930

their subject. In this attempt, the tangible, graspable reality content of forms was exaggerated to the point of naivety, and reached by its very concreteness moments of trite absurdity. In Neue Sachlichkeit, depersonalization, the obliteration of the artistic personality as a necessary condition of objectivity, was the aim. Gustav F. Hartlaub[17] considered this attempt as an overcompensation for Expressionist individualism, and stated that objectivity too can become a mania of a cold, illusion-free cynicism. He distinguished a left wing and a right wing in Neue Sachlichkeit; the left he described as critical and demagogical, the right as timeless and static. Grosz parodied the objective artist's approach in a drawing entitled *Neue Sachlichkeit* (fig. 140), where he depicted the artist measuring the proportions of a woman's behind, which a painter should know without having to measure it. Durus, the pseudonym for Alfred Kemenyi, who wrote on art for *Die Rote Fahne*[18] criticizing Neue Sachlichkeit as the bourgeois art form produced by the new, relatively stable state of capitalism, made the same point that Hartlaub made when opposing the 'objectivity' of bourgeois art to revolutionary factuality of proletarian art. Durus perceptively defined Neue Sachlichkeit as 'the experience of the world as still life', be it in classical Greek, Renaissance or Biedermeyer disguise.[19] Grosz's own flight into still life seemed to confirm what Durus had in mind.

In his paintings of the summer of 1927 Grosz now strove for an artistic quality as such, separate from its content, and in that search he found neither the convincing form nor the content. 'About my work: I have painted a few still life pictures, very ordinary things, very simple, puritanical, nothing ferocious or mysterious. [*Still life, with bread, pot and fruit* (fig. 141).] A cane chair, a stone floor, a pot with potatoes . . . a child's trumpet, and a palette. Painted realistically, simple and quiet, aiming at architectonic pictorial effect—my hobby horse. Then a landscape, street with seamen's bar—brown—cart with donkey—very colourful'[20] (fig. 143). He goes on to describe the pink house, the yellow curtain with red embroidered flowers, window shutters blue-grey-violet, chairs green, sky strong blue, etc. All in pure oil painting—colours mixed on the palette and placed next to one another.

The childish Grosz drawing shows clearly and competently what he had in mind; the painting does not. In his letters, he repeatedly reported that he did 'pure painting'. *Cassis* (fig. 144) is more successful—quiet, balanced, but empty, and the emptiness is not a meaningful void but one of quiet boredom. These pictures of 1927, in subdued tone, show the simple but awkward approach to a not very meaningful solution of a non-subject—at least for Grosz. This was an oil of *Bar in Pointe Rouge* of which a drawing was made (*Bar in Pointe Rouge*, fig. 142) in a letter to Schmalhausen in July 1927.

Whenever he looked out of his window, Grosz saw 'the bluish pale grey mountains in ever-changing illumination and mood'. He had, he wrote, 'plenty of motifs'. This is a strange terminology coming from Grosz and he sensed it: 'I am not a particular friend of motifs. A house, a few trees, a piece of sky, the sea, are sufficient. There are enough difficulties composing these few things . . . if one does not wish to paint in an everyday smudgy style.'[21] For the first time Grosz is in search of a 'style'. As long as he knew what he wanted to say, the style came with the meaning. Now, looking at

141
Still life with bread, pot and fruit 1927
oil on canvas, $19\frac{7}{8} \times 25\frac{5}{8}$ in.,
50.5×65 cm.
Formerly Gallery Flechtheim,
Berlin

142
Bar in Pointe Rouge July 1927
pen drawing from a letter
July 1927
George Grosz Archives,
Princeton, New Jersey

143
Bar in Pointe Rouge 1927
oil on canvas, $25\frac{5}{8} \times 32\frac{1}{4}$ in.,
60×82 cm.
Formerly Gallery Flechtheim,
Berlin

144
Cassis, 1927
oil on canvas, $23\frac{1}{2} \times 28\frac{1}{2}$ in.,
$59 \cdot 8 \times 72 \cdot 4$ cm.
Formerly Gallery Flechtheim,
Berlin

motifs which were not his, he was looking for a style which couldn't be his own either. It seemed as if the goddess of 'pure art', the art he had despised and mocked, was taking her vengeance. He began to understand what a painter who is concerned with himself has to know: 'essential direct experience can only be won in work. All problems, the order of colours, lines, planes, are achieved on the canvas, on the paper, in a non-platonic fashion . . . The square of canvas always remains your partner in torture . . . in the studio you are alone with your doubts and your art.'[22] Grosz knew what every artist knows; he lacked neither knowledge nor skill, but hope.

Count Kessler was an exceptionally intelligent diplomat. His assessment of a person had that professional touch. He had long ago noted that Grosz's 'devotion of his art exclusively to depiction of the repulsiveness of bour-

geois philistinism is, so to speak, merely the counterpart to some sort of secret ideal of beauty that he conceals. . . . His is an excessively sensitive nature which turns outrageously brutal by reason of its sensibility.' Grosz, Kessler observed, held a secret ideal of beauty which, Kessler said, Grosz 'conceals as though it were a badge of shame, and protects from the public gaze like something "sacred" '.[23] If Grosz wanted now to fulfil in art his secret ideal of beauty, he had to overcome his hatred of man which, as Mynona had also discovered, 'was an inverted form of self-hatred, but also an assertive love of his own self'.[24]

During these years Grosz began to destroy deliberately the clarity of his line. He wanted to achieve non-linear compositions by blending and merging areas of colour. His work thus appears diffuse, which it never had been previously. His effort to establish himself as a painter reacted on his drawing, and a touch of uncertainty and hesitancy replaced what was once clear. A watercolour of the period, *Kakimono* (fig. 130), though harking back to collage and simultaneity, is not the work of the former Grosz. Here he tries to separate line from colour—to *paint* rather than to *draw*. He refined his methods. His letters overflow with recipes for mixing varnishes and colours, and he devoured tracts on painting and techniques. He experimented, worrying himself and his paint. But in his attempt to please, he did not please himself or anyone else, including Flechtheim who eventually cancelled the contract, telling Grosz: 'You can draw a little, but you can't paint at all'.[25] To tell that to the painter of *Panizza* was an insult. The truth was that Grosz couldn't paint for Flechtheim's shop.

In his work for *Der Knüppel*, Grosz succeeded in achieving a new style in two of his great compositions. On the occasion of the *Fürstenabfindung* (Restitution of the property to the former ruling princes of the German states, including the Hohenzollern), Grosz depicts the Kaiser as a ghost, still robbing the people, the living presence of the defunct regime is evoked, strengthened by the title: '*See, I am with you alway*' (fig. 145). Another dark and powerful cartoon was published: *The True Jacob's Ladder* (fig. 146). This refers to a series of horrifying murders by a right-wing organization which had remained undiscovered or well-protected for a long time. Anyone who revealed the existence of Germany's secret army (the Black Reichswehr) or Germany's illegal re-armament, both contrary to the peace treaty, was murdered by a secret organization, known as the *Feme*. When at long last the *Weltbühne* revealed the story in a series of articles written anonymously by Berthold Jacob, Grosz's cartoon appeared, later to be republished in *Die Gezeichneten*. The drawing was then entitled *Traitors will be dealt with by the Feme*. These works gain their power from being rooted in Grosz's emotions and thoughts of the post-war days. It is, in a way, a return to his first hate.

That Grosz often did dull drawings for the communist periodicals is less important than that he did so much excellent work. But there remained a gulf between himself and his communist friends. Internal party debates on art, and the role of art in the party, reached their height in those years.[26] It is known that Grosz was an argumentative and violent debater; it is more than likely that he took unkindly to any form of discipline, and he had said himself that theory was not his strength, though he took his misanthropy for theory.

145
'*See, I am with you alway*' 1926
pen, brush and ink drawing
Der Knüppel June 1926

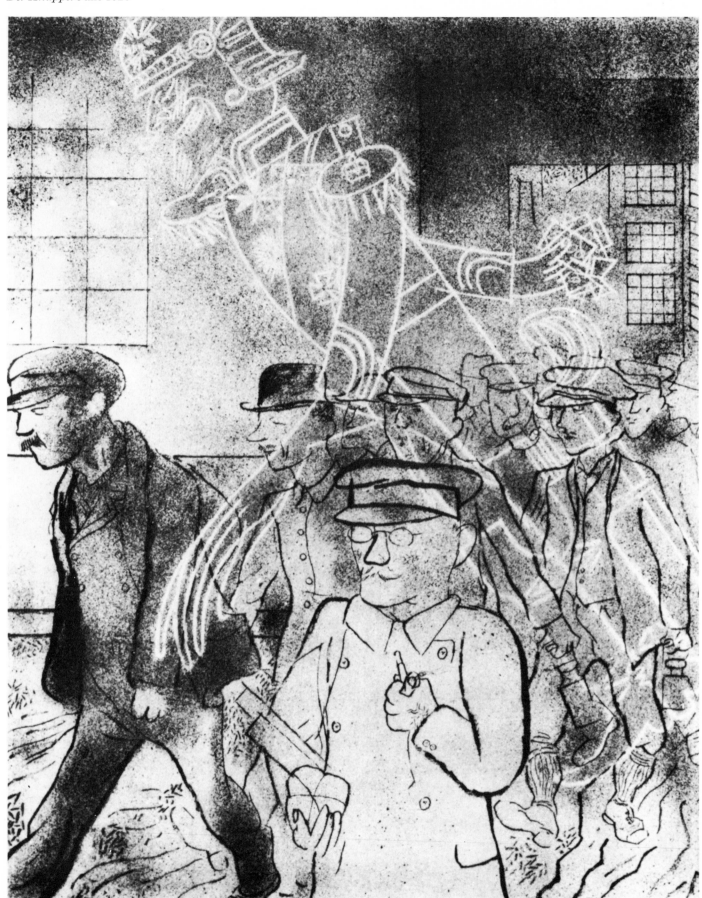

146
The true Jacob's ladder 1926
crayon, pen and ink drawing
Der Knüppel December 1926

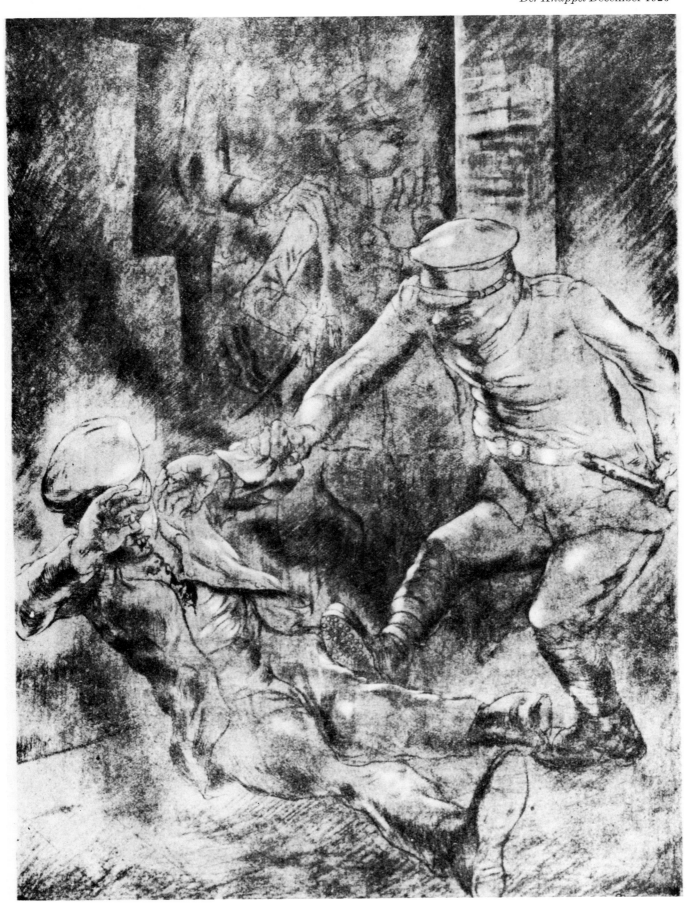

Grosz painted man as he knew him in his work: man as the reflection of social evil. There he could castigate society by its products. But in his own life Grosz failed to reverse the thought process. By assuming evil to be eternal, he denied any possible change of society. Thus, even in his most critical work, his cynicism is an expression of his own temperament, an expression of despair. When Grosz dealt with men as they were, he tended to eternalize them as they were. There is no hope for the figures in Grosz, but there is also no hope for Grosz. It was his deep and lasting pessimism which made Grosz's collaboration with his friends in the Communist Party often painful and difficult. At the time he had a minor quarrel with some communists. He explained in a letter: 'My crime is that I once laughed at left fetishes, bureaucrats, K.P.D. bosses, tame functionaries, paid revolutionaries, and that I laughed with malice. They can't take that . . . and I have to be content with my usual role of a traitor . . . a petty bourgeois anarchist.'[27] Obviously, Grosz's disagreements went back some time, and the accusations he parodied were neither new, nor would they ever be silenced.

All the time, however, he fulfilled his duties, encouraging other artists to contribute to *Der Knüppel*, of which he was joint editor with John Heartfield. The Malik Grosz was a different animal from Grosz on his own. Wieland was his political conscience, not his mentor. In fact, it had been Grosz in the early days who was vastly more radical and harder than either Wieland Herzfelde or John Heartfield. Grosz's work was recreated in Wieland Herzfelde's publications, adding a whole dimension to its power. Wieland Herzfelde produced Grosz as a good producer produces a play, never betraying the author, but making even the author aware of the full potential of his work. Not every artist has such luck in finding the right producer. It was Wieland's optimism which kept Grosz out of negative despair when he succumbed to despair in man as he knew him. Grosz had the same enemies as the communists, but not the same friends—neither the heroic working class nor the Soviet Union inspired him with love or hope. It is not accidental that Grosz's growing separation from commitment, his disillusionment with illustration, and 'stupid propaganda (*unsere kotzdämliche Propaganda*)' as he himself now calls it,[28] and his search for a new style and a purely artistic expression, go together in time and spirit.

7. The last years of the Weimar Republic 1928-32

In 1927 Piscator had produced *The Good Soldier Schweik*, one of the most memorable productions of the time, in his own theatre in Berlin, which was devoted solely to revolutionary drama. Piscator had met Wieland Herzfelde as early as 1917, and had been connected with the group of writers and artists around the *Neue Jugend*, who became his writers and designers. Grosz worked with him on *Schweik* in 1927. In his marginal notes on the subject Grosz wrote: 'It was Erwin who brought photomontage into the theatre in his transformation of the old stage setting. It was he who made the theatre truly alive and eventful, as real theatre should be . . . he set out to give back to the stage its moral force with the power to inspire men, to improve them, to fill them with joy and, where necessary, with horror.' Grosz, given a practical task, became inventive and enthusiastic. 'Erwin provided me with an enormous drawing board covered in white paper. This was set up at the back of the stage, and as events took place on the stage I accompanied them with huge symbols, my hands darting back and forth across the paper. Thus, I could emphasize or suggest meanings . . . What a medium for the artist who wants to communicate directly with the masses! Of course new dimensions demand new techniques; a new, clear and concise style of drawing—very good training for the muddle-headed! Here, young artist of 1928, is a wall. If you have something to say, use it!'[1], echoing the early days of the Russian Revolution. *I love you!* (fig. 147), one of these backgrounds, shows Grosz as a caricaturist, and what any good caricaturist has to be, a good actor at his most spontaneous best.

147
I love you! 1927
pen and ink drawing
no. 5 in *Hintergrund*

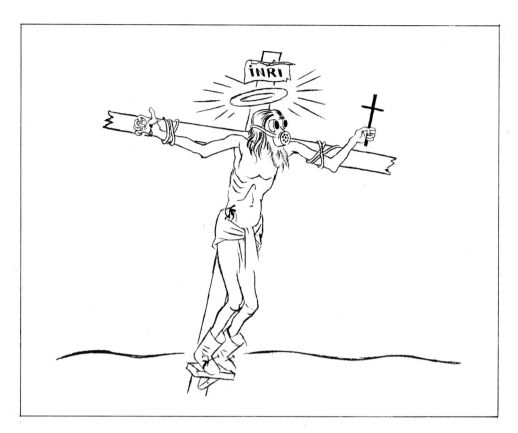

148
Christ with the gasmask 1927
crayon drawing
17⅜ × 22¼ in., 44 × 56·5 cm.
Wieland Herzfelde, Berlin
GDR
Signed and inscribed

The designs for *Schweik* were published by Malik, as *Hintergrund* (Background). One of the seventeen drawings became Grosz's most discussed single work: *Christ with the gasmask* (fig. 148), for which George Grosz, as artist, and Wieland Herzfelde, as publisher were tried for blasphemy.

In strict legal terms, the charge was not blasphemy, but, under paragraph 166 of the criminal code, for 'insulting institutions of the Church', and the case became known as the Blasphemy Trial. Three drawings, numbers 2, 9, and 10 from *Hintergrund*, were considered to have given offence, number 10 *Christ with the gasmask* being the cornerstone of the accusation. In the first trial the accused were found guilty, but they appealed and were acquitted.[2] The arguments accepted or rejected by the courts are still of interest. The institution which the accused were supposed to have offended, was 'the cult of Christ'. That this concept is an institution of the Church, 'goes without saying', ruled the first court. The picture, *Christ with the gasmask* was described in the court's ruling as 'An emaciated crucified Christ represented in the usual tradition, yet with the following special characteristics. The face is covered by a gasmask; he has boots on his feet, through which the nails of the cross have been driven; the left hand is not nailed to the cross, but holds a crucifix.'[3] The picture was entitled: '*Maul halten und weiterdienen*', of which an adequate English translation would be: 'Yours is not to reason why, yours is but to do and die', though the literal translation is much harder: 'Shut up and carry on'.

The court rejected Grosz's statement that he had symbolized crucified humanity, to whom the words of the title were addressed. The court chose to interpret the title as the words of Christ, arguing that the unusual crucifix in the hand of Christ gave this effect, an effect which, in the view of the court, it must have had on the spectator, and that Christ, in spite of his own sacrifice, had nothing better to offer mankind as a consolation than the words: 'shut up and carry on'. This travesty of Grosz's intention produced a verdict of guilty. The appeal court ruled that Grosz wanted to express: 'As little as the gasmask and jackboot fit the picture of Christ, as little does the teaching of the Church in support of the war fit true Christian doctrine. The artist wanted to show that those who preach war have reduced Christ. The highest symbol of the Church, the crucifix, appeared most fitting to the artist, to show to mankind and the Church the error of fanning the flames of war.'[4] The appeal court's judgement was imbued with a strong pacifist spirit, vindicating the artist and publisher.[5]

These two different verdicts manifested two different views of the world. There are more ways than one to see a satire. If this book creates the impression that Grosz was well-known, admired and loved, this is only part of the truth. Grosz was also hated, loathed and reviled. In fact, the higher court appealed against the acquittal and at a further trial, under the same judge, Siegert, Grosz was acquitted for good.

If in the years around 1928 the illusion of a revived and stable economy and a return to prosperity could be maintained, the world economic crisis of 1929 shattered the illusion. Grosz's simple drawing *Black Friday* (fig. 149) depicted this realization in an everyday allegory.

149
Black Friday 1929
pen and ink drawing
In *Das neue Gesicht der herrschenden Klasse* p. 52

The twenties were coming to an end, and their most lively participants were not only getting older but also more settled and more secure in their domestic lives. But the feeling of security was totally false. Gone were the early days of the cabaret *Schall und Rauch*, with its provocative songs and aggressive music; the days of Café des Westens, nicknamed by Berliners *Café Grössenwahn* (Café Megalomania), where the artists of the *Sturm*, the friends of Franz Pfemfert's *Die Aktion*—Mühsam, Else Lasker-Schüler and Däubler—spent their days, and where Grosz, in a checkered suit, his face painted white as a clown's, posed as the 'saddest man in Europe'[6], as portrayed in *Lovesick* (fig. 50). But something remained of those days, and Grosz's love of clowns had not diminished. He wrote an illustrated article on clowns and eccentrics for *Das Illustrierte Blatt* (fig. 150).

The people who liked Grosz were many. He was a charming and witty companion—ill-tempered and noisy when drunk, which was not infrequent, but unfailingly loyal and helpful. He must have known nearly everyone in Berlin, and certainly everyone knew him: Piscator and Brecht, Pechstein and Beckmann, Dix and Schlichter, Tucholsky and Mehring—actors, poets and writers, boxers and cyclists, and all the chance acquaintances whose names are forgotten.

The remarkable feature of the time was that the talk of the cafés and studios, the wild schemes and projects as well as the more sober ideas, could all be materialized. The activity of the cafés did not remain empty talk, but materialized in cabarets, songs and drawings, in ephemeral publications and books, in the theatre and in workers' agit-prop groups. Grosz's work was in demand and he was constantly engaged in designing books and scenery. To include works by George Grosz gave a radical publication the stamp of authenticity.

150
Paul and Albert Fratellini 1925
pen and ink drawing
Das Illustrierte Blatt 1926

Grosz's work thus appeared in many settings. The reason was not his versatility in adapting himself to different tasks and finding different styles; on the contrary, it was the utility of Grosz's line which lent itself to so many adaptations. His work gained new significance in different contexts. It never lost its Groszish quality, and when he drew, for books or magazines, he always added a new dimension to the illustrated text. In that sense his work was never illustration, but an extension of the meaning of the works which his drawings accompanied. Examples of his books are the editions of Wieland Herzfelde's lyric poems *Sulamith* (see fig. 51). or his prose, *Tragigrotesken der Nacht* (see fig. 101); the strictly proletarian ones by Oskar Kanehl—*Steh auf Prolet* and *Die Strasse frei* (see fig. 110); Hülsenbeck's *Dr Billig am Ende* (figs. 77 and 80) and *Deutschland muss untergehen*, and *Phantastische Gebete*, of the Dada phase; Franz Jung's *Proletarier* and *Die Rote Woche*; Munke-Punke's *Lady Hamilton* and *Dionysos—groteske Liebesgedichte* (see fig. 107). Grosz's work played an important role in the reception of the illustrated work. Illustrations for Upton Sinclair's play *Die Hölle*, Brecht's *Drei Sodaten* (fig. 164), Heinrich Mann's *Kobes* (see fig. 114) and Ernst Toller's *Brokenbrow* (in English and French only), indicate the range of his work. His illustrations for Hans Reimann's parodies of German philistines created type figures of real popularity (see fig. 96). Grosz's themes reappeared in *Querschnitt, Stachelschwein, Ulk* and *Simplicissimus*. He was busy and successful, and yet his success and reputation, somewhat similar to that of an actor or a celebrity, did not satisfy him. He wanted to be recognized as a painter.

Whilst Grosz was struggling with his painting, his earlier drawings went on appearing in public. In 1930 Bruno Cassirer published *Über alles die Liebe* (Love above All), sixty new drawings and watercolours. These were chosen thematically, illustrating by juxtaposition married and unmarried relationships in the middle and lower-middle classes. In the process of selection, the venom was taken out of the bite, and the work reduced to the level of a mildly daring exposure of bourgeois morality (see fig. 160). In the same year the Malik Verlag published *Das neue Gesicht der herrschenden Klasse* (The New Face of the Ruling Class), subtitled 'sixty new drawings'. 'New' meant not previously published in a Malik portfolio, and whilst many of them were new drawings, several were not; some had appeared as cartoons in *Der Knüppel*. The intention was decidedly more political, contrasting the rich and the poor, commenting obliquely on current events. The drawings themselves lack some of the bitter precision of the earlier work (see figs. 138 and 149). In *Die Gezeichneten*, some of the most powerful drawings of the past fifteen years reappeared. Because the new work of Grosz and the old appeared and reappeared at the same time, the stylistic development did not become obvious to the public. Not that it mattered; Grosz's work was serving the purpose for which he intended it.

But apart from the well-known public George Grosz, there remained the private Grosz who was not satisfied with being known only as a satirical draughtsman. His concern with technique became an ideological subterfuge, hiding the true problem from the painter's own consciousness. 'I am exploring new roads. I begin with colour—no more drawing—impasto—no glazes. I hope to reach pure painting.'[7] *Still life with cornpipe*, an oil of *c.* 1928/29 (fig. 151), is one such pure painting, owing a bit more to the despised

l life with corn pipe 1928
n canvas
merly Gallery Flechtheim,
lin

152
Masked ball c. 1930
watercolour, signed,
$19 \times 25\frac{1}{2}$ in., 48×65 cm.
Roman Norbert Ketterer,
Campione de'Italia,
Switzerland

Cubists than Grosz would have liked to have admitted. It proclaimed a man-of-the-world snobbery in subject matter. The American pipe, English beer and French brandy, are somewhat programmatic of the self-conscious traits of the little man. His memories of high life viewed from below-stairs were never lost; he saw himself as an outsider in his own pictures and in his own life.

His still-life paintings were meant to be allegorical. In a series of fishes, porcelain cats and celluloid swans, the question of the 'thing' or 'object' is raised. Do they exist in material or in metaphysical space? There is a pseudo-philosophical intention in his work, which brings the paintings near to surrealism. *The Christmas carp* (fig. 153) is only one of many paintings of fish, porcelain cats and other symbolic animals. The allegory of Christmas, cottage, carp, moon and flower, presumably held a deeper intention than becomes apparent. *Waiting objects* (fig. 154) shows stuffed shirts and starched collars of Dada memory as hollow containers waiting for a form of life to fill them. The mood is sinister, with instruments of torture in the culvert. Did Grosz intend to construct a Bosch-like modern allegory? It appears to be so.

His thoughts were turning to his own problem, that of the artist transforming reality. Writing for *Das Kunstblatt* in March 1931, he deplored the separation of the artist from the people. The artist should, in 'this materialist age without faith', show men the face of the devil, destroy the store of consumer goods, and show the ghostly void behind the façade. Let us look

153
The Christmas carp 1929
oil on canvas, signed and
dated, $22\frac{1}{16} \times 29\frac{15}{16}$ in.,
56×76 cm.
Private collection, Germany

backwards, he argued, to our forbears: Bosch, Breughel, Huber, Altdorfer. Why not continue with our *German* tradition? As an artist he was concerned with his own place in the tradition and with the possibility of an allegorical transformation of the world into works of art of his time. The concern of his still life is death. But to him social life is also death. The reality around him became unimaginable for Grosz, appearing to him like a medieval carnival, even more grotesque because alive, a nightmare in bright light. *The World of the city* (fig. 156) depicted the corruption of men and things, themes which had accompanied him from his past. They are drawn and painted with hectic intensity, creating a spontaneous and unified picture.

But his picture of the world at this time is out of true. He equated the left and the right as civil war parties, dominated by the masses. He saw the end of a liberal era, and predicted an epoch similar to the waning Middle Ages.[8] He believed that the Middle Ages, full of terror, had been fruitful for the artist; for Grosz this was the beginning of an apocalyptic vision. It is his transformation of a political reality into a mystical event outside human control.

154
Waiting objects 1929
oil on canvas
Formerly Gallery Flechtheim,
Berlin
opposite

156
World of the city 1931
oil on canvas, signed and
dated, 48 × 35 in.,
122 × 89 cm.
Arnold Saltzmann, New Y
opposite

155
Cain 1944
oil on canvas, signed and
dated, 39 × 48$\frac{13}{16}$ in.,
99 × 124·5 cm.
Estate of George Grosz

Grosz then attempted not only to raise the significance of his new work in form and content, but to read his new paintings as a higher form of his consistent endeavour. In his notes for Piscator he wrote: 'Erwin created . . . a variety of possibilities, far more tempting to the arts of 1928 than . . . producing cheap high-brow trash for posh people with culture.'[9] Grosz could never have been satisfied with art for art's sake, hence his need to force a meaning into his pure painting. In his *Instead of a Biography*[10] he wrote 'For many, art is a flight from this "plebeian" world unto a better star.' Grosz was now thinking of this world as plebeian, and his art took flight, not unto a better star, but into a darker night.

As an intermediate transposition of his view of life and his apocalyptic vision, he painted pictures like *Funfair* (fig. 126), in which his concern with still life is applied to a scene where the expected gaiety and noise have been frozen in a garish silence. Grosz's own private symbol of mean poverty had been for him the pressed coal briquette of the poor, here given prominence on a poster, but in fact suspended over the deadly scene. In a painting of 1928, *Third-class funeral* (fig. 157), the trade mark of the wood- and coal-merchant, which had haunted Grosz since childhood,[11] is given the symbolized meaning of the wood—ashes to ashes. That symbol of two crossed hammers remained in Grosz's memory since the Wöhlerstrasse, where a coal-merchant had his store opposite the basement flat. To Grosz it still reeked of poverty.

Grosz's concern with the poor was unchanged. The vulgar contrast between rich and poor in the same street, not compassion, was depicted in the watercolour *Nocturno, Berlin* (fig. 158). For this work he employed a

157 (*opposite*)
Third-class funeral 1928
oil on canvas, signed and
dated, 29 × 21 in.,
73·5 × 53 cm.
De'Forscherari Gallery,
Bologna

158
Nocturno, Berlin 1928
watercolour, signed and dated
Private collection

looser manner of watercolour on wet paper which he had used for several years, developed to a very fine point of harmony in the pictorial sense, which contrasted with the disharmony of the content. This juxtaposition of a sweet manner and a bitter commentary coincided with Brecht and Weill's *Threepenny Opera*, where a 'sweet' music underlines a 'bitter' text. *Masked ball*, of *c*. 1930, uses similar modes in a more consciously vulgar fashion (fig. 152).

A successful adaptation of Grosz's draughtsmanship to painting is *Ballroom* of 1929 (fig. 159). Grosz aims at a contrived naivety and directness, not unlike the more genuinely naive and self-taught work of Dix. That Grosz's academic draughtsmanship was never naive, and at his best can rank with some of the great masters of the past, is seen in *Seated girl* (fig. 162). The happy, petty bourgeois couple in *Married couple* (fig. 161) is Grosz at his most factual and, in his way, kindest form of representation. Berlin Society

160
Pressball c. 1928
pen and ink drawing
no. 37 in *Über alles die Liebe*

161
Married couple c. 1930
watercolour, signed,
26 × 18⅝ in., 66 × 47·5 cm.
Tate Gallery, London

162
Seated girl 1929
pencil drawing, signed and
inscribed
Formerly Collection Count
Harry Kessler

163 (*opposite*)
Artist and model 1928
oil on canvas, 45½ × 29¾ in.,
115·6 × 75·6 cm.
Museum of Modern Art
New York
Gift of Mr and Mrs Leo Liormi

is the subject of *Pressball* (fig. 160), the annual gathering of Berlin's
'*Prominenz*' as the celebrities liked to be called.

The versatility of the artist in these years is somewhat bewildering. His
many attempts at a style or a mode of expression betray not so much a
pictorial richness and inventiveness, but a growing uncertainty of aim.
Hitherto, Grosz had separated his still-life manner from his treatment of
the human figure. The figures were conceived as drawings from the time
he achieved his own style. However, in these years, his mode of painting
objects was transferred, at least experimentally, to the human figure.
Sometimes the style was successful: *Artist and model* (fig. 163) gains an
allegorical element and it would probably be right to treat the figures,
too, as elements of a supra-personal intention, particularly as here the
figures are Grosz and Eva. Grosz's concern is primarily with painting as art.
The attempt to find a form of painting in which the old Grosz is not lost,
and from which a new painter can emerge, appears to be the right reading
of this and other domestic subjects, where nothing was at stake except the
question of the work of art.

164
Three soldiers 1931
pen and ink drawing, signed,
$23\frac{5}{8} \times 18$ in., 60×46 cm.
Title page for *Die drei
Soldaten* by Bertolt Brecht

However, Grosz was still doing some of his best work in the illustrations of Brecht's *Three Soldiers*. Recollection of his own work of 1917, matured by years of bitterness and despair, gave Grosz a truly frightening vision held firmly in the frame of living history. Here Grosz recognized that no flight into another world was needed for the creation of a work of art—understanding of events as lived and known is the material ground in which a symbol and a truth can grow (fig. 164).

In 1928 the National Socialists had twelve deputies in the Reichstag, and in 1930 one hundred and seven. The very types Grosz had condemned were undismayed by his work. They looked, acted and thought as Grosz had seen and depicted them. Grosz had ceased to be a caricaturist, he had become a realist because real people looked the way he saw them. He was aware of it. A long letter from Prerow on the Baltic described vacation life on the beach two years before the Nazis came to power:

'If I had drawn them, one might think I had plundered the old *Meggendorfer Blätter*. For instance, there is a Hauptman von Levetzow—you should see him—brown swastika shirt on his beer drinker's belly, naturally a swastika armband to make known where he belongs, and—hard to believe—a long beard and a monocle! This legendary dignitary [*sagenumschwirrter Würdebold*] goes daily to the railway station with his two sons bearing a big Nazi flag in their hands, and when the train gets in he goes to the platform to check for Jews. If any arrive, he goes near them and, with his commanding officer's voice, lets loose a fierce tirade, advocating the annihilation of the Jews. Incredible isn't it? Well that's how it is. It doesn't lack a certain ghastly humour.'[12]

He then described the sandcastles on the beach, which German families on holiday usually build, decorated with ornaments and inscriptions formed by seashells and pebbles from the beach. The inscriptions read: 'Castle of Defiance', 'Perish Juda', 'The Brown House', 'Germany Awake', 'Hitler our Motto', 'Young Siegfried', with swastika flags flying in the sea breeze. Grosz commented that black-white-red (the monarchist conservative colours) were considered left-wing in Prerow, but Prerow was typical. *A Man of opinion* (fig. 165) corresponds to what Grosz described in his letter.

It may seem surprising that there are hardly any directly anti-Nazi cartoons in Grosz's work, particularly from those last years when the menace was clearly visible. The reason is not that Grosz failed to see the menace, but that it was simply too much for him. The threat seemed to confirm his despair. What he had foretold was happening, and he could not do his work all over again. The struggle had to be resumed against the same forces, the same types who had refused to abdicate. That was the historic situation. The incredible had become true; the credible, the logical, the expected, were the chimera; the ghosts of yesterday were coming to power.

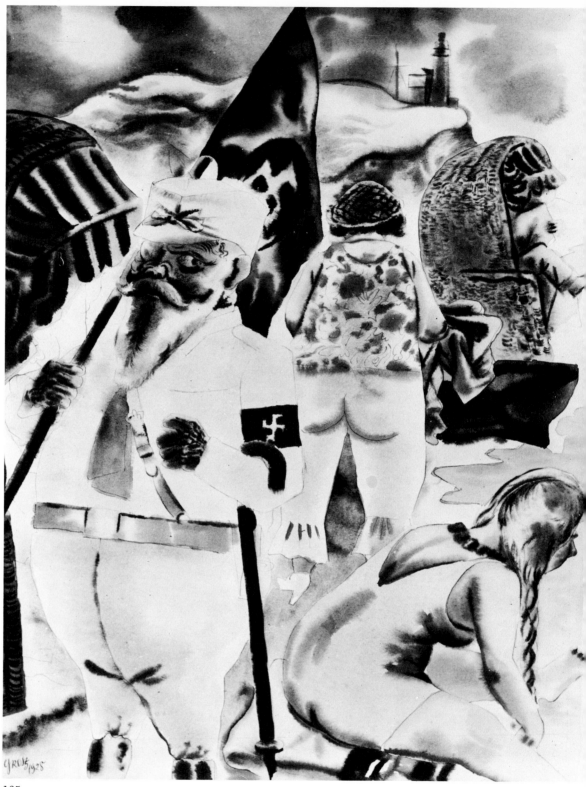

165
A Man of opinion 1928
watercolour, signed, dated,
and inscribed, $24\frac{1}{2} \times 18\frac{1}{2}$ in.,
47×62 cm.
The Joseph H. Hirshhorn
Museum and Sculpture
Gardens, Smithsonian
Institute, Washington, D.C.

8. The new world of George Grosz 1932-34

In April 1932 the Art Students League, New York, invited George Grosz to teach a summer and a winter class there that year. Grosz accepted for the summer and embarked on 26 May 1932 for the United States. He found the journey uneventful and slightly disappointing, lacking the glamour which the boy from Stolp had expected from an ocean liner, but consoled himself with his dreary fellow travellers: 'if one observes people as a naturalist observes and studies insects, one will never get bored'.[1]

As early as 1925 J. B. Neumann had written from New York to George Grosz in Berlin that the election of Hindenburg as President of the Republic proved that more Germans liked the Kaiser than the Republic. If ever Grosz thought of emigrating to America, J. B. Neumann would do all he could to help him.[2] He was as good as his word, and had already arranged with Maurice Sterne, always referred to as 'America's most popular painter of society portraits', to open an art school together with Grosz in the autumn, when Grosz's summer course was over. Reinforced by Neumann's promises of a great future in America, not only with the school, but also as an artist, Grosz was seriously thinking about a possible future for himself and his family in the United States. Like most artists he had had to live from hand to mouth, and since the economic crisis he did not even get the money he was owed any longer. Grosz had always believed in America and in success.

When he arrived in America Grosz faced a paradoxical situation. He was received as the political satirist, whose fame surprised him, as a man who was known and admired for the ruthless description of the German social scene, which he had understood from within. But Grosz was now faced with a new situation. As a satirist he was expected to satirize, and to be able to do so one must understand the scene and dislike it. As long as one does not understand the scene and likes it, then all possibility for satire is gone. He had to be optimistic. 'The saddest man in Europe' was hoping to become the happiest man in America. 'New York—that great, wonderful city. I love this town. I have seen tramps sleeping on newspapers in Union Square . . . I have seen Negroes, Chinese, red-haired Irishmen, sailors; Broadway aglow at night; the huge department stores; workers in overalls

suspended between steel girders . . . Wall Street and shouting brokers at the stock exchange . . . I have seen obscene shows, where sweet girls stripped to the applause of the men . . . this town is full of pictures and contrasts . . .'[3] Thus Grosz described the New York of the tourist, the New York of the picture postcard, the New York of his education and his dreams.

That New York he wanted to capture in his work. He made some sketches and a watercolour, and did a series of drawings with subjects from the burlesque shows. He sketched in the streets, as he had always done since

166
Burlesque, 42nd Street,
New York 1932
watercolour, signed, dated and
inscribed, 25 × 20 in.,
63·5 × 50·8 cm.
Achim Moeller Ltd, London

the days of Colarossi's studio in Paris. He filled a lot of sketch books with his quick notes as material for later drawings and watercolours.[4] One of his burlesque watercolours is shown in fig. 166. Stylistically, this is very close to his watercolours of the last years in Germany. In a drawing, *Street scene, New York* of 1932 (fig. 167), he was trying to come to terms with the American scene. The townscape is somewhat reminiscent of his former fantastic cities, but now reduced to an everyday reality.

In the evenings he went to variety shows, the cinema, or burlesque shows, and assured his wife, in a long series of voluptuous letters, of his fidelity.

Grosz had hoped also for work as an illustrator, but between the role of the positive artist and the satirist there was no room for compromise. He discovered 'that our sense of humour [has] . . . a dash of the barracks and the jackboot',[5] whilst American humour was boyish and slapstick. Grosz's style not only had to live on its material, it was of the same spirit as the material. It took Grosz's jackboot to satirize the jackboot. This knowledge should have told him that it would not be easy to become an American satirist. J. P. McEvoy of the *New Yorker* saw the problem and expressed it very clearly: 'But it is only fair to Grosz to warn him—he will not find caricature too easy in America . . . Grosz will not find a dearth of material for his savage pen . . . And not only raw material, but the finished products: our gangsters, politicians, nightclub hostesses, reformed bootleggers, divorce lawyers, alimony hunters, bridge-playing collegians, movie stars.'[6] That is where the trouble started. The real America—that of the gangsters, organized as corporations or freelancing as criminals—was admired by Grosz. He had bought the American dream, and was selling it to himself. He tried to break into the system, not to break it.

Grosz did not know that middle America knew of his arrival. It spoke in an unmistakable language through the mouth of the Reverend John Mingen, who wrote on 15 July 1932 (in German) from St Camillus Hospital, 10 100 W. Bluemond Road, Wauwatosa, Wisconsin: 'You know, Herr Grosz, that by some of your work you have been morally condemned by the German people. A leading German periodical (*Deutsch-Amerika*), which stands for Truth and Justice, has warned the American public of the "notorious modernist painter" George Grosz . . . beware, Herr Grosz, not to offend by your work the mentality of all Christian thinking Americans. Beware of the moral judgment of the Christian religions in the USA. Accept this plea as a friendly advice.'[7] The Reverend John Mingen from Wauwatosa had been one of the bores whom Grosz had met on the boat, and Grosz had failed to recognize middle America when he met it. At home he would not have failed to recognize the type.

During the summer the political situation in Germany had deteriorated. The Reichstag had been dissolved and Papen was preparing for Hitler to take over. Grosz was determined to emigrate. In a revealing letter to his favourite aunt he wrote: 'Yes, I want to leave Germany, not because I dislike it—not for that . . . over there, there is no chance any more for a painter of my stature.'[8]

Before Grosz returned to Germany, the Art Students League arranged an exhibition of his work. The subjects were Bowery Street, burlesque shows, Coney Island, 6th Street, and Harlem.

As Grosz had made some contracts for illustrations and had sold some pictures, he was hopeful for his future in the United States. Returning to Germany, he claimed that he was already 'suffering from nostalgia for America. . . . I am not megalomaniac, but I want to get on. I am tired of being a king without a country.'[9] He painted a very rosy picture of the future—a house in the country, the Rockies, Havana, Bermuda—'I feel this is my country, here I belong . . . I can see us already in the country. . . . I hope to make my sons Americans.'[10] Grosz lived his American dream, in the hope of becoming the figure of his dream; the reality never took hold of him.

167
Street scene, New York 1932
pen and ink drawing, signed,
$22\frac{1}{16} \times 17\frac{1}{8}$ in., 56×43.4 cm.
Estate of George Grosz

In October 1932 Grosz returned to Germany on the steamer *Dresden*. In the Reichstag's election of that summer the Nazis had for the first time lost votes. All the more reason for them and their backers to seize power soon. During the winter of 1932–3 the writing was on the wall. One would have had to have been blind not to have seen it, and Grosz had never suffered from blindness. Yet despite this knowledge it was in blissful ignorance[11] that he and Eva embarked on 12 January 1933 for New York, eighteen days before Hitler was appointed Chancellor and the rule of Nazi terror began. Eighteen days stood between his life and his death, for Grosz would have been one of the first names on any extermination list. Later, he realized, with delayed shock, the fate he had so narrowly escaped. Meanwhile, he was travelling peacefully on a German boat to the land of his hopes. On 23 January he arrived. A week later, on 30 January, the enemies of Grosz were in power, and organized an *auto da fé* of his books, together with those of his friends. German left-wing artists, writers and poets were defamed, imprisoned, murdered, exiled or silenced.

A letter from an old friend, Hans Borchardt,[12] put Grosz in the picture, congratulating him on his timely escape. Hellmut von Gerlach, Carl von Ossietzky and Alfred Kerr had been deprived of their passports. Kurt Tucholsky could not return, and how Wieland Herzfelde would fare, nobody knew. All newspapers had been suppressed, except the Nazi press. Lotte Schmalhausen was the first to report the Reichstag fire, and the total terror which she sensed gave her a feeling of disgust and shock.[13] Wieland had gone underground. Hülsenbeck soon wrote: 'Be glad you are over there. Nobody can imagine what it is like here.'[14] In a watercolour, *1932* (fig. 168), Grosz symbolized his escape from the holocaust; the picture might be called 'the sleepwalker' and should be dated 1933 or possibly slightly later. In treatment it is not dissimilar to a series of Manhattan watercolours of the years 1932–3.

Grosz now had to face the America of his dreams—and the real one. The logic of his new position drove him further away from the struggle in which he had been engaged, and from which he had escaped, almost like a sleepwalker. He adopted both defensive and aggressive positions towards himself and towards his old friends. Grosz was too intelligent a man, and too good a writer ever to have left his position unclear, yet in the determined clarity of his letters there remains an assertive stridency which has an aggressive note and reads like self-defence and self-justification. He was convinced of the incorrigible, unalterable, evil stupidity of men. He believed in nothing except money and success.

To consider George Grosz as a renegade in the political sense of party allegiance or loyalty would be to only scratch the surface of the question. The truth was more complex and more destructive. His renunciation of his past was for Grosz a self-denial, which went much deeper than political passivity—it bordered on self-destruction. In the process, he was to succeed not only in destroying his old self, but also in destroying the new self which he stifled at birth. The dream had to come true, and when it did not Grosz was broken by the power of his imagination. In his mind there grew a certainty that every theory, or group, was wrong, and his belief that he, the supreme individualist, knew that there was no answer, had a trace of megalomania. His tragedy was not that of a disillusioned partisan, nor of

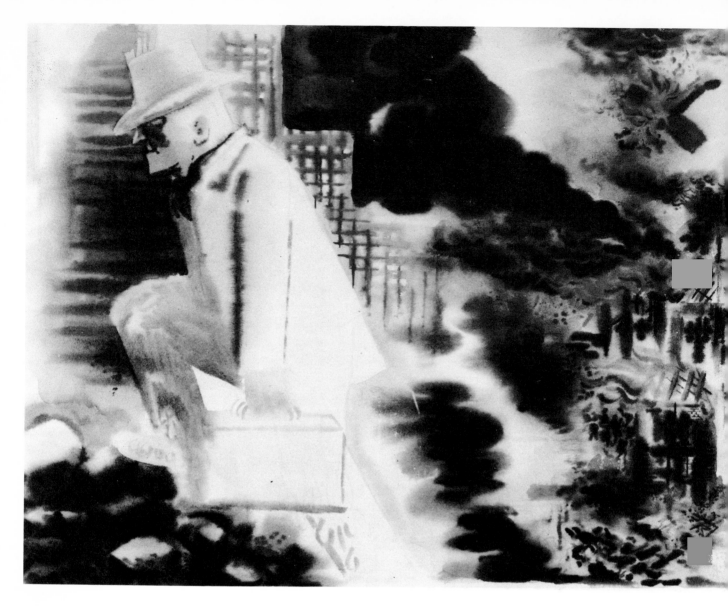

168
1932, c. 1933
watercolour, signed,
18 × 24 in., 48·3 × 63·5 cm.
De Cordova Museum, Lincoln,
Massachusetts, Gift of Mr and
Mrs C. A. Pertzoff

a renegade (although he came pretty close to it), but of a thinking, active, intelligent man, who chose success as a substitute for life, and who mistook the fortune he was chasing, and which always escaped him, as the key to the life he was never to lead. He was not insensitive to the political situation. In a serious mood he wrote: 'How could it happen that millions of communists failed so completely. . . . There is something tragic in the German working class movement. . . . I have much sympathy with many of my friends over there. Now the embittered Right will take its revenge—this time it is real reaction—they are real Fascists.'[15]

For the moment, Grosz stood between the two worlds, but his future had to be in America. He had arrived as the well-known German satirist whose satire had been surpassed by events, and was expected to become an American satirist. None of his skill as an artist had been lost, but he had

lost his subjects. He had to redefine himself, not as a satirical draughtsman, but as an artist in his own right. He had to turn to what was left to him, and that was art itself. When Frans Masereel wrote to ask Grosz to prepare a 'series of drawings on the Germany of our dear friend Hitler!—something similar to those you published with the Malik Verlag',[16] he refused to do them. Through this self-denial he was trying to assert himself as a new man. Grosz went further, he wrote: 'Let them burn my books.'[17] In denying his political past he denied his artistic past. For Grosz himself, the old Grosz was dying or dead, but for his friend Wieland he was alive.

When Grosz had said, 'Let them burn my books', Wieland was writing from Prague where he and the Malik Verlag had found refuge. 'I am still worried whether we shall succeed in saving some of Grosz's originals and lithos, particularly because in those very months these drawings have come to life in the most uncanny way . . . the devil may know how you have reacted to the events in your work . . . maybe there is a possibility sooner or later to bring out a book of yours.'[18] Grosz answered Wieland in a series of letters:

'Yesterday I completed a huge long letter to you, but when I re-read it I found it too Groszish and I decided not to send it—it would have angered you too much. It was a colossal tirade of unbelief in any form of progress. . . . Yes, the age-old individualist Grosz broke out again with vehemence and insulted everything from left to right, covering all with bitter scorn and ridicule. . . . My unburnable pages are concerned with military brutality—my other best work with the ghastly human countenance [Fratze]. Barely in a political sense . . . I have no more illusions. One has to survive. That's all . . . The field for me, with certain limitations, is the field of my art.'

His despair in man as such had to end with despair in himself. 'I am no longer an idealist in the sense of the betterment of man. . . . The old song is finished—dead.' But Grosz went further than that. 'When we met in 1915, I was a little man with fierce hatred, and a sentimental and idealistic fool. An anti-militarist. The horrible, so-called scientific communism has made me what I am today—a scornful sceptic.' He welcomed the disappearance of German left-wing publications: 'It won't be a loss to culture if the Linkskurve, Tagebuch, Weltbühne, don't exist anymore. . . . I won't say any more about these symptoms of decay, even though I took part. I have never loved these ideas and they have never filled me with enthusiasm.' In the same letter he could say 'to me the working class is the basest of all. . . . Please do not publish my works any more. As often in the past, I greet the cheerful sympathetic emptiness of life.'[19] That is his faith and it will fail him too.

Wieland knew what was happening to Grosz better than Grosz himself. He wrote: 'When I read that part of your letter where you renounce your own work and *do not wish to see it published* . . . then what sort of an artist have you become? . . . It is only logical that you distance yourself from your work, but if you go further than that and exercise censorship over what you have formerly created, then you are moving very close to those who have confiscated your books in Germany. . . . As little as I obey them,

I shall obey you.'[20] Wieland paid Grosz the compliment that his work belonged to history. Grosz hated not only his past, but he hated himself for hating it. He felt a need to explain his past by his temperament and personality. 'From early on I was plagued by pessimism and frequent terrible depressions. . . . There was an unknown urge, a sort of demoniac power forcing me to see the world and men like that. Some strong remnant of a religious survival.'[21]

During April 1933 he took out his 'first papers' (naturalization papers). Grosz was on the way to becoming an American artist. 'You only have to look here—there are pictures. What a town! There are many painters here, but they can't paint here, they have to go to the South of France. What

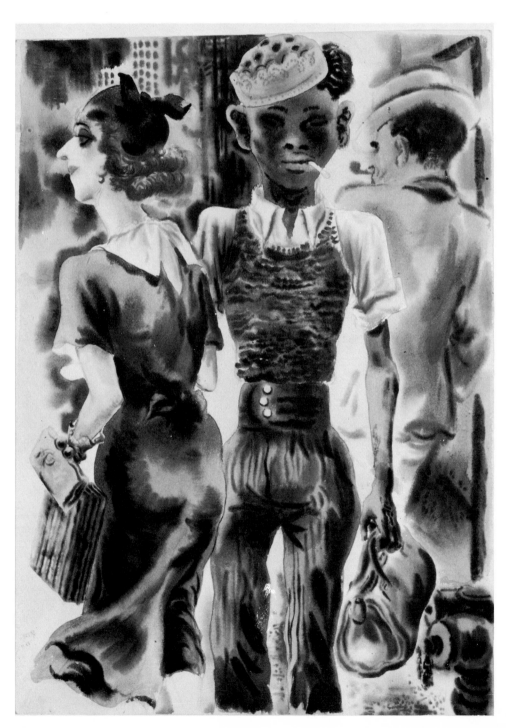

169
Three figures, New York Street Scene 1933
watercolour
Private collection

fools!'[22] He produced sixty works, with New York as their subject and his own accomplished mode of large watercolour drawing as technique.[23] He always felt secure as a draughtsman and less secure as a painter, though he had a marvellous colour sense when he used colour as a vital force in his drawings. In his attempt to develop a typology of American characters in his watercolours of those years, he laid emphasis on tonal unity and colouristic effects, yet retained a very clear delineation of the characters. These early American watercolours are accurate, though not penetrating statements of life around him, as exemplified in *Three figures* (fig. 169) and *Street cleaner* (fig. 170). Meanwhile, he had sold a few pictures and reported that he was satisfied with his new work.[24]

In the first days of October Eva arrived in New York with their two sons. Grosz wrote a dutiful letter to his mother to reach her for Christmas. 'We are living outside New York—it is somewhat like an English country house, a tender autumnal horizon. The sun shines above it all, the climate is typically American Spring-like.'[25] Exaggerating a little to keep up his courage, he lived in two seasons at once.

Unlike most of his German friends in New York, Grosz did not think of himself as a refugee but as an immigrant. Though his own life was not easy and he had to work hard for his living, he believed in his future. The nostalgic attitudes and the endless arguments and intrigues of so many refugees irritated him. A drawing of 1933, *Happy insanity* (fig. 171), appears like a commentary on the futility of refugee activities. The refugees could not come to terms with their new life—Grosz could. But, like them, he lived in two worlds: the old and the new. Grosz remained in touch with the diaspora of his friends, now distributed in Prague, Moscow, Paris, London and New York. From Paris he heard from Flechtheim[26] that some of his pictures, which Flechtheim had been able to save, were now with the Galérie Billiet in Paris, but there was little hope of any sales.

Often he would rhapsodize over success American style.[27] 'Free competition, and again and again one can see the sensational rise, but also the fall, of gifted brutal go-getters. The same in the field of the arts and the film. Yesterday unknown, tomorrow rich and famous.' Art had been his road of escape from poverty. To Wieland he wrote: 'If I had thought differently, I could have stayed in the Wöhlerstrasse in the midst of the dungheap of small workmen and small people. . . . I have always aimed to get away from that mass . . . and to get to the top was my aim.'[28]

The American dream and Grosz's dream coincided. What Grosz really wanted was success. He tried to get work for the cinema, and sent theatre designs to Carl Laemmle, mentioning his experience with Reinhardt's Lustspielhaus, the Rotter Brothers, *Die Truppe*, directed by Bertold Viertel, and his work with Piscator and the Berlin Volksbühne.[29] This raised his hopes—'maybe we shall live in sunny California where oranges grow the size of pumpkins'[30]—but nothing came of it, and, though lightly taken, the disappointment appeared to have hit Grosz quite hard. Maybe his biggest chance to get rich quick had gone.

In his watercolours of 1934, such as *New York street types* (*three figures*) (fig. 172), Grosz struck a tougher note. He had seen some thoughts behind a face, and he was not unaware of the hostility of his potential enemies, but he had no intention of arousing their anger. In *Broadway* (fig. 173) he came

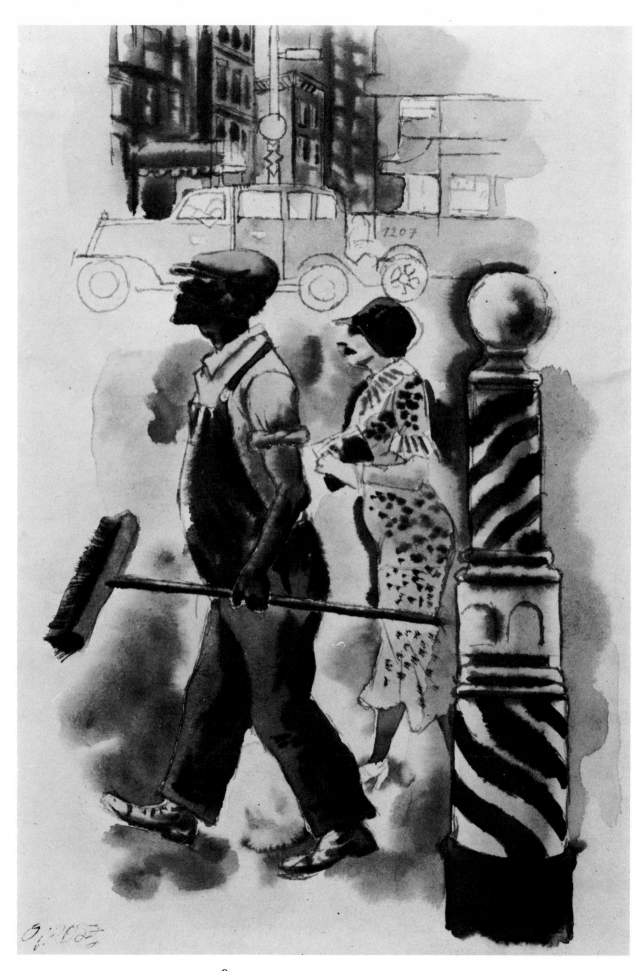

close to combining elements of his former style; rich with new observations, there are Futurist overtones in the simultaneity of events depicted. 'The world is so full of grotesques and hellish happenings, that one can hardly make a joke. Everything fire-red, blood-red, black and profanely dark, and this bloody pastry is served with stinking mustard. That is where laughter ceases.'[31] This imagery is deeply engraved in Grosz's mind, and his apocalyptic paintings were to be dominated by a horrible colour scheme of mustard browns and yellows, blood-red and black. The other problem Grosz had raised, that one cannot joke about such horrors, was the underlying reason why caricature was beginning to fail him. The true horrors were too great to be reformed as works of art. They had to be transposed into a different form of symbolic representation. A watercolour, *The Fire* of 1933 (fig. 174), which presages the apocalyptic pictures, is a new attempt at symbolic representation. The horror underlying Grosz's early work was attached to social events. This picture of a conflagration remains an illustration of

170 (*opposite*)
Street cleaner, New York (two figures) c. 1932
watercolour, signed,
$12\frac{1}{2} \times 8$ in., $31\cdot5 \times 20\cdot5$ cm.
Collection of Basil Sherman, London

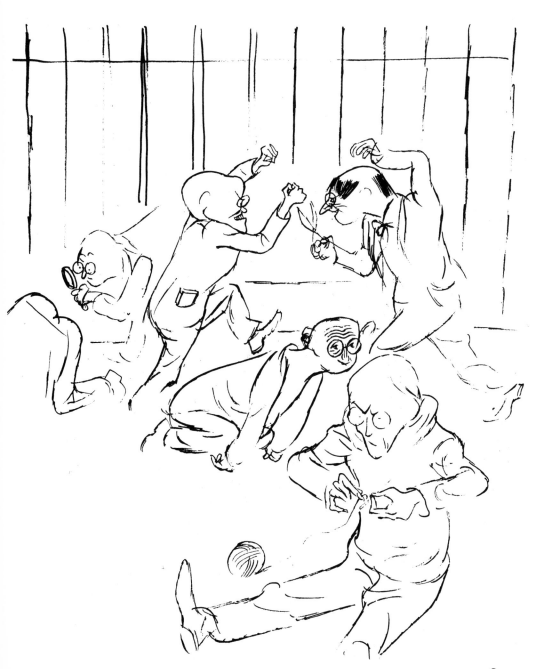

171
Happy insanity c. 1933
pen and ink drawing,
$25\frac{9}{16} \times 20\frac{3}{8}$ in., $64\cdot9 \times 51\cdot8$ cm.
Estate of George Grosz

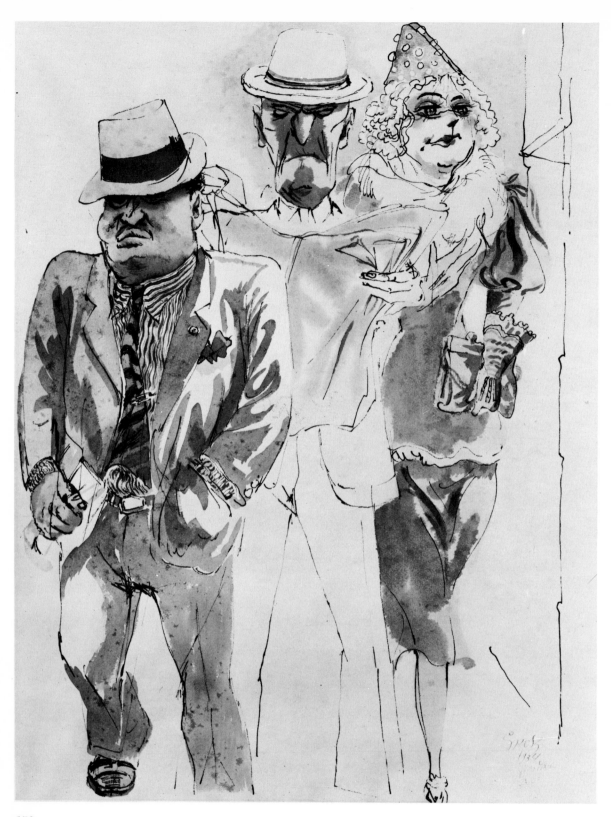

172
New York street types (*three figures*) 1934
watercolour, signed and dated, $25 \times 18\frac{15}{16}$ in., 63·5 × 48·1 cm.
Ella Winter, London

173 (*opposite*)
Broadway 1935
watercolour, signed, dated and inscribed, $19\frac{1}{8} \times 26$ in., 48·5 × 66
Estate of George Gro

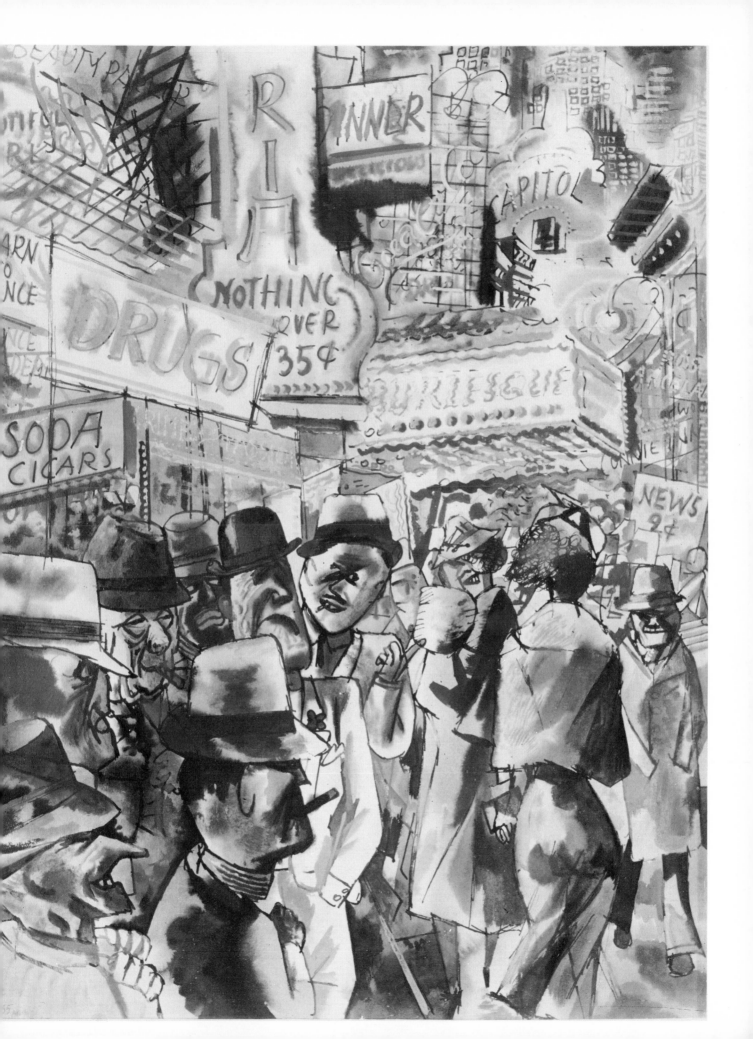

174
The Fire 1933
watercolour, signed and dated,
17¾ × 22 in., 45·1 × 55·9 cm.
Wadsworth Atheneum,
Hartford, Connecticut

175
Washed out 1936
watercolour, signed, dated
and inscribed
Wieland Herzfelde, Berlin,
GDR

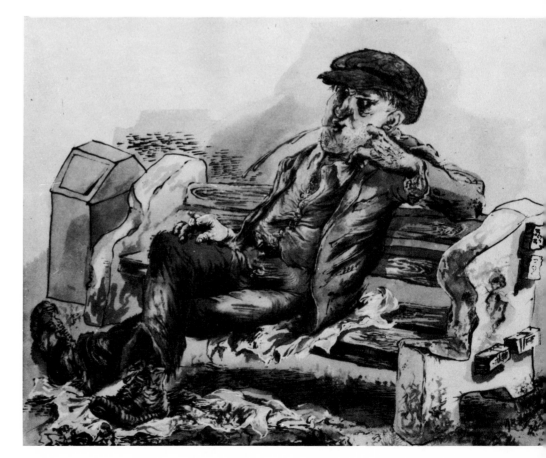

horror without guilt. It is fate without a reason which had dictated that event. 'I dwell on the idea of senselessness and accident in the world with diabolic glee,' he wrote to Wieland. 'I am in need of such a philosophy . . . to be creative.'[32] Logically this statement should have led Grosz to Surrealism. This he never developed fully, but traces of Surrealism can be sensed in much of his work. He had always rejected becoming a modern abstract, formalist artist. 'Great art must be discernible to everyone. The ivory tower artist can achieve some things, but it is not my line.'[33] A genuine dilemma and a genuine paradox are revealed in this letter to Fiedler: the desire to be an artist who can be understood by everyone and yet not an artist who is unique. Grosz was looking for a role which he assumed had once existed but did not exist any more. He could never solve his problem, because he set himself a hopeless task, and one almost fears that he set it because he knew it was hopeless.

Grosz was treading an uneasy path between satirical realism and a form of allegory. His work in Germany had gained in political dimension by its use in everyday life. In the United States his work was not 'used', he himself had to instil a meaning into the work. *Washed out* (fig. 175) is an American human document, sad and true, but it is not an indictment. The work has no context, and as Grosz attempted to give it an 'eternal' rather than a 'temporary, topical' quality, the picture exemplifies that individual bad luck that is not tied to any particular time or place. In *The brothers*, also called *Europe and America*, and subtitled: 'thus I saw myself' (fig. 176), Grosz questioned his identity and his fate. He painted the dream and the failure, the past and the future. His life in America was only beginning.

Grosz had every right to feel himself lucky and reasonably content, and he said so plainly. He and his family were safe. Compared to those in concentration camps, he was, in his own words, '10,000 times better off'.[34]

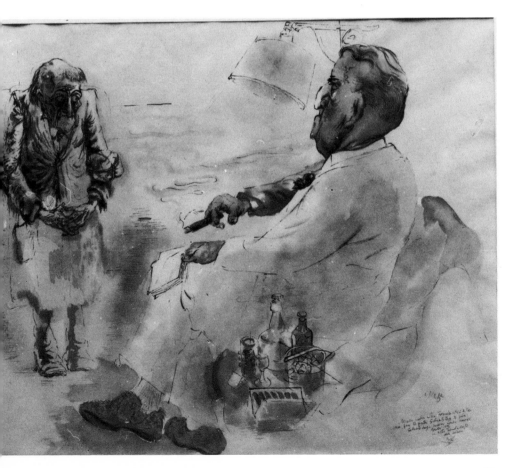

176
The Brothers c. 1934
watercolour, with pen and ink, signed and inscribed
Wieland Herzfelde, Berlin, GDR

9. Before the next war 1934-39

Grosz rented a house outside New York in Douglastown, where he was happily installed. He had been given interesting work: twenty large watercolours for short stories by O. Henry. He worked hard. At least three days a week were spent at the school which had opened shortly after his arrival, and at the Art Students League classes, but the rest of the week was his own. 'During the last years in Berlin, I did too many coloured drawings. I have now introduced a stronger, painterly treatment.'[1] The nature note is struck again: 'the country is beautiful. Nature! One should not live in cities for too long . . . it is beautiful, yes healing.'[2] At this time nature with its promise of healing a torn mind was beginning to play a part in Grosz's work—a very surprising part. A painting of *Central Park* (fig. 177) typifies his approach to nature: even nature is disturbed, not to say evil. His calmest studies of rocks and grasses hold sinister surprises, as if all nature were inhabited by evil. These visions anticipate the use of landscape in the apocalyptic pictures, and prepare the way for them.

Grosz wrote to the painter Herbert Fiedler about his pictorial problems: 'I feel very strongly the general upheavals which go through the world today. I have such a dramatic instinct, and now, in my latest work, I attempt to express it.'[3]

The news from Europe was consistently depressing, political news as well as personal news. Flechtheim's gallery had been closed and the remaining pictures sold on behalf of creditors.[4] Grosz's watercolours were safe in London, but unsaleable at £5 each. Paintings were even more difficult to sell. The necessity to take a positive view of his American future was reinforced by the fact that the past was over, and there was little hope of salvaging anything from the German wreckage. Occasionally, Grosz succeeded in his American types, but whether these looked the same way to American eyes remains an open question (*Americans*, fig. 178).

Of all his friends the one whom Grosz respected the most, apart from Wieland Herzfelde, was Bertolt Brecht, whom Grosz knew well in Berlin. What Grosz liked about Brecht was his ability to laugh and to see several sides of the situation. There is evidence[5] that Grosz intended a series of works, which unfortunately never saw the light of day, as illustrations to

Brecht's plays. In 1934 he wrote to Brecht, who was living in Denmark at the time, 'Yes Bert, I would, with pleasure, illustrate your plays. I am probably the only one today who could do it well (and who would enjoy doing it).' He asked Brecht to suggest ideas for 'accompanying drawings which, in the tone of the plays, would syncopate the text'.[6] The plays were to be published by Malik in Prague. Grosz told Wieland: 'I am looking forward to illustrating Brecht's books. . . . I shall try to be as hard-hitting and topical as possible.'[7] The illustrations for Brecht were not to materialize, and the reason will become clear.

177
Central Park at night 1933
oil on canvas
Present ownership unknown

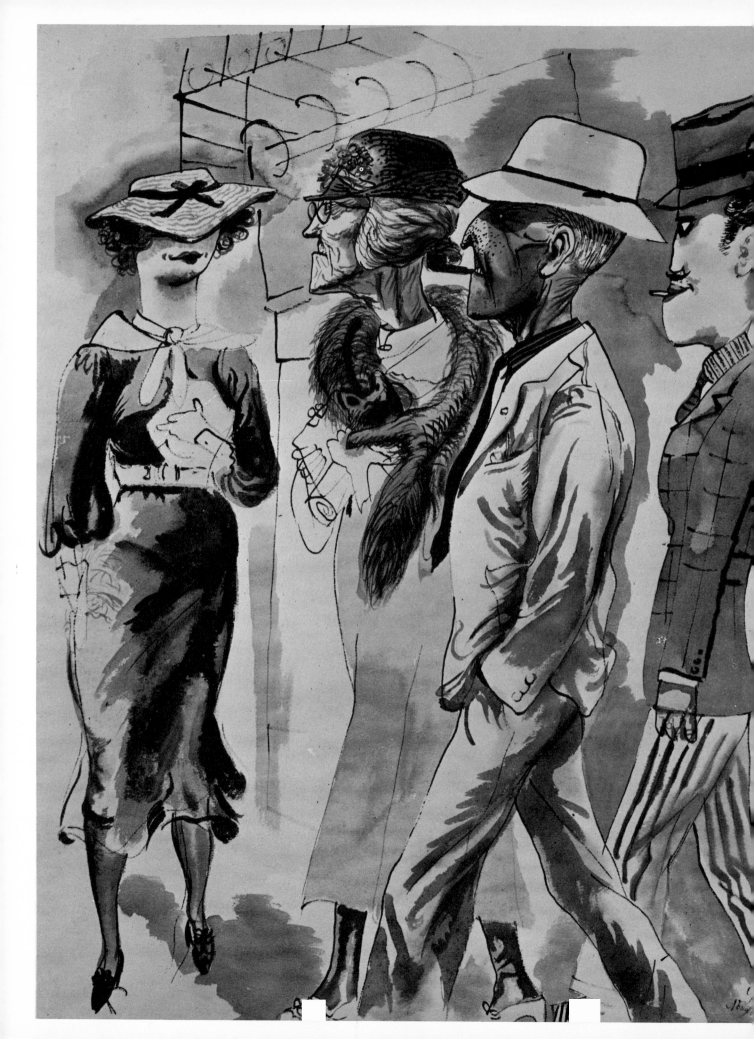

Grosz had always been an individualist, and appeared to himself as unchanged, but he had to battle with the other Grosz, the famous Grosz, who haunted him. He could not separate himself from the impact of the work he had created. It had become a reality, and his own creations had become more powerful than he himself. His former work grew stronger with time; Grosz was fighting a losing battle. He had to adopt a defensive position towards his old friends, who were becoming critical of his art, his life, and his political attitudes. 'Formerly, I still saw a purpose in my art —not any more. . . . It is my own decision, and I have to bear alone the consequences.' Yet at the same time he could report that he had painted 'some very sombre pictures—shelled cities—corpses murdered by uniformed men—recently of street fighting—related to the scenes in Vienna',[8] where his compassion and involvement once more found expression. *Street fight from the roof* (fig. 179) concerns the heroic defence by the Social Democratic workers of their municipal homes under artillery attack by government forces. Grosz stressed[9] that he had done political drawings on Hitler, marching S.A. men, horror scenes, which laid claim to an inner truth. In a drawing *That'll learn 'em* (*A writer is he?*) (fig. 181) the well-known faces and figures of Grosz's early work reappear in action. Another version of the same title appears in fig. 180, inspired by the ill-treatment and death of his old friend Erich Mühsam. He wrote to Wieland Herzfelde: 'I am as ever in sympathy with your work, even if I can't take an active part . . . I am not a believer.'[10] Another recurring motif is his total despair with Germany: 'I do not feel myself a member of "the better Germany". I have to live with my pessimism.' In the same letter he enquired if Wieland knew what had become of his picture *Germany, a winter's tale*,[11] and asked after *Ecce Homo*, *Gott mit uns* and *Hintergrund*. '*Ecce Homo*,' he said, 'is often in demand.'[12] To Felix Weil, his old patron, who was critical of Grosz's latest work, he wrote: 'I am sure that the old Grosz is still alive. . . . If I am not anymore as clear in my contours as formerly, this derives from a certain concept of such things, but you should not overlook the apocalyptic darkness, menacing . . . blackness, which is often expressed in the landscapes.'[13]

In 1935 Grosz went back to Europe for a summer holiday. Whereas once upon a time Paris had seemed like a metropolis, now it struck him as small and provincial. He went to Svendborg where Brecht lived. Before visiting Brecht, he had tried to persuade him to come to America. He wrote, not without malice: 'Start learning English . . . maybe you could manage without it as hearsay is of greater value to your clever mind than it is for lesser realists.'[14] Writing to Richard Hülsenbeck, his old Dada companion, he reported that he spent a day or two with Bert Brecht 'discussing like old Greeks',[15] which, in a letter to Nazi Germany, sounds like a veiled reference to 'dialectics'. He had invited his mother to join him for a family holiday at Ostrestrand, near Lohals, where the landscape of the Baltic was reminiscent of his childhood Pomerania. The beach, he said, was a bit like Ahrenshoop. Grosz was happy and cheerful on his holiday after his years of struggle in New York. From Bornholm he wrote that, in accordance with his gothic nature, he was discovering *Das Kleinleben* (the life of small natural objects): 'painted beach grasses, gnarled branches, age-old mosses, etc. What richness of forms, of different textures of juxtapositions. Magnificent! It excites my draughtsman's heart.'[16] What

178
Americans 1935
watercolour, signed and dated
Private collection

193

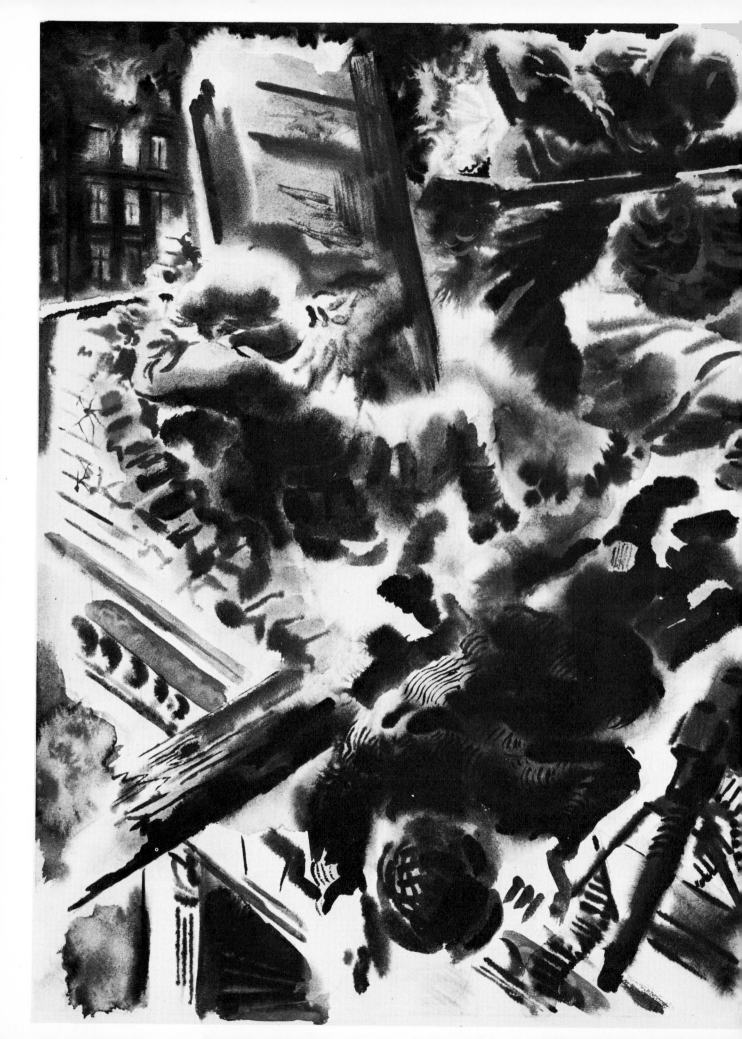

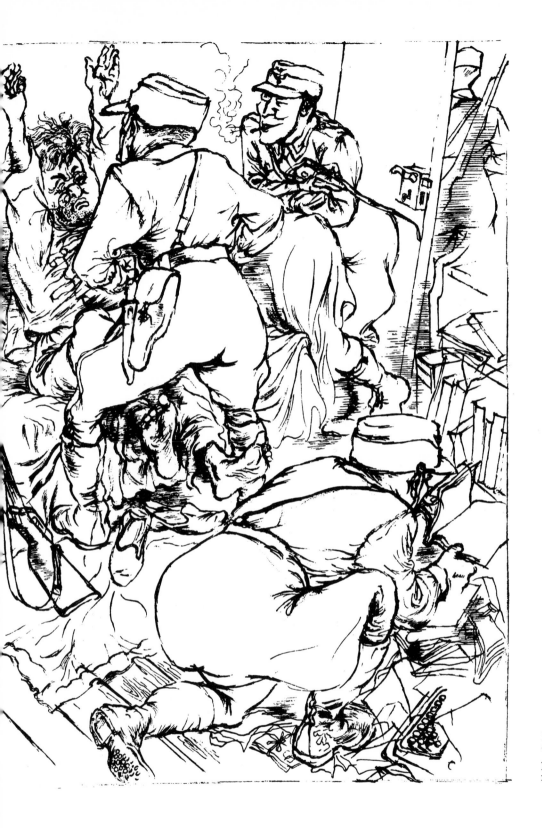

180
'*A writer is he?*' c. 1935
pen and ink drawing
no. 45 in *Interregnum* 1936

181
'That'll learn 'em'
(*A writer is he? II*) c. 1935
Pen and ink drawing, signed
no. 18 in *Interregnum* 1936

Grosz called the *Kleinleben*, the German Romantics had called the *Erden-leben*, the pantheistic feeling of God manifesting himself in every piece of creation, which they had discovered in Dürer's *Hare* and *Blades of grass*. The German Romantics, with whom Grosz discovered an affinity, developed their art in the wake of the reactionary wave which swept the countries of Europe after the French Restoration. 'I would love to spend a few years as a hermit on an island like this one, devoted to the study of nature.' He then proceeded to parody himself 'as a traitor, lying in the grass, looking at flowers—a half-rotten petty bourgeois'.[17] *Rocks and ferns* of 1935 (fig. 182) dates from the Bornholm months, and shows the artist seemingly concerned with natural forms. Actually they are deformed by his temperament, and are already charged with a meaning, as Grosz had written to Felix Weil. When in the watercolour *Cain and Abel* (fig. 183) a Nazi's jackboot tramples over the torn fragments of a banner demanding Freedom, Bread and Peace and his murdered victim, Grosz's 'nature studies' reveal the unity of his moral intentions. To depict political disasters as unavoidable fate is romantic and, as Grosz well knew, petty bourgeois.

'Technically, I can master watercolour. . . . I have not got this wonderful freedom in oils. For a long time now I have wanted to paint some large pictures,' he wrote from Bornholm.[18] Grosz had painted some of the most original paintings of the century in oils, but to him these great paintings belonged to his life as a satirist. When he painted them he had not even been conscious of the difficulties he had overcome without effort.

On his return to the United States, Grosz had to take over the school on his own, as Maurice Sterne had withdrawn to live in Italy.[19] During his two years in America Grosz had disappeared from the public eye. His connections were still mainly with refugees, and his quite numerous American friends esteemed the old Grosz. Grosz lived by teaching at the ·Arts Students League and at his own school, and found it very strenuous and unrewarding. Occasionally he sold some watercolours and paintings. He loved working out of doors. 'Nature is rejuvenating—like spring water. . . . Formerly I was gripped by the hellish phantasm of the big city and . . . the damned, avid faces of little men. . . . Today I am rediscovering the world of my boyhood, building in a willow tree a Red Indian look-out.'[20] Overcoming his recent past, he returned to his boyish dreams. He stated that his vision had been enriched, and often a stone or the filigree of trees, or a near piece of bark and grasses, spoke to him as formerly a face did. He studied drawings by Wolf Huber and Altdorfer, whilst illustrating fairy tales. He identified himself with a lost raven in a German forest; a lost soul in his homeland.[21] It was a flight into childhood and German Romanticism.

182
Rocks and ferns at Bornholm
1935
pen and ink drawing, signed,
$15\frac{1}{2} \times 19\frac{3}{8}$ in., 39·4 × 49·2 cm.
Estate of George Grosz

In *Hansel and Gretel* (fig. 184) Grosz recaptured the spirit of the sinister folk tales collected by the brothers Grimm. An allegorical oil of 1936 was entitled by Grosz: *The sea, the rocks and the everlasting moon*, and the autograph note on his original photograph said 'remembering the last time I saw Europe brooding and foreboding disaster and war, 1935' (fig. 185). This painting is truly in the German Romantic tradition, with its unearthly illumination. It has the simple futile faith of popular religion, and in that sense is a genuinely naive picture. But allegory is altogether naive; the literalness of meaning is an illiterate phenomenon.

'The American landscape is often, where man has abandoned it, of apocalyptic wildness.'[22] A landscape of 1938, entitled by Grosz *Apocalyptic landscape* (fig. 186), is only indirectly related to his statement. It is not a landscape abandoned by man, but invaded and destroyed by him. Whenever Grosz painted nature as he experienced it, it was bare and barren, twisted and tortured.

183 (*opposite*)
Cain and Abel 1935
watercolour with pencil, pen and ink, 25⅛ × 19⅝ in.,
63·7 × 49·7 cm.
Mrs Lester Avnet, Great Neck, New York

184
Hansel and Gretel c. 1934
pen and ink drawing, signed and inscribed, 19 × 24⅛ in.,
48·2 × 63·2 cm.
Illustration to *Hansel and Gretel*, by the Brothers Grimm
Estate of George Grosz

185
Rocks and moon 1936
oil on canvas, 33 × 12 in.,
83·8 × 30·5 cm.
Private collection

Grosz was always to be interested in the theme of the city—transposed, elevated to a form of art. 'Maybe,' he said, 'I am the only one today who is trying to do that . . . It is a fantastic agglomeration of detail; a highly interesting mixture of pure colours, broken planes and firmly drawn lines. A hugely confusing task.'[23] That is exactly the way Grosz and the Futurists had visualized the painting of the big city of the future, but now that the future was visible, the problem had shifted. A watercolour, *The Filling station* of 1934 (fig. 187), balances between a Futurist past and a Realistic present.

Not much of Grosz's work had appeared in public. In January he discussed a contract with Caresse Crosby to produce a book 'dealing with the history of events in Germany',[24] which was to contain over a hundred

186
Apocalyptic landscape 1937
oil on canvas, signed and dated
Present ownership unknown

drawings. The contract was not too favourable for Grosz, but it did at long last mean a publication for some of his drawings. The portfolio eventually appeared under the title *Interregnum*, including some American work, very much on the lines of his past work. The drawing *Fifteen pounds underweight* (fig. 188) has its origin in the long tradition of accusatory illustrations of poverty, whilst *A little child shall lead them* (fig. 189) has its source in Grosz's own earlier work. A drawing *No let up* (fig. 190) has a painting as a counterpart.

187
The Filling station 1934
watercolour, signed and dated,
$24\frac{1}{4} \times 17\frac{1}{16}$ in., $61 \cdot 6 \times 44 \cdot 2$ cm.
Yale University Art Gallery,
New Haven, Connecticut,
Gift of Mr and Mrs George
Hopper Fitch

188
Fifteen pounds underweight
1936
pen and ink drawing, signed
no. 8 in *Interregnum*

189
A little child shall lead them
1934–5
pen and ink drawing, signed
no. 8 in *Interregnum* 1936

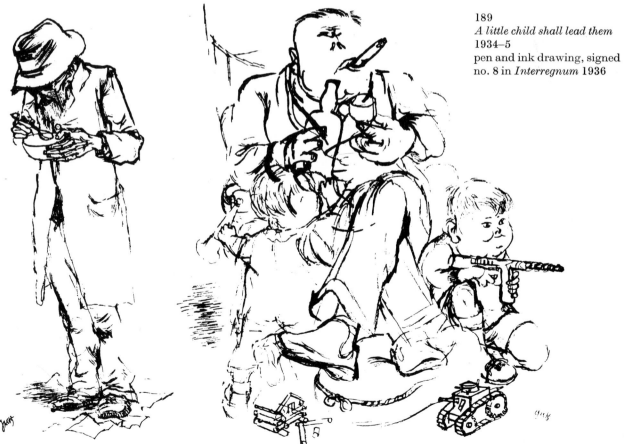

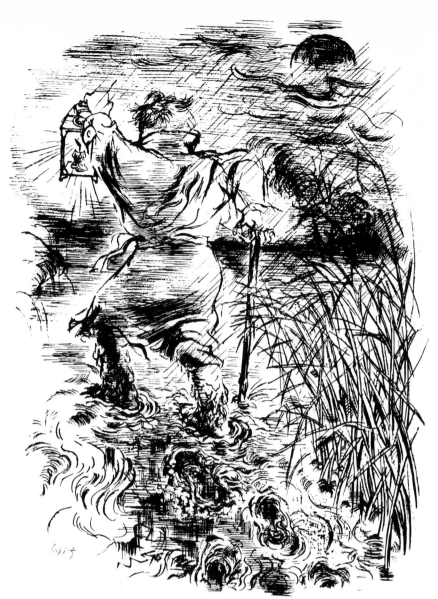

190
No let up 1936
pen and ink drawing
no. 63 in *Interregnum*

Grosz had tried publishing in American magazines, but had had little success. He could not come to terms with their taste, and they could not come to terms with his. 'Funny situation anyway . . . the magazines and papers think my stuff too gloomy, too German,' he wrote to J. P. McEvoy,[25] 'and the more snobbish people think my stuff has lost all that they liked to be thrilled with around 1924 . . . but I don't give a damn . . . my new work has some fine qualities . . . they want you to do the same stuff your whole life long.' This then was Grosz's genuine dilemma. His old audience wanted him to be as he had been, whilst he himself was certainly right in wanting to change and move on. He defended his former work but firmly put it in the past. 'I have to withdraw nothing. My pictures, and especially a few dozen drawings, will live as documents. I am happy to have made them, and often look at them with satisfaction.'[26] Grosz had to change, but in what direction?

He refused to join the American Artists' Congress when he was invited. 'I feel I don't belong there with all my doubts and scepticism. I was one of the very first artists who raised his voice ... against the dark forces, against war and Fascism. And I said it in my work too. You may call me disappointed. O.K.! But I'm not.'[27] While not denying his past, Grosz had a new and higher aim: art. 'Propaganda is something entirely different from art. ... Don't overrate the meaning of our outmoded profession.'[28] This reads not only like a confession of a lack of faith in propaganda, but in art as well, since the two can now be separated in Grosz's mind. The crisis affected both sides of his work which once were unified in the artist's activity.

Wieland wrote from Prague to say that the Brecht drawings had not arrived. 'What grieves me,' he wrote, 'is the thought that your own production suffers from your judgments. ... I hope I am wrong.'[29] Grosz replied immediately. 'To come to the illustrations. I have tried again and again, and did a few drawings. Brecht himself has seen some of them (and thought they were good, but B.B. has no idea of art) ... maybe in my present surroundings Brecht's problematics seem alien ... I live in a totally different country, and would have to cast my mind back several decades. ... B. is too abstract for me. It was my mistake that I did not immediately understand that and so spare you these difficulties.'[30] A week later Grosz wrote urgently to Wieland:[31] 'Please consider my last letter as unwritten— at least the part about the illustrations. I was in a terrible mood then ... I shall try to finish the drawings as quickly as possible. It is a pity that you are not here. We could, in spite of all difference (you the believer, I the unbeliever), work so very well together, and I would have done the drawings long ago.' Grosz knew that he was lacking support and understanding in his new situation. Wieland generously replied, 'An artist cannot take his own subjective emotions lightly. Thus I understand your attitude, though I regret it.'[32]

It is a far cry from Malik to *Esquire*, but at the time Grosz was working for this magazine, and he recommended to the editor, Mr Gingrich, to do as Wieland Herzfelde used to do. 'Sometimes in earlier days, my friend and publisher, W. Herzfelde, used to drop in and pick out from my stock of drawings just those he thought fitted in ... it gives more freedom for fancy and imagination.'[33] But Grosz forgot to add that there was then a mutual understanding and a common purpose. John Dos Passos wrote an article on Grosz's work for *Esquire*. Grosz would have liked *Esquire* to have printed his drawings larger—they were being used only as little vignettes. Writing to Ben Hecht[34] he said that he did his illustrations in a typical Grosz way, making no concessions. How could he compete with all the 'sweet' and clever American illustrators? 'If a big magazine like *Esquire* would dare to hold on to me and reproduce quite a number of bigger drawings, I could make a re-appearance as draughtsman over here.' This was a critical moment. As Grosz rightly said, if an important magazine had stuck with Grosz for a number of years, he might have made a new name and found his place.

In March 1936 Grosz cancelled his contract with the Arts Students League, for the coming winter, as he meant 'to take a full year to devote to my work only'.[35] By the end of 1936 he had given up teaching altogether.

'These years devoted to teaching society girls how to paint and draw have been quite a job. Well, now I am happy to have time for my own things.'[36]

The choice of his subjects was traditional: still life, self-portraits in growing numbers, portraits of friends, and New York cityscapes. His still-life paintings really became exercises in painting what he had once ironically described as *peinture*. *Still life with walnuts* (fig. 192) is a solid painting of textural uniformity though it remains a picture from an older generation. In *New York harbor* (fig. 191) only does Grosz attempt to realize a vision which had not been expressed in the same manner before.

From July onwards he lived in Douglaston, Long Island, where for a number of years he was happily settled in a house and a park which he liked very much. In the distance, through beautiful trees, he could see the Ocean Sound with sailing boats. The family were always very hospitable. Grosz's friends, German as well as American—Walter Mehring, John Dos Passos, Ben Hecht, Felix Weil and Erich Cohn, old patrons of Grosz—all came to see him.

From Douglaston Grosz asked Hemingway[37] to write an introduction to a forthcoming book of Grosz's work, 300 reproductions, which would 'not

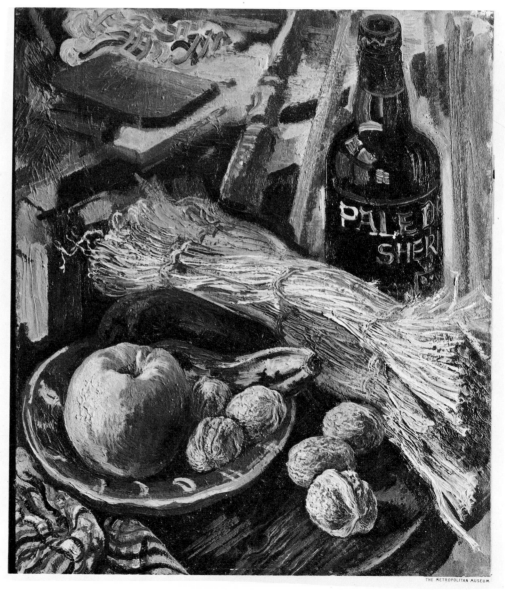

THE METROPOLITAN MUSEUM

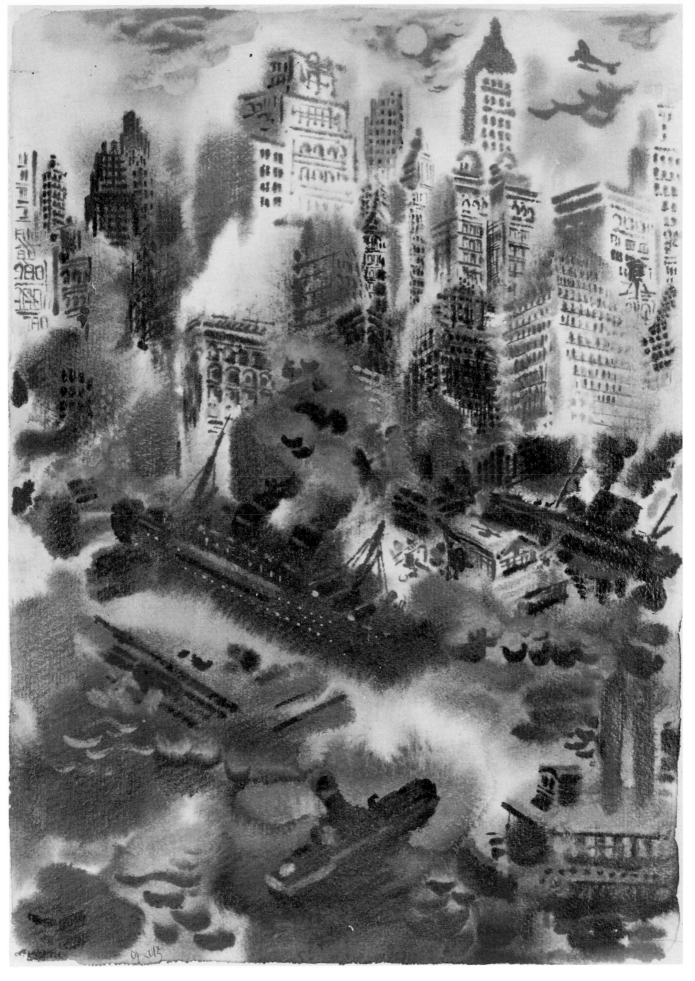

only show the political side of my work, but the other side too . . . my portrait work, my composition'. Thus Grosz himself made the distinction between his political and his artistic work. 'It is marvellous to handle again brushes and paint. A new beginning has been made. If Art is a Mistress, she is very dominating . . . and hard to please.'[38] For the first time, Grosz defined himself as an artist. Once more he asked for literature on medieval painting methods.[39] He was preoccupied with technique—the materials and the methods—and experimented continuously with filters and jars, dripping oil through sand and charcoal to refine it. These and various other such pastimes were a sign of impotence, a false activity as a substitute for painting. Searching for medieval painters' skills, looking for something like a secret, an alchemist's attempt to capture the spirit of perfection—these efforts, practically useless, became nearly obsessive.

From his reasoned, though negative, political arguments of the immediate past, he now departed into anger and fury. He began to deny his past and his friends. The left-wing periodical, *The New Masses*, asked him for a contribution for their twenty-fifth anniversary number, to which Earl Browder, Sherwood Anderson, John Dos Passos, Theodore Dreiser and Upton Sinclair were to contribute, but they received no reply.[40] The International Workers' Order asked Grosz to act as a member of the jury and were refused.[41] But the Daughters of the American Revolution obtained permission to reproduce Grosz's painting *Third-class funeral* (fig. 157).[42] 'As a matter of fact, I had been in a very bad condition, near something they

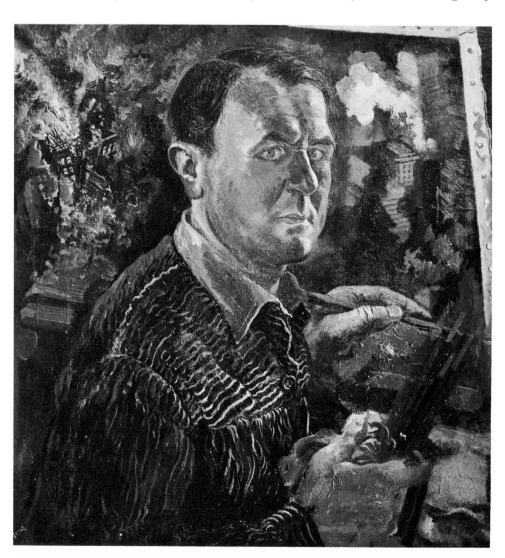

193
Self-portrait No. 2 1936
oil on canvas, mounted on board, signed, dated and inscribed, 24 × 20 in.,
61 × 50·7 cm.
Estate of George Grosz

call a total breakdown, but now I am better.'[43] This evidence simply and honestly expresses what in bigger words is called a 'crisis of identity'. An artist is only an artist when he functions as one, and since Grosz had decided to be an artist, he had to live up to his own image, so when he failed he had to break.

During April his wife went to Berlin to visit the family[44] and Grosz wrote that he had painted a beautiful new still life and wanted to start a new self-portrait. He had begun a composition *Old Warrior*, and had an idea for painting a medieval *Adam and Eve* in Hans Baldung Grien's spirit. 'I am working hard and I drink very moderately.' This reassurance given by a very heavy drinker tells us that all was not well. He was on the way to becoming an alcoholic and his early efforts to break the habit were as unsuccessful as they usually are. When drunk he became violent, aggressive, argumentative, and, of course, miserable and repentant, but the chain of events was repetitive. Even without the documentary evidence of his own letters, his state of mind can be traced from his work, pervaded with loneliness and despair and wholly autobiographical. *Self-portrait* (fig. 193) shows the painter Grosz at an easel, and behind him a burning town, a vision of the Spanish Civil War—in his mind a foreshadowing of the war to come. *Remembering* (fig. 194) depicts the painter huddled in a ruined house—his own world, or the world of all of us. The man, Grosz, in *The Wanderer* (fig. 195), is accompanied through mud and war by the raven of his recurring vision; he is a lost soul in a world without hope.

194
Remembering 1937
oil on canvas, $28\frac{1}{2} \times 36\frac{1}{2}$ in.,
72·4 × 92·7 cm.
Estate of George Grosz

In 1938/9, Grosz worked on a subject which he variously called *The Last bataillon* and *A Piece of my World II* (fig. 196). He wrote about it later: 'My oil painting *A Piece of my World* belongs to a series of paintings which I named "apocalyptic", "prophetic" or just "hell-pictures". How much my own memory of my youth in Germany or a certain heavy teutonic inheritance, a liking for death and symbolism, is involved, I can hardly say or explain.' In manner it anticipated a number of horrifying pictures. 'Maybe, in a more normal period, I would have been just a good historical painter, a positive one, and not a haunted one.'[45] Here resides a truth of which Grosz had become aware: the more his Berlin years faded from his mind, the more the older artist linked himself to his school days, to the artistic ambition of his youth. But he overlooked the fact that he had been one of Europe's greatest, if not its only, history painter.

Stylistically, the new Grosz had some kinship with the work of Dix, whose apocalyptic vision of war in the trenches hovers uncomfortably between realism and apotheosis. There are memories of the work of other Expressionists like Davringhausen, and yet the pictures are very much of Grosz's own making. They feel true to his despair and his view of the world, and also to the role of the artist of whose insignificance he was convinced. Painting appeared to be a paradox which could not be solved, and that is possibly the deepest significance of the work. He seemed to hate the medium of paint, so that paint itself becomes the mud in which Grosz buries himself. A painting called *The Muckraker* (fig. 197) expresses this in an almost literal form.

195 (*opposite*)
The Wanderer 1943
oil on canvas, signed,
30 × 40 in., 76·2 × 101·6 cm.
Rochester Memorial Art
Gallery, Rochester, New York

196
A Piece of my World II
also *The Last Bataillon* 1938
oil on canvas, signed,
39½ × 65 in., 100 × 140 cm.
Estate of George Grosz

197
The Muckraker 1937
oil on canvas, 39 × 32 in.,
99 × 81·3 cm.
Estate of George Grosz

For Grosz there were only two choices, both extremes: either remaining the political artist, or becoming the pure artist who could detach himself totally from the concerns of this world and enjoy the creation of pure aesthetic forms. Grosz was capable of neither extreme; he despised the purely aesthetic concern with form, and he could not free himself from the political events in Europe. The Spanish Civil War produced some sober drawings such as *Street fight in Madrid* (fig. 198). The objective side of his work was engulfed by his own subjective struggles with his self-definition as the painter of universal doom.

In 1937 the National Socialists staged a large exhibition of what they had designated as 'degenerate art', a term which to them comprised all modern art. The works of Grosz were displayed, together with Cézanne and Gauguin, Picasso, Chagall, Liebermann, Corinth, Klee, Kandinsky, Kokoschka, Nolde, Matisse, Derain, Kirchner, Marc, and many other masters. Quotations were displayed around the exhibition; one by George Grosz read: 'It is worth your while taking Dada seriously.' History had come back as a farce, but as a farce with too many levels to be understood by the Nazis. The farce was not a joke, it was a pogrom. The exhibition in Munich had been preceded by the confiscation of nearly all works by modern artists in German public collections, including 285 works by George Grosz. There is no contemporary recorded comment by Grosz on the 1937 exhibition, but on a similar exhibition in 1933 he had written to Felix Weil that his drawings had been 'in the foreground as a warning example . . . secretly I am a little proud of them. Yes—then art had a purpose . . . this was my Germany —it was the truth.'[46]

In 1937 Grosz wrote about his work, 'I am, it seems, on the way forward, and hope to make some better things. After going through a real hell of depressions, drink and doubt, I often put all my tools away—never to touch them again.'[47] He was planning larger compositions—it was a new road for him—and he wrote that as 'the painter of unclad figures I might

198
Street fight in Madrid 1937
Pen and ink drawing, signed,
dated and inscribed
18⅛ × 24 in., 46 × 71 cm.
Bernard Reis, New York

make a very personal contribution'.[48] Grosz chose as his new theme the very conventional subject of the nude, which the Futurists in one of their manifestos had proscribed. In Grosz's oeuvre there are many unclad females. In the earlier works they usually played a role in the chosen situation of the picture. In the work of 1939 and 1940 the nude's role is to be the painting—art for art's sake. The quality of the drawing has great force and sensitivity, and as can be seen in the pencil study Grosz made a highly personal contribution to a long tradition (fig. 199). In his oils, however, Grosz attempted a great variety of different approaches, and, although he painted many nudes, no unified style became apparent. They are, accordingly, astonishingly uneven in quality. *Before the bath* (fig. 200) is a mildly, attractive, but somewhat empty, painting. *Woman undressing* (fig. 201) is a far more solid and determined composition. *One summer* is an allegorical

199
Nude 1939
pencil drawing, signed and
dated
Private collection

200
Before the bath 1940
oil on canvas, signed and
dated
Private collection, USA

201
Woman undressing 1941
oil on canvas, $13\frac{3}{4} \times 8\frac{1}{4}$ in.,
35×21 cm.
Mr and Mrs W. B. Johnston,
Bath, Somerset

painting (fig. 202), where Grosz places the work of art and the artist's tools on driftwood, symbolizing the uncertainty of art. Grosz had become a sceptical Romantic; that, too, is a unique achievement, as the essence of Romanticism is faith. Grosz also painted a detail of the picture he called *Small Driftwood* on its own, as an allegorical still life, a modern Vanitas, and a piece of autobiographical allegory.

The year 1939 marked a very low point in the life of George Grosz. For anyone closely linked by memory and knowledge to the European scene, the year 1939 was one of tragic foreboding. Grosz sank deeper into loneliness and drink. The defensive armour which he had built around his past became the straitjacket of an anti-faith. The situation was Kafkaesque. He grew the carapace of denial and self-denial, but in that hard shell neither he nor his art could grow.

From 20 March to 15 April 1939 the Walker Galleries held a Grosz exhibition. In the foreword to the catalogue Allan Ross MacDonald wrote:

'A few critics vainly imagined then that he would continue to use his pencil as a weapon . . . They left out of account, however, the wide difference that lay between the moral climate of post-war Germany and that of America . . . they also overlooked the natural growth of the man and the artist . . . George Grosz, rightly acclaimed . . . as a master satirist, a master draughtsman, a master water-colourist, may now with equal force be acclaimed a modern master of pure painting.'

Such approval for his new work was rare. The Walker Galleries held fifty oils and hundreds of watercolours and drawings, almost all of the American period, and this first major exhibition gave an account of the artist's work since his arrival in America.

Apart from his drawings of nudes, many of them done in connection with his work at his school, he attempted New York cityscapes, social commentary on Harlem shoe-shine boys, butchers' shops, as well as political commentary on Austria, Spain and Nazi Germany. There were also landscapes and the sea, leaves, roots, rocks and grasses, still life and allegorical paintings. By choosing so many different subjects, Grosz revealed that he was looking for a content, for when he had a subject to form, he was a great enough artist to find convincing forms for it.

The family spent part of the summer[49] at Wellfleet, Cape Cod, where Grosz relaxed, swam and sketched. There were a number of artists and writers there, and Grosz enjoyed their company at friendly parties, mostly out of doors. His income was barely sufficient for a comfortable life, and the struggle for money was mostly hard and hectic. Grosz received a small regular stipend from Felix Weil, which he asked him to continue, as he wanted to survive as an artist. 'Don't fool yourself about my standard of living (my profession in a capitalist society is similar to that of a tight-rope walker).'[50]

Grosz, like all other anti-Fascists, had known that Fascism meant war. In September 1939 Hitler started the war in Europe. A new influx of refugees arrived, amongst them Wieland and his family. Grosz was as helpful as ever; friendship meant much in his life.

The German/American Writers' Organization asked Grosz to contribute

to a forthcoming special issue of *Equality*, together with Thomas Mann, Professor Einstein, Oskar Maria Graf, and Ferdinand Bruckner. Grosz was asked to send a drawing 'as he had twenty years ago prophetically drawn present-day Germany'.[51] He wrote back, 'I can't send you anything. Why should I reproduce old drawings? They belong to a time which has passed.'[52] That was exactly where Grosz and his friends disagreed. Their contention was that the time had not passed, and that the forces Grosz had drawn were now in power. Grosz treated history as his history; for him that time was over; whilst, in truth, he had been ahead of his time, and time was catching up with him.

On the outbreak of the war Grosz wrote to his mother a consoling letter.[53] He was not to see her again. At the very end of the war, she and her sister disappeared with the house in which they lived, in a bombing raid on Berlin.

202
One summer c. 1940
oil on canvas, signed,
20 × 28 in., 51 × 71·1 cm.
From the private collection of
Mr George M. Gross, Sands
Point, New York

IO. The Survivor 1940-45

Grosz was never accepted in America as an illustrator. Lack of success with *Esquire* was followed by a failure to negotiate a big scheme for *Fortune*. Yet Grosz was recognized in the world of art. When the Walker Galleries gave a big promotion party, C. V. Whitney, Alfred H. Barr Jr, James J. Sweeney, Conger Goodyear, Nelson Rockefeller and Alfred McCormack were present. The purchase of three watercolours by the Metropolitan Museum[1] was publicly announced, and a telegram from the Pennsylvania Academy informed him that his *Self-portrait* had won a gold medal.[2] 'Altogether I can't complain; America has been kind to me. Yet my *name* is larger than my finances.'[3] A watercolour of the time, *Model undressing (artist and model)* (fig. 204), demonstrates the mood of his work, and shows Grosz himself at work as a painter and a self-caricaturist.

The summer was again spent at Cape Cod, where he saw John Dos Passos and Edmund Wilson regularly. 'I work a lot—it is as if I have lost too much time with worthless things. I have so little contact with my former self . . . I painted a little picture—*The Wanderer* (fig. 195)—myself of course . . . The resonance of explosion and destruction often shakes me bodily. Maybe all this will one day form itself into greater things. I do not want to survive *only* as a Callot.'[4]

If Grosz was hopeful for his work, his friends were not. A devastating letter reached Grosz from Felix Weil. 'I saw both your exhibitions, and it hurts me deeply to see the American *gleichgeschaltete* Grosz. I would understand you if you said that for purely material needs you have to paint nudes, landscapes and still life, and that you could paint your social-critical works only for yourself and your friends. But you seem to make a virtue of necessity and seem to believe the swindle yourself. Thus you have again returned to "Art".'[5] Grosz wrote a spirited defence. 'I love art above all. I always wanted to be a painter. That I succeeded in my drawings, has nothing to do with their content . . . The line and the colour will go on living as a melody . . . Long live painting and the Old Masters.'[6] He had returned to eternal *Art*. 'I don't like the work of my "filthy" period, that is behind me . . . I have always been a secret classic and romantic.'[7] Grosz now reversed what Count Kessler had read in his mind: he proclaimed his 'ideal

203 (opposite)
Fairy tale 1942
oil on canvas, signed
Present ownership unknown

of beauty' and wore his satire like a 'badge of shame'. 'I shall survive—that is my propaganda, that of a disillusioned former fighter . . . I am still making pictures which have direct meanings in actual life.'[8]

Fairy tale (fig. 203) is clearly a continuation of much of Grosz's earlier work; and more is revealed about it if the same spirit of despairing negation is seen in the earlier work. 'I am a follower of Swedenborg, and my world appears to me as a symbolic world, a caricatured heaven. Hell is down here; behind my chair looms the abyss, but I don't look.'[9] My present oils are truly German, maybe romantic where Death, a very medieval Death, appears . . . they are surely symbols of a time of horror and anxiety . . . they are more apocalyptic than . . . actual.'[10] '*I'm glad I came back*' (fig. 205) may stand as one example of Grosz's nightmare. His new pictures, he wrote,

204
Model undressing (artist and model) 1941
watercolour, signed and dated
Present ownership unknown

218

'have their roots in a form of religiosity'.[11] He was living in a world of his own making: 'A curious distorted Heaven or Hell—right here next to me, for instance, are the rats.'[12] Grosz's rats began to play a similar role to that of Sartre's crabs in the *Sequestrés d'Altona*. The hero of this work is not that far removed from George Grosz, for both are imprisoned in their political past.

In this period of deep depression, he accepted an invitation to write his autobiography,[13] although the book was not to appear until four years later. When he had completed the total reversion of what the world thought George Grosz had been, he was to rewrite the history of his life. This autobiography is entitled *A Small Yes and a Big No* and is a very strange book indeed. It is written from within and from without. Grosz presents himself, fools himself and tells some form of truth all at the same time. He has a good sense of places, people and situations in his literary work, as in his drawings, but, although every bit may be true, it appears out of focus. His view of himself cannot coincide with anyone else's view of him. Of all the books that could have been written about Grosz, he himself has written only one, whose focus is determined by the fact that it was published in 1946. Grosz was not a historian (no man can be his own historian) but apart from that, his sense of history was so slight that in his life, as in his book, he may well have experienced himself in the fragmented way in which he presented the George Grosz he knew. He claimed that he wrote the book for the money, and claimed it with such emphasis that one suspects other reasons. At heart, he felt the need to explain himself, because, having suffered from the attacks against both his personal integrity and against his art, he knew that his integrity was unimpaired. He had never been the political propagandist which others saw in him. In a self-mocking complaint, he told Hans Borchardt[14] that he couldn't write books because he had to leave school too early. Borchardt picked up the challenge. 'You *could* write a marvellous biography, though as I know you well, you will not do it, but tell jokes, anecdotes and confessions . . . if you could forget, at least while you are writing, your megalomania, which tells you that the "masses" are unworthy. This . . . has created your unrest and your pain, not only since yesterday.'[15] Grosz answered brutally, but the brutality was turned against himself, not against Borchardt: 'I write my book, not from inner necessity . . . I want money and thus I sell the bit of magic which I have.'[16] This very self-abasement sounds more like punishment than truth.

By January 1943 Grosz had to think seriously of giving up his house and moving into smaller quarters in New York. 'Business has come to a standstill . . . I am not a social success . . . art today is a bourgeois luxury.' This he had believed as a Dadaist, and he still held the position.[17] He had that core of integrity which prevented him from becoming a faker, a surrealist imitator, a pseudo-abstract painter. In his search for his own art he was severe and persevering. But he did not ask the dialectical question of why he could not find it in himself, although he knew the answer in his most disheartened and clearsighted statement: 'I am painting to fool myself.' In the same letter he admitted, 'I have no public.'[18] His self-exclusion from history paid him back with a vengeance.

America had entered the war. For Grosz the American, the old enemy of German militarism, that was the moment to take new hope. The battles of

205
'I'm glad I came back' 1943
oil on hardboard, 28 × 20 in.,
71·1 × 50·7 cm.
The Olive B. James Collection
of American Art, Arizona
State University, Tempe,
Arizona

206
Lake Garnet 1943
watercolour, signed, dated
and inscribed
Present ownership unknown

1942 were grim, but signs of victory over Nazism could be detected. However Grosz saw nothing of it, withdrawing into his own bitterness and the isolation of the lonely drinker. Throughout the war years he went on painting in the hope that he would find a solution. His daily life with his family and his friends was undisturbed. He had successes and failures. The Museum of Modern Art arranged a travelling show of his work in 1943. In April of that year the *New Yorker* published one of its famous 'Profiles' on George Grosz, a comprehensive and sensitive account which delighted him. Brecht tried to arrange an exhibition of Grosz's work in California, and had been very impressed by the exhibition in New York.[19]

Columbia Broadcasting System invited Grosz to contribute occasional illustrations for booklets.[20] Altogether, Grosz's mood and his material situation improved during 1943.[21] In December, Bernard Reis arranged for him a commission for illustrations.[22] He had to complete twenty-six drawings within three days for $1,000. For three days and nights he lived on black coffee; it was as in the old days. Grosz said that it was his best month in America, that he never had earned that much—the *New Yorker* profile had been good publicity—and he hoped that his luck would hold. His happiness stemmed from his activity; he was wanted, engaged and rushed. Like an actor, he needed a play to be in. In this happier mood even nature

appeared to Grosz to be happy. As a result of his new outlook he brought back from Lake Garnet a number of watercolours of a quite restful quality, but even there an evil grasshopper acts as the signature of Grosz as clearly as the formal signature (fig. 206).

Grosz's periods of relative contentment were interrupted by fresh outbreaks of despair. In a letter to Ben Hecht, he said 'sometimes I myself succumb to a senseless and utterly suicidal nihilism . . . Of course, I try to come back to a little idealism . . . I start to paint a nude . . . and all of a sudden there is fire and ruins and mud and grime, debris all over, as if somebody more knowing and utterly destructive were leading me on.'[23] Grosz felt pursued by a demon: the demon was Grosz himself. Having lost his sense of actuality, he was left with his demon, with himself alone.

The Ambassador of good will of 1943 (fig. 207) already foretells Grosz's final phase, and stands as an indictment of 'Man' in an allegory of universal madness. As this is an impossible assumption it cannot form a possible representation. Grosz's apocalyptic pictures, where he intended to express the spiritual situation of his own time, were bound to fail, not because of any artistic weakness on his part, but for historic reasons. It is an error to consider Fascism and war as an apocalypse, because they are historical

207
The Ambassador of good will
1943
oil on canvas, signed,
27 × 33 in., 68·5 × 83·8 cm.
The Metropolitan Museum of
Art, New York
George A. Hearn Fund

208
I, I was always present 1942
oil on canvas, signed and
inscribed, 36 × 28 in.,
91·4 × 71 cm.
Collection of Eva Ingersoll
Gatling, USA

events not supernatural ones. The holocaust is the result of policy decision, paper work, railway timetables, and an ideology preceding it. Grosz's misreading of history brought him to the point where he could 'symbolize' something which did not need symbolization but analysis. Instead of destroying the myth, he elevated the non-analysed events into symbolic art. By painting Hitler on a heap of skeletons, meant as an accusation, he makes him almost penitent, and so the picture becomes a form of absolution (fig. 155). The title, *Cain*, justified the evil with the respectability of an Old Testament pedigree. This flight from reality into a religious disguise obscured the truth about what was happening, thus his apocalyptic pictures were a retreat from reason. In admitting that, 'It is a medieval world to which I am drawn'[24] Grosz was making a faulty analogy between the Middle Ages and the twentieth century. Within an irrational world picture, an apocalypse was thinkable; within a rational world picture, it was unthinkable. Mass murder is not apocalyptic, it is a documented affair; the *Führerbriefe* and the Pentagon papers are evidence of its non-apocalyptic nature. Grosz's Horsemen, called *Rider of the Apocalypse*, or the oil, *I, I was always present* (fig. 208) are images not applicable to the twentieth century —not even the air cavalry would do.

The Survivor (fig. 209), which won a prize in the Carnegie exhibition in 1946, depicts a world not worth surviving in. Grosz's own comment on the picture: 'Grotesque, horrible reflection of Europe. It could also be called "The Rat Hunt" or "Before the Suicide" or "Murder", or only "Dirt", "Madness", "Hunger-fantasies". I got a cheque too, which heightens my spirits. I had once more begun to suffer from the fatal belief that one has been forgotten.'[25] Behind the despair, there loomed something even less reasonable and more destructive. In a very drunken letter to his old companion Rönnebeck, Grosz wrote: 'In America one gets more bored than in Europe. You too? We could found a little club—three of us—Huelsenbeck, you and me—the Three Vacuum Brothers . . . Statutes: we are not against

209
The Survivor 1944
oil on canvas, 31 × 39 in.,
78·8 × 99 cm.
Ralph E. Sandler, Madison, Wisconsin

boredom, also not against suicide, or drinking ourselves to death . . . let us together make the already existing boredom more boring . . . every member receives a beautifully stamped-out hole (in Tula Silver)—not a ring, but a hole . . . The hole symbolizes the Vacuum.'[26] This vacuum figures largely in Grosz's paintings to come. There are too many pictures with a hole to overlook their significance. *The Painter of the Hole (uprooted)* (fig. 210), is one picture amongst many. The content is the void—the message is boredom. There is nothing left to paint.

210
The Painter of the Hole
(uprooted), 1947–8
watercolour, $35\frac{1}{4} \times 27\frac{1}{4}$ in.,
89.6×69.3 cm.
Busch-Reisinger Museum,
Harvard University,
Cambridge, Massachusetts

11. After the war 1946-49

The war in Europe was over, and new decisions could be made. Many of Grosz's friends who had considered themselves as exiles hoped to return to Germany. Grosz never wanted to feel an exile, yet he had not totally convinced himself of his Americanism, though he hoped that his sons would become true Americans. Max Horkheimer tried to arrange for Grosz to do some anti-Nazi work in Germany after the surrender, but Grosz refused.[1] When peace came: 'We had a drink and toasted to the future—a brighter one . . . My mother died in one of those later air raids over Berlin . . . That was, maybe, the only tie which existed between me and Berlin or Germany. We survivors have to survive, and that's all. Surviving up to the next holocaust.'[2]

Since 1936 he had painted what he called 'topical pictures'.[3] 'Often, when in the evenings I walked along the Sound, it was like lightning on the horizon. Thus I began to paint my visions . . . I painted *A Piece of my world* (fig. 196), and there were already the ruins, the rats, and people like ants, in a trampled-down antheap. I painted the *Ambassador of goodwill*' (fig. 207). On *The Pit* (fig. 213), which was to be exhibited at the Carnegie Exhibition, Grosz commented: 'Hieronymus Bosch has a strange kinship with me—I did not know it. For instance, two otherwise disembodied hands encircle a woman's body . . . exactly as my symbol of the erotic in *The Pit*, but I had not seen the Hieronymus before. To me, the hand, which in *The Pit* touches the woman, was the hand of all men.'[4] Grosz believed that universal statements could be made, and that the artist could reveal a truth and be true to tradition, even beauty. 'I too try to create beauty, but every time the beautiful world collapses into rubble and horrifying human ruins.'[5] The painting does owe much to Bosch, but is also umistakably the work of the master who painted *Dedicated to Oskar Panizza* (fig. 64). The unity of his intention which had been preserved was the presentation of madness as eternally apocalyptic. 'Yes, I think I am, maybe, the only living artist who painted such pictures—and not abstracted them.'[6] 'I also painted a picture: *Peace* (fig. 211), a self-portrait coming out of ruins . . . The death of my mother touched me very much . . . I often saw the horrors and all-devouring fires on distant horizons. *Peace* is almost a requiem for my mother.'[7]

Grosz began a heroic effort of parcel-sending, buying and packings for members of his family and friends who were still alive in Berlin. For years to come, week in, week out, Grosz sent food and clothing, paper, canvas and paint to artists. This activity brought Grosz back to life and reality. At long last he had a function. From letters he heard terrible stories about the war and its aftermath; from Fiedler in Holland and from Davringhausen in Paris. Long-lost figures turned up again, and the hidden history of the previous twelve years unfolded before his eyes. Bob Bell turned up, and Grosz added him to his ever-growing list of parcel recipients and sent him brushes, paint and canvas.[8] Like an actor, Grosz had a profound loyalty to his trade and his colleagues. He felt with them as one of a band of outcasts, actors, or circus performers. But the oddest recipient of Grosz's generosity

211
Peace II 1946
oil on canvas, 47 × 33¼ in.,
119·3 × 88·5 cm.
Collection of the Whitney
Museum of American Art,
New York

212
Golden City 1946
oil on canvas, 24 × 15 in.,
60 × 38·1 cm.
Mr and Mrs W. A. W. Stewart
Jr, Palm Beach, Florida

was Professor Müller from Dresden, his former teacher at the Academy, who had been dismissed by the new authorities in Dresden for his Nazi past and, so the students claimed, for removing Grosz's work from the Academy walls. Undismayed, Grosz sent him cigarettes.

For Grosz 1946 was to be important. His largest exhibition at the American Artists Association was being planned and timed to coincide with the appearance of his long-delayed autobiography.[9] Among his new paintings were: '*I'm glad I came back*' (fig. 205), *The Last soldier* and *The Survivor* (fig. 209) where he had attempted to summarize the experience of a generation. He painted some factual and painterly pictures of the New York skyline. *Golden City* (fig. 212) has a fine feeling for mass and space; another version of the same theme, *Silver City*, is more atmospheric in treatment. In these

213
The Pit 1946
oil on canvas, $60\frac{1}{4} \times 37\frac{1}{4}$ in.
153×94.6 cm.
Wichita Art Museum,
Wichita, Kansas, Roland F
Murdock Collection

214

215

216

217

214

Grosz as clown and variety girl 1958
collage, signed, $12 \times 10\frac{3}{8}$ in.,
30·5 × 27 cm.
Estate of George Grosz

216

Woman in evening dress 1958
collage, signed, $13\frac{5}{8} \times 10$ in.,
34·6 × 25·4 cm.
Estate of George Grosz

215

Bericht Marc . . . in seinem Atelier
(report Marc . . . in his studio) 1958
collage, $11\frac{1}{2} \times 8\frac{1}{2}$ in.,
29·2 × 21·6 cm.
Estate of George Grosz

217

Frankfurter sausage 1958
collage, 13×10 in.,
33 × 25·4 cm.
Estate of George Grosz

paintings Grosz achieved a spatial organization for which he had aimed already in his simple townscapes from Cassis. Here the city itself gives the structure, which Grosz transforms into paintings without much theorizing and with no other intention than that of doing justice to the overwhelming visual impression.

When Pegeen Sullivan asked Grosz to suggest someone to write the introduction to the exhibition catalogue, he suggested Wieland Herzfelde, Myron Taylor of the Metropolitan Museum, George Biddle, James J. Sweeney, A. H. Barr Jr, Bert Brecht, Edmund Wilson, James Thurber and Edward James.[10] Grosz enumerated those whom he considered to be his main supporters. When it appeared in October 1946, the catalogue had a preface by Grosz, Herzfelde and Ben Hecht.[11] 'My opening was packed. I was photographed with Charles Laughton and Brecht . . . later only with Charles Laughton—as BB is not well enough known . . . I am doing all that only for money—had I been born under an elegant star (i.e. independent and rich) I wouldn't ever have gone into the funfair business [*Schaubudenbetrieb*].' Grosz was not only honest with himself, he was accurate.

Grosz had always suffered from what one might call the 'jackpot syndrome'. Though he was totally realistic about his needs—good food and drink and smart clothes—his unfulfilled ambitions were totally different. At heart he was a gambler for high stakes, but they never came his way. He dreamt of a huge fortune and huge fame. He suffered from the drawbacks of his milieu, seeing the power of wealth in dreamlike forms, and when he saw them realized by men of lesser ability his envy knew no bounds. It was not the Rockefellers he envied—they were rich—it was Remarque and Dali, artists who had hit the jackpot. That was the reason why in Stolp he had seen himself as an artist. Even in the days when he was successful, Grosz was always aware that he was a failure measured by his ambitions. This illusion is shared by criminals, whose faith in the jackpot is unlimited. But that road was not in Grosz's make-up; his honesty and decency, his inability to transcend the morals and aspirations of his milieu, prevented him. Grosz remained true to himself: the artist as clown, as entertainer and showman. He had always known that this was the role of the artist. He was playing the game as well as he could, but his heart was not in it any more.

His final word on aesthetics is a classic: 'Only a sold picture is beautiful.'[12] In exactly the same spirit he wrote to his sister Martha about his forthcoming autobiography, 'I am not a writer, and would never have written it if I did not need the goddam money.'[13]

It hurt him very deeply that his new work was not received with the same enthusiasm as the work he had done in the past. He valued all the more the positive comments he did receive. Willy Wolfradt, who already in 1921 had written a small book on Grosz, now wrote to him: 'The hour I spent in front of your pictures, was the first hour over here which made sense to me . . . I am shaken by the consequences of . . . your work, and of the marvellous painterly progress!'[14] Grosz's reply to Wolfradt is a briefer and more honest apologia for his life than his published autobiography. 'Your words give me approval and encouragement . . . you are one of the first who has written about me . . . I am happy not to have disappointed you. . . . I have always remained fundamentally the same. I was terribly embittered then, and did not want to know my past. If they only knew what it means for an artist,

here in Manhattan, to start afresh. My trials came also from within. I turned to nature, that gave me peace as far as I could find peace, because the old Europe was very much in me. I was very lonely.'[15]

During the last month of the year, the house which Grosz liked and where the family had been living ever since they had settled down was sold to Claudio Arrau, the pianist. Grosz had to find a new home. He found it in Huntington,[16] the coach house of a large elegant estate belonging to a friend of his. With so many contacts in Germany re-established, and the exchange of letters and ideas with old friends, Grosz seemed to live more in the present. His activities were again more directly concerned with life and with people. But possibly this fact made him even more aware of his loneliness and his deep unhappiness. He had lived through the war and had been in America for nearly fifteen years, difficult years, not only for him. A perceptive comment comes from Schmalhausen who had survived in Berlin: 'I have asked myself often—why is he so unhappy? Why has he not found harmony in the States? I can read from your pictures the disharmony [Zwiespalt] of your work.'[17] The truth, which Schmalhausen suspected, was that Grosz was disappointed with America, that is with his own failure to establish himself as a power in the land. His dream of America and his dream of himself were not working out. It was not his fault alone; there were many concessions he had not made—for he did not aim to please—he became neither a slick illustrator nor a phoney modern artist. His comments on the fashionable art of the day are scathing and precise. For all his professed desire for money, he did not debase himself to get it, and had no admiration for saleable art. He was temperamentally not a conformist, and his sense of absurdity was too profound to accept the going assumptions.

In earlier years Grosz had made a fantastic collection of absurd postcards: all the trash, Kitsch, jokes, involuntary surrealism, proto-Dada, and the outpourings of the naive mind, attracted him. He acquired military, erotic, sentimental absurdities wherever he could find them—in postcards souvenirs, and advertisements.[18] Now he started to amass a collection of idiot books.[19] Grosz's predilection is shown in a list of titles which he ordered from a bookshop in Girard, Kansas. A brief selection: *Secret of Self Development, How to Improve Your Conversation, Zoology Selftaught, Hypnotism Made Plain, How to Cane and Upholster Chairs, Facts to Know about Palmistry, Ventriloquism Selftaught, How to Throw a Party, How to Psychoanalyse Your Neighbours, Sideshow Tricks Explained, Wine Women and Song, The Magic of Numbers, Reincarnation Explained, Facing Life Fearlessly.* Altogether, eighty titles were ordered, but among them were Pepys's *Diary,* Kant and Chekov. In a letter to Zingler he said: 'I have read far too much in my life. *Bildung* (education) leads to more *Bildung,* and more *Bildung* leads nowhere.'[20]

The sardonic humour of his idiot book collection coincided with a new and bleak departure in his painting. A long series of pictures with a hole was Grosz's description of emptiness and boredom. He had talked about the hole as the symbol of Nothingness, and now he wanted to make the invisible visible—he made the hole for Nothingness a concrete statement. One picture is called *The Poet of the Hole,* another *The Musician of the Hole,* and a third *Painter of the Hole.* 'They consist of thin lines, which give no shadow. Grey in grey their standard, as the Romans called it, it is a

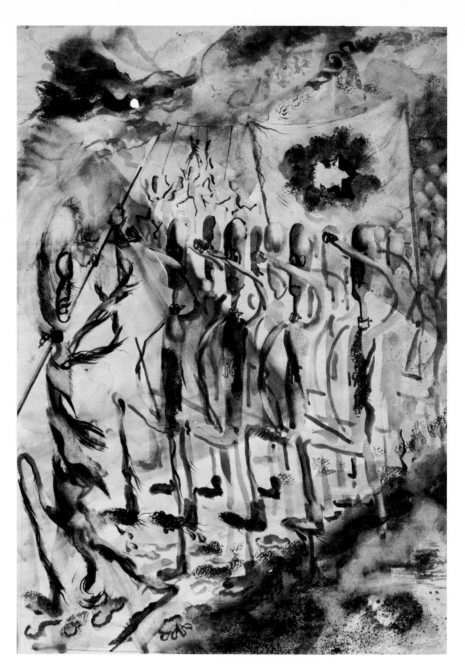

218
The Bataillon of the hole c. 1947
watercolour
Present ownership unknown

real tattered canvas hole—Fantastic! The painter has hundreds more such hole-like sketches (he is, he remembers, also interested in beauty), for instance the fine, superfine gradations of grey—everything is grey there, "the rats".'[21] This then is Grosz's own description of the pictures of the Hole—representing in his work a not unexpected, yet new and logical conclusion. *The Bataillon of the hole* (fig. 218) is Grosz's comment of utter despair with marching crowds, behind a flag, saluting a void, disembodied madmen or robots. *Waving the flag* (fig. 219), is another comment by Grosz on any form of hope. He developed what might be called the 'frazzled form'

—this is not a clear and precise form, nor is it an ambiguous form which contains several meanings, nor is it the deliberately broken form of a destructive-constructive intention. The frazzled form is not only frazzled on the edges where it is uncertain about itself, it is similar to a frazzled sentence, a statement which dissipates its strength by being uncertain of its content and relation. Over and above the technical problems is the strictly mental problem of control. It appears as the outcome of a fuddled, hazy mind, unable to place firmly what is only vaguely perceived. His philosophy had become that of the void. A philosophy has a material home, and that material home is the man who holds it. George Grosz's condition as an alcoholic at this stage of his life could explain the forms and even the content. It was his physical and psychological inability to grasp the form and the meaning. The literary, painterly description of an actual Hole is not a possible artistic solution, even for a nihilistic view of man.

The year 1948 was difficult for Grosz. He wrote, 'It is as if the seven plagues of Egypt had hit us.'[22] Eva was suffering from an illness, due to high blood pressure, affecting her eyes. Her state was very depressing for

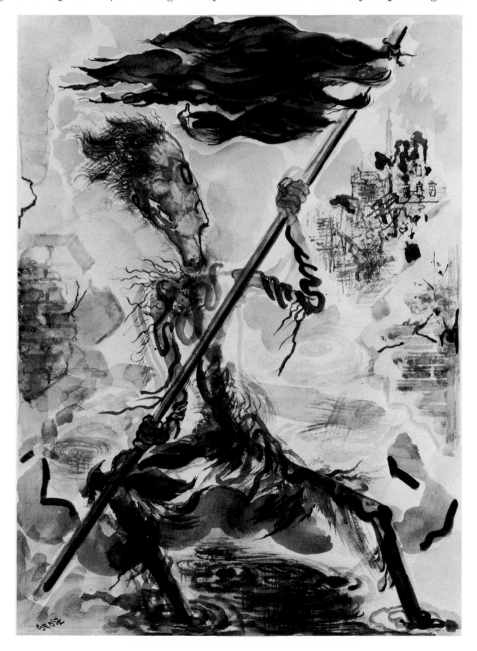

219
Waving the flag 1947–8
watercolour, signed,
25 × 18 in., 63·5 × 45·8 cm.
The Whitney Museum of
American Art, New York

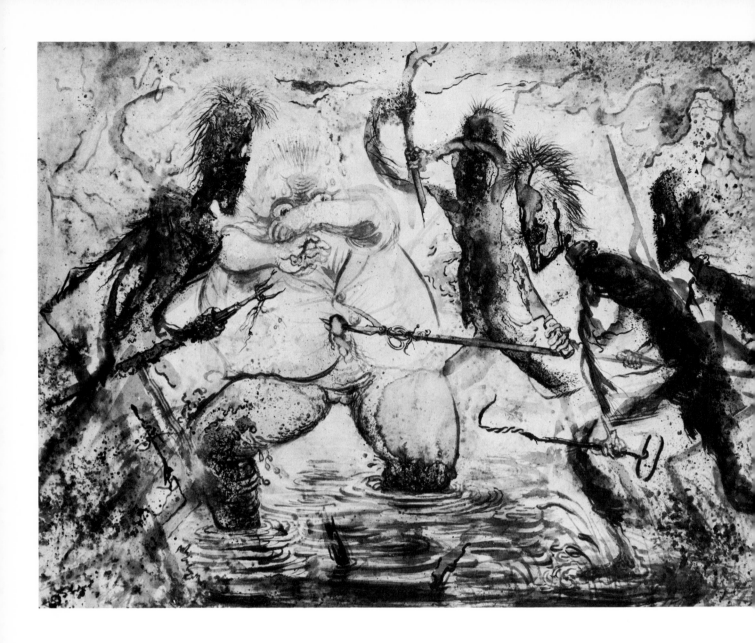

220
Attacked by stickmen c. 1947
watercolour, signed,
18×23 in., $45 \cdot 8 \times 58 \cdot 4$ cm.
Private collection, USA

both. Financially he was very badly off. After having saved a little, the removal and alterations and doctor's bills had eaten into his savings. Since the previous year he had sold nothing. 'I am world famous—but I am a king without a country.' Neither his more beautiful nor his more hellish pictures sold. He wrote that his watercolour show, of a series he called 'The Stickmen', had a critical success, but no sales.[23] *Attacked by stickmen* (fig. 220) is of that series. *Homeward*, an oil of 1947 (fig. 221), proves that even in his most nihilistic phase, when even line escaped him, he could compose a very powerful image of reality, the reality of millions in Europe.

A new problem now presented itself to Grosz. Should he return to Germany? Professor H. Ehmsen wrote from the Hochschule für Bildende Künste an official letter enquiring from Grosz if he would accept a professor-

ship at the Berlin Art School.[24] Many young students and the faculty had asked for Grosz as a teacher. The offer was most generous; he could reside abroad, teaching only one Masterclass, and be appointed full professor. Professor Ehmsen stressed that Grosz could be certain of the love and admiration of the young people of Germany. The thought of going back reminded Grosz of the undocumented history of his life, and he now revealed what had never been mentioned before.[25] 'If I had listened to certain letters of 1934, when everyone was enthusiastically for Hitler, then I would be a different failure today—a German failure, not an American one. Still, I prefer to be poor and a failure over here, than a failure and poor over there.' In answer to Uli Becher's suggestion that Grosz should return to Germany, he used almost the same words: 'I have been a failure since I came to the USA. I am not a deserter; I stick with my failure,' but adds 'I am lying to myself whilst telling the truth.'[26]

221
Homeward 1947
oil on canvas, $31\frac{1}{2} \times 39\frac{1}{2}$ in.,
$80 \times 100 \cdot 3$ cm.
Private collection

Having invested his moral capital in America and received no dividends, he had neither the strength nor the faith to return to Germany. He saw it as the final and total admission of defeat, in contrast to his political friends who saw their return as a victory. He was not a refugee, nor one of the 'better Germans'; he was, in his own words, by now an American failure. He wrote to Weil: 'Never before have I known such frustration, working in total emptiness.'[27] He went on to confess that often at night he considered making an end of it all, never to wake up again. This lowest point of his despair was linked to a full realization of his position as an artist. 'My attempts in painting were modest—too literary, branded in Paris, New York, Tokyo (I am world famous) as a satirical illustrator. *They* do not expect a new *Grosz*.'[28] Grosz was in the position of the comedian who would have much preferred to have played Hamlet—it is a well-known syndrome. 'I have wanted it thus—and I am (somewhat discontentedly) content with what I have wrought. Here I am, a poor guy—that is the simple grey truth. All else are debts, clowneries, confidence tricks and *savoir vivre* (*Lebenskunst*). I live like a freebooter—I act the famous artist —but behind that fame there is a big hole.'[29] This straight and honest statement is proof of his tenderness and realism.

In Germany the once banned and defamed artists and their works were enjoying a renaissance. Maybe their reception was somewhat artificial, hectic and guilt-ridden. Grosz's work, too, was acquired or reacquired by public collections, and demands for reproduction rights and reissues were frequently addressed to him.[30]

The 'Stickmen' pictures were to Grosz an equivalent for the experiences of the concentration camps. Reading *Der Totenwald* by Ernst Wiechert, on his experience in Buchenwald, and Hermann Kasak's *Die Stadt hinter dem Strom*, he wrote 'many chapters have a striking similarity to my prophetic stickman pictures'.[31] This, then, is the way in which Grosz identified himself with the gruesome events which had happened, and of which he was emotionally and imaginatively aware. He attempted to generalize a deep suffering of humanity in a shorthand allegory. 'I am a "stickman" myself by now. . . . One always somehow paints oneself, even in a bit of landscape or a washed-up tree trunk, or a bleached-out plank of a once proud ship.'[32] He recognized clearly the question of allegory. 'Warfare is very difficult to render in paint. The same with modern machinery. An auto is not an angel.'[33] Grosz understood why allegory did not work. One could paint angels because they do not exist, they were only imagined, but a car exists and is its own allegory. Grosz now reflected, and realized the true reason for the impossibility of allegory within a rational world picture. But he went further in understanding the function of art when he said: 'Motion pictures and photographs do in general a much better war.'[34] He knew much more than he could paint; he even knew that it could not be painted. He proved to himself that Art was dead. Throughout his life he was the Grosz who had written *Die Kunst ist in Gefahr* in the early twenties. 'A car, as I have said, is not an angel. The discontent in culture is enormous. Can one present a worldly-social Utopia in Pictures, similar to the visions of the Middle Ages?'[35] Here Grosz asked the fundamental question of the artist: can moral concerns still be represented? Grosz had remained the great moralist, and had not lost his understanding of the futility of formalist art. He was

thus caught between the two extremes of his own understanding—that art should be moral, and that morals cannot be formed into art; that the aesthetic art market is a swindle. Grosz was very aware of the dilemma of art. 'It is difficult to see a way out of the prevailing chaos—all schools are dissolving. It is a total liberation from all conventions and rules.'[36] In a phase of non-normative aesthetics, Grosz felt lost because he was not the megalomaniac individualist he thought he was. He could not draw the consequences of his own, often proclaimed, freedom; he remained a moralist.

Grosz had not changed his views. Even his first motivation for becoming an artist—as an escape route from poverty—he also remembered. 'We live in comfort, always on the edge of bankruptcy, but with wine, good food, Havannas, etc. I grew up in an officers' mess. These are determining impressions of my youth—champagne corks have to pop—and it has remained so.'[37]

The relation of art to its public had been one of his concerns throughout life. He was still very modern. In fact, he was ahead of his time in some respects, such as in thinking that reproductions were then so perfect that nobody needed originals; they looked so much better than the real thing.[38] 'The magic of this country you will never understand. Sometimes one finds it on the label of a tin, or in a still life. The product of the machine has a greater power of seduction than elsewhere.'[39] This is not the voice of the past, it is the voice of the immediate future. This one observation contains the possibility and relevance of Pop Art—the machine product being elevated to art—the modern still life in the form of a tin, the interrelationship of the product and its image. Once more Grosz's analytical mind and eye are ahead of his moment in time, but he did not then dream of turning this knowledge into pictures. And when he eventually did, he did not recognize it himself. The link between old Dada and new Dada could have been made by Grosz himself, but he said in the same letter 'my clock stopped in 1932'.[40]

12. The Bitter End 1950-59

In 1950 Grosz considered visiting Germany, but hesitated because he thought that once there he would be dragged into the arena of public debate.[1] He was very conscious of the continuing debate on his own role, as he had to live with his past and his present much more than most artists. 'My own deeds and achievements of the past I view critically, and often (almost masochistically one might say) condemn and reject them.'[2] And yet he was proud of them. 'My drawings will naturally stay true— they are fireproof. They will later be seen as Goya's work. They are not documents of the class struggle, but eternally living documents of human stupidity and brutality.'[3] This he had known for the last twenty years. In Germany the work of the early Grosz was coming to life again.

As always, Grosz was concerned with the function of art. His logic drove him to consider that painting may altogether have been superseded. 'Painting has become enormously dull. Film and photography are so much more interesting and mysterious.' He went to see every important exhibition, and did not like what he saw, nor did he like the racket. 'Here, art, at long last, has become merchandise. Wonderful!'[4] With this inexorable logic, Grosz confirmed what he already knew in 1920.

In fact, Grosz was returning to the political arena, but as a lonely outsider trying to come to terms with the content of the mass media. He proclaimed himself 'an interested student of ordinary human stupidity'.[5] He analysed what Roland Barthes has called the 'Mythologies' of popular imagery: 'lobsters on ice—how the rich live, and how the little man can share the pleasures in colour reproductions'. Grosz showed himself aware of the theory of the ideology of art as a myth-making enterprise. He had practised 'de-mystification' long before the term became part of the political vocabulary, only now he had given up his faith in de-mystification, believing that the power of money and advertising, plus the stupidity and gullibility of the masses, would win over his own work, as they had done in the past. Knowing the reasons for this defeat he believed that his own efforts had been doomed from the start.

He had always been interested in the effectiveness of his own work, and many of the arguments with his communist friends had centred around the

question of 'Art and the Masses'. He reminded Wieland of the 'ridiculous, scholastic disputes (*Pfaffenstreitigkeiten*) of RAPP',[6] maintaining that 'for proletarians optimistic cinema and photography is best'. In a letter to Brecht[7] he had written, 'for the stupid masses no Brecht, Grosz or Heartfield is needed'. It was not easy for him to find work in which he could believe. His faith in propaganda had gone long ago, and his faith in art as such had never been great. The most devastating realization came to him through his visionary clarity about his own work. 'Much is buried in my pictures, beneath the colour and the debris.'[8] This is a true but terrible sentence, from an artist who knew what he wanted to say but realized that it could not be seen. It is a rare form of perception to see one's own work and recognize it as unrecognizable. There are few painters whose self-knowledge allows them to see that the results have eliminated the idea, but the price to be paid is that such a degree of critical knowledge is the most destructive form of knowledge. This sentence was his own funeral oration as an artist.

During May 1951 his eldest son, Peter, married. Grosz had always been an exceptionally good father and a most faithful husband. He had all the virtues of a solid citizen; ambitious for his sons, wanting nothing more than an established family and a happy contented life. Having inherited some money ('peanuts' he said), he had enough to spare to go to Europe, maybe for a whole year.[9] He went to France, Italy, Switzerland, Austria and Holland, visiting old friends. Of course, he also went to Germany and recalled: 'It was dreamlike sometimes, and strange too, seeing one's own country . . . after so long a time. . . . Nothing much left of old memories . . . after a visit to Berlin I fled.'[10] By December he was back at home, and all the younger members of the family came for Christmas visits: Peter and his wife Lilian, Justus, Schmalhausen's son, and Martin, his younger son.[11]

After his trip he expressed the hope to make enough money in half a year in America to spend the other half in Europe. Grosz had an art class at home with about twenty pupils, paying quite well, and improving his financial stability, and with it his contentment. During the summer of 1952 the house he had rented was up for sale. He either had to buy it or leave. He decided to stay, and bought the property and rebuilt it to his own liking. 'The house looks nice, and my studio very fine. The first *real* studio I have had after nineteen years.'[12]

It was altogether not an unhappy period. In 1952 he was invited to visit Dallas, where he had obtained a commission to paint pictures of the city from Leon Harris, the owner of a department store. 'Dallas, its People, its Industries, its Character' were the terms of reference given to him. This was work with a purpose, which Grosz enjoyed. At long last he could paint America as he saw it. In style, his work went back to his first impressions of the United States, to his New York subjects. *A Dallas Night*, a watercolour (fig. 223), is lively and factual. The study of heads, *A glimpse into the negro section of Dallas*, also watercolour (fig. 222), is a cool observation painted with sympathy. Both pictures owe something to the cinematic view, which was not a new discovery for Grosz. They are *shots*, much more than compositions, and all the more successful for that. Other watercolours Grosz composes very deliberately. There is a hint of the symbol in the treatment which makes them more akin to American magazine illustration of the

222
*A glimpse into the Negro
section of Dallas* 1952
watercolour, signed
$24\frac{3}{8} \times 16\frac{7}{8}$ in., $61 \cdot 9 \times 42 \cdot 8$ cm.
Museum of Fine Art,
Foundation for the Arts
collection, Anonymous gift,
Dallas, Texas

Fortune variety, than to his own manner. But the most unexpected painting
in the 'Impression of Dallas' series is *Cotton harvest* (fig. 224), a tribute to
Millet, from whose work the spirit and the treatment has been borrowed.
It is an honest transference of Millet's compassionate concern with peasant
labour to the American South, and, like Millet's work, Grosz's picture is
more of an apotheosis than an accusation.

In Princeton, Lilian arranged an exhibition which was visited by Pro-
fessor Einstein, to whom, no doubt, Grosz was a well-known figure from
his own earlier years. His old self and his new one were briefly united.
While Grosz was re-reading Panizza's *Visionen der Dämmerung*, one of his
old pictures turned up at the Museum of Modern Art. It had been stolen
from his deposit in Germany, but he was powerless to regain the work.

223 (*opposite*)
Dallas Night 1952
watercolour, signed
$21 \times 13\frac{3}{4}$ in., $53 \cdot 3 \times 34 \cdot 9$ cm.
Museum of Fine Art,
Foundation for the Arts
collection, Anonymous gift,
Dallas, Texas

Another earlier picture (one of the versions of *John, the little murderer*) was in Grosz's studio. The Whitney Museum was planning a large one-man show, and Grosz viewed the world with renewed interest. He had, in those last better years, taken a fresh interest in the contemporary political situation and in his own work of former days: 'Don't think that I am aloof. Part of a once familiar world remains interesting to know.'[13] 'Would you make a parcel of my best drawings,' he asked Schmalhausen, 'also smaller oils—please tell me what there is left.'[14] Standing between his two worlds Grosz said, 'I have been living here for nearly twenty years, and the country is still a riddle because it has not found a form.'[15] That is one way of stating his truth, but not only had America not found a form, Grosz had not found a form for America. In January 1954 his exhibition at the Whitney was opened. It was an honour, but not a success. Sales amounted to $3,500, and he wrote 'that as a receipt of a lifetime's work. I am truly disappointed.'[16] Grosz was made a life member of the American Academy. 'Now such "honours" come a bit too late. I am not a cynic, but I can't appreciate such things as much as I could have twenty years ago maybe.'[17]

The last few years of Grosz's life were not very productive. What depressed him most was the state of contemporary art. He dismissed nearly everyone as a charlatan, and had no intention of competing. He did four anti-Russian cartoons for *Life*—'it's a sort of comeback', he thought,[18] but it was only a comedown.

In May 1954 his wife went to Germany and Grosz followed somewhat later. There he received a commission for book illustrations[19] and did theatre work for Ernst Aufricht—sketches for the curtain, costumes and figurines for *Bilderbogen aus Amerika*. Three pictures by Grosz were used as backdrops for the performance of a piece by Brecht in New York, whilst at the same time the Whitney Museum acquired new works from him. Two watercolours of 1954–5 are of more than stylistic importance. Stylistically, *The Bert Brecht story* (fig. 225) links all of Grosz's own modes of drawing in one picture. In spite of what he had said about his work, this draws its inspiration from the class struggle. In *The Hemingway story* (fig. 226) Grosz stays with his loosest but most expressive manner of brush drawing. Less documentary than the Brecht picture, it has its own form of penetration and expression.

During his long stay in Germany most of Grosz's time was taken up by the preparation of *Ein grosses Nein and ein kleines Ja*, the German edition of his autobiography. The German version was slightly modified. The editor was Willy Wolfradt of former days. Grosz was astonished to discover how much interest his work aroused in Germany, and was very touched by the reception of the Kultur Senator in Berlin. Grosz would have liked to have seen the Whitney Museum exhibition shown also in Germany: 'It is a pity that such a fine show should be dissolved without going abroad.'[20] He would have been happy if his American work had been shown in Germany, thus demonstrating the unity of his achievement. 'The second *Wiedersehen* with Germany', he described as 'uncanny, a *déja vu*. . . . The Germans have not become more beautiful—black gloves over wooden arms . . . and the people opposite you—one man who finishes his eighth glass of beer—he was a parachutist. Two others were in Stalingrad. Someone told of shooting Alpinis on the retreat from Italy.'[21] The songs, the folklore, frightened him,

224
Cotton harvest, Dallas 1952
oil on canvas, signed
38⅜ × 29¼ in., 97·5 × 74·3 cm.
Museum of Fine Art,
Foundation for the Arts
collection. Anonymous gift,
Dallas. Texas

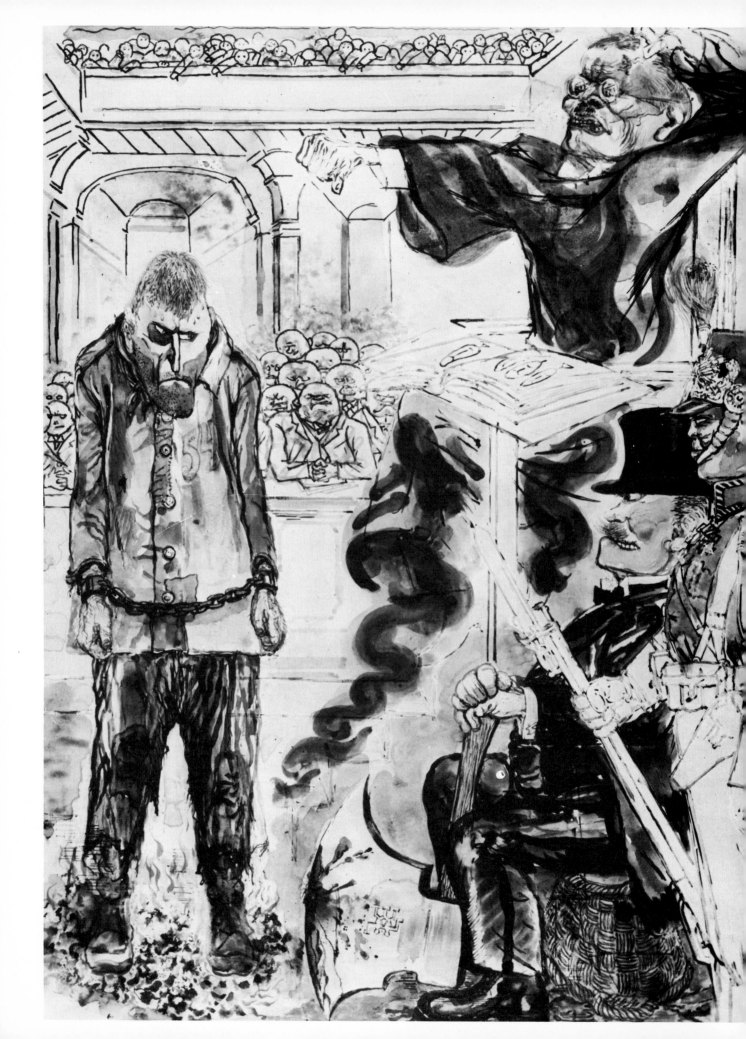

like Hackbart's Wine Restaurant in Stolp in 1908. For the film *I am a camera* Grosz did what he described as 'filmdecor'. One of his sketches of 1954, *High life at a Berlin party, 1930* (fig. 227), is illustrated. Grosz went to London to work on the film during October and November.[22]

Back in the United States, during the height of the McCarthy period, Grosz was investigated by the FBI. His answers are preserved, in the form of memoranda to his lawyer (McCormack). He acknowledged his membership of the German Communist Party, which he claimed he left in 1923 after his visit to Russia. He acknowledged that his work had appeared in *Die Rote Fahne*, but went on to state that 'many of my bitter satirical drawings were not exactly illustrations of party slogans . . . often pirated from my portfolios—the pirates just changed the captions'.[23] This statement conflicts with his earlier assertions that he had not been used or misled, though in a letter to Piscator he wrote in a mock-serious tone: 'But in my young days I fell in with bad company. I now have to live out the perversity (*Verkehrtheit*) of my fate.'[24] Answering the FBI question on his American contacts he stated that he never had any connections with the Communist Party of America, or with the American Labour Party, or with any other group or organization. 'Since coming to the United States, I have not made any drawings of a political character and have rejected all invitations to do so.'[25] This we know to be the case, but unfortunately he was proud of it.

225 (*opposite*)
The Bert Brecht story 1954–5
watercolour, 22½ × 17 in.,
57·1 × 43·2 cm.
Private collection, USA

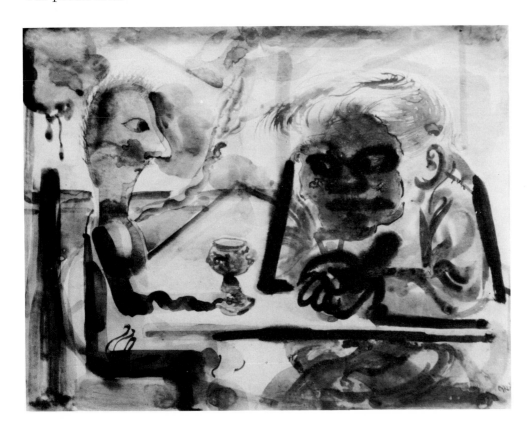

226
The Hemingway story 1954–5
watercolour, signed,
15 × 19 in., 38·1 × 48·2 cm.
Mr and Mrs Ben Kimelman,
Great Neck, New York

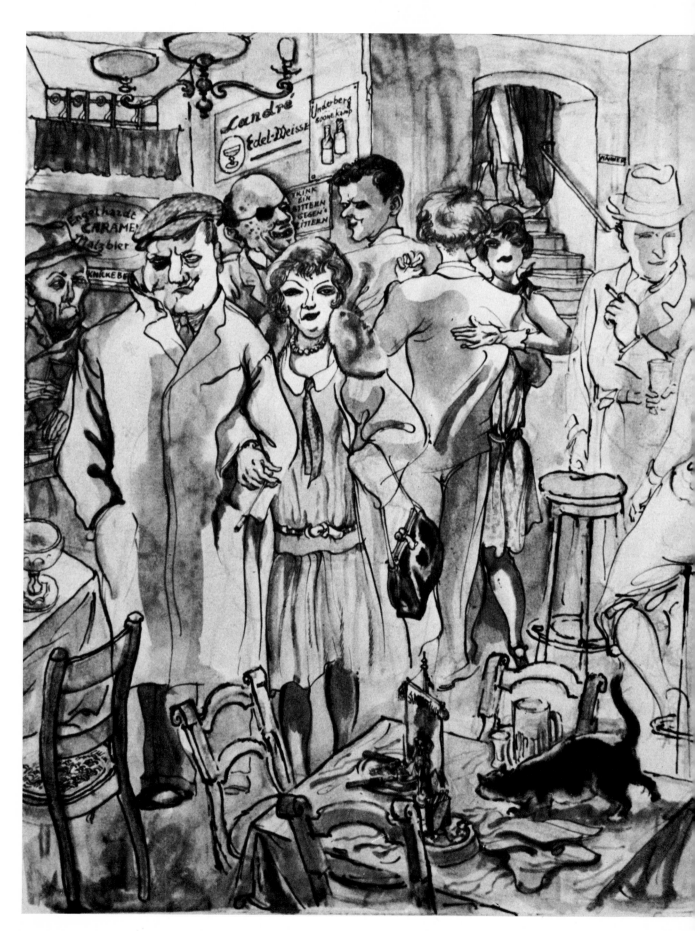

Early in 1955, after a few years of greater activity and some success, borne with resignation, Grosz again fell into despair. 'I hardly do any work. . . . I worry too much about art and artists, and present-day painting makes me unquiet, unsure, sad and unbelieving. In dark labyrinthine hours, I fight the demon alcohol. . . . I did not drink for pleasure, but suicidally to get away from myself, but I just couldn't get rid of myself.[26] I see art only as a by-product of life. To me, as an old inveterate Dadaist, I as a "Vorbeidada" (has-been Dada) do not overrate art—I have no prejudices.'[27] In a letter to Herbert Fiedler,[28] he described himself as an aged and outmoded artist. On 6 April 1958 Eva wrote to Wieland Herzfelde: 'You probably know that I am the one who is pushing for our return to Germany. Here everything has outlived itself. George worries me greatly —the only thing you can rely on are his two days' teaching at the Art League. The four days of the weekend are painful; he drinks constantly, acts accordingly and does no work. With all that he is physically very well. It is a great pity to watch the decline of a great artist.' Eva, who had not been well, was glad to get away, and spent the best part of the year in Germany.

Whilst Eva was in Germany Grosz wrote to her, 'I am beginning to work again, like Thomas Mann on *Felix Krull*. I am working up some old sketches, am also doing Collage.'[29] These collages have only recently come to light. There, in one brief moment, Grosz discovered Pop, and with great brilliance invented a range of images which do not qualify him as a 'Vorbeidada', but as an 'avant-gardist'. Grosz could not possibly have been serious about Dada, which he, better than anyone else, knew never had been serious. Nor could Grosz take the pretences of modern artists seriously, so his collages were to him one more good joke against himself. 'Whatever Dada has been, it was . . . alive once in the twenties, but alive more as a nihilistic and often practical joke. The few months which were given to the movement were quite amusing . . . but rehashed?'[30] The four collages in figs. 214–7 are real inventions, where his art achieves a metamorphosis of images, where in the juxtaposition of elements new visual ideas arise. There is no moral aim; it is the old Grosz who loved freaks and idiot books, and Kitsch, and who proclaimed that if he believed in the art trade, he could have produced the merchandise as well as the next man. When Grosz heard that one of his autograph letters had fetched 160 Swiss francs at an auction in Berne,[31] he wrote to Eva: 'Keep all my letters',[32] and went on to report that he was making more collages, enjoyed doing them, and refused to go to a sanatorium.

In August 1958 Grosz flew back to Berlin to see his wife. Uli Becher suggested to Grosz that he should return to Germany for a year and draw 'New Germany', the Americanized Germany, or fifty years of Germany 1910–60.[33] It was a well-meant suggestion, inducing Grosz to link his past and his present in an active form. When Grosz saw a colour reproduction of his own *Panizza* (fig. 64) in a catalogue of the Museum of Modern Art, he told Schmalhausen 'I liked it.'[34] He acquired one of his own early pictures. 'The picture I bought back is a very beautiful one of the same period I painted my famous *Panizza*. It is in my studio now—it sparkles like fireworks. It has a Futuristic influence, but at the same time it has a certain gothic glow, a kind of penetrating quality.'[35] The National Gallery

227
*High life at a Berlin party in
1930* 1954
watercolour, with ink and
charcoal drawing, signed,
(for *I am a Camera*)
19¼ × 15¼ in., 49 × 39 cm.
Arnold Saltzmann, New York

249

in West Berlin had just acquired *Pillars of society* (fig. 136).[36] Grosz's old work began to make him an 'Old Master' in his lifetime. The Akademie der Künste in West Berlin, at an extraordinary meeting of the Visual Arts section, elected George Grosz a full member of the Academy, on 24 November 1958. The Academy in Berlin offered Grosz a studio.[37] He wrote to his sister, Martha: 'I have been elected a member of the Berlin Academy (too late). *We want to return to Germany*, sell everything here.'[38]

In February 1958 he made his will.[39] To Bernard Reis, his lawyer and friend, he sent his last income tax papers for advice. 'Moving out after almost twenty-five years.'[40] 'Even my American dream turned out to be a soap bubble—it was a very pretty, iridescent one.'[41] On 15 January 1959 the National Institute of Arts and Letters awarded Grosz a Gold Medal, and on 20 May he was able to attend the ceremonial of the American Academy of Arts and Letters and the National Institute of Arts and Letters for the presentation of the 'Gold Medal for Graphic Art'. This was Grosz's last public appearance on the American stage. He closed his file at the Social Security, New York: 'I am retiring.'[42] On 29 May he sailed back to Germany. His two sons remained in America, having become Americans—that part of Grosz's dream had come true. For a short while George Grosz and Eva lived in Berlin with their relatives, looking for a place of their own. On 6 July George Grosz came home in the early hours of the morning. He had been out with old friends, who saw him to the house because he was not very steady on his feet. They led him into the entrance hall and left. Grosz mistook a door, and fell down the cellar steps, where he was found still breathing in the morning. Help was called, but it came too late. His end was like a tragic scene from his own work.

Biographical photographs

i. Grosz at home, Berlin 1920

ii. Grosz at home before his marriage, Berlin 1920

iii. George Grosz in 1921

i

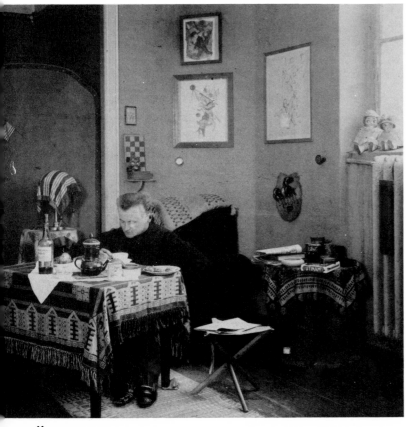

ii

iii

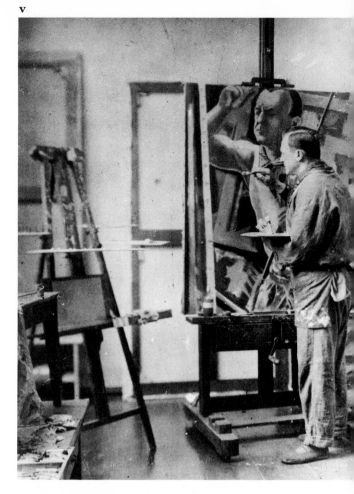

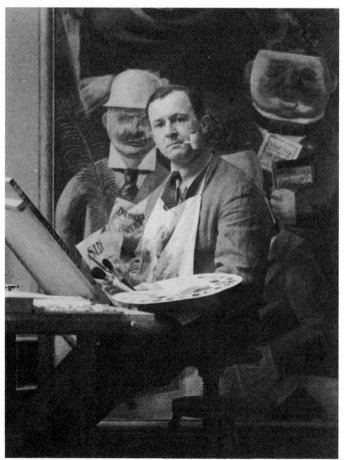

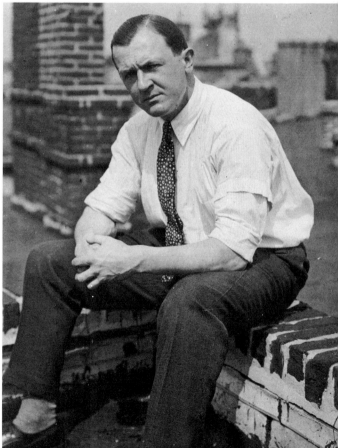

iv. George Grosz at home, Berlin 1920

v. In his studio with a self portrait, Berlin 1930

vi. In his studio with *Pillars of Society*, Berlin 1926

vii. Grosz in New York, 1932

viii. Grosz painting *Cain*, Douglaston, Long Island, 1944

ix. At Martha's Vineyard, 1949. Photo Marc Sandler

x. Grosz in America, 1949

viii

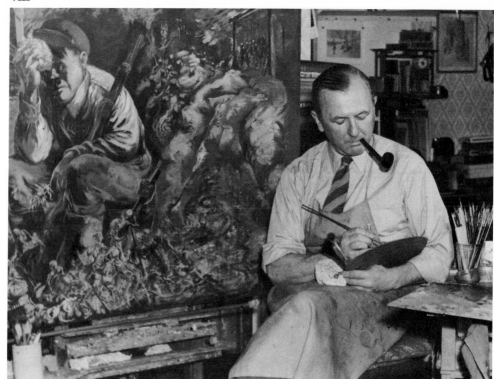

x

Notes

Translations are by the author. All material is unpublished except where stated.

1. *Growing up in Stolp (pp. 9–13)*

1. Letter to his sister Cläre Steiner, 23 February 1974.
2. 'Erinnerungen', typescript notes by G. Grosz for autobiographical article for: *Das Kunstblatt* vol. 13, 1929, in the Grosz Archives, Princeton, New Jersey. Unless otherwise stated, the information for this chapter has been drawn from these notes, pp. 2, 3, 43, 45–6.
3. Letter to Otto Schmalhausen, 23 January 1947.
4. Letter to Ulf Wilke, 'achter monday 1945', in English, (probably January).
5. Letter to Herbert Fiedler, 18 February 1937.
6. Letter to Arnold Rönnebeck, December 1943.
7. George Grosz *Ein kleines Ja und ein grosses Nein*, Rowohlt Verlag, Hamburg 1955. (The German edition of George Grosz's autobiography has been used throughout in preference to the American: *A Little Yes and a Big No: The Autobiography of George Grosz* The Dial Press, New York 1946, as the German text is fuller.) See chapter 2.
8. Letter to Otto Schmalhausen, 2–5 March 1954.
9. Letter to Hans Borchardt, 10 March 1943.
10. George Grosz: op. cit., p. 26.
11. ibid., see pp. 26, 27, for this and preceding paragraph.

2. *At the Academy of Dresden (pp. 14–19)*

1. For this and the preceding paragraphs, see George Grosz: *Ein kleines Ja und ein grosses Nein*, pp. 54, 56, 58, 59, 66.
2. Letter to Otto Schmalhausen, 2 June 1947.
3. Letter to Bob Bell, 17 September 1931.
4. 'Erinnerungen', typescript notes by G. Grosz for autobiographical article for: *Das Kunstblatt*, vol. 13, 1929, in the Grosz Archives, Princeton, New Jersey. Unless otherwise stated, the information for this chapter has been drawn from these notes, pp. 30, 39.
5. For this and the two preceding paragraphs, see *Ein kleines Ja und ein grosses Nein* pp. 68–9, 86.
6. For the preceding passage see ibid. pp. 73, 75–6.
7. Letter to Hans Borchardt, 10 March 1943.

3. *In Berlin before the war (pp. 20–45)*

1. See George Grosz: *Ein kleines Ja und ein grosses Nein*, pp. 88, 94, 95, 97.
2. For this and the preceding passage see ibid., pp. 94–5.
3. ibid., p. 86.
4. ibid., p. 97.
5. 8 January 1956.
6. See *Ein kleines Ja und ein grosses Nein* p. 98.
7. 24 May 1913, from Thorn.
8. To Bob Bell, 13 July 1913.
9. ibid.
10. *Ein kleines Ja und ein grosses Nein* p. 100.
11. Letter to Herbert Fiedler, 2 March 1946.
12. Letter 18 February 1936.
13. Letter to Herbert Fiedler, December 1938.
14. Letter to Herbert Fiedler, 11 March 1946.

4. *Against the war (pp. 46–80)*

1. Letter to Uli Becher, 6 February 1945.
2. Wieland Herzfelde and George Grosz, *Die Kunst ist in Gefahr* Berlin 1925, p. 19.
3. See letter to Otto Schmalhausen, 15 March 1917.
4. Letter to Bob Bell, dated 'Grosz 1915' (probably May).
5. Wieland Herzfelde 'The Curious Merchant from Holland', *Harper's Magazine* Vol. 187, November 1943, pp. 569–76.
6. Letter to Bob Bell, dated: 'Ausgang September 1915' (end of September).
7. ibid.
8. ibid.
9. ibid.
10. ibid.
11. To Bob Bell, undated, postmark: 28.6.1915.

12. ibid.
13. ibid.
14. Letter to Bob Bell, undated, probably late 1915 or early 1916.
15. George Grosz *Ein kleines Ja und ein grosses Nein* p. 202.
16. Wieland Herzfelde and George Grosz, op. cit., p. 19.
17. ibid., p. 21.
18. Letter to Bob Bell, undated, probably late 1915 or early 1916.
19. ibid.
20. ibid.
21. Letter to Otto Schmalhausen, 22 April 1918.
22. ibid.
23. Wieland Herzfelde *Immergrün* 'Meine erste Begnadigung', Hamburg, 1951, pp. 81–2.
24. Wieland Herzfelde 'The Curious Merchant from Holland', *Harper's Magazine* vol. 187, November 1943, pp. 569–76.
25. Wieland Herzfelde and George Grosz, op. cit., p. 22.
26. Foreword to special publication collected *Neue Jugend* edition, Malik Verlag, Berlin 1921.
27. Quoted from *Neue Jugend Almanach* 1917, no pagination (p. 87), Berlin, 1916.
28. Vol. IV, no. 11, Oct.–Dec. 1915, pp. 167–70.
29. ibid., p. 167.
30. Postcard to Otto Schmalhausen, postmark: 18.I.1917, from Guben.
31. To Bob Bell 'Grosz 1915' (*c.* end of May)
32. Postcard to Otto Schmalhausen, postmark 18.1.1917, from Guben.
33. George Grosz *Ein kleines Ja und ein grosses Nein*.
34. 'Grosz on Piscator', Catalogue 'Hintergrund', p. 33.
35. Wieland Herzfelde and George Grosz, op. cit., p. 23.
36. *Die Aktion*, no. 17/18, col. 76.
37. As reported in *Die Post*, Berlin, 6 January, 1916, in *Die Aktion* no. 17/18, col. 388.
38. *Die Aktion*, no. 17/18, col. 543.
39. On 7 September 1927.
40. *Die Aktion* no 17/18, col. 543.
41. Wieland Herzfelde and George Grosz, op. cit., p. 22.
42. Hans Richter *Dada – Art and Anti-art* Thames & Hudson, London, 1965, p. 102.
43. See ibid. 'Herzfelde'.
44. Letters to Otto Schmalhausen, 6 December 1917 and 30 June 1917.
45. Letter to Otto Schmalhausen, 30 June 1917.
46. Alexander Dückers, Introduction to the catalogue 'George Grosz' Exhibition, 1971, pp. 5–6.
47. Letter to Schmalhausen, 18 February 1917, quoted in A. Dückers, op. cit., p. 6.
48. *Diaries of a Cosmopolitan* Weidenfeld & Nicolson, London, 1971, p. 64.
49. Vol. 3, nos. 1 and 2, June 1917, p. 20.
50. Letter to Otto Schmalhausen, 18 February 1917.
51. 22 February 1930.
52. pp. 2–3.
53. *George Grosz*, Dresden, 1922, p. 8.

5. *Revolution and counterrevolution* (*pp. 81–118*)

1. Count Harry Kessler *Diaries of a Cosmopolitan* Weidenfeld & Nicolson, London 1971, pp. 36–7.
2. Berlin.
3. Wieland Herzfelde and George Grosz *Die Kunst ist in Gefahr* Malik Verlag, Berlin 1925, pp. 29–30.
4. Count Harry Kessler, op. cit., p. 88.
5. ibid., p. 60.
6. ibid., p. 91.
7. Wieland Herzfelde and George Grosz, op. cit., p. 23.
8. ibid., pp. 27–9, 32
9. ibid., pp. 17–18.
10. 2 July 1918, letter.
11. Whitsun 1918.
12. Kurt Tucholsky *Gesammelte Werke* vol. I, Rowohlt Verlag, Hamburg 1960, p. 752.
13. See Hans Richter *Dada – Art and Anti-art* London 1965, chapter 4.
14. Wieland Herzfelde and George Grosz, op. cit., pp. 23–4.
15. 'Zu meinen neuen Bildern', in *Das Kunstblatt* vol. 5, no. 1, 18 January 1921, p. 15.
16. Wieland Herzfelde and George Grosz, op. cit., p. 24.
17. op. cit., pp. 10–16.
18. *George Grosz* Dresden 1922, p. 19.
19. *Truce* vol. III of *Men, Years, Life* McGibbon & Kee, London 1963, p. 16.

6. *Berlin in the twenties* (*pp. 119–154*)

1. 25 March 1947, in English.
2. See *Ein kleines Ja und ein grosses Nein* pp. 172–3.
3. Verbal communication by Wieland Herzfelde, Berlin, April 1973.
4. Letter to Otto Schmalhausen, 8 April 1924, from Paris.
5. ibid.
6. ibid.
7. ibid.
8. 'Die Fratzen von Grosz', *Gesammelte Werke*, vol. I, Rowohlt Verlag, Hamburg 1960, pp. 815–17.
9. In *Europa-Almanach 1925*, Gustav Klepenheuer Verlag, Potsdam, 1924 pp. 42–6
10. To Rudolf Schlichter, from Paris, 10 May 1924.
11. Letter to Lotte Schmalhausen, from Paris, 2 August 1925.
12. Evidence in numerous letters by George Grosz in the Grosz Archives, Princeton, N.J.
13. Letter to Otto Schmalhausen, 27 May 1927, from Pointe Rouge, Marseille.
14. Count Kessler *Diaries of a Cosmopolitan* Weidenfeld & Nicolson, London 1971, p. 287.
15. To Eduard Plietzsch, 16 August 1926, from Leba, Pomerania.
16. Gustav F. Hartlaub, Introduction to catalogue of exhibition *Neue Sachlichkeit* Kunsthütte, Chemnitz, 13 December 1925–7 January 1926.
17. ibid.
18. 1 January 1929.
19. See reprint in *Die Rote Fahne*, Uni Taschenbücher, no. 127, Wilhelm Fink, Munich 1973, pp. 365–8.
20. Letter to Otto Schmalhausen, undated, end of July 1927, from Cassis.
21. Letter to Otto Schmalhausen, *c.* 20 May 1927, from Marseille, for this and previous passage.
22. Letter to Otto Schmalhausen, 27 May 1927, from Pointe Rouge, Marseille.
23. Count Kessler, op. cit., pp. 87–8.
24. See *George Grosz*, Dresden 1922.
25. Letter to Herbert Fiedler, 18 February 1937.
26. See note 6, chapter 12.
27. Letter to Otto Schmalhausen, undated, end of July 1927, from Cassis.
28. ibid.

7. *The last years of the Weimar Republic* (*pp. 155–174*)

1. 'Marginal notes on the subject', on: 'Schweik production', in Catalogue to the Exhibition 'Erwin Piscator, Political Theatre, 1920–1966', 1969, pp. 33, 34.
2. 10 April, see Alfred Apfel, 'Reichsgericht über George Grosz' in *Die Weltbühne*, 24 June 1930, p. 952–7.
3. ibid.
4. ibid.
5. ibid.
6. Letter to Rudolf Schlichter, 14–23 January 1953.
7. Letter to Eduard Plietzsch, 18 October 1930.
8. See *Das Kunstblatt*, vol. 15, March 1931, Potsdam, pp. 79–84.
9. Erwin Piscator exhibition, op. cit., p. 33.
10. *Statt einer Biographie*, 16 August 1920, in *Der Gegner*, vol. 2, no. 3, Berlin, 1920–21.
11. George Grosz 'Erinnerungen', typescript notes by G. Grosz for autobiographical article for *Das Kunstblatt*, vol. 13, 1929, in the Grosz Archives, Princeton, New Jersey, p. 3.
12. Letter to Eduard Plietzsch, 23 August 1931, from Prerow, Pomerania.

8. *The New World of George Grosz* (*pp. 175–189*)

1. Letter to Eva, 27 May 1932, on board the liner *New York*.
2. 27 April 1925.
3. Letter to Otto Schmalhausen, 14 July 1932, from New York.
4. See letter to Eva, 4 August 1932, from New York.
5. Letter to Max Hermann Neisse, 5 May 1933.
6. Article by J. V. McEvoy (June 1932, copy of typescript enclosed in letter to Eva, 4 June 1932, from New York).
7. Letter in Grosz Archives, Princeton, N.J.
8. Letter to his aunt, Elisabeth Lindner, 7 September 1932.
9. Letter to Felix J. Weil, 14 July 1932.
10. Letter to his aunt Elisabeth Lindner, 7 September 1932.
11. See letters to Max Pechstein, Eduard Plieztsch and Felix J. Weil, 15 March 1933, from New York, as well as many later letters in the Grosz Archives, Princeton, N.J.
12. From Berlin, letter started 19 February 1933, finished 27 February 1933.
13. Undated, 28 February 1933.
14. 23 February 1933.
15. Letter to Felix J. Weil, 15 March 1933.
16. 27 April 1933, in French.
17. Letter to Hans Borchardt, 3 May 1933.
18. 13 May 1933.
19. 6 June 1933, from New York.
20. 20 July 1933, from Prague.

21. Letter to Wieland Herzfelde, 4 August 1933, from New York.
22. Letter to Herbert Fiedler, 13 June 1933, from New York.
23. ibid.
24. To Eva, 6 September 1933, from New York.
25. 13 December 1933.
26. 15 April 1934.
27. Letter to Wieland Herzfelde, 3 August 1933 (not sent).
28. ibid.
29. Letter to Karl Laemmle, 25 August 1933.
30. Letter to Eva, 25 August 1933.
31. Letter to Felix J. Weil, 7 January 1934.
32. 31 January 1934, dispatched 3 February.
33. Letter to Herbert Fiedler, 12 October 1934.
34. Letter to Wieland Herzfelde, 3 August 1933 (not sent).

9. *Before the next war (pp. 190–216)*

1. Letter to Herbert Fiedler, 12 October 1934.
2. Letter to Wieland Herzfelde, 31 January 1934, dispatched 4 February 1934.
3. 8 March 1934.
4. Letter from Alfred Flechtheim, 15 April 1934.
5. Letter to Bertolt Brecht, 10 October 1934.
6. ibid.
7. 24 November 1934.
8. Letter to Wieland Herzfelde, 30 June 1934 (not sent).
9. Letter to Wieland Herzfelde, 8 March 1935.
10. Letter to Wieland Herzfelde, 3 August 1933 (not sent).
11. 24 November 1934.
12. 24 May 1935.
13. Letter to Felix J. Weil, 12 April 1935, 'I am sure that the old Grosz is still alive', in English, the rest of the letter in German.
14. 23 May 1935.
15. 21 July 1935, from Bornholm.
16. Letter to Hans Borchardt, undated, around 10 August 1935, from Bornholm.
17. ibid.
18. Letter to Otto Schmalhausen, 6 August 1935.
19. Information in letter to Cläre and Victor Steiner (sister and brother-in-law), 5 October 1935.
20. Letter to Herbert Fiedler, 20 November 1935.
21. See letter to Otto Schmalhausen, 1 May 1935.
22. Letter to Otto Schmalhausen, 8 March 1935.
23. Letter to Herbert Fiedler, 25 November 1935.
24. Comments on the agreement with Caresse Crosby, 16 January 1936, New York, in Grosz Archives, Princeton, N.J., in English.
25. 29 May 1936, in English.
26. Letter to Rudolf Wittenberg, late May 1936.
27. June 1936.
28. Letter to Arnold Blanch, 10 June 1936, in English.
29. 28 June 1936.
30. 7 July 1936.
31. 14 July 1936.
32. 5 January 1937.
33. 15 July 1936, in English
34. 18 August 1936, in English.
35. Letter to Arts Students League, 27 March 1936, in English.
36. Letter to Emanuel (surname not known – possibly an art critic), 23 September 1936, in English.
37. 24 July 1936.
38. To Mrs Anna Peter (mother-in-law), 17 November 1936, from Douglaston.
39. Letter to Herbert Fiedler, 18 February 1937, from Douglaston.
40. 22 October 1936.
41. Letter (probably 30) October 1936.
42. Letter 2 November 1936.
43. To Bernhard Cooper, 24 March 1937, in English.
44. Letter to Eva, about 10 May 1937.
45. Letter to Emily Genauer, 29 April 1947, in English.
46. 21 July 1933.
47. Letter to I. B. Neumann, 17 March 1937.
48. Letter to Eva, *c.* 10–15 May 1937.
49. See letter to his sister Cläre Steiner, undated, (probably 24) August 1939.
50. Undated (probably 20–22) October 1939.
51. 15 October 1939.
52. 24 October 1939.
53. Undated, after 3 September 1939, from Truro, near Cape Cod, Massachusetts.

10. *The Survivor* (*pp. 217–226*)

1. 17 February 1940.
2. 26 January 1940.
3. Letter to Mr Schück, undated, November or December 1940.
4. ibid.
5. 29 October 1941.
6. November 1941.
7. Letter to Erich Cohn, Friday 19 (probably January) 1942.
8. ibid.
9. Letter to Paul Westheim, 26 February 1942.
10. Letter to Erich Cohn, Friday 19 (probably January) 1942.
11. ibid.
12. Letter to Miss Varga of *Life*, 27 February 1942, in English.
13. May 1941.
14. 5 May 1942.
15. 8 May 1942.
16. 9 or 10 May 1942.
17. Letter to Rudolf and Annott Jacobi, 8 January 1943.
18. Letter to Hans Borchardt, 30 May 1942.
19. Letter to Lily Latté, Stendhal Art Galleries, Los Angeles, California, 14 June 1943.
20. Letter from Columbia Broadcasting System, 29 November 1943.
21. See letter to Erich Cohn, 18 December 1943.
22. Sydney S. Baron *One Whirl*, Introduction: Mortimer Hayes, Lowell Publishing Co., New York 1944.
23. 21 May 1944, from Douglaston, in English.
24. Letter to Otto Schmalhausen, 10 April 1946.
25. Letter to Marlene and Hermann Kesser, 7 January 1946.
26. 30 March 1945.

11. *After the war* (*pp. 227–239*)

1. Letter, 17 April 1945.
2. Letter to Ben Hecht, 23 June 1945, in English.
3. Letter to Elisabeth Lindner (aunt), 2 April 1946.
4. Letter to Erich Cohn, 29 July 1947.
5. Letter to Bertold Viertel, 27 October 1947.
6. ibid.
7. Letter to Herbert Fiedler, 13 February 1946.
8. See letter to Bob Bell, 22 January 1947.
9. Letter from Pegeen Sullivan, 28 August 1946.
10. Letter to Pegeen Sullivan, 30 August 1946.
11. To Hans Borchardt, 8 October 1946.
12. ibid.
13. Letter to his sister Martha Fimmen, 8 October 1946.
14. 18 October 1946.
15. 21 October 1946.
16. Letter to Rudolf Wittenberg, 16 December 1946.
17. 10 November 1946, p. 4 of letter started 24 September 1946, posted 16 November 1946.
18. George Grosz Archive, Akademie der Künste, Tiergarten, Berlin.
19. Order to Haldeman-Julius & Co., 13 February 1947.
20. 6 March 1947.
21. Letter to Bertolt Brecht, n.d., '*Dreissigste 1 pm*' (*c*. 30 March 1947).
22. Letter to Felix J. Weil, Spring–Summer (Grosz's dating), 1948.
23. Letter to Otto Schmalhausen, 29 April 1948.
24. 6 May 1947.
25. Letter to Elisabeth Lindner (aunt), 15 August 1948.
26. July 1948.
27. September 1948.
28. Letter to Annott Jacobi, October 1948.
29. Letter to Otto Schmalhausen, October 1948.
30. *DND* (*Deutscher Nachrichten Dienst*, German News Agency) *im Bild*, 16 July 1948.
31. Letter to Marc Sandler, 11 March 1949.
32. Letter to Otto Schmalhausen, October 1950.
33. Letter to Miss Hughes, 11 March 1949, in English.
34. ibid.
35. Letter to Otto Schmalhausen, 3 July 1948.
36. Letter to Herbert Fiedler, 7 August 1949.
37. Letter to Otto Schmalhausen, 29 May 1950.
38. Letter to Herbert Fiedler, 7 August 1949.
39. Letter to Otto Schmalhausen, 28 August 1950.
40. ibid.

12. *The Bitter end (pp. 240–250)*

1. Letter to Otto Schmalhausen, 15 June 1950.
2. Letter to Hans Borchardt, 27 July 1933.
3. Letter to J. B. Neumann, 17 March 1938.
4. Letter to Herbert Fiedler, 14 January 1951.
5. Letter to Liselotte, Georg and Mona Sachs, 21 April 1951.
6. 30 June 1934, from New York. RAPP stands for Russian Association of Proletarian Writers.
7. 23 May 1935 (not sent).
8. Letter to Otto Schmalhausen, 29 May 1950.
9. Letter to his son Martin Grosz, 17 May 1950, in English.
10. Letter to Priscilla Henderson, 11 April 1952.
11. See letter to Otto Schmalhausen, 14 December 1951.
12. Letter to his son Martin Grosz, 8 January 1953, in English.
13. Letter to Otto Schmalhausen, 12 February 1953.
14. Letter to Otto Schmalhausen, 20 April 1953.
15. Letter to Rudolf Wittenberg, 20 January 1953.
16. Letter to Otto Schmalhausen, 25 March 1954.
17. Letter to Otto Schmalhausen, 5 March 1954.
18. ibid.
19. Desch Verlag, 20 July 1954, for Uli Becher.
20. Letter to John H. I. Baur, Whitney Museum, New York, 7 August 1954, from Osterhofen, Bayrisch Zell.
21. Letter to Ernst and Herta Ashton, 9 August 1954, from Osterhofen, Bayrisch Zell, in English.
22. Postcard to Otto Schmalhausen, from London
23. 31 May 1955.
24. 2 May 1945.
25. Statement to his lawyer Cloyd Laporte, 31 May 1955.
26. Letter to Herbert Fiedler, 25 May 1957.
27. Letter to Otto Schmalhausen, 14 October 1957.
28. 8 January 1958.
29. 12 July 1958.
30. Letter to Sally Falk, 1 April 1954.
31. Kornfeld and Klipstein, Auction 89, 14 May 1958, cat. nos. 40 and 41, reported by Otten in the *Berliner Tageblatt*.
32. 24 July 1958.
33. June 1957.
34. 14 October 1957.
35. Letter to Richard Feigen, 28 May 1958.
36. For 12,000 DM, information in letter to Eva, 12 July 1958.
37. See letter to von Butlar, 1 May 1959.
38. Letter to sister Martha Fimmen, 17 January 1959.
39. With Thomas A. Black of 50, Broadway, New York.
40. Letter to Bernard Reis, 4 April 1959.
41. Letter to Andre and Lois Grotewold (nephew and his wife), 14 March 1958.
42. 6 May 1959.

Biographical table

1893 Georg Ehrenfried Grosz born 26 July in Berlin, Jägerstrasse 63. Third child of Karl Ehrenfried Grosz and his wife Marie Wilhelmine Luise née Schultze. There were two sisters, Cläre and Martha.

1898 Family moves to Stolp in Pomerania.

1900 Father dies, mother moves to Berlin-N., Wöhlerstrasse. Late 1900 or early in 1901.

1901 Returns to Stolp, Blumenstrasse. Private Sunday classes in drawing.

1908 Expelled from grammar school. Prepares for entrance examination to Royal Academy, Dresden.

1909 Passes examination in September. Next two years at the Academy in Dresden. Lives in Dresden-Striesen, first with a family Kühling, then in Dornblüthstrasse.

1910 Sends drawing to *Ulk*, first drawing published. Holidays in Thorn on the Vistula.

1911 Leaves Academy with Honours Diploma. Summer Holidays in Thorn.

1912 Arrives 4 January in Berlin. Lives until April in Charlottenburg, then Südende, Lichterfeldestrasse 36. Attends Art School attached to Museum of Arts and Crafts until 1917. Works at book illustrations, sends drawings to *Ulk* and *Lustige Blätter*. Starts painting in oil. Holidays in Thorn.

1913 To Paris early August until November. Studies at Atélier of Colarossi. Stays at no. 14 rue Delambre, Montparnasse. First bookjacket appears. July on Heligoland and in Thorn, some days in Hamburg.

1914 Second prize for drawing at the Academy. Volunteers 13 November, enrolled in Kaiser Franz Garde Grenadier Regiment 2, 1. Kompagnie Bezirkskommando V., Berlin, No. 2553.

1915 5 January transfer to 1st Reserve Battalion, 11 May released from the army. Berlin with sister Cläre, Hohenzollerndamm 201, 7 July to Berlin-Südende, Stephanstrasse 15, where he lives until 1918. Meets Wieland Herzfelde during the summer. First poem and first drawing published in *Die Aktion*.

1916 Works for Herzfelde's *Die Neue Jugend*. September changes his name from Georg to George Grosz. Meets Theodor Däubler in May. October first article on Grosz in *Die Weissen Blätter*. Reads own poetry at *Die Neue Jugend* literary evenings in Berlin, Dresden, Munich, Mannheim.

1917 Called up 4 January to Landsturm-Infantrie-Batallion, Guben near Berlin. Transferred to Hospital 'Kronprinz' 5 January, transferred to mental home in Görden near Brandenburg/Havel 23 February. 27 April released from army. Return to Berlin, May with sister Cläre, from June in Südende. Publication of first portfolio in Spring. Works for Malik Verlag. Sells first oil painting to Sally Falk, Mannheim.

1918 Works with Heartfield on animated film *Pierre in St Nazaire* for *Militärische Bildstelle*. August in Zingst, Baltic with Eva. October moves to Nassauischestrasse 4, Berlin-Wilmersdorf, where he stays until 1921. 31 December joins Communist Party with Wieland Herzfelde, John Heartfield, Erwin Piscator.

1919 Member of Berlin 'Club Dada'. Works for Malik Verlag periodicals and books. Dada Collages, period of Grosz-Heartfield Collages.

1920 Illustrates books and publications for Malik, Sektion Dada. April, first one-man exhibition at Hans Goltz, Munich. 26 May marries Eva Louise Peter. Organizes and exhibits at first international Dada Fair June to August. Portfolio *Gott mit Uns* is confiscated. Runs political cabaret *Schall und Rauch* with John Heartfield in basement of Reinhardt's theatre. First theatre designs for Reinhardt. Produces theatre designs until 1930. 'Mechanical construction' period. Summer, visits his patron Felix J. Weil in Portofino, Italy.

1921 Political drawings for portfolios and periodicals, and satirical book illustrations. 21 April trial for slandering the Reichswehr, fined 300 marks. July and August at Ahlbeck (on Usedom) and Klosters (on Hiddensee). Moves to 201 Hohenzollerndamm.

1922 Six months visit in summer to Petrograd and Moscow via Denmark, Vardö, Kola Fjord, Murmansk. Book illustrations. Stops painting in oils.

1923 Publication of portfolio *Ecce Homo*, confiscated by Public Prosecutor for obscenity. Alfred Flechtheim becomes his dealer, first exhibition in Berlin. August in Baden-Baden and Genova.

1924 16 February trial for obscenity, and fined 6,000 marks. Works from now until 1927 regularly for communist satirical weekly *Der Knüppel*. 30 March to Paris until end of May. Stays Hotel Odessa, 28 rue d'Odessa. November first exhibition in Paris. Contributes to *Querschnitt*, regularly from now until 1933.

1925 15 June to Paris, Hotel Odessa. July to Boulogne-sur-mer, at house of Frans Masereel. 24 July in Paris, 15 August to Ile de Bréhat, Britanny, house of Jacques Sadoul, from there until September to Douarnenez, Baie de Trepasses, Quimper, Paimpol, Audierne, Point du Rasy, Quimper, Tours, Blois. Two weeks Paris, two weeks in Ajaccio, Corsica via Marseille. Return to Paris via Nice and Avignon. 15 October return to Berlin. Represented at *Neue Sachlichkeit* exhibition in Mannheim. Starts painting in oils again.

1926 First son, Peter Michael, born 22 May. July and August at the Baltic in Leba. Works in oils. Contributes regularly to *Simplicissimus* from now until 1932. Reportages for *Das Illustrierte Blatt*.

1927 May to Marseilles, Pointe Rouge. End of May by car through Provence. Returns to Pointe Rouge. Lives at 'Des Rosiers', avenue des Acacias. Middle of July to Cassis-sur-mer. Stays at Campagne de M. Agostine, chemin de St Joseph. Paints many oils. Returns ta Berlin, October. Background drawings for Erwin Piscator's production of *Schweik*. Exhibition at Flechtheim gallery of 25 oils. Publication of *Der Knüppel* ceases, last drawings in August.

1928 Works on 'background' for *Schweik*, 23 January 1st night. Publication of portfolio *Hintergrund*. 20 December Blasphemy trial, Grosz found guilty. Brief visit to London in September. Moves to Trautenaustr.12, where he stays until 1933.

1929 10 April Appeal court quashes blasphemy conviction. August in Viganello near Lugano, Villa Bondy. October exhibition at Bruno Cassirer.

1930 27 February acquittal of 10 April 1929 annulled by Reichsgericht. New trial 3–4 December acquits Grosz a second time. 28 February second son Martin Oliver born. August and September at the Baltic in Ahrenshoop with Max Pechstein. Exhibits at the Biennale, Venice.

1931 October exhibition in Berlin of new oils, watercolour exhibition in New York. August, September at the Baltic, in Prerow. Watson F. Blair Purchase Prize, Art Institute of Chicago.

1932 4 June in New York, teaches from June to August at Art Students League. Stays at Great Northern Hotel, 118 West 57th Street. Becomes staff member on monthly *Americana*, contributes watercolours to *New Yorker* and *Vanity Fair*. Meets James Thurber and George Gershwin. Brief visit to Philadelphia. Watercolours of New York scenes. Leaves New York on 6 October.

1933 12 January leaves Germany with Eva from Bremen. Arrives New York 25 January. Briefly at Great Northern Hotel. February moves to Cambridge Hotel, 60 West 68th Street. Teaches at Art Students League and at Sterne-Grosz School in 49th Street. 13 March watercolour exhibition, New York. April applies for American citizenship. Moves to Greenwich Village, 57 Christopher Street, until end of September. Brief stay at Hotel Raleigh, moves to Bayside, 40–41 221st Street, Long Island, where he stays until 1936. Watercolours of New York scenes.

1934 Commissioned by George Macey to illustrate O'Henry Stories. Teaches at Art Students League, and at Sterne-Grosz School. School moves 15 October to Squibb Buildings, 745 Fifth Avenue. Watercolours, New York Street scenes.

1935 Spring exhibition in New York. June to September visit to Europe: some days in Paris, brief visit to Brecht in Svendborg, Denmark, via Harwich, July at Ostrestrand, 29 July to Hasle on Bornholm until 20 August. Via Copenhagen to Laren, North Holland. Visit to Herbert Fiedler, stays at his house, Klooster 6. 15 September returns to New York. Teaches at Art Students League and the Grosz School.

1936 Contract for first American book *Interregnum* in January. 20 July moves to 202 Shore Road, Douglaston, Long Island, lives there until 1946. Teaches only at own school. Paints again in oils.

1937 Guggenheim Fellowship. His own school wound up in Spring. First summer in Cape Cod. Walker Gallery, New York becomes his dealer. His work included in Degenerate Art exhibition in Munich. Paints 3 self-portraits.

1938 Guggenheim Fellowship. Exhibition in Chicago, 33 oils. Becomes American Citizen 16 June. Summer Cape Cod. First Apocalyptic Paintings.

1939 New York Exhibition, 12 oils. Summer in Truro, Cape Cod. Cape Cod Paintings. Wieland Herzfelde arrives in New York.

1940 Receives Carol H. Beck Medal from Pennsylvania Academy of Fine Arts. Awarded Watson F. Blair Purchase Prize Award, Chicago Art Institute. Summer Cape Cod. Paintings of Dunes and Nudes.

1941 Exhibition New York 'Paintings of the Nude', 20 oils. Commissioned to illustrate 1001 *Afternoons* by Ben Hecht. Asked to write autobiography. Lectures at School of Fine Art, Columbia University. Teaches at Art Students League. Changes to Associated American Artists Galleries as his dealer. Summer Cape Cod.

1942 Lectures at Columbia University. Summer Cape Cod.

1943 January, exhibition New York, 38 oils. May, exhibition Washington D.C.: illustrations to Fairy Tales by brothers Grimm. Commissioned to illustrate Dante's *Divine Comedy*, and *One Whirl*. November–December, 'Profile' in *New Yorker*. Teaches at Art Students League. August Adirondaks, Lake Garnet.

1944 Exhibition, Baltimore. Teaches Art Students League. Summer Hyannis, Cape Cod.

1945 June to October Wellfleet, Cape Cod.

1946 October exhibition New York: A Piece of my World in a World without Peace. Second Prize Carnegie Institute. Publication of autobiography. In Italy, Italo Ballo publishes book on Grosz with 63 plates from portfolios.

1947 12 June moves to The Cottage, Hilaire Farm, Huntington, Long Island. 'Stickmen' and 'Painter of the Hole' watercolours and oils.

1948 New York, Exhibition *Stickmen*, watercolours.

1949 Cambridge, Exhibition. Teaches summer Art Students League.

1950 Exhibition Cleveland and Boston. Teaches Summer Term Art Students League.

1951	Leaves 23 May for visit to Europe: (France, Holland, Belgium, Italy, Switzerland, Monte Carlo). Returns New York 5 December. Teaches Art Students League.
1952	May and June, Dallas (Texas). Exhibition Dallas. Museum of Fine Arts.
1953	Teaches Art Students League. Opens private Art School in his house.
1954	January to March retrospective Exhibition at Whitney Museum, 38 oils, 87 water-colours and drawings. Elected member of Academy of Arts and Letters. Teaches at Art Students League and own school. 12 June second European visit: Hamburg, Berlin. Reception by Berlin Senate. July to middle of September Osterhofen/Bayrisch Zell (Gasthaus Kyriss). From Berlin c. 30 September to London (Whites Hotel, Hyde Park). Film decor *I am a Camera* for Remus Film. Leaves London 6 November via Hamburg to Berlin. Middle of December to Munich, Monte Carlo, brief visit to Dix at Hemmenhofen. 26 December to Hamburg.
1955	2 January returns to the United States. Teaches Art Students League and at own school. Exhibition in Syracuse. German version of autobiography is published.
1956	August teaches at Skowhegan school of painting and sculpture, Maine. November guest instructor at Des Moines Art Center. Teaches at Private School.
1957	Teaches at Art Students League and Private School.
1958	2 September to Berlin. Elected 24 November extraordinary member of Akademie der Künste. Returns to New York 3 December.
1959	15 January Gold Medal National Institute of Arts and Letters. 28 May returns to Germany. Dies in Berlin 6 July.

Exhibitions

1920
Munich April–May, Galerie Neue Kunst, Hans Goltz, 59th Exhibition, 'George Grosz', 10 oil paintings, 11 watercolours, 40 drawings, 18 lithographs, *Die kleine Grosz Mappe* and *Erste Grosz Mappe*.

Berlin July–August, Kunsthandlung Dr Otto Burchardt, 'Erste Internationale Dada-Messe', 26 collages, watercolours, oil paintings, 8 Grosz–Heartfield montages and 3 Grosz portfolios.

1921
Hanover 20 February–13 March, Kestner-Gesellschaft, 'George Grosz' and 'Junge Niederländische Kunst, oils, watercolours, drawings, and lithographs.

1922
Hanover April, Galerie von Garvens, 'George Grosz', 10 oils, 7 collages.

1923
Berlin Galerie Flechtheim, 'George Grosz', 16 watercolours, 30 theatre designs and figurines, 6 'constructions', 51 drawings. Exhibition then to:

Vienna (1924), Kunsthandlung Würthle.

1924
Paris November, Galérie Joseph Billiet, 11 watercolours, 15 drawings, 6 lithographs.

1925
Mannheim Summer, Städtische Kunsthalle, 'Neue Sachlichkeit', paintings. Exhibition then reduced.

Chemnitz 13 December–7 January 1926, Kunsthütte.

1926
Berlin 24 March–24 April, Galerie Flechtheim.
December, Kunsthandlung Wasservogel, 96 drawings.

Cologne 3–21 January, Kunsthandlung S. Salz,

1927
Berlin Galerie Flechtheim, 'Oelgemälde von George Grosz und Kongo-skulpturen', 25 oil paintings.

1929
Berlin March, Galerie Bruno Cassirer, watercolours and drawings.

Düsseldorf Galerie Flechtheim, oils.

1930
Zürich March, Kunsthaus.

Venice XVII. Biennale, 5 oils.

1931
Berlin 4–22 October: *George Grosz, Neue Werke*, oils

New York Weyhe Gallery, watercolours and drawings.

1933
New York 3 March–3 April, Barbizon Plaza Hotel, watercolours.

Chicago Arts Club.

Milwaukee Art Institute.

1934
London Mayor Gallery, 5 oils.

1935
Cambridge, Mass. Busch Reisinger Museum, Harvard University, 'George Grosz'.

1936
London Leicester Galleries.

Omaha Municipal University.

Chicago March, Art Institute, Group Show, Grosz: 25 watercolours.

1938
Chicago Art Institute, December–January 1939, 33 oils, 26 watercolours, 20 drawings.

1939
New York 20 March–15 April, Walker Galleries, 'George Grosz', 12 oils, watercolours and drawings.

Manchester, New Hampshire Currier Gallery of Art, 'George Grosz'.

1940
New York Museum of Modern Art, circulating group show (16 watercolours and drawings) (?).

1941
New York 31 March–26 April, Walker Galleries, 'George Grosz: Recent Paintings: 'Paintings of the Nude', 20 oils.

Andover Addison Gallery of American Art: 'European Artists in America'.

New York Museum of Modern Art: 'George Grosz'. Also circulating show 1941–2. Associated American Artists Galleries, 'George Grosz'.

1943
New York January, Associated American Artists Galleries, 'George Grosz, 38 oils.

Washington D.C. May, The G-Place Gallery: 'Drawings pleasant and unpleasant', 24 drawings, illustrations to Fairy Tales by the brothers Grimm.

Denver Art Museum, one-man show.

1944
Baltimore Museum of Art.

1945
Chicago Associated American Artists Galleries, Grosz only or group show.

1946
New York October, Associated American Artists Galleries, 'A Piece of my World in a World without Peace'.

1948
New York April (?), Associated American Artists Galleries, 'The Stickmen', watercolours.

1949
Cambridge Busch Reisinger Museum, Harvard University, 'George Grosz'.

Cleveland The Print Club.

1950
Cleveland The Institute of Art, 'George Grosz'.

Boston The Swetzloff Gallery, 'George Grosz'.

1952
Dallas October, Dallas Museum of Fine Art, 'Impressions of Dallas', 4 oils, 17 watercolours.

1954
New York Whitney Museum of American Art, 'George Grosz', 38 oils, 52 watercolours, 35 drawings.

1959
Cold Spring Harbor 3–23 May, Vera Lazuk Gallery, 'George Grosz, A retrospective show', 16 oils, 17 watercolours, 1 collage.

Huntington Heckscher Museum, 'George Grosz', 13 oils, 39 watercolours, 1 egg tempera, 24 drawings, 18 lithographs.

1961
Chicago 18 January to 25 February, Richard Feigen Gallery, 'George Grosz', 10 oils, 57 watercolours and drawings.

New York Feigen Gallery.

1962

Berlin Akademie der Künste, 7 October–30 December, 'George Grosz', 40 oils, 93 water-colours, 165 drawings. Exhibition, reduced in size, was shown in York, London, Bristol, in 1963.
Galerie Meta Nierendorf, 8 October–17 January 1963, 'Ohne Hemmung', 129 watercolours and drawings.

1963

Milan 13 February to beginning of March, Galleria del Levante, 50 watercolours and drawings, 1 lithograph. This exhibition then went to *Rome*, 7 March until end of month, Galleria Don Chisciotte, extended by 5 lithographs, *Ecce Homo* and books.

York 20 April–12 May, Art Gallery, 'George Grosz', 17 oils, 47 watercolours, 95 drawings, 2 colour montages.
Same exhibition in *London*, Arts Council Galleries, 1 June–29 June, and *Bristol*, City Art Gallery, 6 July–6 August.

New York 24 September–12 October, Forum Gallery and E. V. Thaw, 'George Grosz', 19 oils, 72 watercolours and drawings.

1964

Beverley Hills 1–26 June, Kantor Galleries, same exhibition as in New York 1963, without the oil paintings.

1965

Chicago 5 November–9 December, B.C. Holland Galleries, 'The Unknown George Grosz', collages.

Vienna 7 February–17 March, Graphische Sammlung Albertina, 'George Grosz', 4 oil paintings, 100 watercolours and drawings. This exhibition also went to *Linz*, Neue Galerie der Stadt Linz, Wolfgang Gurlitt, 25 March–25 April, and *Graz* 30 April–23 May, Neue Galerie am Landesmuseum Joanneum.

1966

Paris February, Galérie Claude Bernard, 'George Grosz', 60 watercolours and drawings.

Dresden 31 July–13 November, Albertinum, Kupferstichkabinett, 105 watercolours, drawings and lithographs.

1968

London April, Marlborough Fine Art (London): George Grosz: 44 watercolours and drawings.

New York 5 February–2 March, Peter Deitsch, 'George Grosz, 50 early drawings'.

1969

Stuttgart 3 July–7 September, 'George Grosz, John Heartfield'.

1970

Munich March, Galleria del Levante, 'George Grosz', 22 watercolours and drawings. This exhibition then went to *Milan*, Galleria del Levante.

New York March–April, Peter Deitsch, 'George Grosz, Berlin watercolours and drawings', 61 watercolours and drawings.

Krefeld 29 November–31 December, Krefelder Kunstverein, 'George Grosz, Der Verrat an der Scheinheiligkeit', 61 watercolours and drawings.

1971

Düsseldorf 15 January–7 February, Städtische Kunsthalle, 'George Grosz', 1 oil and 53 watercolours and drawings.
This exhibition then went to *Parma*, April–May, Salone di Contrafforti in Pilota (5 works less), and *Berlin*, June–July (Dahlem).

Berlin 21 May–27 June, Staatliche Museen, Kupferstichkabinett, 'George Grosz, frühe Druckgraphik, Sammelwerke, Illustrierte Bücher', 101 items.

New York 16 October–27 November. Richard L. Feigen & Co. 'George Grosz, Dada Drawings 1912–1920'. 26 items.

1973–74

Cambridge, Mass. Busch Reisinger Museum, Harvard University, 'Theatrical Drawings and Watercolours by George Grosz', 60 items.
Travelling show by the Busch Reisinger Museum.

1974

Zurich Autumn, Marlborough Galerie, Oils, watercolours and drawings.

Selected bibliography

Portfolios and books of Drawings

Erste George Grosz-Mappe 9 original lithographs, 1 title page, 50·3 × 39·1 cm., 19¾ × 15½ in. Heinz Barger Verlag, Berlin, Spring 1917.

Kleine Grosz-Mappe 20 original lithographs, four-page title page with verses by Grosz, 28·2 × 21·6 cm., 11⅛ × 8½ in., Malik Verlag, Berlin–Halensee, autumn 1917.

Gott mit uns 9 lithographs, 1 title page, 49 × 35·5 cm., 19¼ × 14 in. (20 de luxe copies were larger). Malik Verlag, Berlin, June 1920.

Das Gesicht der herrschenden Klasse 55 political drawings, bound, 1 book jacket. Kleine revolutionäre Bibliothek, vol. 4, Malik Verlag, Berlin, Spring 1921, 1st edition. November 1921, 3rd enlarged edition, new book jacket. Reprinted in 1972 by Makol Verlag, Frankfurt a.M., including 'Statt einer Biographie' a biographical table and reprint of *Abrechnung folgt*.

Im Schatten 9 lithographs, 1 title page, 49·5 × 37·5 cm., 19½ × 14¾ in., Malik Verlag, Berlin, December 1921.

Mit Pinsel und Schere, 7 Materialisationen. Black and white reproduction after watercolour collages, 32 × 25 cm., 14 9/16 × 9 13/16 in. Malik Verlag, Berlin, July 1922, loose leaf and bound.

Die Räuber. Neun Lithographien zu Sentenzen aus Schillers 'Räuber'. 9 lithographs, 1 title page, 70 × 50·5 cm., 27¾ × 19¾ in. Malik Verlag, Berlin, November 1922. 'Organization' edition 1923.

Ecce Homo 84 drawings, 16 watercolours in seven-colour offset, 1 title page, 37 × 26 cm., 14½ × 10¼ in., bound, de luxe edition loose leaf in portfolio. Malik Verlag, Berlin 1923. Facsimile editions by Jack Brussel, New York 1956 (Introduction by Lee Reeves); Grove Press, New York 1966 (Introduction by Henry Miller); Rohwolt Verlag, Hamburg 1966 (Foreword by Günther Anders).

Abrechnung folgt! 57 politische Zeichnungen Kleine revolutionäre Bibliothek, vol. 10, Malik Verlag, Berlin 1923. Reprinted by Makol Verlag, Frankfurt a.M. 1972, including 'Statt einer Biographie', biographical table, and reprint of *Das Gesicht der herrschenden Klasse*.

Der Spiesser-Spiegel. 60 Berliner Bilder nach Zeichnungen mit einer Selbstdarstellung des Künstlers. Biographical statement by G. Grosz, pp. 5.12. Introduction by Walter Mehring: 'Der Spiesserbiologe', pp. 13–14. Carl Reissner Verlag, Dresden 1925, revised edition, 1932. Reprint without text and one substitute drawing, Arani Verlag, Berlin 1955; Arno Press, New York 1966.

Hintergrund. 17 Zeichnungen zur Aufführung der 'Schwejk' in des Piscator-Bühne 17 hand-printed drawings, title page and cover drawing, 17 × 26 cm., 6¾ × 10¼ in., Malik Verlag, Berlin, (January) 1928.

Das neue Gesicht der herrschenden Klasse. 60 neue Zeichnungen. Bound, Malik Verlag, Berlin 1930. Reprinted by Friedrich Bassermann Verlag, Stuttgart 1966; VEB Verlag der Kunst, Dresden 1969.

Die Gezeichneten. 60 Blätter aus 15 Jahren Bound, Malik Verlag, Berlin 1930. Reprinted in 'Love above all and other Drawings', Dover Publications, New York 1971.

Über alles die Liebe. 60 neue Zeichnungen. Bound. Bruno Cassirer Verlag, Berlin 1930. Reprint 'Love above all', Dover Publications, New York 1971.

A Post-War Museum 28 plates, Criterion Miscellany no. 21, Faber & Faber, London 1931.

Bagdad-on-the-Subway. Six watercolours of O'Henry's New York 6 signed watercolours in portfolio, Print Club, New York 1935.

Interregnum 64 drawings and an original coloured lithograph. Introduction by John Dos Passos, edited by Caresse Crosby. Bound. The Black Sun Press, 1936.

George Grosz Drawings 49 drawings and 3 watercolours, mainly of the American period. Introduction by Grosz 'On my Drawings'. Bound. H. Bittner & Co., New York 1944.

George Grosz: 30 Drawings and Watercolours 29 drawings and 4 watercolours from 1915–44. Introduction by Walter Mehring. Bound. Erich S. Herrmann, New York 1944. Reprinted by Paul L. Baruch, New York 1948.

George Grosz 85 drawings and watercolours, 3 in colour. Edited by Imre Hofbauer. Bound. Introduction by John Dos Passos, Nicholson & Watson, London 1948.

Ade Witboi 51 plates (4 in colour), 14 text illustrations. Edited by Walther G. Oschilewski, postscript by Otto Schmalhausen. Bound. Arani Verlag, Berlin 1955.

George Grosz Drawings, watercolours, 2 oils, 114 plates (6 colour). Bound. Edited by H. Bittner, Introduction by Ruth Berenson and Norbert Mühlen: 'The Two Worlds of George Grosz'. 'On my pictures' by G. Grosz. Arts Inc., New York 1960. Dumont Schauberg. Cologne, 1961.

Contributions to journals

Die Aktion, editor Franz Pfemfert, vol. 5, 24 July, 1 drawing, Verlag der Wochenschrift Die Aktion, Berlin 1915, column 370.

Neue Jugend, monthly, vol. 1,
 no. 7, July, 2 drawings, pp. 127, 134
 no. 8, August, 1 drawing, p. 155
 no. 10, October, 1 drawing, p. 201
 Verlag Heinz Barger, Berlin 1916.

Der Almanach der Neuen Jugend auf das Jahr 1917, Verlag Neue Jugend, Berlin. n.d.,
 4 drawings, pp. 61, 89, 145, 171.
Neue Jugend, monthly, vol. 1, nos. 11–12, February–March, 4 drawings, Malik Verlag,
 Berlin 1917.
Jedermann sein eigener Fussball, bi-monthly, editor Wieland Herzfelde, 8 drawings by
 Grosz and Heartfield, vol. 1, no. 1. 15 February, Malik Verlag, Berlin 1919.
Die Pleite satirical supplement to *Der Gegner*, bi-monthly, vol. 1,
 no. 1, February 1919, cover and 2 drawings
 no. 2, March, *Schutzhaft* (cf. under: Books illustrated by G. Grosz)
 no. 3, April, cover and 2 drawings
 no. 4, May, cover and 2 drawings
 no. 5, 15 December, cover and 1 drawing, and co-editor with John Heartfield
 no. 6, January 1920, cover and 2 drawings
 no. 7, July 1923, cover and drawings, and co-editor with John Heartfield
 Malik Verlag, Berlin 1919, 1920, 1923.
Der Gegner, monthly, editors Julian Gumperz and Wieland Herzfelde, vols. 1–3, 1919–22,
 drawings by Grosz in all nos.
Der Blutige Ernst, satirical weekly, editors Carl Einstein and George Grosz; typography and
 layout Grosz–Heartfield. vol. 1,
 no. 3, 'Die Schuldigen', cover and 9 drawings
 no. 4, 'Die Schieber', cover and 3 drawings
 no. 5, 'Rückkehr der Monarchie', cover and 1 drawing
 no. 6, 'Schulze', cover and 5 drawings
Der Dada, no. 2, editor Raoul Hausmann, 1 drawing, Verlag Freie Strasse, Berlin 1919.
Der Dada, no. 3, editors Grosz, Heartfield and Hausmann (Groszfield, Hearthaus, Georgemann),
 cover Grosz-Heartfield montage, Malik Verlag, Abteilung: Dada, Berlin, April
 1920.
Der Knüppel, bimonthly, satirical workers' paper, vols. 2–5, 1 to 2 drawings in nearly every
 issue, Vereinigung Internationaler Verlags-Anstalten, Berlin, 1924–7.

Books illustrated by Grosz and cover designs or bookjackets

Holländer, Felix *Sturmwind im Westen*, Ein Berliner Roman, Fischers Roman Bibliothek,
 S. Fischer Verlag, Berlin 1913. Drawing for book jacket.
Herzfelde, Wieland *Sulamith* Gedichte, Heinz Barger Verlag, Kriegsdruck der Cranach
 Presse, Berlin 1917. Cover design.
 Schutzhaft. Erlebnisse vom 7. bis 20. März 1919 bei den Berliner Ordnungstruppen. No 2
 Die Pleite, Malik Verlag, Berlin 1919. Cover drawing and title page.
 Tragigrotesken der Nacht. Träume. Malik Verlag, Berlin, May 1920. Cover (back and front),
 inside papers, 21 drawings and 1 collage.
Hülsenbeck, Richard *Phantastische Gebete, Verse.* 2nd revised edition, Abteilung Dada,
 Malik Verlag, Berlin 1920. Cover and 13 drawings.
Andersen-Nexö, Martin *Die Passagiere der leeren Plätze. Ein Buch mit 14 Erzählungen und
 einem Vorspiel.* Malik Verlag, Berlin-Halensee, November 1921. Cover drawing and 12
 illustrations.
Daudet, Alphonse *Die Abenteuer des Herrn Tartarin aus Tarascon.* Translation by Klabund.
 Erich Reiss Verlag, Berlin 1921. Coloured cover drawing, end papers, title page, 97
 illustrations. (20 full-page handprinted drawings.)
Hülsenbeck, Richard *Dr Billig am Ende, Ein Roman.* Kurt Wolff Verlag, Munich 1921.
 8 full page drawings.
Jung, Franz *Die rote Woche.* Rote Roman Serie, vol. 3, Malik Verlag, Berlin 1921.
 9 drawings to the text.
Meyer, Alfred Richard *Munkepunke Dionysos. Groteske Liebesgedichte.* Das geschriebene
 Buch, vol. 7, Fritz Gurlitt Verlag, 1921. 6 original lithographs.
Reimann, Hans *Sächsische Miniaturen,* Vol. 1, Paul Steegemann Verlag, Hanover
 1921. 14 drawings.
Sinclair, Upton *100%. Roman eines Patrioten.* Translated by Hermynia zur Mühlen.
 Rote Roman Serie, vol. 2, Malik Verlag, Berlin 1921. 10 drawings.
Goll, Iwan *Methusalem oder der ewige Bürger. Ein satirisches Drama.* Costumes and
 scenery by G. Grosz and J. Heartfield. Der dramatische Wille, 8. Gustav Kiepenheuer,
 Potsdam 1922. 3 figures by Grosz.
Kanehl, Oskar *Steh auf Prolet! Gedichte.* Vol. 12, Kleine revolutionäre Bibliothek, Malik
 Verlag, Berlin-Halensee 1922. 7 drawings.
Mann, Heinrich *Kobes.* Propyläen Verlag, Berlin 1925. 10 lithographs.
MacOrlan, Pierre *Port d'Eaux-Mortes.* Sans Pareil, Paris 1926. 8 lithographs.
Toller, Ernst *Brokenbrow: A Tragedy.* Translated by Vera Mendel. Nonesuch Press,
 London 1926. 6 drawings. French edition *Hinkemann. Tragédie.* Les Humbles, Paris 1926.
Sinclair, Upton *Die goldene Kette oder die Sage von der Freiheit der Kunst.* Translated by
 Hermynia zur Mühlen. Malik Verlag, Berlin 1927. (2nd and 3rd ed. 1928.) Cover photomontage
 drawing by Grosz and Heartfield.
Kanehl, Oskar *Die Strasse frei. Neue Gedichte.* Der Spartakusbund Verlag, Berlin 1928.
 Drawing for bookjacket and 15 drawings.

Gumbel, E. J. *Verräter verfallen der Feme! Opfer, Mörder, Richter, 1919–29*. With help from Berthold Jacob and Ernst Falck. Malik Verlag, Berlin 1929. Book jacket drawing.

Brecht, Bertolt *Die Drei Soldaten. Ein Kinderbuch*. Versuche 14. Gustav Kiepenheuer Verlag, Berlin 1932. 25 drawings.

Hecht, Ben *1001 Afternoons in New York*. Viking Press, New York 1941. 86 illustrations.

Baron, Sydney S. *One Whirl*. Introduction by Mortimer Hays, Lowell Publishing Co., New York 1944. 27 illustrations.

Dante, Alghieri *The Divine Comedy*. Modern Library, Random House, New York 1944. 32 drawings.

Miller, Henry *Plexus*. Rohwolt Verlag, Hamburg 1955. Bookjacket, watercolour.

Own writings

Poem in *Die Aktion*, vol. 5, 6 November, column 573, Verlag der Monatsschrift Die Aktion, Berlin 1915.

Poem in *Neue Jugend*, vol. 1, no. 9, September, Verlag Heinz Barger, Berlin 1916, pp. 183–4.

Four poems in *Neue Jugend*, vol. 1, nos. 11–12, February–March, Malik Verlag, Berlin 1917, pp. 236–44.

'Man muss Kautschukmann sein!' and 'Kannst du radfahren?', anonymous articles in *Neue Jugend*, weekly, no. 1, June, Malik Verlag, Berlin 1917.

Poem in *Almanach der Neuen Jugend auf das Jahr 1917*, Malik Verlag, Berlin n.d., p. 144. For various reprints of the above poems see bibliography in Beth Lewis *George Grosz*, University of Wisconsin Press 1971.

'Der Kunstlump' (with John Heartfield) in *Der Gegner*, vol. 1, nos. 10–12, pp. 48–56, Malik Verlag, Berlin c. 1919. Reprinted in *Die Aktion*, vol. 10, columns 327–32, Verlag der Wochenschrift Die Aktion, Berlin 1920.

'Statt einer Biographie', Berlin, 16 August 1920 in *Der Gegner*, vol. 2, no. 3, Malik Verlag, Berlin 1920–1.

'Zu meinen Neuen Bildern', November 1920, *Das Kunstblatt*, vol. 5, no. 1, January, 5 pl., Verlag Gustav Kiepenheuer, Berlin 1921, pp. 10–16.

'Der Mensch ist nicht gut – sondern ein Vieh!', in Catalogue Grosz Exhibition, Hanover 1922.

'Abwicklung', *Das Kunstblatt*, vol. 8, no. 2, February, 8 illustrations, Verlag Gustav Kiepenheuer, Berlin 1924, pp. 32–8.

Die Kunst ist in Gefahr (with Wieland Herzfelde) Drei Aufsätze (3 essays) 'Die Kunst ist in Gefahr! Ein Orientierungsversuch', pp. 5–32, 'Paris alst Kunststadt', pp. 33–8, 'Statt einer, Biographie', pp. 39–45, vol. 3 Malik-Bücherei, Malik Verlag, Berlin 1925, 2 illustrations, 1 cover drawing. Russian Edition: Introduction by V. Perzov, translated by Z. L. Svarchman, State Publishing House, Moscow, 1926.

'Souvenirs de Jeunesse', *Variétées*, vol. 2, no. 7, 15 November; no. 8, 29 November, translation by M. Mirowitsch, Edition Variétées, Brussels 1929, pp. 473–81 and 575–81. (Translated from 'Jugenderinnerungen', *Das Kunstblatt*, vol. 13, June, July, August 1929.)

'Lebenserinnerungen' in *Kunst und Künstler*, vol. 29, October, November, December 1930. Part I, pp. 15–22, 10 illustrations.
Part II, pp. 55–61, 8 illustrations.
Part III, pp. 105–111, 10 illustrations.

'On my Drawings', in *George Grosz Drawings*, H. Bittner & Co., 1944.

'A Piece of my World in a World without Peace' in Exhibition Catalogue to *A Piece of my World in a World without Peace*, 1914–1946 New York, October 1946.

A Little Yes and a Big No: The Autobiography of George Grosz. Translated by Lola Sachs Dorin. 38 plates and numerous text drawings, The Dial Press, New York 1946. Italian edition *Un picolo Si e un grande No*, Longanesi, Milan 1948.

Ein kleines Ja und ein grosses Nein (based on Grosz's manuscript before translation into English and extended by him). Rowohlt Verlag, Hamburg 1955.

'Marginal Notes on the Subject' (reprinted and translated, by Margaret Vallance from 'Randzeichnungen zum Thema', *Blätter der Piscatorbühne*, Berlin, February 1928)in *Erwin Piscator, Political Theater* 1920–1966, catalogue to a photographic exhibition from the German Democratic Republic, organized by the Deutsche Akademie der Künste zu Berlin, Arts Council, London 1971, pp. 33–6, 5 illustrations and 1 cover drawing.

Books and articles on Grosz

Ahlers-Hestermann, Friedrich Statement on Grosz, in exhibition catalogue *George Grosz*, Akademie der Künste, Berlin, October–December 1962.

Anders, Günther *George Grosz*. Die Kleinen Bücher der Arche, Verlag Die Arche, Zurich 1961. 3 drawings, 1 cover drawing.

Foreword to *Ecce Homo*. Facsimile edition, Hamburg 1966.

Apfel, Alfred 'Reichsgericht über George Grosz – Aus der Prozessgeschichte', *Die Weltbühne*, 24 June 1930, pp. 952–7.

Ballo, Ferdinando, ed. *Grosz*, introduction by Gillo Dorfles. Includes many published essays on Grosz from 1920 onwards. Documenti d'Arte Contemporanea, Milan 1946. 58 plates, 5 colour plates.

Baur, John I. H. *George Grosz*. Catalogue for Grosz exhibition at the Whitney Museum of American Art, New York, Macmillan, New York 1954; Thames & Hudson, London 1954. 39 illustrations, 2 in colour.

Boyer, Richard O. 'Profiles, George Grosz: 1. Demons in the Suburbs.' *The New Yorker*, 27 November 1943, pp. 32–43.
'Profiles, George Grosz: 2. The Saddest Man in all the World.' *The New Yorker*, 4 December 1943, pp. 39–48.
'Profiles, George Grosz: 3. The Yankee from Berlin'. *The New Yorker*, 11 December 1943, pp. 37–44.

Brauneck, Manfred, ed. *Die Rote Fahne*, Uni Taschenbücher 127, Wilhelm Fink Verlag, Munich 1973, pp. 63–5, 72–3, 274, 322, 368, 471, 478.

Däubler, Theodor 'Georg Grosz', *Die Weissen Blätter*, vol. 3, no. 11, (Oct.–Dec. 1916), Verlag Rascher, Zurich and Leipzig 1916, pp. 167–70. 7 illustrations, pp. 160–66.

Dückers, Alexander Introduction '*Aus unveröffentlichten Briefen und aus Schriften von George Grosz*', in exhibition catalogue *George Grosz* Berlin, May–June 1971.

Friedländer, Salomo (Mynona) *George Grosz*, vol. 3. Künstler der Gegenwart, Rudolf Kaemmerer Verlag, Dresden 1922.

Hecht, Ben 'George Grosz', in exhibition catalogue to *A Piece of my World in a World without Peace* 1914–1946, New York 1946.

Herzfelde, Wieland 'The Curious Merchant from Holland', *Harper's Magazine*, vol. 187, November, pp. 569–76. New York 1943. Reprinted in *Immergrün*, Rowohlt Verlag, Hamburg 1961, pp. 82–95, and *Unterwegs – Blätter aus fünfzig Jahren*, Aufbau Verlag, Berlin 1961, pp. 114–32.
'The Man who gave me new eyes', in exhibition catalogue to *A Piece of my World in a World without Peace* 1914–1946, New York, October 1946.
'Wieland Herzfelde über den Malik Verlag', in *Der Malik Verlag, 1916–1947* exhibition catalogue of Deutsche Akademie der Künste zu Berlin, Berlin East, December 1966 – January 1967. Contains a complete bibliography of Malik Verlag publications, 12 drawings by Grosz, 2 in colour, 2 poems, 3 photos of Grosz.
John Heartfield, VEB Verlag der Kunst, Dresden 1961; second revised and enlarged edition, 1971 3 illustrations, pp. 24–5, 29; poems, plates 1–5, 4 photos, pp. 22–3, 26–7.

Hess, Hans Introduction to exhibition catalogue *George Grosz*, includes 'Instead of a Biography', translation Hans Hess of 'Anstatt einer Biographie', London 1963.
'George Grosz' in exhibition catalogue *George Grosz – Der Verrat an der Scheinheiligkeit*, Krefeld, November–December 1970.

Klingender, Francis D. 'Grosz goes West', *Contact*, London 1946.

Knust, Herbert 'Grosz's Contribution to the Berlin Schwejk Performance of 1928', in exhibition catalogue to *Theatrical Drawings and Watercolours by George Grosz*, Busch-Reisinger Museum, Harvard University, Cambridge 1973–4.

Koschatzky, Walter 'Der George-Grosz-Ausstellung zum Geleit', in exhibition catalogue *George Grosz*, Vienna, February–March 1965.

Lang, Lothar *George-Grosz-Bibliographie*, in *Marginalien*, Zeitschrift für Buchkunst und Bibliophilie, edited by the Pirckheimer-Gesellschaft, no. 13, Berlin, July 1968.

Lewis, Beth Irwin *George Grosz: Art and Politics in the Weimar Republic*. Contains complete critical bibliography under heading 'Check List'. University of Wisconsin Press, Madison, 1971. 89 illustrations, 1 title page, 5 photos of Grosz.

McOrlan, Pierre Foreword in exhibition catalogue *George Grosz*, Paris 1924.

Mehring, Walter *Berlin Dada*, Verlag der Arche, Zurich 1959, 8 drawings, 1 on the back of the jacket, 2 photos.
Statement on Grosz in exhibition catalogue *George Grosz*, Akademie der Künste, Berlin, Oct.–Dec. 1962.

Piscator, Erwin 'Statement on Grosz' in exhibition catalogue *George Grosz*, Akademie der Künste, Berlin, Oct.–Dec. 1962.

Ray, Marcel *George Grosz* in series *Peintres et Sculpteurs*, Les Éditions G. Crès & Cie, Paris 1927. 30 plates, 10 text illustrations, 1 title page, portrait photo.

Richter, Hans 'George Grosz: Das Feuer' in *Dada Profile*, Verlag die Arche, Zurich 1961, pp. 56–8.
Dada – art and anti-art, 3 Berlin Dada 1918–1923, Thames & Hudson, London 1965, pp. 101–29.

Tucholski, Kurt 'Der kleine Gessler und der Grosse Grosz', *Collected Works*, vol. I, Rowohlt Verlag, Hamburg 1960, pp. 751–2 (reprinted from *Freiheit* 24 October 1920).
Der Dada – Prozess', ibid., pp. 800–804 (reprinted from *Die Weltbühne* no. 17, 28 April 1921). Die Fratzen von Grosz', ibid., pp. 815–17 (reprinted from *Die Weltbühne*, no. 33, 18 August 1921).
Die Begründung', vol. III, pp. 52–6 (reprinted from *Die Weltbühne*, ibid., no. 12, 19 March 1930).

Wilson, Edmund Review of *A Little Yes and a Big No*, *The New Yorker*, 4 January 1947.

Wolfradt, Willi 'George Grosz: Der Abenteurer', (reprinted from *Der Cicerone*, vol. 11, no. 23, 1919) in exhibition catalogue *George Grosz*, Munich, April–May 1920.
George Grosz, monograph, *Junge Kunst*, vol. 21, Klinkhardt & Biermann Verlag, Leipzig 1921. 32 plates and text illustrations, coloured title page.

Zahn, Leo 'George Grosz', in exhibition catalogue *George Grosz*, Munich, April–May 1920.
'Über den Infantilismus in der neuen Kunst' (reprinted from *Das Kunstblatt*, vol. 4, no. 3, March 1920).

Photocredits

Pictures of which the present ownership is unknown, have been reproduced by courtesy of the Estate of George Grosz from photographs bearing the artist's autograph inscription.

Associated American Artists 185, 203; Oliver Baker 1, 219; Lotte Esser·Darmstadt 58; Bittner & Co. 199; Sally Chappell 4–7; Geoffrey Clements 16, 213; Colten Photos 129, 193, 195, 198, 203, 205, 218, 220; Cuming Wright-Watson 40, 67, 72, 78, 96, 97, 99, 117, 172; Eeva-inkeri 41, 48; Foto Guilka 88; Galleria d'Arte Galatea, Turin 61, 106; David Hoinkis Görlitz vi; Peter A. Juley & Son 221, 222, 224; Ralph Klein 54; Ralph Kleinhempel 87; Kleopatra 46; Vera Lazuk 119, 168, 200, 201, 202, 212, 225, 226; Richard di Liberto 124; Marlborough Fine Art, London 35, 62, 114, 126, 130, 132; Robert E. Mates 155; W. F. Miller & Co. 175; Achim Moeller 18; Ann Monchow 134; Hilda Peill 42; R. Petersen 11, 12, 34, 133; Eric Pollitzer 157; Rampazzi 55; Nathan Rabin 17, 19, 38, 76; Percy Rainford 169; Rheinisches Bildarchiv 52; Walter J. Russell 165; Marc Sandler ix; Staatliche Kunstsammlungen Dresden 45, 102; Staatsbibliothek, Berlin 14, 15; Lotte Schmalhausen 43, 54, 71, 77, 89, 93, 104, 115, 116, 120, 127, 129, 135, 138, 143, 149, 162; Sotheby & Co. 68, 74, 152, 170, 208; Walter Steinkopf 60; Sunday Times 214–17; Charles Uht 183; VEB Verlag der Kunst, Dresden 51, 121, 122, 123, 137, 139, 145, 146, 175, 176; Walker Galleries, New York 158, 173, 186, 194, 197.

Index